THAI TATTOO MAGICK

"A powerful account of traditional Thai magick written into the skin of a dedicated spiritual seeker. Sheer Zed approaches his pilgrimage and healing journey with great sensitivity and bravery and is transformed in partnership with the Ajarn and living spirits who now share his body. An important resource for those drawn to the transformative magic of tattoo and the traditional magical arts that the Thai people have gifted to the world."

PETER GREY, AUTHOR OF *THE RED GODDESS*
AND COFOUNDER OF SCARLET IMPRINT

"An authentic initiate, Sheer Zed has written an intriguing, in-depth exploration of Sak Yant and the complex initiation practices of Thai Buddhism, sharing his own moving story of loss, discovery, and transformation during four separate pilgrimages. Essential reading for anyone interested in Thai tattoo magick."

JUNE KENT, EDITOR OF *INDIE SHAMAN*

"A fascinating glimpse into the *invisibilia* of Thai culture, and one that invites—even needs—participation in order to be fully understood. Herein, the reader will find luck-bringing Jing Jok spirits, a 'redneck ghost doctor,' and a person seeking—and perhaps finding—something clear and real while still sitting with

human(e)-ness with its foibles, its messiness, and its often-unseen beauty. Sheer Zed takes us along for the trip through an autobiography *en spiritu* traced upon skin and etched in the heart-mind."

JOHN ANDERSON, DAOM, AUTHOR OF
THE WAY OF THE LIVING GHOST AND
OPENING THE VERMILLION SPIRIT

"Sheer Zed offers this fascinating account of the forgotten sacred art of body inscription. Vivid, visceral, and valiant. Stories of integrity and adventure abound. As readers, we travel on the author's words to a world rarely seen and reverently understood."

SARA MCCARTHY, MUSICIAN AND
PROFESSIONAL TAROT READER

THAI TATTOO MAGICK

THE INITIATORY PRACTICES OF THE THAI BUDDHIST MAGICIANS

A Sacred Planet Book

Sheer Zed

Inner Traditions
Rochester, Vermont

Inner Traditions
One Park Street
Rochester, Vermont 05767
www.InnerTraditions.com

Text stock is SFI certified

Sacred Planet Books are curated by Richard Grossinger, Inner Traditions editorial board member and cofounder and former publisher of North Atlantic Books. The Sacred Planet collection, published under the umbrella of the Inner Traditions family of imprints, includes works on the themes of consciousness, cosmology, alternative medicine, dreams, climate, permaculture, alchemy, shamanic studies, oracles, astrology, crystals, hyperobjects, locutions, and subtle bodies.

Copyright © 2025 by Sheer Zed

All rights reserved. No part of this book may be reproduced or utilized in any form or by any means, electronic or mechanical, including photocopying, recording, or any information storage and retrieval system, without permission in writing from the publisher. No part of this book may be used or reproduced to train artificial intelligence technologies or systems.

Cataloging-in-Publication Data for this title is available from the Library of Congress

ISBN 979-8-88850-171-9 (print)
ISBN 979-8-88850-172-6 (ebook)

Printed and bound in the United States by Lake Book Manufacturing, LLC
The text stock is SFI certified. The Sustainable Forestry Initiative® program promotes sustainable forest management.

10 9 8 7 6 5 4 3 2 1

Text design by Debbie Glogover and layout by Kenleigh Manseau
This book was typeset in Garamond Premier Pro with Rocky Compressed and Newbery Sans Pro used as display typefaces.

Photographs by Sheer Zed unless otherwise noted.

To send correspondence to the author of this book, mail a first-class letter to the author c/o Inner Traditions • Bear & Company, One Park Street, Rochester, VT 05767, and we will forward the communication, or contact the author directly at **linktr.ee/SheerZed**.

Scan the QR code and save 25% at InnerTraditions.com. Browse over 2,000 titles on spirituality, the occult, ancient mysteries, new science, holistic health, and natural medicine.

This book is lovingly dedicated to the memory of Muriel Griffiths, my mother who died during the last stages of my completion of this manuscript.
I will always love you, Mum x

The person who reaches the sacred, the
Inexpressible,
Who has permeated his mind with it,
Who is in control of his senses,
Is one bound upstream.

THE DHAMMAPADA

The seers protect the evidence from the truth;
they have encased their greatest designations in a secret.

RIG VEDA 10.5.2

Contents

	Acknowledgments	xi
	Preface: A Life Transformed	xiii
1	**Sak Yant** *The Spiritual Hallmark of Sacred Mastery*	1
2	**Entering the Stream** *Many Tributaries Lead to One Ocean*	17
3	**Thai Magick and Buddhism** *A Short History of Sorcery and the Death of My Father*	42
4	**Preparing for the First Trip** *A Convergence and Assembly of Spirits*	53
5	**The First Pilgrimage** *Go East, Young Man*	59
6	**First Rituals and Mistakes** *Renouncing Alcohol and the Past*	70
7	**A Punched Solar Plexus** *Setting My Laundry to "Fuzzy"*	81

8	**The Power of Amulets**	87
	The Amulet Chooses You	
9	**The Second Pilgrimage**	95
	Lost in Exotic Pastures	
10	**Thursday Is Lersi Day**	104
	Serm Duang Ritual Bath and the Second Sak Yant	
11	**Wat Phra That Doi Saket Jing Joks**	122
	Trapped in a Strange Unending Time Loop	
12	**The Acquisition of the Miit Mhor**	139
	Lek Nam Phi, Akhara Script, and the Keris Blade	
13	**The Year between Pilgrimages**	153
	Transformations and Processing Magickal Rituals	
14	**The Third Pilgrimage**	161
	Personal Revelations and Reaching the Golden Temple	
15	**The Ouroboros Effect**	174
	Muang On Caves and the Hair of the Buddha	
16	**The Cult of Mae Surasatee**	189
	In Praise of Twenty-One Catfish and All Sentient Life	
17	**The First Hell Garden**	202
	Chiang Dao District and Offerings for Phra Rahu	
18	**Phaya Nāga in Chiang Dao Caves**	218
	Yant Ittipiso Paed Tidt and Unseen Energies	
19	**Wat Mae Kaet Noi**	229
	Ajarn Perm Rung's Gift and Goodbye to the Cats of Varada Place	

20	**On the Precipice of Pandemic** *The Benefits of Acquiring Magickal Protection*	237
21	**Cat Yants, Baphomet, and Jackfruit** *Following the Trail of Peter Christopherson*	249
22	**Remote Rituals** *Ajarns Are Buddhist Technicians*	257
23	**The Final Pilgrimage** *The Death of My Mother and the Arrival of Magia Thai*	265
24	**Modern Lersi** *Ajarn Nanting's Magick and the Living* *Spirit of Suea Yen*	278
25	**Aftermath of the "Cool Tiger" Sak Yant** *Homage to Ganesha and the Takrut Needle*	296
26	**The Countryside Sorcerer** *Rivers, Mountains, and the Temple to* *Luang Phor Tuad*	314
27	**The Proverbial Full Back** *One Whole Side of My Body Becomes* *a Sacred Talisman*	328
	Conclusion: This Magickal Mapping *Ruminations on Silence, Chanting, and* *a Spiritual Pathway*	335
	Bibliography	347
	Index	357

Acknowledgments

Sheer Zed wishes to thank Ajarn Suea, Ajarn Nanting, Ajarn Apichai, Ajarn Daeng, Ajarn Perm Rung, Ajarn Tui, Ajarn A Klongkarn (Ajarn Suthep), Kruba Pornsit, Kruba Noi, Kruba Teainchai, Lersi Nawagod, Ajarn Spencer Littlewood, Magia Thai, The Warriors House in Chiang Mai, Thailand, The Udee Cozy Bed & Breakfast, Chiang Mai, Erzebet Barthold at Hadean Press, Jake Stratton-Kent for your ex-libris books purchased via Midian Books smelling of old tobacco and magick, Mogg Morgan, Phil Hinc, Bristol Museum, Peter Grey at Scarlet Imprint, Paul Watson at The Lazarus Corporation, my cousins Grace Radford and Karen Bendtsen for their generosity, kindness, and loving thoughts, John Conway for being a good friend, Sara Mason for her kindness and making helpful scheduling changes, Sue and Mar for being wonderful neighbors, Thai Airways, National Express coaches, Ehud Sperling, Courtney B. Jenkins, Chris Cappelluti, Manzanita Carpenter Sanz, Kelly Bowen, Jeanie Levitan, Albo Sudekum, Jodi Shaw, and Jon Graham at Inner Traditions for their vision, kindness, timely emails, and professionalism, and finally but by no means least, Richard Grossinger for believing in me in the first place. Praises to Mae Surasatee and Phra Rahu.

PREFACE

A Life Transformed

Writing has an amazing way of prying open the darkness and lighting up the hidden corners in all manner of things that have lain invisible or dormant just under the surface of the mind. I have read that writing is a form of exorcism, a magick ritual, a summoning, that casts out demons that have been trapped or prevented you from moving forward in your life. Unspoken and unwritten words can thus be seen as chains or handcuffs of denial that make any attempt at moving on or achieving closure almost impossible. I have reams of unpublished poems, for example. How can one live an authentic life if you can't even process or acknowledge the life that you have already lived? Maybe memory and the implementation of those memories as words can be seen as spookish attempts at some form of permanence in an impermanent world. Typesetting the ever-shifting air and thought streams of existence does not have any special appeal to me and yet type I must. Reading however in my mind is as equally as important as writing.

One book that struck a firm resonant chord that has lasted deep inside of me for many years is *Tantric Quest* by Daniel Odier (Inner Traditions, 1997). I came into contact with it during my time working as a bookseller in Borders Books and Music in Torrance, Los Angeles,

xiii

during the early 2000s. This tale of a young devotee seeking a master to help him penetrate and explore beyond the intellectual for wisdom and spirituality did much to fire my hungry inquiring mind. Many years later this work has found itself in a very prescient place in my library since it strangely pre-visualized my own later life experiences while on pilgrimages to Thailand, if not in exact detail or specific spiritual pathway, then most certainly in the spirit and direction of its subject matter. The depth of intimacy of experience shared in this book did much to move me to dig deeper into my spiritual pursuits and I heartily recommend it to anyone that has an interest in undertaking their own personal spiritual quest.

Thai Tattoo Magick is the result of the long and unending polishing of the stone over the course of four pilgrimages between the years 2017 to 2023, where I was transformed into a magickal being through various magickal rituals, some of which were extreme in nature. The deaths of both of my parents and my sister have been the touchstones and engine for this extensive quest. Treading on a pathway is fraught with hidden dangers. It's how one faces them is what defines us. As Odier writes in *Tantric Quest*, "All nature is subject to transformation."

Thai Buddhism is a unique and highly unusual conglomeration of many seemingly different traditions. It is made up of numerous facets, like a diamond. Necromancy, astrology, animism, psychic mediumship, temples, shamanic rituals, Buddhism, magick (which is seen as not black or white or otherwise but just a tool to do a specific job), along with *Sak Yant* (sacred and magickly functional tattoos), amulets, and *buchas* (sacred statues with active magickal ingredients though this term also means "to praise or worship") all loaded with active spiritual ingredients. The number of Thai magick rituals I've undergone is extensive: The Satuang Ritual; a cleansing bath with Ajarn Suea thrice, an invisible, clear oil based ink Mae Surasatee Sak Yant from Ajarn Nanting, The Kasin Fai Ritual and The Na Naa Thong Ritual or "gold face

blessing" with Ajarn Apichai. This doesn't include the numerous separate Sak Yant rituals I've undergone, many with the remarkable Ajarn Daeng. To say the least, I am not the same man that stepped off the plane at Bangkok Airport in September 2017.

This book catalogs some of my own transformations over time, though not all of them. For like bubbles rising up the side of the glass, some experiences vaporize, never to be seen again. Like passing thoughts they are lost, forever unrecognized. I may observe them, but hold no attachment to them. While meditating in a cave in Thailand my presence of mind became becalmed within the realms of my land. My encrypted astrological birth time and day coordinates were inscribed by an Ajarn onto a magical takrut and embedded deep inside the golden statue of the Buddha inside a sacred golden temple on a hilltop overlooking Chiang Mai. I close my eyes and I am transported immediately into the Buddha's central core. Wherever I am on the face of this planet, here I reside, in bliss with inner peace, all attachments renounced and all suffering extinguished.

<div align="right">SHEER ZED ॐ</div>

1
Sak Yant

The Spiritual Hallmark of Sacred Mastery

Spirituality founded on materialism is ultimately devoid of meaning. Likewise, there is a huge difference between "spiritual tourism" and meaningful pilgrimage. Preparation, contemplation, and meditation are essential prerequisites for any successful pilgrimage abroad. When entering a new, alien, and unknown environment, one must do their best to be sincere, flexible, and undemanding rather than stubborn. For me, Sak Yant is not just a "spiritual tattoo" and—despite the undeniable esoteric charm, gravity and magnetism they exude—is not just a "souvenir" or ordinary road-side tattoo. The sublime living spirits inherent to Buddhist magick actively inhabit the countless myriad forms of Sak Yant. My encounter, engagement, and full immersion into Thai Theravāda Buddhism is characterized by what can only be described as a predestined affinity, a journey over a long and serpentine pathway in which I explored many other variants of this profound philosophy.

To place undue limitations and definitions upon the forms that are known as Sak Yant would be of course to reduce its exquisite and pristine essence. Sak Yant is definitely a commitment to living in a very specific manner. The fine print requires one to uphold certain values that reflect the magickal components of this deliberately constructed

tattooed spell. Irrespective of whether the monk or Ajarn is more than happy to accommodate Westerners in its application, it is extremely important to understand that Sak Yant is an ancient animist, faith-based, shamanic, cosmic, and ultimately Buddhist magickal spell that will profoundly alter one's mind and psyche. Equipping oneself with a basic working understanding and knowledge of Thai Buddhism and animism (which have evolved alongside each other and in tandem with many other esoteric practices) before plowing headlong into acquiring a Sak Yant tattoo, is to demonstrate the basic respect required in order to properly receive such a powerful form of magick. Unthinkingly scouring the internet or books for designs to match one's personal, ego-driven urges, much in the way one might shop for new clothes, is not a good idea. However, meditating upon messages and signs that arise while in meditative absorption or contemplation is heartily encouraged. If your own deep intuitive impulses lead you to a very specific design this means that this particular design is calling you. I encourage seekers to find an Ajarn to assist them.

An *Ajarn* is a Thai language term, which translates as "professor" or "teacher." It is derived from the Pali word *ācariya*, and is a term of respect, similar in meaning to the Japanese *sensei*. Personally, I liken the term *Ajarn* to "magician." This is because Ajarns can perform Sak Yant rituals, magickal rituals, blocking spells; create amulets and Pha Yants (magickal hanging cloth); and bless all manner of situations and occasions. The experienced Sak Yant practitioner has absorbed and memorized whole sets of scripts and yantra in ancient languages such as Khom, Pali, Lanna, Tai Yai, Old Mon, and Burmese.

Abstract, mystical designs resembling yantra initially birthed themselves during early Indian history in the Harappan Culture Civilization, an Indus Valley Bronze Age civilization in the northwestern regions of South Asia (3300 BCE to 1300 BCE). Then, through subsequent cosmic symbolistic evolutions in Vedic (c. 2000 BCE) and later tantric renaissance (700 CE to 1200 CE), they eventually migrated from India

into Southeast Asia. The yantra of the ancient sacred geometry of the Vedic Brahman tradition, considerably older than Thai Buddhist yantra, encountered numerous influences, and, while still being an integral and essential part of the spiritual landscape for centuries, yantra underwent its own very unique evolutionary reinterpretation in Southeast Asia. References to sacred tattoos date back to second-century Chinese records of the Cambodian Funan Kingdom located around the Mekong Delta from the first to seventh centuries. It is widely accepted however that the Cambodian tattoo tradition can be traced back to northern Thailand. In the fourth century CE, Chinese records refer to the tattooed P'u people on their southern borders as wearing "skin garments." I was blessed to have spiritual guidance via the visions of Ajarn Suea, who, on two occasions—and much like a doctor prescribing medicine to a patient—saw (or "diagnosed") specific Sak Yant designs for my body.

One would not be remiss to view Sak Yant design as a piece of magickal software written onto the hardware of the human body. After all, they rewrite the mind, body, and spirit of the person that wears them. Sak Yant should not however be viewed as a security patch. These are extremely potent, active talismans, each one a rock-solid and powerful piece of yantra firmware that fundamentally changes those that have it implemented onto their body. Certain Sak Yant designs such as tiger (Suea Yen) and Hanuman cannot be worn by just anyone. The devotee must be able to control these Sak Yant. Much like driving a fast, high-powered vehicle that one does not know how to properly control, Sak Yants can prove fatal if not managed and handled correctly by those that hold them upon their body. Yes, it is possible for anyone to get a Sak Yant; as of the writing of this book, there is no bar whatsoever as to who can obtain one. And yet, the consequences of allowing these designed yantra spells to take residence upon your body without proper understanding or knowledge range far and wide. Being unaware of the religious and cultural sensitivities of the unknown places you visit for the first time is not advisable and can even ultimately end in your arrest

4 *Sak Yant*

and deportation. For example, activating the Sak Yant in the proper manner, requires one to understand and adhere to the basic Buddhist precepts* that surround Sak Yant, which—while I will go into these in more depth later—I will lay them out here as follows:

1. Do not kill
2. Do not steal
3. Do not indulge in sexual misconduct
4. Do not make false speech
5. Do not take intoxicants

The Eight Precepts—of which I hold the eighth—are the first Five Precepts plus three more, which are listed below. The Eight Precepts are observed by nuns, lay Buddhists, and are observed on special days of observance as forms of purification, cleansing, and aiding meditation. In Thailand, if one of the eight is broken, they are all broken.

6. Abstaining from taking food at the wrong time (before noon only)
7. Abstaining from dancing, music, visiting shows, flowers, make-up, the wearing of ornaments and decorations (extremely difficult for me being an amulet-and flower-loving musician!)
8. Abstaining from sleeping in a tall, high sleeping place (I sleep on a ground level futon)

It is important to note that there are invisible karmic wires attached to receiving Sak Yant. Blessings chanted by an Ajarn or monk can incorporate taking refuge in the three jewels of Buddhism namely the Buddha (Siddhartha Gautama, most commonly referred to as the

*Mark my words, it behooves you to understand these Five Buddhist Precepts; I know from personal experience that not doing so results in real-world consequences.

Buddha), the Dharma (The Buddhist path to liberation, referred to as awakening), and the *Sangha* (a Sanskrit word used in Indian languages, including Pali, meaning "association," "assembly," "company" or "community"). The initiatory chanting of the three jewels of Buddhism is viewed by some as a ritual facilitating one's formal conversion to Buddhism. Do the countless waves of tattoo-hungry Westerners flooding into Thailand to acquire Sak Yant understand that they are converting to Buddhism when they receive a Sak Yant? Maybe. Maybe not. Either way, don't assume that leading the life of a dissolute Westerner (of which I counted myself as one before encountering the Ajarns of northern Thailand in 2017) in any way excuses you from a duty to uphold the Five basic Precepts necessary to maintain the efficacy of your Sak Yant.

If you do not uphold the precepts, your Sak Yant will fail to work as it should. However, on the other hand—in my personal experience—upholding the precepts guarantees results that are nothing less than magick. Some say that upholding the Buddhist precepts makes Sak Yant "superstitiously effective." I find use of the word *superstitious* here to be dismissive and therefore urge caution in its use. In Thailand, what many Westerners would label "superstition" is in fact a deeply embedded part of Thai tradition, heritage, and cultural landscape. The earliest known use of the word *superstition* in the West as a noun can be found in the work of early Romans such as playwright Plautus, poet and writer Ennius, and lastly, the author Pliny, who refers to it as the art of divination, namely "divinatory practice." From the first century CE we are given another meaning, which is to "practice outside official religion."

Do you have to be a strict, practicing Buddhist to receive Sak Yant? No. Indeed, sex workers, criminals, and all manner of people with a multiplex of personal behaviors can and do get Sak Yant. Still, it is absolutely necessary to have a basic working understanding of what you are getting into. Luang Pi Nunn of Wat Bang Phra states that faith is the

undeniable force that powers Sak Yant, "You have to have faith to get a tattoo for it to work. You have to believe in it. Otherwise these tattoos are worthless." Wat Bang Phra is a mecca for Sak Yant that hosts an important four-day Wai Khru (meaning to pay homage to one's teacher) festival held on the temple grounds once a year during the beginning of March, when thousands of disciples gather to pay respect to the spirit of the great Sak Yant master Luang Pho Poen and are tattooed in relays or have their preexisting Sak Yant blessed and reempowered. This iconic Buddhist temple and monastery is located thirty miles outside of Bangkok in the province of Nakhon Pathom.

Because the practice of Sak Yant tattooing predates Theravāda Buddhism (the tradition it is now most closely linked to), there is an ongoing debate in Thailand as to whether Sak Yant even actually belongs solely in the Buddhist tradition. Regardless, Thai Sak Yant is shaped and influenced by a wide range of complex influences including Buddhism, Animism, Thai folklore, Shamanism, Brahmanism (there are fewer than fifteen actual ordained Phra Phram Brahmins in the whole of Thailand), and Hinduism.

Sak Yant has a brick wall, life-changing impact and power. Being prepared in mind, body, and spirit is important and cannot ever be underestimated. Dissuading you (and thus denying all of the hardworking and devout Thai monks and Ajarns of prospective donations) is not my intention however. Travelers will journey and seek, as is their wont. Ajarns will require your devotion—as I have done and continue to do—long after the first pilgrimage has ended, to be continued throughout your remaining lifetime. It is neither appropriate nor wise to question the wishes of Ajarns, who, despite making decisions that are seemingly beyond your understanding or that may trigger reactions inside you, are teachers who must always be respected. In the book *Thai Magic Tattoos*, Isabel Azevedo Drouyer and René Drouyer highlight the importance of the teacher as a master of extaordinary power: "Once the Yant is complete, the tattoo must be consecrated. During the consecration cer-

emony the master recites a magical sequence of syllables and evokes the spirit of the Yantra, asking it to enter and possess the characters of the tattoo. This spirit may belong to a Ruesi, a god, a hero, a monk or to a deceased master." Most Ajarns have spent time as monks. For some Western students time spent as a monk can be as short as one to six months while many native-born Thai practitioners as much as sixteen, seventeen, or even twenty years, accumulating enough merit, knowledge, purification, along with experiencing various stages of samādhi, to understand and comprehend many unseen things, unknowable to most.

There will always be an ongoing conveyor belt of tourists who are basically just looking for a good time, which is of course, not a crime. That being said, Thai tourism, still staggering after a severe and crippling three-year shutdown and ensuing financial abyss from the global pandemic, is slowly but surely turning its attention away from the promotion of the sex and drug industry in favor of a so-called *soft power** approach. What this means in real terms is that Thailand's reputation amongst Westeners as a party destination (a place for those who desire a drug and sex-fueled vacation to visit) is slowly giving way to one that in which spiritual, magickal attractions feature more prominently. Given that the Theravada Buddhist tradition has prevailed in Thailand since 1902 (when the Sangha bureaucracy was initially established), it only makes sense that Thailand would choose to promote these aspects of its culture as it seeks to establish a unique (and more highly respected) place in the international tourism scene.

The heavily publicized event of Ed Sheeran acquiring a Sak Yant on his upper thigh in February 2024 reflects the tourist industry's move away from flagrant debauchery and more towards Thailand's traditions and culture. Ed Sheeran's Jatutit Yantra—a combination of a modified Fon Saen Ha or Rain Talisman design incorporating the Ittipiso Paed

**Soft power* refers to the ability to influence or shape the preferences of others through attraction rather than coercion.

Tidt (8 Directions) magickal text and blessing by the respected master Ajarn Neng—signifies this broadening of the Westerner's concept of Thai culture to include more traditional elements.

In all honesty, my initial gut reaction to the publiclity surrounding Sheeran's Sak Yant event—which in no way reflects my feelings about highly respected Ajarn Neng—was a questioning of Sheeran's intentions. Does Sheeran regard his Jatutit Yantra as just another tattoo among a plethora of others on his body? Or does his acquiring of a Sak Yant signify the beginning of a lasting philosophical and devotional commitment to following a specific pathway? His thousands of fans and admirers would of course unquestionably defend him against anyone (such as myself) who questions his motives or intentions for acquiring a Sak Yant. And yet question I must. Angelina Jolie—who acquired her first Sak Yant (by the revered Ajarn Noo Kanpai) back in 2003—is another story entirely. As a highly regarded global humanitarian, United Nations High Commissioner for Refugees (UNHCR) Goodwill Ambassador, advocate of human, child immigrant, and women's rights, and conservationist, she has proven time and time again her profound devotion and highest respect for the sacred Sak Yant on her body.

To be certain, it is my sincerely heartfelt personal belief that Sak Yant are a deep calling from spirit residing within the inner planes, carrying a sacred and holy message, meant to be followed and upheld. My intent in advocating for the preservation of Sak Yant's Thai, Burmese, Laos, and Cambodian traditions and recommending caution around the impulse to deliberately lower the standards and integrity of a spiritual pathway in order to generate financial gain should in no way be interpreted as a push to become a nationalist or Buddhist extremist. Forbid the thought! I say this here because I was surprised—after expressing my thoughts on this matter on social media—to find myself accused of being a "gatekeeper" by a random person on the internet. In the end, however, this interaction served to show me that my fierce willingness to defend the sanctity of Buddhism can never be without doubt.

Sak Yant 9

For me, the magickal act of acquiring Sak Yant is directly tied to the act of pilgrimage. My call to pilgrimage arrived when—through my love and practice of music—Mae Surasatee reached out to me, prompting me to follow what would turn out to be a life-changing path to Thailand. During my travels, I learned firsthand how essential physical sacrifice is to any act of pilgrimage. Although not explicitly recognized by Buddhist teachings, the value of pilgrimage is directly tied to the level of suffering pilgrims endure on their journey. In this sense, the act of acquiring Sak Yant is, in and of itself, a form of pilgrimage. After all, the Sak Yant rod, driven into one's flesh, cannot be anything less than an act of physical sacrifice. And yet, these rituals comprised only one aspect of the considerable suffering I encountered in my personal life, physically and emotionally, before, during, and after my pilgrimage.

Upholding more than just one of the Five Precepts (at the very least) while acquiring a Sak Yant is, in my mind, also essential. This is in spite of Sak Yant's origins in an ancient, animist, and shamanic past, which—to some in Thailand—renders it an unsophisticated and un-Buddhist remnant from a bygone era. I myself am devout and yet playful. I am disciplined and yet rebellious. I am not in any way whatsoever perfect. Very far from it. I have lapses, and I both ruminate and regularly laugh at my own fallible human shortcomings. And yet, making attempts at upholding the basic principles and precepts underlying the magick of Sak Yant must still be made. Depending on the Ajarn and the design, some Sak Yants have a limited charge, which require recharging by the Ajarn. Some more powerful Sak Yant require a longer term of user agreement between the Ajarn and the devotee. To maintain the power of my Sak Yant, I chant khatha (mantras) every single day, morning, noon, and night. I also have a stock of Sompoi (an herb used to cleanse the body of defilements), which also acts to energize the Sak Yant. My fastidious approach to Sak Yant maintenance is again because the wearer of Sak Yant must uphold Buddhist ethics in order to prevent weakening of the blessing's core effects. If one transgresses these

rules, depending on the level and depth of the transgression, heavy fallout can occur, ranging from mental illness, loss of employment, a slow and painful death, or rebirth in a hell realm. In order for the Sak Yant to consistently work one must also carefully follow the rules (precepts) as laid down by the Ajarn who delivered the Sak Yant in the first place.

As a reminder, Ajarns often display their own specific interpretations of these very specific rules of conduct—some of which originate from the rules for novice monks—on the walls of their Samnak. On the walls of Ajarn Daeng's Samnak for example, a sign reads:

> Do not eat the meat of a dog or a snake, the food from an altar or leftover food from someone else. Do not walk under clothes lines, under the stairs or steps and do not go under banana trees. Do not disrespect parents or Ajarns. Please keep the five precepts, especially the third precept concerning not having an affair. Please say kata (khatha) every day. If your yants have no kata then say Namo Dtassa to the Buddha please. If any of the rules are broken please return to the Samnak and make an offering of flowers, incense and candles to the altar and bathe in Sompoi to cleanse the yants of defilement.

While these may differ from Ajarn to Ajarn they all have an inherent, basic form. Confusion arises, usually in posts on social media, when different rules from various lineages and backgrounds are thrown together in a hodgepodge of dos and dont's. For example, while peculiar and seemingly bizarre, the following precepts originate from Wat Bang Phra, some of which—as in Ajarn Daeng's rules for Sak Yant—directly relate to the training of novice monks only:

- Do not eat star fruit, Makham Pom, green pumpkin, or any other "gourd" type vegetable
- Do not eat food from a funeral
- Do not duck under a washing line, or an overhanging building

Sak Yant 11

- Do not duck under a banana tree of the type Tani Banana Tree (Nang Tani "Lady of Tani" is a female spirit of the Thai folklore and according to folk tradition, this ghost appears as a young woman that haunts wild banana trees)
- Do not cross a single head bridge, large or small bridges are forbidden
- Do not sit on a ceramic urn, especially a cracked, or broken one
- Do not let a woman lie on top of you, or sit on top either
- Do not permit a man to be brushed by the blouse or skirt of a woman, or crossed in front of, especially during the menstruation period

It is important to note that in Thailand blood from menstruation is viewed as a powerful and destructive force against the magickal cohesive power of Sak Yant. This particular belief strain could quite possibly stem from the attitudes, superstitions, and beliefs that are based on Hindu influence, which were strong in Burma/Myanmar up until the eighteenth century. While I personally believe that women are not just powerful beings of life-giving energy and extremely important in all matters of spirituality, they also hold an important place in Thailand as practitioners of Buddhist magick since the standards demanded from them are considerably higher. For example, despite Thailand's Supreme Sangha Council persistently arguing that the lineage of the bhikkhuni order, under which women could become a fully ordained Buddhist nun, died out long ago, fully ordained nuns must follow 311 precepts (while monks adhere to only 227), ranging from celibacy and poverty to archaic ones like having to confess after eating garlic. It did momentarily cross my mind that the strong aversion to menstruation blood, specifically in regard to Sak Yants, was quite possibly a form of male envy. In Indian Tantric folk practices, sex with menstruating women, accompanied by the ingestion of a drink composed of semen, blood, and bodily fluids (described in song as a "full moon at the new moon") is a rebellious and

diametrically opposed ritual of refusal against any repressive male orientated conservatism. Thai Buddhism has woven into itself traditions from surrounding cultures while still very much retaining its own robust philosophical powerhouse identity. It may not be too much of a stretch to imagine that the Chinese folk practice of taking Hsien T'ien Tan Ch'ion pills, which are made up of menstrual discharges of attractive young girls, may have at some point possibly crossed the borders with traveling merchants into the realms of Thailand.

The Western misuse of Asian Buddhist symbols in tattoos is a subject that has the potential to spark much controversy and violent reaction. In 2011 for example, the Thailand Ministry of Culture proposed a ban on religious tattoos for tourists. In Spring of 2015 a billboard next to an international airport in Thailand informed tourists that it was considered inappropriate to get tattoos of the Buddha. A few months later, state officials arrested Jason Polley, a Canadian tourist, and his girlfriend, Margaret Lam, at their Myanmar hostel after photographs of Polley's Buddhist tattoos went viral on social media. And again in 2015, Matthew Gordon—a law student from Melbourne, Australia—while sitting at a restaurant in the southern city of Bangalore, India, with his girlfriend, was surrounded by a dozen activists from the ruling Hindu nationalist Bharatiya Janata Party who began harassing the couple. The confrontation arose around the issue of a tattoo on Matthew's shin of the Hindu fertility goddess Yellamma, mother of Parashurama, the sixth avatar of god Vishnu. The group of activists, which quickly grew to twenty-five men, blocked the restaurant making clear to Matthew that the tattoo had offended their religious sentiments, ordering him to remove it. "One of them came to me and confronted me about my tattoo. Soon they surrounded us and threatened to skin my leg and remove the tattoo," Matthew stated in the press. Fortunately, the police intervened, remanding Matthew and his girlfriend to the Ashok Nagar police station "for their own protection." At the time, the incident was seen as part of a growing climate of intolerance and lack of free expres-

sion under Indian Prime Minister Modi's right-wing extremist government. This is not the complete picture, however. What Matthew had failed to understand, despite being a devotee of the Hindu faith and having a large tattoo of Ganesha on his back, is that tattoos of female deities below the waist on the skin of a man are seen as offensive and very sacrilegious.

If he had placed the tattoo above the waistline and had covered it up, then quite possibly he could have continued to enjoy his meal (and the rest of his trip to India) without issue. However, any person bearing a tattoo of a Hindu deity must absolutely be seen to have a clean body and even more importantly, a clean mind and thoughts. Matthew later stated that he had placed the tattoo on "the only bit of space I had left on my body." Placing the Hindu fertility goddess Yellamma on a part of the body that is near to the ground is viewed as being very untoward, much in the same way statues of Buddha placed directly on the floor is viewed in Thailand. It's bad practice and creates negative karma for anyone acting without doing solid research and acquiring proper information prior to any permanent decision-making. Matthew's choice of location for his tattoo was ultimately a reckless decision, incurring the wrath of the local population. Often viewed as being actual living entities themselves, images of all deities are considered sacred, holy, and spiritually active representations of that deity.

While some of these startling examples are worthy to take note of, it is always good common sense to educate oneself on best practices to follow when traveling in a country that has a rich, deep, and in my mind beautifully complex traditional and cultural history such as Thailand. A special decorum and protocol is required when venturing far away from home; things such as reputable guides, good travel insurance, and a well-read background in the subject of your fascination never hurts when considering a pilgrimage to another country. Exercising caution when adapting symbols without prior knowledge, skill, or sensitivity to the culture that one is stepping into is strongly advised.

Religious tattoos are also not without precedent in India. The Ramnamis, followers of the Ramnami Samaj religious movement, tattooed the Hindu god Ram's name on their bodies and faces more than one hundred years ago, sometimes using a dye made from mixing soot from a kerosene lamp with water. This act of devotion is also an act of defiance; after being denied entry to temples and forced to use separate wells due to their low-caste status, for these Hindus the act of tattooing Ram's name on their bodies was a message to higher-caste Indians that god is literally everywhere no matter what your perceived caste or position in society may be. Caste-based discrimination was eventually banned in 1955. Children born into the Ramnami Samaj community however are still required to be tattooed on their body, preferably on the chest, at least once, by the age of two. The name of Ram is chanted daily by the Ramnamis and images of him adorn their homes both inside and out.

In Borneo, the Philippines, and Indonesia, several tribes maintain traditions of spiritual tattoos. Joe Cummings and Dan White's excellent book, *Sacred Tattoos of Thailand: Exploring the Magic, Masters and Mystery of Sak Yant*, draws upon an Iban proverb in Borneo that should give all seekers of Sak Yant an indication of the cosmic scrutiny one may come under when undertaking and acquiring this most visible of talismans: "A man without tattoos is invisible to the gods."

I have been made aware that certain viewpoints from various quarters may look at my pilgrimages as a form of exoticization and my encounters with the Ajarns as appropriation of another country's cultural heritage purely for personal gain. After much self-reflection around this particular view, I have decided that I cannot for the life of me wear this ill-fitting and blatantly untrue hat. It just doesn't fit me and certainly does not enter into any part of my world or self-view. I am first and foremost

Sak Yant 15

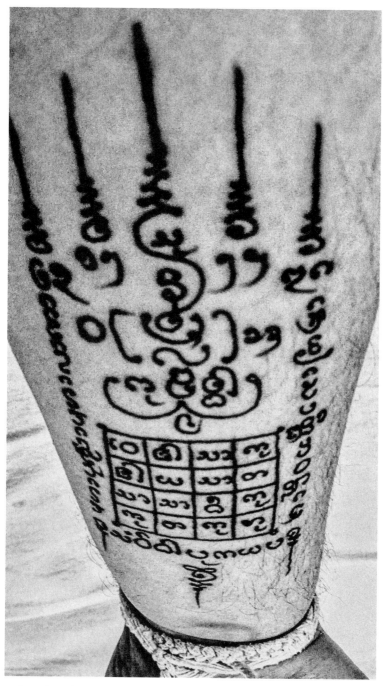

Khun Phen Chom-Talat Sak Yant on the author's left forearm by Ajarn Daeng.
Photo by Sheer Zed (2023).

answering a true calling that comes from a predestined affinity with Buddhism, which has a very strong and clear basis and history in the spirit that has persisted throughout my troubled and turbulent life. Like an epic trail of spiritual bread crumbs, I have followed with an honest and earnest heart a very specific pathway, and this—oddly enough—is where I have finally found myself. While I believe that, within the context of the current global hybridization of cultural elements, the fear of losing traditional cultural definition is valid, I also see that the future holds a magnificent peacock fan of remarkable evolutionary possibilities that can serve to enhance and honor the initial point of origination. Sak Yant in Thailand is the result of an evolutionary process that has taken thousands of years to emanate into the here and now from the very first prehistoric shamanic-inked spots placed upon human skin to aid healing.

The magick of Thai Sak Yant for me is very real and extremely potent. After a number of life-threatening situations (including one late night visit to a local emergency department for potentially stroke and heart attack–inducing high blood pressure) I have concluded that the Sak Yant upon my body has given me an undeniable edge of protection. I genuinely feel and see the activity of their functionality working in the foreground or background of any given situation. I for one am very grateful and deeply appreciative for all the past and present masters, lineages, designs, and undeniable superior magick of Sak Yant's magnificent divine holy presence and unassailable history.

2
Entering the Stream
Many Tributaries Lead to One Ocean

Throughout my life there have been countless inexplicable—one could say experiences—relating to *otherness* that have led me to this point. My childhood and adolescence were marked by various messages and encounters that—looking back—now seem fated. Some of these took the form of popular media and cultural references. I remember distinctly my first encounter with the image of the Buddha all the way back in 1981. It appeared on a BBC2 show called *Saiyūki*, which translates to "Account of the Journey to the West" in English, also known as *Monkey* in the United Kingdom. The show was based on the sixteenth-century Chinese novel *Journey to the West* by Wu Cheng'en. One day during my seventeenth year my mother brought home a sculpture from her art class. The teacher in my mother's class had tasked all of the students with sculpting the famous image of Buddha in the seated Lotus position. I was fascinated by the shape of it; not just of the physical statue my mother had sculpted but the shapeless shape of the philosophy surrounding it. My mother was a messenger and the message was duly delivered. Seeing this image again transpire in our home, its enigmatic presence exuding calm, caught my attention and ultimately my complete devotion.

18 *Entering the Stream*

Another point of pop culture inspiration in my 1970s childhood—and an important portal of awakening for many that saw it—was the TV show *Kung Fu* featuring the actor David Carradine. The image of a Shaolin monk walking across a long strip of rice paper without breaking it gave me the perplexing but nevertheless enticing impression that human magick was real and possible with the correct training and discipline. Transfixed by the slow-motion fighting sequences, Chan Buddhism, and Shaolin Kung Fu philosophy, I soon found myself enamored with the subject of Eastern philosophical thought. Interestingly, although it was actually Bruce Lee who first pitched to Warner Brothers the idea of a traveling peace-loving Shaolin Kung Fu fighting monk (*Warrior*), Warner Brothers—in a blatant act of racism—stole Lee's idea and cast Carradine in the lead role instead. Allegedly, an unnamed ABC executive said, "You can't make a star out of a five-foot-six Chinese actor." In spite of ABC's massive blunder, I still have much respect and love of this remarkable TV series.

Of note here is David Carradine's death, which I was first saddened and later fascinated by due to the strange and particularly weird and occult-tinged circumstances surrounding it. My fascination is not with the technical cause of death (he died in June 2009 by autoerotic asphyxiation) but due to how the underlying supernatural nuances of the location of his death relate to the cause of death. The Swissôtel Nai Lert Park Hotel in central Bangkok, where David Carradine stayed while filming *Stretch* (2011), was next door to the Chao Mae Tuptim shrine—also known as the Penis Shrine. At the entrance of the shrine was a metal sign that read:

The origins of Chao Mae Tuptim are obscure. It can only be recalled that a spirit house was built by Nai Lert for the Spirit who was believed to reside in the large sai (ficus) tree. The basic offerings are fragrant wreaths of snow-white jasmine flowers, incense sticks, and pink and white lotus buds. Chao Mae Tuptim has received yet

another less conventional kind of gift, phallic in shape, small and large, stylized and highly realistic. Over the years they have been brought by the thousands, and today fill the area around the shrine. Confronted by the extraordinary display the shrine has automatically been concluded to be dedicated to fertility.

In June 2020, a local Google guide known only as "Dragonfly" reported that the shrine had been demolished, reduced, and moved two hundred meters south. It is my opinion that David Carradine, after being neglected by the film company during the last three days of shooting, had become possessed by a spirit that had led him directly, during an act of misguided autoerotic asphyxiation, to become a living sacrifice who accidentally and unwittingly died for the pre-Buddhist Southeast Asian tree spirit residing inside the large sai tree at the Penis Shrine nearby. My theory is supported by the natural growth of the sai tree, which shares a common "strangling" habit found in many tropical forest species, particularly of the genus *Ficus*, which is also known as a "strangler fig." I believe that the tree spirit of the strangler fig was embodied by David Carradine and personified in the act of his autoerotic asphyxiation.

For those of you who may be aghast or even amused by such an idea, I will endeavor, throughout this book, to offer evidence of my encounters with the spirits in Thailand. I hope to shed some light on the inexplicable events that surrounded my participation in the extreme rituals and initiations within the Thai Lanna Buddhist magickal system and throughout my life thereafter. Over the course of seven years, I undertook four ritualistic pilgrimages to meet and work with the Ajarns of northern Thailand. My encounters were ultimately life changing. These pilgrimages happened after many years of study, devotion, sacrifice, personal growth, and the occasional visits to shrines in and around London that finally led me to realize and embrace a very specific and particular pathway.

Literary sources have also provided much inspiration, gently directing me toward the spiritual path I was to eventually follow. One source of fascination and interest to me while growing up in South Wales in the 1970s, was the book *Magic, Words, and Numbers* by Stuart Holroyd. Purchased by my parents as a part of their monthly book club membership, not only did it quench my insatiable hunger for visual imagery, it exposed me to various people and profound occult ideas that would come to play an important part of my life decades later. The book features the infamous occultist, ceremonial magician, poet, philosopher, political theorist, novelist, mountaineer, and painter Aleister Crowley in various photographs (plus one wildly psychedelic ritualistic painting). This book was the initial starting point and beginning from which I entered into the endless world of the occult, supernatural phenomena, and spirituality.

I was drawn to the images and ideas inside *Magic, Words, and Numbers* like a bee to a swollen bloom. Chance, magick, synchronicity, rituals, stone circles, Alfred Watkins and ley lines, and Austin Osman Spare all appeared to me from the pages of this book. A veritable Pandora's Box of ideas and thoughts was absorbed into my mind. A quote from Austin Osman Spare's work *The Book of Pleasure (self-love)* meaningfully jumped out of the page from Holroyd's book: "This is my wish, to obtain the strength of tiger."

During Crowley's extensive travels on the Indian subcontinent, he was awestruck by the traditions of Buddhism and Hinduism during his yogic immersion and subsequent transformation. This was inspired wholly through his friend Charles Henry Allan Bennett, member of the Hermetic Order of the Golden Dawn, second Englishman to be ordained as a Buddhist monk (bhikkhu) of the Theravada tradition and instrumental in introducing Buddhism in England. Crowley studied under him both in Ceylon and Burma (Myanmar) and was

able because of this to add the Nikāya (non-derogatory substitute for Hīnayāna or early Buddhist schools) Buddhist columns to his book *Liber 777*. During Crowley's stay with Bennett in Burma he learned preliminary samatha meditation techniques as well as other techniques, in order to answer the question "Who am I?" Bennett was England's first Buddhist emissary, training and mentoring Crowley in the basics of magick while installing in him a devotion to white magick. In retrospect it can be safe to say that Charles Henry Allan Bennett had laid the groundwork for my later burgeoning and blossoming interests in Buddhism. In *Berashith: An Essay in Ontology with Some Remarks on Ceremonial Magic* Crowley says, "The task of the Buddhist recluse is roughly as follows. He must plunge every particle of his being into one idea: right views, aspirations, word, deed, life, will-power, meditation, rapture, such are the stages of his liberation, which resolves itself into a struggle against the laws of causality. He cannot prevent past causes taking effect, but he can prevent present causes from having any future results." Furthermore, Crowley goes on to state, "On mature consideration, therefore, I confidently and deliberately take my refuge in the Triple Gem. Namô Tassa Bhagavatô Arahatô Sammâ-Sambuddhassa!"

As I grew up, I gained a voracious appetite for the Beat poets' oeuvre, in particular Allen Ginsberg,* Jack Kerouac, and Gary Snyder. This did much to fuel my growing quest for all things pertaining to Zen Buddhism including the writings of D. T. Suzuki during the late 1980s. Gary Snyder's "Buddhist Anarchism" viewpoint is to this day very much of great interest to me. I continue to progressively study and absorb various occult-themed philosophies that I find either personally attractive or satisfying while very much still "supporting any cultural and economic revolution that moves clearly toward a free, international, classless world."

*I was present at what is thought to be Ginsberg's last public reading at The Booksmith in San Francisco on December 16, 1996.

In 1972, my father was diagnosed as a clinically depressed, fully blown schizophrenic. Since I could walk, I inherently knew that there was something very wrong and was instinctively wary of him. When I was at the tender age of four, he attempted to kill me during a psychotic rage. My relationship with him over the years was dysfunctional, and severely impacted by these mental conditions. His behavior was interspersed with questionable episodes and various standpoints that deliberately made life harder not just for myself, but also for my sister and mother. Although over the years I tried to establish what could be called a normal and functioning relationship with him, my many attempts were consistently thwarted by his ongoing mental illness, which eventually also came to plague my schizophrenic sister.

Witnessing my father sexually abuse my sister in the very same bed right next to me while we were on holiday in a farmhouse in Laugharne, Carmarthenshire, during the 1970s is a memory that would only be excavated decades later in therapy. At the time of this incident my understanding and ability to comprehend what was actually happening was practically zero, though later a tidal wave of disgust, fury, and rage poured in while my previously repressed memory resurfaced. I then fully recalled him slamming his fist down near my small head as I hid under the bed clothes, enraged at the discovery that his son was watching him through a tiny opening in the blankets. I had prevented him from taking his abuse further. Such a bane was the role that he cast me in over his long and dissolute life, and even beyond. Not once did he ever say that he loved me.

Oddly enough, my first introduction to magick came long before my pilgrimages to Thailand. My first encounter with "black magick" was within the circle of my own family. My father's study, in one of the spare upstairs bedrooms, was a small room littered with books, astrological tables, and journals, which in turn filled the air of our home with

an atmosphere of mystery and occult foreboding. My father dabbled, like a child with a high-powered gun, in the dangerous and precarious pursuit of power through the invocation of demons. I first learned of it through my mother, who told me that, my father had confessed to her that in the 1950s—while in the National Service based in Germany, he had performed a "black magick ritual in the Black Forest." I found it peculiar that when I later asked my mother about it, she fully refuted ever saying this to me. It may well be that she felt the apple doesn't fall far from the tree and didn't wish to encourage or validate my inquisitiveness into this realm in any way whatsoever. I gathered that he had drawn demons into himself using a magick circle and the correct incantations.

Once, while attempting to have an extremely rare father and son evening in central London in the mid-1990s, my father left me standing by a concrete chess table under a pagoda-like folly in the center of Chinatown, while he drunkenly sought out an old dive bar frequented by the Kray twins for us to have a drink at that he used to visit in the 1960s when he was manager of a large betting shop. After an hour passed, I realized that he had deliberately left me standing there alone in an act of cruelty and spitefulness. Before the hour had fully passed however, a huge gust of wind pushed past me carrying a tabloid newspaper over the cobbled street floor. The hand of totality personified itself for a moment in the very wind itself, as it fanned and flicked open the pages before me to a large bullet point headline inside that read: "I Lost Him to Cruel Demons That Lay Lurking in His Soul." It was at that eschatonic point that I knew my father—astrologer, gambler, computer programmer, and magician—was indeed possessed by some unidentifiable demons, and that he had summoned them into himself while serving his tour of duty in Germany. I clearly understand that black magick is a real and potent force in the world and that any interface within such a system, ethos, or paradigm is to be undertaken only with extreme caution, deep limitless inner protections, and rugged self-circumspection, much

24 *Entering the Stream*

in the same way for example that one approach a deadly virus capable of catastrophic repercussions. Double masking in this case is always highly recommended.

Since my childhood I have also experienced numerous instances of leaving my body, some of which were instigated by what can only be called traumatic experiences. It has taken me a very long time to assimilate, process, and learn to work with these extremely intense occurrences. It has taken even longer to speak about this to anyone, let alone raise the necessary courage to write about it. In 1973, when I was eight years old, during a Christmas party game of pass the parcel* in Rhiwderin Primary School in South Wales, I was forced to do a striptease in front of the whole school. The teacher that led this ritualistic abuse knew my family; his father used to sell our family the lettuce from his kitchen garden allotment and make unwanted passes toward my mother. I was wearing my sister's hand-me-down vest at the time as I felt the gut-wrenching violence of standing outside of myself. I imagine the shock of being forced to take off my clothes in front of the school with teachers and children present to an instrumental song called "The Stripper" was enough to trigger my anxiety and immediately cause an adrenaline-driven massive disassociation from my body. In order to hide the pink-flowered frilly vest underneath, I took off my jumper and vest together. It was here the forfeit was stopped, my bare chest shutting down this cruel and primeval sick ritual.

Another out-of-body experience occurred while looking into a mirror, again at eight years old, my body observed by my spirit as it moved away from the flesh body in the reflection. Screaming seemed to help but ultimately did nothing to stop this from happening other than alerting my mother to a child freaking out in the bathroom. Another time occurred in my teens. The same thing all over again. My spirit

*Pass the parcel is a classic British party game in which a parcel is passed from one person to another. When the music stops and you are holding the parcel you then have to undergo challenge or a "forfeit"—a silly or embarrassing act.

pulling out of the flesh body and moving away, this time vertically moving up toward the ceiling while taking a hot bath. No screams this time.

My research of how and why people leave their bodies during waking hours has found that hypnogogic hallucination is just one reason for this happening. My schizophrenic father regularly experimented with astral traveling and so I feel there may be some connection with this fact. An out-of-body experience, which some might also describe as a dissociative episode, is a sensation of your consciousness leaving your physical body. Depersonalization-derealization disorder is a type of dissociative disorder. Its primary symptoms are feeling disconnected from your surroundings, thoughts, or body.

I found these early dissociative episodes to be tasters for meditation. Some meditation techniques—such as Anapanasati (mindfulness of breath) and Vipassanā (literally "special, super, seeing," a Buddhist term that is often translated as "insight" or "seeing clearly")—can be dissociative. Though it is important to mention here that the meditator should not completely ignore all thoughts and fall into dissociation. Feeling detached from your body and seeing the world as unreal can cause problems and a certain amount of anxiety. I have deliberately and mindfully integrated the experiences of leaving my body into the language of spirit, spirituality, and sacred meaningfulness. This has helped me to integrate my experiences in a more positive and less clinical manner while at the same time respecting and honoring the sacred elements of my personal practice. Invisible internal worlds require sustained support and organization. Going into trances and experiencing internal drift have been a regular part of my life. Taking drugs has temporarily relieved and in part assisted this ongoing state of affairs but it has been my daily spiritual practice that has been the overwhelming factor in the personal management and stabilization of my wild, shamanic hard drive. The regulation and respectful feeding of one's demons with daily optimizing disciplines such as chanting, rituals, and offerings have been the framework for my improved internal experience. Since there is order

within chaos and chaos within order, finding a middle pathway of balance has been a lifetime's work and stabilizing practice for me.

At an early age I had also already been exhibiting certain nesting behaviors indicative of what I now understand to be an uncanny ability to sense unseen currents with the highly detailed precision of a magician. These behaviors consisted of placing various objects in exacting orderliness and symmetry in specifically chosen locations and sculpting my bedroom into an arranged shrine of my art, with posters, models, toys, a glow-in-the-dark anatomically correct cardboard human skeleton hanging on the back of my bedroom door, and a large variety of handmade art pieces I had affixed to the walls. Spiritually speaking, clustering objects with what can only be viewed as an OCD-driven impulse was in my case, a symbol of growth, abundance, and the journey toward enlightenment.

Another major threshold in my spiritual development and something that has continued to influence me greatly throughout my life, arrived in the form of acoustic wave vibrations perceived by my brain. Specifically music. I recall the first time I heard an acoustic guitar. At the age of two years old I toddled down the hallway of our home in Newport, South Wales, drawn magickly by the deep tones of what I would discover was a guitar. The sound emanated from behind a fence in the front garden. I then climbed the high fence and traversed the top into the wildly panicked arms of my sister and her friend. There lay the wooden machine of which rang the magickal tones that had so driven me. The girls then allowed me to strum the guitar. Much to my awe it was this simple device that had created such beautiful and transcendent sounds.

Memories of sitting cross-legged on hard painful wooden floors while being forced to look upward toward a sunlight deflector flapped TV set during primary school "Watch With Teacher" sessions are invari-

ably prepacked with the accompanying electronic background music of the BBC Radiophonic Workshop soundtrack of my youth. Children's programming in a 1970s Britain was haunted and soundscaped with the dystopian sound of synthesized music. One night while hiding under the bed sheets in my room I came into contact with an alien life-form. With a flashlight and a small transistor radio tuned in to Radio Luxembourg I beheld inside my ears the space ghost machine sounds of Kraftwerk's seminal audio document *Autobahn*, pulsating and oozing from the tiny speaker. I thought for one moment it was maybe an alien being communicating what the sound of traveling in a vehicle was like here on earth. Here my interest and then later deep love affair with electronic music was birthed.

Moving from the large city of Newport at age three, to a small village called Rhiwderin (Bird Hill), afforded me further contact with the power and majesty of sound. Here, the voices of the choir, the melody of the skylarks, and the notes of an occasional train passing by all collaborated to create the rich sonic tapestry of my new surroundings. There is one sound in particular, however, that I will never forget. One day, my mother would ask me to take our broken vacuum cleaner over to Mr. Entwistle, a local man known for his ability to fix things, who would repair mechanical household items for a small fee. As I approached his 1930s art deco–style home, which lay hidden behind tall evergreen trees, I heard a vast, pounding, and throbbing sound, the vibrations of which reverberated throughout the walls, windows, and the very air itself, well out into the street. I was completely transfixed. Never before had I felt sound on such a deep level. It encompassed my entire being, a small boy lost in awe and in astonishment. I later learned that the sound had come from Mr. Herbert Entwistle's adult son John Entwistle, bassist of The Who, who had a bass guitar set up in a spare bedroom upstairs and would play occasionally whenever he visited his dad.

My early exposure to John Entwistle's bass in the early 1970s would affect me long after hearing it. On July 14, 1978, I bought The Who's

single "Who Are You" and played it incessantly. I have been asking myself the question in the song's lyric "Who the fuck are you . . ." ever since hearing it.

Later, I discovered the music of artists whose work was born of the integration of music and the occult. If my journey into magick resembles a helix, a type of smooth space curve in the shape of a spiral staircase, with tangent lines at a constant angle to a fixed axis, then in my case, the fixed axis of my path came in the form of the vinyl LP: *If You Can't Please Yourself You Can't, Please Your Soul.* Released in 1985 by Some Bizzare Records, the record was a compilation of pioneers of experimental, post-punk, and industrial music—though genre tags fall short trying to capture something so new and radically challenging.

More than a record, *If You Can't Please Yourself You Can't, Please Your Soul* is a totemic and nuanced vortex of spiritual blood-fire dripping in edge and tactical posture with a sublime mutant expressionism. A full, rich, and panoramic experience. I remember the day in 1985, while at Acorn Records, in Yeovil, Somerset, ritually flicking down the aisles of vinyl, when I happened upon what was possibly the only copy of this compilation in Yeovil and quite possibly in the whole of Somerset. It was like finding a lost segment of the Dead Sea Scrolls. I hurriedly purchased it. Taking out the album from the record bag the full impact of the cover arrested me for quite some time. I waited to play the record until an hour or so had passed and I was able to take in the entire contents—the inserts and magnificent artwork by Huw Feather and the late Andy "Dog" Johnson, and the stunning face-ripping front cover art by Val Denham.* Even a series of unfortunate runs of home-

*I had the immense pleasure to meet Val Denham, who is one of my favorite visual artists, at the 2016 Psychoanalysis, Art, and Occult Symposium, where she signed my personal copy of this album. She has done work for Marc Almond, Throbbing Gristle, and Psychic TV to name a few. Her books *Dysphoria* and *Tranart*, published by Timeless Editions, are an essential part of any good art library.

lessness in the 1990s were not enough for me to lose grip of my beloved copy, which I eventually sold at auction in 2024.

Acts on the Some Bizzare Record label's roster included the bands Depeche Mode, Soft Cell, The The, and Blancmange, as well as Cabaret Voltaire, Psychic TV, Test Department, Yello, Einstürzende Neubauten, Coil, Swans, and Scraping Foetus Off the Wheel. The label's output was provocative and revolutionary, not just musically daring, but featuring a wild cadre of psychonauts and occultists. This album was a gateway to multidimensional transformation for me, crafted in an aircraft hangar and then rolled out to start its bombing run as one of the most satisfying, rugged, and ravishing compilation records to grace my turntable and possibly of all time.

In a full helical return, in 2012 I had the opportunity to remix Cabaret Voltaire's track "Product Patrol" to be featured in the festival The Dark Outside, which Cabaret Voltaire's own Stephen Mallinder called "an excellent and twisted mix" on his X account (formerly known as Twitter). *The Dark Outside FM* is a radio broadcast featuring previously unheard music donated exclusively for broadcast by The Dark Outside by musicians and producers from all over the world. There is no streaming or recording and all files are deleted after being played, and the broadcast can only be heard by traveling to the site with a radio capable of picking up the signal.

If You Can't Please Yourself You Can't, Please Your Soul was also my first introduction to the band Coil, the impact of which would reverberate throughout my life. Since first hearing Coil's music, a strange and odd logic has taken hold of me, in which I have felt myself guided down a very specific pathway by a hidden hand or force ever since. Little did I know then how true this was and how it would eventually manifest itself, in the many eerie and synchronous encounters (many of which are detailed in this book) taking place in the footsteps and trail left by one Peter Christopherson, one of the founding members of the group Coil.

30 *Entering the Stream*

The Coil track featured on *If You Can't Please Yourself* is "The Wheel." This sublime and unusual track features the line "The wheel is turning." I immediately recognized it as reference to the doctrine of Buddhism, which at the time I was beginning to take a serious and deepening interest in. If the TV show *Kung Fu* had initiated my interests in Buddhism, with this particular song Coil had firmly sealed the deal for me. Even though this may or may not have been the original impetus, intention, or meaning behind the lyric, the lyric's subconscious cognitive architecture had opened a door of meaning and direction for me.

Coil, occultism, and Thailand have long spiraled their highly inquisitive and inquiring tendrils around each other. They always made ample room to allow magickal working to enter into their mindspace and remarkable creations. The preproduction phases for any of their recorded or live performances would often entail exacting preparations, whether drawing on working with carefully planned astrological phases, selecting the appropriate frequencies and colors, or even taking precise care to choose the appropriate incense. Magickal intuition has in fact always been at the heart and baseline of Coil's enduring musical and spiritual pathway. Although rumored to belong to a certain occult organization, they never actually were. Indeed, in this regard they were always the bridesmaid but never the bride.

The hidden hand of Coil's influence on my life includes the role they played in helping to spark inside me an interest in Thailand and Thai culture. John Balance and his partner Peter Christopherson, cofounders of Coil, discussed their exploration of Thailand in an interview with Compulsion Online:

INTERVIEWER: You seem to be spending increasing amounts of time in Thailand. What's the fascination with the country?

COIL: Over the last six years we've gone every year. It's spiritual. It really is spiritual. England is completely fucked-up; it's all to

do with the church where everything is based on guilt here. You're fucked unless the church or society says you're not. In Thailand it is the opposite you're free and if you fuck-up it's your own fault. It's a completely reversed system over there; the whole thing is about having enjoyment in life.

In a later interview with Brainwashed, Peter Christopherson discussed his interface and migration into Thai culture and his encounter with the Five Precepts:

It's true I am not educated in the teachings or ways of Buddhism. However, I do believe that any kind of religious practice can achieve results (in oneself at the very least) and so I participate in local rituals for accumulating "merit" or good karma, and I try to follow the 5 precepts (with mixed success) since you will recall they are: 1. Do not kill, 2. Do not steal, 3. Do not indulge in sexual misconduct, 4. Do not make false speech, 5. Do not take intoxicants. Actually 3 seems to be open to interpretation, and many Buddhist scholars now take a view similar to mine but 5 is still a hard one for me. . . . I believe that the combination of heat and humidity in Thailand results in humans having less awareness of their skin—where they end, and the rest of the world begins. The consequence of this is that people here become more sensitive to other equally tenuous beings, spirits, ghosts, demons etc. and so naturally spiritual.

In November 2008, Brainwashed announced that the second release by Peter Christopherson—under the name Threshold HouseBoys Choir—would be called *Amulet Edition*. This collection was composed of rough soundtrack works that had been made in anticipation of a new film project Peter Christopherson was working on about tattooing and in particular Thai "temple tattooing." Limited to two hundred copies (twenty-three of which included a signed and

numbered certificate with the recipient's name), the release contained four hand-labeled three-inch CD-Rs, and a sticker. The printed track list card reads: "These sketches are works in progress and may form the soundtrack to a film I intend to shoot next year about Thai Temple Tattooing." The album was handsomely rereleased in an expanded edition in 2024 by Infinite Fog Productions. Although (to my knowledge) the film never appeared, some Thai rituals Peter had filmed in the south of Thailand appeared in a DVD that accompanied the Threshold HouseBoys Choir album, *Form Grows Rampant*, which involves the cutting of tongues and the skewering of cheeks. These forms of rituals are included in The Vegetarian Festival, also known as "Tesagan Gin Je" or The Nine Emperor Gods Festival. This annual event of extreme ritualistic practices has its participants pierce parts of the body with a variety of sharp objects and perform fire-walking to show their devotion, resilience to pain, and the protection of the spirit world.

At one point, a rumor reached me that Peter Christopherson had somehow succeeded in smuggling thirty thousand pounds of British currency into Thailand, an amount big enough to float a large Thai family for a considerable lengthy period at that point in time. It would seem that Peter Christopherson's lack of fiscal management however had finally got the better of him. When he died suddenly and unexpectedly in 2010 most of his savings had been completely depleted and he was living hand to mouth. With seemingly no will to speak of, his remaining estate was splashed to the four winds among a variety of people who were in his immediate sphere. In a final act of grace, however, he was given a burial that a Thai dignitary of note could only hope for, resplendent with monks, a cremation, and the dispersal of his ashes accompanied by the chanting of mantras in the Bay of Bangkok. Allegedly, a bone fragment from Peter Christopherson's corpse was placed somewhere in the environs of Chatuchak Park in Bangkok.

Strangely enough, long before I was conscious of its role in guiding me to the spiritual path I'm on now, another twist of fate found me attending a conference to see His Holiness the Dalai Lama at Wembley Conference Centre in the early 1990s. The conference was on the subject and idea of interfaith, an initiative seeking to promote the cross fertilization of faiths in an attempt to help build and create harmony and positive interconnectedness between and among people of various faiths.

While following Nichiren Buddhism, I never graduated to acquiring or building a shrine to hold a *gohonzon* (a generic term for a venerated religious object), which can take the form of a scroll, composed of a calligraphic paper mandala inscribed by the thirteenth-century Japanese Buddhist priest Nichiren to which devotional chanting is directed. As far as I'm concerned, no materialistic paraphernalia whatsoever are required to practice Buddhism. While yes, there is of course a very pleasurable and satisfying element to having an appropriate area of your home or personal space devoted solely to a shrine or magickal workstation, fully decked out in various sublime accoutrements, nothing can replace the will and discipline both being harnessed toward the focus of your intention and the practice of mindfulness requires.

My path would cross and occasionally intersect the path of Peter Christopherson many more times as I journeyed deeper and deeper into what would turn out to be a life devoted to Buddhism and magick. One such instance took place while in the late '90s when I was living in London. Crossfade to a postage-stamp-sized flat in Hackney where a long-haired jobless shamanic space cadet and his Viking-related production assistant girlfriend languish over saag paneer and naan bread while

34 *Entering the Stream*

listening to Funki Porcini's *Love, Pussycats & Carwrecks* after a large and extremely psychedelically dissolute weekend in Shoreditch. A copy of *The Stage* newspaper with an ad seeking actors to become "Warders" at The London Dungeon was brought to my attention. "You should go for this, pet," said she. After studying the advert, I prepared my head-shot, letter, and CV, and mailed it off to The London Dungeon the very next day. One week later, I received a letter requesting that I attend an audition at The London Dungeon. While a student at London's Webber Douglas Academy of Dramatic Art, I lived for two years in a four-story house in Greenwich. Time and again, as I traveled by train to and from school, I passed over and through London Bridge station, occasionally catching a glimpse of The London Dungeon's red-on-black signage as I passed along the curve of the railway lines. Each time I spotted The Dungeon sign a strong persistent flash of a strange and unspeakable knowing feeling took hold of my being. Originally a bloody, torture-themed, psychotic cousin of the Madame Tussauds wax museum, The London Dungeon was in essence a hybrid multimedia haunted house and historical horror waxwork exhibition founded in 1974, which uti-lized numerous theatrical techniques, extreme special effects, and fully costumed live actors. It successfully leaned into its original location at Tooley Street underneath the 1836 railway arches of London Bridge sta-tion, fooling the general public into believing that it was the site of an original dungeon. The blood-red words "Enter at Your Peril," embedded in sandy concrete above and across The Dungeon's entrance, shouted at me as I walked along the long, dark, and forbidding corridor into the bowels of The Dungeon for my audition.

One week after the audition, I was informed that I'd been hired, and soon began what turned out to be a two-year tenure as a "Warder" in The London Dungeon, where I worked eight hours a day, Monday to Sunday, with two floating days off per week, eventually working my way up to the level of supervisor. My responsibilities included organiz-ing the rota for the live actors, placing them into the performance areas,

themed tableaux whereby the performers worked in a theatre-in-the-round situation delivering scripted speeches, improvised dialogue, or performing sequences of sword fighting (which I took part in), under the film-set-like space of the Tooley Street arches. We quite literally inhabited The Dungeon.

By "inhabited" this ultimately meant that as live actors we would often conceal ourselves like ninja into dark corners or plain sight, merging with the exhibits, orchestrating acts of psychological fear and terror upon the visitors. A warning to the general public at the entrance of The London Dungeon made this fact very clear and warned all prospective visitors who may have had any existing heart conditions. Essentially I was a professional ghoul with a license to scare. In my two years spent working there I conservatively frightened and entertained over two million people from across the world.

One of the early hopeful employees of The London Dungeon was none other than Peter Christopherson himself, musician, video director, commercial artist, member of the art design group Hipgnosis, photographer, and one of the founding members of the aforementioned band Coil. The Dungeon hired Peter to help them to create the exhibits which featured lifelike mannequins of various historical characters engaged in numerous gory and macabre situations that filled their dark, labyrinthine corridors. Because of his time spent working with the Red Cross and St. John's Ambulance, Peter had developed profoundly realistic techniques for creating and photographing stunningly authentic-looking wounds. Some of his remarkable work can in fact still be found in instruction manuals for paramedics. Sadly, when Peter delivered his work to The London Dungeon, they were somewhat horrified. Apparently, the work he had created was deemed far *too* real and unsettling and was subsequently rejected for a more Disneyfied product by another supplier.

36 *Entering the Stream*

During the early 2000s, before moving to Los Angeles to live with my then-wife Angel (one of our two marriage ceremonies in 1999 was carried out at the Jamyang London Buddhist Centre for Meditation and Tibetan Buddhism), I had a very important dream that still sits firmly within the core of my mind. It was not so much a dream but more of a visitation, if you will, the clarity and color of which still leaves me in a state of awe. A thin and bony sādhu in a state of mortification with long white hair, blue eyes, and curly extended fingernails sat in the cross-legged lotus position while performing kaleidoscopic swirling and spiraling mudras with his hands. The sādhu quietly observed me as his body—surrounded by golden, effervescent light—levitated off the ground. Nothing else whatsoever happened in this dream. It was as though the entity wished only to make their presence known to me, which it most certainly did, leaving in its wake a memory that has remained tattooed in my mind ever since.

During my time in Los Angeles, I avidly studied Tibetan Buddhism and read out loud in my room sections from *The Hundred Thousand Songs of Milarepa* as translated by Garma C. C. Chang and *The Lotus Sutra* as translated by Burton Watson. At one point I assumed that the dream visitation had been the spirit of yogi and poet Milarepa himself. Now I am uncertain of this idea, though this does not in any way reduce or lessen the impact that this dream has had and still has on me. It remains deep in my mind and is firmly a part of my life as a living sacred glyph transpired from divine emptiness.

However, the double-edged sword of attachment and the necessary acts of renunciation required to experience the austerities necessary for contemplation and enlightenment must be balanced and fully considered. The priest Nichiren Daishonin for example faced hatred, imprisonment, and death to deliver to us all the final distilled mantra "Nam Myoho Renge Kyo," which all practitioners—irrespective of whatever pathway they follow—can chant to reduce suffering, eradicate negative karma, and reduce karmic punishments from both previous and present lifetimes.

Entering the Stream 37

At one point in the early 1990s I became interested in Nichiren Buddhism, a branch of Mahayana Buddhism and one of the "Kamakura Buddhism" schools based on the teachings of the thirteenth-century Japanese Buddhist priest Nichiren Daishonin. Its teachings derive from some 300–400 extant letters and treatises written by Nichiren. Two of my friends, who swam in the same social circles as I did, had immersed themselves in this very specific form of Buddhism, which had acquired a rather unfortunate reputation in my mind for somehow suggesting that materialistic things such as cars, houses, and possessions could be chanted for and delivered, as opposed to the focus of one's devotion, that being the practice itself. How this particular idea evolved is of no or little interest to me now. Regardless, as far as I can see, the faith has a solid Zen, which could be broken down into three single facets:

1. The faith in Nichiren's Gohonzon;
2. The chanting of "Nam Myoho Renge Kyo" with varying recitations of the Lotus Sutra; and
3. The study of Nichiren's scriptural writings, called Gosho.

One day, one of the two friends who dabbled in Nichiren Buddhism found themselves backstage via some VIP tickets with the boy group Take That. My friend told me they talked to a member of the group about Nichiren Buddhism and then taught them the mantra "Nam Myoho Renge Kyo," which allegedly, the group member chanted as he went on stage.

My ultimate fascination with this story is in how an unnamed member of a mainstream, 1990s boy band had managed to come into contact with a mantra of ancient Buddhist scripture, which means "Devotion to the Mystic Law of the Lotus Sutra, Glory to the Dharma of the Lotus Sutra," had become beguiled by it, and then proceeded to chant it before singing onstage at Wembley in front of a potential audience of 90,000 people. Chanting the right mantra in the proper

38 *Entering the Stream*

way is believed to be a key that unlocks the structure of the cosmos. The utterance of the mantra "Nam Myoho Renge Kyo" at this specific moment was in my mind a transformative and powerful action. It was clear to me the fecund and ultimately supernatural nature of this profound mantra enables the chanter to enter into spaces and situations that normally wouldn't be so easily available.

I eventually moved away from Nichiren Buddhism and began diving further into textual studies. A core personal focus throughout my life has been the chanting of mantras. As the George Harrison album said, "Chant and be happy." After I moved to Los Angeles, I worked for four years at a flagship Borders Books and Music store. My employee discount, combined with the healthy allotment Borders gave employees to buy books and music, allowed me to pursue my study of numerous Buddhist and occult texts. I was very grateful to be in such a position, and now have a considerable library as a result.

While in Los Angeles, my main practice in terms of chanting involved the recitation of the mantra of "Om Ah Hum Vajra Guru Padma Siddhi Hum" (pronounced in Tibet as "Om ah hung benza guru pema siddhi hung"), which is the mantra of Guru Padmasambhava ("Born from a Lotus"), or Guru Rinpoche (Precious Guru) and the Lotus from Oḍḍiyāna, a tantric Buddhist Vajra master from India. During this time, I assembled a rudimentary shrine composed of various, small devotional objects that I had acquired from a reputable local dealer in Redondo Beach. It was while chanting this remarkable mantra continuously over many times on one occasion that I experienced what could only be called a vision. My grandfather appeared immediately in front of me, beckoning me to come with him. Although I continued to chant, I was somewhat perplexed to see him; why would my grandfather be asking me to come with him? Experiencing ancestral visions for me are usually a good sign, but this particular visitation didn't make any immediate sense to me. The vision was reinforced and then resolved in my mind while traveling on the freeway one day after a considerably

emotional healing session at one of the Agape International Spiritual Center ministries that I attended to help me heal from my messy and ugly divorce. I casually glanced to the right while on the freeway home and there before me I saw a large sign advertising Disneyland. In massive, large letters it said: "Come Home." I knew in an instant that my time in Los Angeles was coming to an end and that I needed to start planning my move and migration back to Britain—away from this beautiful, crazy, pressurized, chaotic city that rumbled, crumbled, and vibrated on the edge of its own destruction. My chanting had summoned my grandfather's wisdom and perception, in order to help direct me in the next step I needed to take.

Grateful as I was for the nudge of guidance from the spirit of my grandfather, my return home from the United States was a devastating and incredibly depressing event. While trying to manage numerous pieces of luggage during my search of an overnight hotel in London to stay in before my journey to Dorset, I nearly fainted. Feeling sick, tired, and completely drained, I ended up vomiting in the street. Panicking, I wondered if my return to Britain had been a mistake. I felt as if I was coming out of a prolonged warp drive. My time in California had included frightening episodes of domestic and workplace violence, divorce, discrimination, the death of my father-in-law, killer bees, exploding houses tented for termite extermination, next-door neighbor crack-addled tenants taking hostages with the ensuing S.W.A.T. team lockdown, and hard-won downtime recording sessions at a local music studio called Media Kitchen. The Californian light had now darkened to a dull British gray, the pace now much slower, more brutal, more compressed, and the general demeanor of the people in the street resembling the crushed and isolated flotsam and jetsam of humanity. It took four months before I knew for certain that my return to Britain had been a wise choice.

40 *Entering the Stream*

The dust for me finally settled in George Street in Sherborne, Dorset. The tiny cottage I now occupied served well as a bolt hole from which to resume my life in Britain. A small, printed advert in a local community hall advertising classes in Tibetan overtone chanting techniques in a local hall told me I was in the right place at the right time. When faced with the term *overtoning* many often think of the beautiful Tibetan bowls that are regarded as meditational tools of healing and chakra alignment. My experience was somewhat different. The teacher, who made much of the fact that they had spent hundreds of pounds acquiring this knowledge from a certified and authentic master, showed unintentionally in one single lesson the basic precepts of overtoning in, around, and through the mother of all mantras, "Ōṁ," which is the sound of the sacred spiritual symbol representing the essence of the Ultimate Reality, which is consciousness.

I believe that this was a mistake on their part, for they had transmitted the pith instructions so well I knew immediately any further lessons would be unnecessary. The idea and technique of expanding and vibrating the mantra "Ōṁ" around the spherical portal of my head and upper chest firmly clicked inside my head while the instructor walked around the class watching carefully as each student intoned around the phonetic vowels of *A E I O U.*

In her essay "The Importance of Words and Writing in Ancient Magic," Caroline Tully says:

> Vowels spoken in just the right way made magical ritual more precise. Seemingly unintelligible strings of vowel-chants were thought to be effective because of an innate power inherent within them which reflected elements of the cosmos or the gods themselves.

Mantras are mathematical word and sound spells that attempt to express the inexpressible. Through poetic, phonetic, and catalytic hidden meanings, they are able to transform the sacred through ritualistic

constructs into present reality. Spiritual and mystical experiences transpire into the mind becoming the living essence of various consciousnesses. I have always viewed mantras as living spirit organisms hiding in a form of flat world, waiting for the energy of incantation to rehydrate them into the real world. By moving the mantra "Ōṁ" through the phonetically droned vowels of *A E I O U* the mantra is opened up, energized, and enabled to move through all of the chakras, realigning the mind and opening up the body's central nervous system. The sound, once it is intoned though the vowels, can become a living glyph of consciousness energy, reflecting the higher realms within and without, a portal of divine access for self-knowledge, a cosmic sound that is celebratory of the creative force of the universe beyond the sun.

Over the course of my four pilgrimages to Thailand in 2017 (the year of my father's death), 2018, 2020 (in January, before the pandemic took hold of the world), and 2023 (the year of my mother's death), I underwent a series of profound rituals that have been completely life changing. And it was Coil, in all of their cosmic and all-encompassing ritualistic majesty, who continued to reappear throughout my journey, as if guiding me from afar. Indeed, it was my fascination with this beloved experimental electronic music group and a very particular form of Eastern philosophy, through consistent and continuous study, pursuit, meaningfulness, love, and selfless devotion, that brought me to this very strange and surreal place in space and time.

3
Thai Magick and Buddhism
A Short History of Sorcery and the Death of My Father

Thai magick and sorcery are an elaborate exquisite hybrid fusion of incorporated, Indigenous beliefs, and each Ajarn has his or her own particular and individualistic view of how it is to be practiced, dependant on their studies under and contact with various and numerous different temples, teachers, monks, and sorcerers. This diversity of approaches does not make it in any way less powerful or incohesive. The subconscious mind, divination, visions, and dreams play an active and robust role in informing and evolving the ongoing growth of this deeply fertile magickal environment. Thai Buddhism is a seemingly systemless system in which—once you enter into it—it becomes extremely difficult to differentiate between various aspects and to identify exactly where they originated from. Syncretism, the practice of combining different beliefs and various schools of thought, is in fact the mechanism that has created this highly eclectic—and for me personally a deep and endlessly extraordinary—emanation of features present in Thai Buddhism.

All that being said, there are core practices, but again, these tend to vary from Ajarn to Ajarn. The earlier migration of nomadic shamanism as it moved down into northern Indochina toward the middle

of the first millennium BCE may have very possibly laid the ground for both powering and preparing for the fluid merging of seemingly disparate philosophies in Southeast Asia on the Indochinese peninsula. Traditionally a landform that has given powerful strategic isolation for the fermentation of all manner of human development, the word *peninsula* derives its original meaning from the Latin *paeninsula*. Paeninsula consists of *paene* meaning "almost," and *insula* meaning "island," or both together meaning "almost an island." Ritualistic shamanism has left clear hallmark traces in the rituals and traditions inherent in Thai Buddhism. Buddhism itself can ultimately be seen as the glue that binds this myriad of magico-animistic, necromantic, and syncretic views that have all become inextricably intermingled and fused together.

Animistic devotion—the belief that objects, places, and creatures possess a distinct spiritual essence—still remains strongly intact and integrated in Thailand today and was present long before Thai people adopted Buddhism. Indeed, it is pertinent to say that animism has pervaded and continues to do so across and throughout the spectrum of Thai culture. The "cosmic flow of life energy" is recognized in many ways in Thai culture. The protective land spirits and founders of the land are clearly and devotionally seen through countless sacred geographical, elemental, animal, and landscape features.

In her 2017 paper "Potent Places and Animism in Southeast Asia," Anne Yvonne Guillou details the depth to which people of Southeast Asia view the manifestation of spirits:

> . . . termite mounds signifying "living," "growing" land; some animals or insects considered to be the embodiment of the protective spirits of the place; majestic old trees, found systematically in certain sacred places; stones which, combined with other natural elements, point to these special places; dreams via which these places themselves express their needs and feelings to their human

44 *Thai Magick and Buddhism*

neighbours or visitors; and accidents and illnesses, sometimes fatal, that strike those who do not behave properly in these places.

Buddhism was initially introduced to Thailand after the third Buddhist Council at Pataliputa (modern Patna) in the third century BCE through the slow and gradual saturation of travelers, medicants, and monks across the Bay of Bengal from India and Ceylon into Burma (Myanmar), China, and Thailand. Through oral and written myths, the introduction of Buddha often replaced local gods and resolved the ongoing conflict between man and vast unknown supernatural powers that preyed upon Thai society. The ongoing evolutionary process of Southeast Asian spirituality, however, is a very complex subject and the extraordinary transit of cultural ideas cannot be simplified into a few choice sentences.

In Nidhi Aeusrivongse's 1976 work, "The Devarāja Cult and Khmer Kingship at Angkor," we are afforded a small glimpse of what may have possibly occurred during this vast long period of evolutionary gestation:

> It is thus possible to imagine that in the process of "Indianization," a number of local gods with Khmer names were "merged" with gods holding Hindu names, their figures (if they had any recognizable figure) being transformed to a linga or even an image. The cult surrounding the local gods was also instilled with new elements from Sanskrit texts which were introduced by indigenous or Indian brahmins. This process appears to have continued from the protohistoric period down to Angkorean times and to have left its vestige in the inscriptions.

And then, in Prapod Assavavirulhakarn's excellent book *The Ascendancy of Theravada Buddhism in Southeast Asia*, the author draws the reader to the important idea of the dangers of applying Judeo-Christian Western academic thinking to Southeast Asian religious

texts in order to acquire a singular definition. The danger lies in viewing the canonical Veda and Sanskrit texts as a method of constructing an actual working model. In practice—through the solid application of anthropological fieldwork—one will always find phenomena that lie beyond and outside of the textural records. It is in this particular area of potential discovery that I decided to undertake my pilgrimages to Thailand. Indeed, in the four separate pilgrimages I undertook to access the sublime Ajarns of northern Thailand, I underwent what I can only call magickly transformative experiences that have completely changed my life.

Over the course of the forthcoming chapters I will discuss each pilgrimage and how my encounters with the culture, Ajarns, and magick of Thai Buddhism transformed me from a self-destructive, anger-filled pathway to a more balanced and peace-centered journey, aware of the magick, spirit, and the sublime and often shifting nature of so-called reality. It has been said by practitioners that internal work needs to be accomplished when attempting some form of magickal ceremony, spiritual journey, or shift in one's own current level of understanding.

Magick has always been an intrinsic and important part of Buddhist and Eastern philosophical practices. Buddhism originated in ancient India from the *Śramaṇa* ("one who labours, toils, or exerts themselves for some higher or religious purpose" or "seeker—one who performs acts of austerity, ascetic") tradition sometime between the fourth and sixth centuries BCE. Mantras, elaborate rituals, and a complex diversity of offerings and necromancy all feature today in the many variants of this vast and at times perplexing Eastern philosophy, which has assimilated on point of contact much that comes into and around its everevolving pathways over cosmic time. The cult of sacrifice developed out of the prayers in the Vedic Samhitas. Ascetic practitioners have developed extraordinary techniques to conjure all manner of necromantic apparitions. These ascetics often dress in black, building fires in the mouths of corpses on cremation grounds to summon the undead and

the demonic personality of Naga Srikantha. Magickal violence, if one could term "black magick" and not the rainbow spectrum that peacock fans around it, can be possibly viewed and seen as a form of "awakening," breaking a cycle of negative or destructive behavior patterns occurring within the chosen target.

Aggression and magickal violence should not be seen in a completely negative light, since attacking a problem with an action that is seen as aggressive in of itself can bring positive outcomes. Does the use of aggressive magick spells and rituals challenge and undermine in this so-called peaceful philosophy that dictates no harm to sentient beings our preconceptions of what would be termed as right and wrong? This complex ethical puzzle is for you and you alone to decide. Ultimately karma (action) and the consequences of this action taken only in the fullness of time can only be beheld by the one that has taken them. In his advice to devotees, Lama Zopa Rinpoche, a Nepali lama from Khumbu (who sadly passed on April 13, 2023, at the age of seventy-six), said that chanting "OM GHA SA SHA KUN HRI TSI DHAKA LA NA BA GA SU BAB SVAHA" will protect and keep you safe from black magick. His advice alone clearly shows that there is indeed not just a strong belief and understanding of magick within Buddhist and Eastern philosophy but also that such an idea is to be treated with total respect and humility. Since my own awakening to Buddhism in the late 1980s I have, over the course of my daily practice, encountered studies and experiences of what could be called "aggressive" or "black magick" in its numerous and many forms.

The color black (which I enjoy) is invariably linked to many ideas: sex, death, deep space, mystery, the night, the unknown, the supernatural, the invisible, depth, the subterranean world, demons, anarchism, eschatological symbolism, and dark ritualistic practices that end in the void, emptiness, death, madness, or destruction. As recently as December 2020, black magickal violence in India made headline news. Allegedly two "tantriks" were arrested reportedly for performing black magick

rituals to kill Maharashtra Cabinet Minister Eknath Shinde. In their hut, authorities discovered a photograph of the minister onto which they had placed green chiles and lemon. In Hinduism, Alakshmi—the goddess of misfortune, inauspiciousness, and grief, described as being "cow-repelling, antelope-footed, and bull-toothed"—is often invoked and summoned using lemon and green chiles, as she likes sour, pungent, and hot things. *Tantra*, meaning "loom, warp, or weave," denotes the esoteric traditions of Hinduism and Buddhism that developed in India from the middle of the first millennium CE onward. Other items related to black magick—including a rooster that they had planned to kill—were discovered inside the "tantriks'" hut.

On average, sixty witchcraft-related murders have taken place annually since 2010 in India. One such incident consisted of a twenty-seven-year-old man who was arrested for killing his mother with an axe, chopping her body into pieces, and then consuming them. In his residence, police found a book on black magick practices as well as the murder weapon, a blood-stained axe. Later the man attempted black magick rituals and reportedly made an offering of some of the body parts at the family temple inside the house. He went on to burn the body in an earthen chulha.* He ate her body parts uninterrupted for three or four days, chanting mantras and drinking her blood before he was arrested.

Mantras are a sonic energy spell and a many-sided instrument, or as Sanjukta Gupta puts it, "the highest forms of manifest sound." The Maha Kaal Bhairav "enemy destruction" mantra, which is referred to as a Tamas ("darkness") mantra, is required to be chanted ten thousand times over a period of twenty-nine days with an "undisturbed" mind, while facing a south-easterly direction and sitting on a buffalo skin or pure sheep wool blanket. The target's name is deliberately placed inside the matrix of the mantra in order to facilitate laser-guided bull's-eye targeting. The number of recorded mantras in existence is conservatively reckoned roughly to be at least seventy to eighty million, which means

48 *Thai Magick and Buddhism*

it is recognized as infinite. The number of mantras regularly used is, of course, finite. Such is the perplexing depth and detail-orientated elements surrounding the fascinating belief systems that pervade this endless subject in India.

Ascetics of the Aghori ("not-fearful" or "fearless") sect can still be found in India today, drinking out of skull cups and hanging out with the dead in charnel grounds, which is itself seen as a magickal act, a partaking of the dead person's life force. It is believed the skull holds the soul or spirit and can be controlled using the correct mantra to become a "genie" or slave both here and in the beyond. During his extensive travels on the Indian continent, Aleister Crowley performed the ritual slaughter of a goat at a shrine.

Milarepa, a Tibetan yogi and spiritual poet I mentioned earlier, was capable of instantaneously creating and improvising verse in song and a highly accomplished Siddha ("perfected one" and "one who is accomplished" with a high degree of physical as well as spiritual perfection or enlightenment). Siddha may also refer to one who has attained a *siddhi* (paranormal capabilities). As a young man, Milarepa was taught and used "black magick" to kill thirty-five guests at a wedding feast at his uncle's house in order to "settle" a long running dispute between his mother and his uncle. His occult training—paid for in gold, initially from Yungton Trogyel—led him eventually to be sent to Nubchung Yonten Gyatso for a two-week retreat to train in the magickal art of destruction using spells and incantations. He learned to control the weather and was allegedly capable of bringing down fierce hailstorms and generate destructive storms that could kill. Anguished by his crimes, Milarepa went to seek a teacher to purify him, and happened upon Marpa Lotsawa, a translator and traveler. Marpa was not against Milarepa's use of aggressive magick and requested that Milarepa make a spell against some highlanders who had showed him contempt. Milarepa

*A *chulha* is a traditional Indian cooking stove, usually made out of clay or cement.

Thai Magick and Buddhism 49

cast a spell that caused the highlanders to turn violently against each other, many of them dying at the point of a sword.

A Tibetan book of spells found in a cave at Dunhuang shows us how varied and numerous these spells may be. Whether it's curing an illness, stopping a curse or evil sign, drying up a lake, reversing a river to make it flow upstream, striking a malevolent person with lightning or a meteor, not being bitten by a dog, breaking up lovers, reconciling old friends, or rendering another person unable to speak or write their name on a piece of paper, this book shows us how the subjects and types of spells are numerous and wide-ranging, showing considerable depth and breadth of desires. In many cases, the spells are activated by the recitation of mantra (usually 108 times) followed by committing an action that acts as a catalyst to seal the deal.

One Tibetan technique to magically and violently attack people is to use astrological tables to ascertain which day your desired target has their "black day" on. In the Tibetan art of magick people are seen to have both "white" (strong life force) and "black" (weak life force) days. Casting a spell against someone would usually entail triangulating your "white day" over another's "black day" for suitably impressive results when spell-casting.

In the Tibetan Bön religion, black magick within the art of spiritual warfare is renowned in a specific instance during an attack by invading Mongol hordes. Revoking their Buddhist commitments and taking Bön Ngakpa vows, 1,900 phurba-wielding Ngakpas,* collectively summoned the Bön deity Phurba Chenpo to repel the hordes. The slaughter was total and immense, the Mongols suffering a bloody defeat that lasted for centuries. This was an extremely rare and unheard-of event of practitioners actually taking human life. John Balance of Coil often liked to recount the story of Bön prac-

*A *phurba* is a three-sided peg, stake, or nail-like ritual knife. A *Ngakpa* is any practitioner of Vajrayana who is not a monk or a nun.

50 *Thai Magick and Buddhism*

titioners setting up camp near a Tibetan village and then chanting over a course of weeks to destroy it. Whether this story is based in fact or hearsay I cannot say, though there are some mantras that are strictly forbidden and deemed very dangerous for those outside of the specific lineage to contemplate, know, or use. However, one eleventh-century Tibetan translator and infamous magician named Ra Lotsāwa Dorje Drak had access to a profound range of spells and techniques. He is said to have engaged in lethal magickal combat with a number of respected lamas, murdering thirteen of them. He allegedly drove a Shaivite teacher to suicide and killed Khon Shakya Lodro with the killing rite of Vajrabhairava. Ra Lotsāwa Dorje Drak is also said to have engaged in a terrible magickal conflict that drew in hundreds of villages over a question surrounding the legitimacy of his teachers. When many villagers marched against him and accused him of harming them with his magick, he then attacked them with his magick and left them all vomiting blood.

The ritual actions of subjugation (dbang) and assault (drag) or indeed magick and sorcery are defined by the mind of the practitioner and the motivation and the intended outcome varies depending on the media used, with spells, mantras, diagrams, herbs, plants, effigies, talismans, amulets, or other material substances and all possible mediums. Only bodhisattvas with the certified skills to lead "liberated" victim's consciousness to Buddha's pure land with the utmost purest of compassionate intentions may ever practice or execute the rites of magickal violent assault. Sorcerers without this highest skill and motivation are rebirthed in the very lowest form of hell. *Aṃboe* has two meanings in Cambodia. "Action" and acts associated with black magick in Khmer. Magicians leaning to the dark side are often called *dhmáp*. Many Cambodians take the power of magick, which is viewed as both good and evil, very seriously indeed.

The Krū Khmer are mystics, healers, and seers who have inherited their healing skills from ancient lineages of traditional medicine,

which—in addition to the ability to tell fortunes—include the ability to cast spells and overturn curses. They inherited their skills from ancient lineages of traditional medicine to heal. These mystics play a large role in rural areas. Krū Khmer is a respected position to hold and yet many harbor ambiguous feelings around their ability to use and employ so-called black magick. The Cambodian mindset can quickly turn to a medieval throwback in attitudes toward magick and black magick in particular. Suspected "sorcerers" have been killed, bludgeoned to death, by mobs sometimes of up to six hundred people, even at the slightest whiff of any seemingly untoward magickal impropriety. Relatives of a deceased woman allegedly saw centipedes around a corpse's head, "proof" for the mob that the woman had been cursed, ending in the death of a renowned healer and well-respected herbalist. Human rights group Licadho recorded one case of a person being killed for sorcery in 2012, and a total of three in 2013. In one case, six people decapitated an alleged sorcerer, another practitioner was hacked to death with a machete, and in yet another, a sorcerer was killed by his own nephew, armed with a scythe. Some perpetrators of the murder of alleged sorcerers have ended up eating the liver of their victim. Most perpetrators are never arrested.

In "Economic Determinants of Witch-Hunting" (2003), two German economists argue that extreme economic hardship and a crushing lack of education play a role in witch hunts. And yet inexplicably among this horrifying casual slaughter, engaging in Brahmanist magickal powers is seemingly linked to having and engaging in Buddhist moral asceticism, refraining from stealing, killing, improper sexual relations, improper speech, and drunkenness. Transgression it seems has some wriggle room in the large expanding black hole of quantum conduct. In one technique used by Cambodian sorcerers a venomous spider is placed inside the mouth of a frog and then sewn shut. Once the frog dies the spider is imprisoned inside it. By reciting a specific mantra, the sorcerer can then provoke harm on the person they want to curse.

52 *Thai Magick and Buddhism*

Such techniques however are not used by Thach Saing Sosak, a highly respected sorcerer and devout Buddhist whose life and work are legendary. His abilities are remarkable and numerous. However, as a musician, my interest in this great master is his work with sound; sound itself is seen by this great visionary sorcerer as the gateway to all magick and all dynamic change. The power of names and the sound that those names make are at the core of his practice. There are thirty-three consonants in the Khmer script, each one representing a number. To solve problems, he calculates the person's name in conjunction with the problem that needs resolution using magickal tables. Once he has formulated a new name over multiple permutations, he then gives the client their new name. This new name then acts as a sonic protection and magickal force in itself that changes the destiny of the client. Using this method, he has calculated where people's names and the names of new partners have caused considerable changes of fortune. Giving the wrong people the right name is seen by Thach Saing Sosak as a highly undesirable thing since this can give rise to people who take advantage of their newfound power to evil ends.

4
Preparing for the First Trip
A Convergence and Assembly of Spirits

My father's death on Wednesday, May 3, at 11 p.m. in 2017 had an incalculable impact on me. His death was like a dark foreboding shadow being lifted from my life. Under law, the contents of his estate were to be shared among the first-born children. However, this proved to be a difficult and protracted affair. Someone outside the family took illegal control of his estate upon his death. She even lied to hospital staff, telling them that she was a family member. It was only after I enlisted an attorney friend to draw up two heavy and stiff legal missives that her interference was stopped. The resulting shares of the estate were equally divided among his natural children and family, and, as fate would have it, my share became the financial source that funded my first pilgrimage to Thailand.

Through an online Sak Yant discussion group I had encountered a man named Ronnie, who would be my companion for my first three trips to Thailand. He lived in Bankok, and throughout our communications, I found he displayed a generous nature, which I found to be thoughtful. Initially charming, I believed Ronnie to be the kind person who would be a fine and excellent guide through this chaotic, complex, and at times bewildering culture. Little did I know how wrong my first impressions would turn out to be.

54 *Preparing for the First Trip*

I can clearly remember Ronnie conducting an early experiment with me online late one night using one of the very first amulets he'd given to me as a free gift. Sent to me in the United Kingdom via parcel post from Thailand, it was a human leg bone amulet submerged inside an oily liquid, which was sealed in a plastic case. Remotely, he guided me through chanting a mantra—or *khatha* as they say in Thailand—that was to energize the spirit within the amulet and then allow it to enter my body. I began to repeat the khatha. Again and again, I chanted the khatha. After a while I felt very strange. A tingling feeling started to spread up my arm from my hand holding the amulet. I then began to feel dizzy and started to swirl as the spirit began to possess me, writhing around inside my body. I told Ronnie that I was about to faint at which point the experiment was stopped. I knew that this complex and sublime system of Buddhist magickal practice was something that I sincerely wished to investigate.

During the grief that surrounded my father's death and the subsequent heavy fallout, Ronnie gifted to me a second amulet, a superb Phra Ngang Panneng amulet by Ajarn Subin. Phra Ngang is a Thai deity that inhabits a spiritual realm and can be identified as a type of demon. Phra Ngang is an animist nature deity that is said to reside on a mountain. Some believe that he is a real creature.

Phra Ngang comes in many forms and has numerous different attributes and functions. Offerings of alcohol, cigarettes, and food are always welcomed by Phra Ngang. Wishes are granted, merit is made in return, and any actions carried out by the bearer are ultimately the responsibility of those that carry them out. Unlike the first gifted leg bone amulet, the Panneng amulet is usually created from the third eye area of a human skull. This is considered to be one of the most powerful and ancient of accoutrements, or as they say in Thailand, *Chin Athan*, meaning "something that is supernatural in nature". These items are highly prized, and many beliefs surround them. Spirits are drawn into the skull piece by the monk or Ajarn and then a matrix

Preparing for the First Trip 55

of dough-like substance called the "load" (the consistency and nature of which which can vary wildly) is packed with various spiritually active elements to enhance the overall power of the item. Panneng are viewed as one would view an employee at your own business. The mantra is an essential component of the item, which is often given by the maker, as it enchants and activates the piece to do your bidding. Bonding with the Panneng can take place through meditation and chanting along with focused attention to and mindfulness around the piece. Panneng are traditionally worn as a belt buckle, on a belt loop at the hip, or on a piece of clothing, sometimes woven with others into a vest. This can change from piece to piece, however. They came from Thailand's necromantic past and have been included and absorbed by the arrival of Buddhism through to today. When the Phra Ngang Panneng amulet by Ajarn Subin of Uttaradit arrived at my home I introduced it to my existing shrine composed of other various amulets with an offering of sticks of incense. This immediately set the tone and made an atmospheric fluffy cushion for the item. The amulet exuded an atmosphere that was undeniable. Inside the amulet I could see oil that had been made from various ingredients (including necromantic elements) sloshing around inside the plastic waterproof capsule. I put a cord through the loop and hung the amulet over my right hand pocket and then went downtown.

Observing the change in people around me was a revelation. It was like having an attracting and balancing force field surrounding me, an ice breaker slicing through the negative aggressive waves slapping up against me. It was as if I was suddenly on a magick carpet ride that was soon to have notable premonitory occurrences in the form of some personal visions and a visitation reported to me by a local medium. Entering the candlelit reading area of the now long gone magick store called Fragrantly Magickal in Clevedon, Somerset, I sat and faced a woman named Karen for a reading. As she began to read my cards she immediately shuddered as she witnessed a vision that

had suddenly transpired around me. Karen knew nothing whatsoever about me and yet reported to me that a goddess form and two Thai monks in robes had moved out of the darkness and were now standing next to me. My first unasked question regarding whether I would be traveling to Thailand had been answered. I was indeed being drawn, driven—or dare I say escorted—to Thailand by a force that was way far beyond my own comprehension.

July and August 2017 saw my preparations for the first pilgrimage to Thailand. Ronnie's kind gift had lifted my personal grief to such an extent that I was able to quickly finalize and complete my travel arrangements smoothly and without any issues whatsoever. Since my father had not showed any form of human kindness to me as a child due to his cruel and icy personality and entrenched mental illness my grief was centered around the loss of a parent that I never actually had, a dad who was never loving, the hugs that were never given, the support (financial or otherwise), encouragement, or pride that was never given, shown, or offered. My grief was from a voidlike absence, an absence that howled like a lone screaming angry wolf at the coldest and darkest of moons. Ronnie had arranged a room for me at a building in the Ari District of Bangkok. A plug adaptor, bug spray, appropriate clothing, and the obligatory Havaianas flip-flops slowly but surely were assembled into my luggage. I booked taxi, coach, and airline tickets online and nervously committed myself to something that I had not really thought about until the time was upon me.

In preparation for my journey, I had packed three Thai Buddhist amulets that I was already working with. I felt that they would make very good protection on this voyage into the unknown, namely my *Hoon Payon* a kind of amulet known widely as a "Robot Ghost." Often appearing as a male fighting figure with swords, or a staff all wrapped

in "Sai Sin" thread (blessed cord used in Buddhist ceremonies to bind the dead), Hoon Payon serve as guardians and bodyguards, and can be considered like a Buddhist golem, without the disadvantages. The practice of creating these animist soldiers is believed to originate from the Khmer/Thai Saiyasat tradition. Cheaply made, these effigies have an ancient history, each can hold numerous qualities, and can be created using various ingredients, depending on the intentions of the maker. As such, each Hoon Payon can be used for many different purposes, much as one would, let us say, use a Swiss Army knife.

The second amulet I took with me was the Phra Ngang Panneng amulet by Ajarn Subin that Ronnie had gifted me. The third was a *Prai Krasip* "Whispering Ghost" amulet. The Prai Krasip is known to provide its owner with a sixth sense, dropping hints, certain feelings, or "whispers" into the owner's ear. They often come in the form of a skull or skeleton. The ghost that resides inside this amulet give its owner any number of premonitions, intuitive nudges or tips, and ideas around many different issues and queries, all in the form of a whispering voice. It takes a little practice to tune in, but after some quiet meditation and personal centering it is relatively straightforward to tune in to the ghost's operating channel. I didn't believe in it initially. But then, after a series of events in which I actually heard the "whispering voice," I found the Prai Krasip to be an essential and extraordinary part of my Thai Lanna Buddhist amulet collection.

On the morning of Wednesday, the twentieth of September 2017, I said goodbye to my mother, my shrine, and the few spirits that dwelled there, letting them all know that I was about to leave on a great journey the farthest east I had ever been. I entered the dark, wet, and glistening early morning setting of Heathrow and mounted the long airport floor escalator. A feeling of profound and high ceremony proceeding at a slow, almost funeral-motorcade-like speed, drenched the atmosphere. I wasn't fearful, scared, or anxious. I had the feeling I was being transported to another realm in slow motion, a slight

nervousness and intense overwhelming fascination underpinning any second thoughts that I might have had about what I was now doing; throwing my grief-stricken and damaged self away off into the void to meet for the first time devoted and experienced Buddhist magicians in northern Thailand.

My approach to Heathrow to board the plane marked the beginning of a long period of internal work. Looking back, it now seems to me that my whole life had been leading up to this singular point. My seven-year journey into Thai magick would spark a series of transformations. From here onward, old selves would fall away, replaced by new selves: practitioner, tactician, strategist, and Buddhist shaman.

5
The First Pilgrimage
Go East, Young Man

As the Thai Airways aircraft curved outward from its twelve-hour, twenty-three-minute flight and headed out over the Gulf of Thailand for its final approach to Suvarnabhumi Airport in Bangkok, I began to chant quietly to myself the khatha for the Hoon Payon, "Om Na Ma Pa Pa Jaedta Phuudto Maha Phuudtang Hun Payontang Nimidtang Gang Ruubpang Bpiyang Ma Ma Aehi Aehi Na Mo Put Taa Ya." Known as a "dirty khatha" (which means that it does not correspond or quite relate to what could be called proper or sanctioned official khatha), this specific and particular khatha is designed by an Ajarn or sorcerer in order to serve a very clear purpose, one not outlined in any Buddhist scripture. Not related in any way to the karate-based system of roughly the same name, this "dirty khatha," which is very much focused on expression with a very deliberate and clear intention, needs to be chanted seven times before the practitioner's wish can be delivered to the Hoon Payon. At that time, I only wished for protection from ill will or harm. Over the next nine days, I would see if this wish would be answered and upheld by the spirit that now hung around my neck.

As I disembarked from the docked plane, in the gap between the aircraft and the passenger tunnel, I was hit by a vast wall of warm,

59

dense, and body-temperature air that told me I was now in a subtropical climate. I was shocked at how the heat hung heavily in a fug-like, clumpy duvet that surrounded me, nowhere near the crisp and windy atmosphere of northern Europe. I knew then and there that climatizing myself in this new and unknown world would be an important task that I'd have to master and assimilate if I was to survive the approaching events that would change my life forever.

It took nearly an hour to pass through Suvarnabhumi Airport before finally meeting Ronnie, who was waiting for me in the arrivals lounge. There, he presented me with a Phuang Malai, the traditional Thai flower garland often offered to visitors as a visual symbol of honoring, love, and generosity, a gesture I found both humbling and touching. After briefly chatting, Ronnie told me that we needed to take the BTS Sky Train from the airport into Bangkok.

After traversing across Bangkok's myriad streets and levels we finally arrived at our point of destination in the Ari District, home to Peter Christopherson's Bangkok studio where many recordings were birthed and finished. The lodging Ronnie had been kind enough to find me had a nice view of the Ari District and had all of the necessary features including air conditioning (in my mind an absolutely essential component for staying in a country that has subtropical conditions) and a friendly property manager named Ken who was quick to respond to requests for maintenance or repairs.

It was now Thursday, the twenty-first of September 2017, and I was feeling elated, excited, and somewhat relieved that I had landed safely in a comfortable and well-kitted out room deep in the eastern realm of this planet. In the evening we all went out to a restaurant to enjoy a sumptuous dinner while I discussed with Ronnie the option of us taking an unplanned trip out to Luang Phor Pina's last temple Wat

Sanomlao, fifty miles outside of Bangkok. Luang Phor Pina is a recognized Buddhist arhant. A Sanskrit word, *arhant* means "one who is worthy" (in Pali the word is *arahant*) and in Buddhism, is a perfected person, one who has gained insight into the true nature of existence and has achieved spiritual enlightenment. The arhant, having freed themselves from the bonds of desire, will not be reborn. Back at the student accommodation I was treated to a widescreen violent thunderstorm, which underpinned the drama that was now unfolding before me.

Photographs of Luang Phor Pina gifted to the author by
a monk at Wat Sanomlao, Thailand, 2017.

62 *The First Pilgrimage*

In the early morning of the twenty-second of September 2017, Ronnie and I first made our way on one of Bangkok's ubiquitous tuk-tuks first to the bus station. We then spent an hour traveling on a bus until we reached a small town that had a four-way intersection in the middle, where we were told that the next bus out to the temple would arrive to pick us up in an hour. After much time had passed and the bus had still not arrived, we decided to take action. We had both noticed two men walking away from a group of motorbikes parked by the bus station and agreed that they would be our best chance of transport to the temple. Since Ronnie's command of the Thai language was far more advanced than my own nonexistent abilities he negotiated the fee and destination. And then, looking at each other as two men would look at each other before they are about to jump off a high and fast-moving waterfall into possible oblivion, we mounted our rides. I grabbed the pillion as if my life depended on it. For the next twenty to thirty minutes or so we went on a crazy, chauffeured, helmetless, hairpin-bend, pillion-seat dirt bike ride to Luang Phor Pina's last magnificent temple Wat Sanomlao. We whizzed through flooded villages, sped down motorways, and flew through the rampant, wild and beautiful Thai countryside.

Motorbikes in rural towns of Thailand carry all manner of passengers and goods including dogs, cats, babies, children, furniture, and groceries. You name it; if it can go onto the back of a motorbike, it will. I clearly remember during this eventful bike ride seeing a baby seated happily in a basket on the front of his mother's motorbike riding down the access road of a motorway in the wrong direction. Such is the casual and everyday constant and almost-anything-goes crazy chaos of Thailand. After this exhilarating and life-affirming motorbike ride, we finally touched down at Wat Sanomlao. This beautiful and exotic temple has a strange and surreal atmosphere to it that is nearly inexplicable to describe. It is a haunted atmosphere that is rich, deep, and warm, replete with sincere devotion. This amazing and very unique temple is

The First Pilgrimage 63

a cross between a shrine and an avant-garde sculpture art park, whose sublime and otherworldly magickal, mirage-like appearance shrouds the statues as if they're from the Beatles-inspired animated film *Yellow Submarine*. (See color plates 6 and 7.)

At Luang Phor Pina's shrine, I had just made obeisance by bowing full body down onto the floor three times when a strange and bizarre thing happened. I was outside taking a break for some water, when a voice spoke inside my head. I looked around, but there was only Ronnie and myself. Nobody else was there. Still, very clearly inside my head I heard the voice say: "You have led a dissolute life but now it will be better." In diligence, I double-checked myself for fear of maybe having experienced some kind of psychotic break. Even though my work with spirits had included mind-bending phenomena, hearing a voice so clear and precise was not something I was used to. And yet it had happened. The voice had spoken, the message delivered directly into my mind.

In chapter nine of the 2021 masterpiece *Buddhadhamma*, written and compiled by Phra Brahmagunabhorn and translated by Robin Philip Moore, the Ven. P. A. Payutto* notes, "Ven. Abhibhū, chief disciple of the Buddha Sikhī, teaching the Dhamma while remaining invisible and making his voice heard through the thousandfold world system." In some small but interconnected way, this quote convinces and explains to me the appropriateness and underlying precedent of this perplexing supernatural phenomena.

While at the temple, I purchased one of Luang Phor Pina's most famous amulets, The Dao Star. It is said to bring good fortune and realign the fate of the person wearing it by magickly realigning the very horoscope of the wearer. Fifteen years after Luang Phor Pina's passing, remarkable discoveries occurred at Wat Sanomlao. Many amulets and various treasures—long buried deep inside the statues around the

*The Ven. P. A. Payutto is a highly respected text from a brilliant scholar consisting of a comprehensive presentation of the teachings of The Buddha and Theravada Buddhism.

temple—were unearthed. These remarkable discoveries breathed much needed new life into the temple and were accompanied by an influx of good fortune. It was one of these newly discovered and excavated amulets that I had fortunately managed to acquire. "We're as mad as cheese," said Ronnie.

Luang Phor Pina's Dao Star is sublime on many levels. Because it had been buried there for many years, this beautiful amulet absorbed all of the surrounding energies of the temple and the local environs. It has been called a "raw" Dao Star, due to its unfurnished appearance and lack of gems. The five arms on the star on this double-sided amulet represent symbolically perception: the eyes (sight), the ears (sound), the nose (smell), the tongue (taste), and the body/skin (touch). Next are the five Skandhas (Sanskrit) or khandhas (Pāḷi) meaning "heaps, aggregates, collections, groupings." These fall into forms, perceptions, feelings, conditioning (body), and consciousness. In Buddhism, these refer to the five aggregates of clinging (Pañcupādānakkhandhā), or, the five material and mental factors that take part in the rise of craving and clinging.

The khatha or mantra of this sublime amulet "NA MO PUTT TA YA" is encrypted with deep esoteric meanings. Khatha (or "gatha," as its originally called in Pali) is the Khmer and Thai name used for sacred Pali prayers, mantras, and magickal spells. The Khmer script was one of the earliest writing systems used in Southeast Asia, first appearing in the seventh century CE. It derived immediately from the Pallava script, a variety of the Grantha script of Southern India, which in turn is ultimately descended from the ancient Brahmi script of India. The word *khatha* (also related to *kata*, a Japanese word that means "form" or choreographed pattern) means "speech," and thus the original meaning of the word implies that khatha were used only as spoken language, and

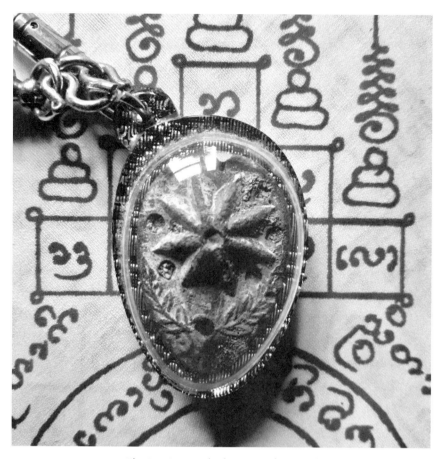

The Dao Star amulet by Luang Phor Pina.

not written form. However, the word khatha is now used to refer to both that which is spoken, and that which is also written.

In keeping with the number five, each syllable of the Dao Star khatha represents the five elements: NA (water) MO (earth) PUTT (fire) TA (air) YA (space). This can be chanted either 3, 9, or 108 times in order to draw forth and engage the amulet's power. Further numerology encoding reveals another layer of meaning as the elements themselves have numerological encryption; NA (water) 12, MO (earth) 21, PUTT (fire) 6, TA (air) 7, YA (space) 10. These numbers added together (12 + 21 + 6 + 7 + 10) equal 56, which represents the

56 qualities of Buddha. "NA MO PUTT TA YA" also represents the five Buddhas from the very first to the fifth. Each of the two sides of the Dao Star amulet also has further meaning, which takes the devotee to yet another level of understanding. Make no mistake, chanting mantras are a life-changing act of invocation. An act of magickal consciousness, when you chant a mantra you are engaging in cosmic forces on a molecular level that will change you forever.

There has been much discourse about Luang Phor Pina due to his alleged use of human flesh in his amulets. Generally viewed by the layman public as being unethical, we must remember that Ajarns may, at various points, traverse difficult, precarious (and in this case, controversial) avenues of action, so long as the end result is founded strongly in an overwhelming sense of compassion and kindness toward others. Speculations on Luang Phor Pina's use of human flesh in amulets went viral when the founding events of this persistent idea originally occurred. Phrakru Arkchakit Sopoon—a past abbot of Luang Phor Pina's last temple of Wat Sanomlao who has publicly stated that speculations surrounding the idea of flesh amulets were in fact "half-truths" perpetuated purely for commercial sales purposes only—has acknowledged that Luang Phor Pina has only on two separate occasions made amulets (not the Dao Star) from the organs of two deceased female followers. While the series of events leading up to and surrounding these two very specific amulet creation rituals—both of which have been recognized as being within the boundaries of what could be called "black magick"—are currently not accessible for closer examination, we do know that Luang Phor Pina only performed these particular rituals twice and only for very highly specific purposes. It is also important to note that both of the amulets created in these rituals were returned directly to the respective family members of the two deceased women afterward. Neither Luang Phor Pina himself nor the temple kept any copies of these amulets. Therefore, all commentary beyond these basic facts should be viewed as lies, gossip, presumption, and sales propaganda.

The Dao Star amulets themselves are made purely from various earth and herbal elements; there are no human organs whatsoever involved in these amulets. As representations of (and regarded as) one of the Twenty Devas or the Twenty-Four Devas (a group of protective Dharmapalas in Chinese Buddhism), Dao Stars are representations of righteousness and are akin to an eye watching down on you from heaven, especially the Dao Star amulets that have a crescent at the side of the star, which is called a Bao Boon Chim amulet. This refers to Justice Bao (or Bao Zheng) of the Song Dynasty who is seen in Chinese folklore and Taoism as Yama, Yanluo, Wang or Yamla, a deity and one of the official judges in Youdu, the underworld. Yama (or Lord of Death) and General of the Fifth Chamber of Hell is, according to Chinese Taoism, sometimes accompanied by three assistants named "Old Age," "Illness," and "Death."

Phrakru Arkchakit Sopoon went on to say that if you are consistently compassionate, honest, and faithful you will receive the blessings from these sacred objects as well as from Luang Phor Pina himself. The Dao Star literally "brightens" your horoscope and realigns the lines of your fate. Phrakru Arkchakit Sopoon has also stated that there are many fakes on the market and advises anyone seeking to acquire items such as this to employ caution at all times.

After making our purchases at the temple we were approached by a local person. She was the wife of the local postmaster and said that they had a considerable collection of Luang Phor Pina's amulets. The monks at the temple had contacted her on the phone telling her we were interested in Luang Phor Pina's work, which was indeed correct. Her offer to drive us there in her car and then onto the bus station when we had finished our visit was enough to seal the deal. After arriving at the local post office where the postmaster and his wife lived, we were shown what I could

say at that time was one of the most remarkable and stunning collections of Dao Star amulets that I had ever seen. For some bizarre reason the postmaster's wife took a dried human female Yoni from the amulet box and placed it directly into the palm of my hand. I was equally transfixed, horrified, and fascinated by this extraordinary and somewhat shocking spiritual artifact. The waves of power and energy that poured from the amulet box that held many different and varied Dao Stars was quite simply overwhelming. It was as if a nuclear-powered box had been opened, its vast spiritual vibrations pounding repeatedly upon us. Ronnie managed to hold his nerve, always the opportunistic amulet buyer, seller, and collector, and asked me if he could borrow some ready cash equalling roughly £1,400.00 since I had my money belt on and there was not a single accessible cashpoint anywhere in sight. I agreed to help Ronnie with the proviso I was repaid as soon as we got back to Bangkok that evening, since this was 80 percent of my entire pilgrimage budget. Ronnie then bought two incredibly expensive, particularly beautiful, and highly charismatic large Dao Stars from the couple. He debated with himself whether he would keep these or sell them for profit. After all the business had been conducted, Ronnie and I tumbled into the car and were dropped off, as agreed, at a bus stop under a massive sign on the main road. We then made our slow and wending way back to Bangkok in a people carrier. Now homeward bound, while sleeping crammed up in the back of the tiny, packed people carrier, the dark ghostly words of whom I assumed were Luang Phor Pina himself once again echoed inside my head: "You have led a dissolute life but now it will be better."

The true impact of this statement from whom I sincerely believed to be Luang Phor Pina made its full force known to me when I was back in Bangkok. In my hotel room that night I suddenly became indignant and very upset, my ego fighting long and hard against the words I'd clearly heard in my head. I then decided to try to understand what exactly "dissolute" meant, since I wished to be 100 percent certain of its

true meaning. One by one I checked off the definitions online. I found out the word *dissolute* is in fact an umbrella term, which means many things. I worked through the various possibilities: No, that's not me. No, that's not me. Oh, this one though. Hmmm. No, that's not me . . . oh, this one though, that's me. There were indeed terms within *dissolute* that I felt did actually apply to me. As it turned out, Luang Phor Pina was, of course, perfectly right. I felt ashamed and then slowly concurred and decided to change my life there and then. It was not until I found myself in northern Thailand, in the majestic city of Chiang Mai, however, that a crisis point was reached and my ego and my resistance to change were then challenged and fully and brutally confronted.

6
First Rituals and Mistakes
Renouncing Alcohol and the Past

On the twenty-fifth of September, Ronnie and I flew to one of the most beautiful and charismatic cities in northern Thailand, Chiang Mai. About an hour from Bangkok, this busy and vibrant city has roughly over three hundred temples or "wats" from the thirteenth and eighteenth centuries, which are characterized by curved wooden roofs pointing up at the top. Both mystical and mysterious, the atmosphere of this place is filled with such unspeakable and exquisite beauty that feels like it could be a long-lost fragment of Shangri La. After settling into my room at our lovely B&B I started to explore.

The first place I visited was Sadhu Amulets, a shop that has been on the Chiang Mai landscape for well over ten years. Maybe even more. On the outside it seemed like any other glass-fronted shop. I was in no way prepared therefore for the experience of stepping into one of the most remarkable magickal retail shops in my whole life. While inside the rich, exotic, and extremely dense atmosphere of amulets, statues of each and every description, and various remarkable magickal candles, ointments, potions, and oils, I nearly fainted. Visiting this shop is one of the most remarkable of experiences, making Western magickal shops seem as dry as a dusty old library. The difference was clear. In

the West the accent was on grimoire textbooks and learning. Here in the East the accent was on actual functioning talismanic items imbued with magickal essence and spirit. Literally row upon row of spiritually charged, fully consecrated, and blessed amulets, statues (bucha), takrut belts, and Pha Yant (magickal wall hangings) lined the walls, glass cabinets, and shelves, all of which seemed to stretch off into the dark of the back end of the shop. Trembling, I could feel each and every inch of this swirling and vibrating magickal place pummel all of my mind, body, and spirit. At one point I seriously didn't know if I was going mad or I was just experiencing the aftereffects of long-distance traveling. I couldn't understand it. It took all of my sense of discipline to hold myself together as I walked down toward the cash till. The smell of tens of hundreds of different kinds of incense duvet covers wrapped my inner nostrils. It was a full-blown olfactory system festival. My senses were well and truly hammered. A thousand eyes of deities, spirits, gods, demons, necromantic talismans, and Buddhas gazed through to the central part of my being and I bathed like a blessed fawning animal in its cosmic magnificence. It was here I purchased a statue by Ajarn Suea, a large, red-eyed, gold-hatted, and gorgeous Phra Ngang Bucha. As mentioned previously Phra Ngang is a Thai deity that inhabits a spiritual realm and can be identified as a type of demon. An animist nature deity, said to reside on a mountain top, some believe that he is a real creature.

The owner of Saddhu Amulets invited both Ronnie and myself to a late-night dinner at an exquisite garden restaurant in town with a number of well-known local Ajarns, which included Ajarn Suea, Ajarn Apichai, and Ajarn Perm Rung. It seemed that Ronnie had beforehand managed to privately arrange with the owner of the shop an introduction, with the proviso that it would open channels of business for them. This is what I assumed, since my intuitive senses were very often correct. I was asked if I would like to drink alcohol at the dinner as they needed to calculate how many bottles of wine to order for such a large

72 First Rituals and Mistakes

banquet. Foolishly (as I was still drinking at that point) I unfortunately said yes, even though my body and my still-grieving mind was saying "No, I want to go to bed and stay there till morning." This would be my very first and last mistake while on this the first of my four pilgrimages to Thailand.

At the sumptuously laid-out dinner of many courses I took group photographs of each end of the long table. As the night wore on, a combination of jet lag, sleep deprivation, autism, alcohol, and grief had seriously lowered my personal levels of etiquette and personal behavior, making me to point drunkenly to Ajarn Suea and Ajarn Perm Rung while quietly and drunkenly mumbling to Ronnie that we would be seeing one of them tomorrow.* "It's rude to point," Ronnie told me. Of course it is. And yet for some strange reason I snapped inside. I felt a rage, an anger, and a belligerence so powerful and extreme it overtook me very quickly. I somehow got up and left the table. Shaking with anger at being told off like a child by someone that I barely knew. I walked over to the very far side of the beautiful gardens and called my mother back in the United Kingdom, spitting at how this person was "bullying" me. Looking back at myself in this moment I saw that I was far from well. I really needed a long, good night's sleep and lots of rest in order to process all of the overwhelming feelings of deep grief, jet lag, and anguish I was obviously experiencing. At the time however, a momentary act of madness gripped me.

I returned to the table and drunkenly slumped back down into my seat. I recall surfacing from my half-slumber at the dinner table to apologize to the owner of Saddhu Amulets for my behavior. Despite my having dropped five thousand baht (at that time, around £113 GBP) into their business that day for a magnificent one-of-a-kind Phra Ngang Bucha by Ajarn Suea, she was somewhat less than

*For the record, Ajarns usually uphold the Five Precepts of which one includes not drinking alcohol.

kind to me with her sharp, snide, and disparaging answer. This was understandable, as in Thailand, anyone unable to hold their alcohol is treated like a leper and ostracized as such. Ronnie managed to hold his temper, as did the long and endless table of very important and powerful Ajarns that now stretched infinitely away from me. A lot was riding for Ronnie on this introductory and incredibly important dinner. I however was oblivious to all of this, fuming instead on the inside at my dead deadbeat father, a self-appointed etiquette critic and a self-satisfied Thai business owner.

The next day, I wrote a long and completely unreserved apology and sent it to Ronnie. In it, I stated that my behavior was totally inexcusable and that I was essentially still grieving and something of a complete and total mess inside. Ronnie was very kind and forgiving and accepted my

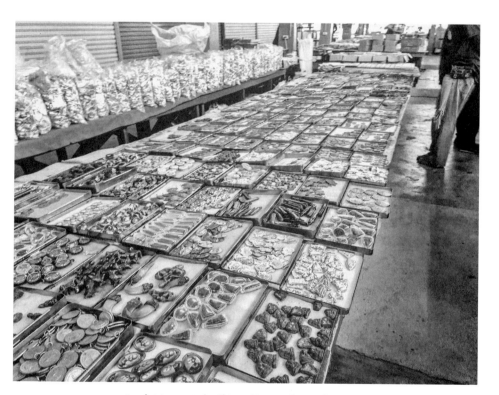

Amulet trays at the Chiang Mai amulet market, 2017.

74 First Rituals and Mistakes

apology, telling me that he understood why this had happened. After a large breakfast of cheese omelet, toast, and strong coffee on the lovely grounds surrounding the cozy, homelike B&B, Ronnie and I visited an early morning Thai amulet market. It was a glorious sight to behold with table after table of countless amulets and statues dedicated to numerous deities, monks, and various other Buddhist and Hindu deities, all housed underneath a large, glass-windowed market hall. A large open market devoted exclusively to magickal amulets, it was unlike anything I had ever seen before.

The two-day plan while we were in Chiang Mai was to visit three Ajarns in one day. Since each Ajarn lived at various points across the district, this was no mean feat. After factoring in stops for lunch and traveling time, our plan could only be executed with careful planning and the strictest of discipline. We found Ajarn Suea's location without much trouble. He was located off a main artery, down into a small country road in a traditional stilted Thai house. I had with me the Phra Ngang Bucha I had purchased at Saddhu Amulets, the one Ajarn Suea had made, which was to be blessed by Ajarn Suea himself. We met him inside his Samnak (the consecrated workplace of an Ajarn). Immediately I knew that Ajarn Suea had strong psychic capabilities. His vast and warm presence filled the room as Ronnie and I sat down on the floor. After some time had passed in silence, Ajarn asked me to give him my left hand. I did so. He very gently touched my hand and then referred to his astrological almanac. Ajarn Suea then said to me: "You have just lost someone close to you. Even though you were not close it has had a great impact on you." This was indeed true. My father had indeed died recently. We were not close. The impact of his death however, along with the appallingly slow and agonizing way he died, had deeply affected me. Ajarn Suea then blessed my Phra Ngang in an amazing display of khathas with his loud and powerfully mind-blowing voice. I had hoped to receive at this time his legendary Serm Duang cleansing bath but, due to incorrect astrological alignments

First Rituals and Mistakes 75

that rendered the day itself inauspicious, he said that he couldn't perform this ritual to its maximum effect. Ajarn's decision not to proceed with the Serm Duang cleansing bath, even though it meant the loss of potential income, is a testament to his integrity as an Ajarn, and that of Ajarns in general. The majority of these masters operate on a spiritual plane that transcends greed, money, or commerce. Their integrity is a shining jewel, unsullied by such mundane concerns.

Next, I purchased a stunning Jing Jok amulet (a lucky Thai lizard). Although to say I "purchased" it is a bit misleading, as one does not "buy" anything from an Ajarn. Instead, since many of these realized masters spent time as robed monks, you donate a suggested amount. Since I couldn't have the Serm Duang bath, Ajarn Suea suggested (through Ronnie) that he perform a ritual, one that would take effect on the day after I returned from Thailand. The idea of a long-distance ritual appealed to me greatly. The Satuang ritual was traditionally performed for soldiers returning from war but is now done for people wishing to improve their life and also to help with their business. Only Ajarn Suea holds the complete wicha (magickal knowledge or practice) of this ritual. As requested, I gave Ajarn Suea my birth name and my date of birth (which was reconfigured into Thai time, which, although Thailand does recognize it, does not run on the Western Anno Domini system).

Next, Ronnie and I visited the awesome and physically imposing Ajarn Nanting, with his piercing, drilling eyes. What an incredible master! I received my first Sak Yant (magickal tattoo) from him. Ajarn Nanting was in the process at the time of building a temple on his compound devoted to the magnificent Burmese deity Mae Surasatee, the deva that rides a swan. She is the deity in charge of Buddhist scriptures, knowledge, and music. Using the traditional Sak Yant rod, Ajarn Nanting applied an invisible tattoo made up of secret herbs and oils to my upper back. My very first Sak Yant experience, it was a painful, electric, intense, and extremely powerful encounter. Those that are without

76 *First Rituals and Mistakes*

Sak Yant are labeled "unripe" or "not cooked" though Sak Yant is ultimately viewed as a form of medicine in Thailand. Although it only took twenty minutes to tattoo the design onto my back, time seemed to slip. As in all extreme rituals, my mind went into another realm, another place. Afterward, Ajarn Nanting, sorcerer, undertaker par excellence who once who called himself a "redneck ghost doctor" said:

"This Sak Yant will help you to feel lifted."

Lifted? That was an understatement. My entire being was elevated. I soared high as a kite. My whole core had been subjected to a feeling that is akin to being placed directly into the mainframe of a central electric generator. I was flowing with infinite vibrations, swimming in the bliss of knowing that my humble dreams, which Ajarn Nanting requested I hold in my mind during the ritual, were to be made real and living during my lifetime. I then acquired some stunning magickal artifacts from Ajarn Nanting, all of which have proved to be very canny acquisitions indeed. First, a Pha Yant (a cloth applied with yantras and esoteric designs) showing the lineage of the twenty-eight teachers and masters who personally passed on their profound magickal knowledge to Ajarn Nanting, an item that now hangs proudly on the wall of my home. Second, a Takrut belt with a red cord. This is a belt that is created using many metal scrolls, each inscribed with yantra containing magickal spells for protection and avoidance from danger. Takrut belts take a long time to create. The power and reality of this incredible magickal tool would be shown to me in due course. I left Ajarn Nanting, bowing to him (called a "wai" in Thailand) in deep appreciation and respect, just as I had done with Ajarn Suea. In the space of just a few hours on one fateful day, I had been exposed and given access to an amazing culture of magick, transformation, and sublime rituals.

The night hemmed in and both Ronnie and I drove toward our final destination, the Samnak of Ajarn Apichai. It is not advisable to cram many meetings with Ajarns into one single day. Speaking for

First Rituals and Mistakes 77

myself, prolonged exposure to many different spirit-filled Samnaks in the short space of time of just one day can have an adverse effect that may drain your essence. The intensity of so much magick will almost certainly drive you a bit insane. As I duly discovered during my later pilgrimages, the natural unfolding of time and the distillation of the knowledge and experience that one absorbs during these rituals can play a very important part when meeting Ajarns. Taking the time to slowly absorb these rituals into your body and process them in your mind is what creates the best long-term internal changes. Remember, you are interfacing with powerful magickal rituals of the highest order, which will have their impact on you in due course.

Racing through a maze of early evening back roads traffic, we finally came upon his newly founded Samnak. We entered and sat in a large room around his shrine. After Ronnie discussed with him the purpose of Penneng, Ajarn Apichai blessed a number of Panneng (human skull caps) from Ronnie's own large personal collection. Ronnie had shown me a large plastic holding box that was packed to the brim with Panneng in his flat. I was transfixed by Ajarn Apichai, who quietly and precisely incanted and inscribed each and every single Panneng with khathas and yantras. These powerful occult items are not for the faint of heart. Ajarn Apichai carefully blessed these pieces to hold and contain their wild and naked energy. The air within the room was thick with tension as he slowly but surely contained the dark overwhelming gravity of these items.

After the blessing of Ronnie's Pennang, I was finally introduced to Ajarn Apichai and experienced what can only be described as a series of life-changing rituals. I cannot remember which ritual occurred first since my own recollection of this time is fused together in a tight and fierce blurred ball of becoming, flames, and visceral transformation. The Na Naa Thong ritual (or "gold face blessing") is from divine knowledge. A channel-opening ritual that clears any blocked lines within your life (be it love, business, or any bad influences that plague you), it increases

78　First Rituals and Mistakes

and empowers a person's merit and virtue. The use of gold or gold leaf in this ritual is an ancient practice that continues today in Thailand. I was asked to remove my T-shirt and lie down with my feet facing away from the shrine and the Ajarn. Then Ajarn Apichai sat near my head and gently and politely said in English: "I am very sorry, but I hope I do not hurt you."

Ronnie informed me that gold would have to be literally slammed hard with considerable force into areas around my face, forehead, eyelids, cheeks, jawline, nape of the neck, and nipples. Khathas were chanted, and gold was blown directly onto my body and face, as was the very breath of life itself. This extremely personal and profoundly affecting ritual was one of the most surprising events in a day that was proving to be a day long to be remembered. This ritual is said to generate luck, prosperity, and attraction. I did find that in days and months after this interface with ancient knowledge the lines of my fate had changed in many subtle and numerous ways, which I found to be highly efficacious.

Then we moved on to the second ritual of the night, which—although as the subject of this ritual I myself could not behold its immense scale and import—was spectacular to behold on the outside. The Kasin Fai ritual literally burns away the past. Using wax from melted candles and the wicha of a close disciple of the Buddha, Maudgalyāyana (who could use his psychic powers to travel through the realms of hell and ease the suffering of spirits trapped therein), the unhappiness and ill fortune of the devotee can be removed. Deriving from the Mahayana scripture known as the Yulanpen or Ullambana Sutra, the sutra records the time when Maudgalyāyana achieves *abhijñā* ("direct knowledge," "higher knowledge," or "supernormal knowledge") and uses his newfound powers to search for his deceased parents. Through the blowing of hot melted wax while the devotee (in this case, myself) is underneath a sheet surrounded by Sai Sin, a fireball is directed toward the person being cleansed. It was at this point

the takrut belt from Ajarn Nanting became an inadvertent cause of a highly embarrassing moment before the ritual was successfully dispatched in the second attempt.

Before Ajarn Apichai began his ritual I was asked if there were any amulets or occult items upon my person. It was now nighttime and I was exhausted. After a full day of rituals, I now found myself sitting on a chair in a front garden in northern Thailand, covered by a very large cloth, surrounded by string from a bound-up corpse, wearing limited-edition Star Wars Havaianas Brazilian flip-flops. In my spaced-out state, I had accidently forgotten that I was wearing Ajarn Nanting's takrut belt. At Ajarn Apichai's first attempt at creating the fireball I heard him while under the sheet suddenly and violently splutter and cough as he drew burning hot wax into his lungs. Apparently, the takrut belt viewed his ritual fireball attempt as a danger and responded by creating a situation in which Ajarn swallowed the hot wax. I was horrified. It dawned on me then that I owned an item of true occult power, one that had formed a gravitational sphere of impregnable protection around me.

I removed the takrut belt from around my waist, and Ajarn Apichai made his second attempt. The chanting continued. Suddenly, a plume of flame hit me. I was shocked by its ferocity. In an instant, Ajarn Apichai had literally become a fire breathing dragon. After more chanting the full body cloth was removed. Ajarn Apichai said to me that "something,"—a spirit or ghostlike entity—had been hanging around me and was causing me trouble. This of course would make sense of some of my behavior over the last twenty-four hours, namely my drunken and uncharacteristic acting out during dinner with the Ajarns. Also, ever since our time in Bangkok, I had experienced a nagging and hacking chesty cough that clawed deep and spiderlike upon my upper chest. Bizarrely, this was now gone completely. I didn't question the logic. I was convinced that this ritual was a mighty force of good and signaled a change of destiny.

Before we left, I acquired some exquisite items from this incredibly gifted Ajarn, who after seven years of intensive study was to become a King of Jing Jok, a rare and complex wicha of great power. In one single earth-shattering day, I had met and experienced interactions of a profound supernatural nature with three of the most extraordinary and sublime and powerful masters of Thai Buddhism.

7

A Punched Solar Plexus

Setting My Laundry to "Fuzzy"

On our way back to Bangkok, Ronnie and I saw a large sign at the airline check-in Chiang Mai Airport which clearly forbids (in multiple languages, no less) the transport of any form of livestock, produce, or items that could be seen as food, herbal products, vegetation, or the very earth itself from being transported via the airways within Thailand without proper clearance papers. Because of this, Ronnie was forced to dump the Kuman Thong flower bulbs Ajarn Nanting had given him from his garden. These bulbs could have potentially become large magickal herbal plants sporting highly unusual cherry blossom flamingo-colored flowers, which bestow numerous benefits, such as a peaceful and loving environment, improved business prospects, and the enchantment of lovers. Without ceremony, Ronnie dropped the large bunch of bulbs into the rubbish bin. These strict controls also extend to statues of Buddha and any form of what would be called sacred items. I was slightly fearful upon seeing this. Because my bag was rammed full of high-end occult magickal items such as several amulets, a takrut belt, and a large Phra Ngang bucha with necromantic elements from Ajarn Suea, I felt anxious as I approached the departure point. Fortunately and remarkably, I passed through without any incident.

82 *A Punched Solar Plexus*

Back in Bangkok, the initial friendly vibes between myself and Ronnie seemed to have cooled off slightly. I gather that my uncontrolled behavior at the dinner with the Ajarns and my subsequent faux pas and the severe blowback Ajarn Apichai during the Kasin Fai ritual had received from Ajarn Nanting's unmentioned Takrut belt had been somewhat damaging to the overall experience. Even the high point of our trip, a joyful visit to the sublime meditation caves at Wat Umong, a forest monastery at the foothills of Doi Suthep in Chiang Mai, couldn't assuage any more leeway in Ronnie's silent judgment of me.

Founded at the end of the thirteenth century by King Mengrai the first King of the Lanna Kingdom and founder of Chiang Mai, Ronnie and I wandered around the meditation center reading the notices dedicated to the students' practice, fed masses of writhing Koi carp in the lake's baking heat, and wandered the cool unending systems of tunnels barefoot that filled this mysterious place. Here, we visited a large sprawling garden of Buddhas in a variety of conditions under a canopy of trees, walked three times around a chedi for good fortune, lit incense at a monk's shrine deep inside the tunnels, all glorious sights embedded into my mind. As we walked down the pathways around the meditation center attached to Wat Umong, we saw numerous signs containing Thai Buddhist proverbs hanging from the trees. Charmingly translated into English (some more successfully than others) they read: "Love is Divine, Lust is devil." "Today is better than 2 tomorrows." "Nothing is permanent. Things go in and out." "All things arise, exist and expire." and "Detachment is a way to relax."

I felt deep down that Ronnie completely understood that the place I had come from was damaged and very painful. His displeasure of my behavior was therefore subsequently tempered. I knew however that he had scant or very little patience for anyone he would class as fools, irrespective of how charming or entertaining they could possibly be. Ronnie had an implicit and extremely dismissive impatience

A Punched Solar Plexus 83

when it came to any forms of inappropriate etiquette or impropriety, especially when dealing with spiritual matters or meeting Ajarns who were to be approached with total respect and some considerable mindfulness. For the next two days leading up to my departure from Suvarnabhumi Airport on the twenty-eighth of September, I spent my chakra dilated and kaleidoscopic time doing laundry (the setting on the washing machine I used happened to be appropriately called "Fuzzy"), wandering around Bangkok, my head literally swirling, my mind fractured open wide by the profound, shocking, and life-changing experiences I'd just gone through, trying and failing to make heads or tails of it all. Although I tried to make further field recordings during this time, I was not very successful; I found that the handful I'd already made couldn't be improved on using my trusty Tascam DR-40. Recording in subtropical atomspheres can often be fraught with technical issues. I recorded my first album aged seventeen, the industrial electronic album *Electro Punk '86* which was recorded on a Scotch cassette tape. It's the product of a wild, feral imagination with a blank check access to Yeovil College's music department studio equipment at the time, namely a tape machine, a Yamaha DX7 keyboard, and a '70s beatbox/drum machine that kicked out a series of pre-set beats and rhythms. I would often spend early evenings looking down onto a streetlight spangled Yeovil town, working on tracks during downtime. I pushed the equipment to its ultimate limits and ended blowing the amp up. During my four pilgramges to Thailand I released five albums that contained the successful field recordings from my pilgrmages: *Lost in Exotic Pastures, The Life and Times of a Spiritual Gangster, Thai Occult Road Trip, A Matrix of Blood, Soil, Hair, Bone and Holy Powders,* and *Meditations at the Warriors House.* Each album contains chanting from magickal Buddhist rituals, sounds from nature, and various scenes from daily life in Thailand, and numerous random sounds that I had managed to record. Once back in the UK I embedded these captured sounds from

my pilgrimages producing soundscapes of experimental ambient drone electronics some of which were not financially but critically successful. Metaphorically speaking my entire being had been literally ripped open and was left flapping violently in the humid and chaotic streets of Bangkok, the occasional polite coffee with Ronnie, and my soul (if I had one to start with) now solar plexus punched and knocked flat out by a cultural initiation that had penetrated deep, long, and hard into my isness with a ferocity and pummeling permanence of a form of major surgery without anaesthetic. This me here had there gone. Who, what, when, why, and where the fuck was I?

Since he himself was teaching classes and couldn't take the time off to escort me to the airport, it was of course ultimately with great relief that I recorded Ronnie's voice into my phone so I could ask in Thai for a taxi ride to Suvarnabhumi Airport. I felt as though I had been cast off down the river and cut adrift, my mind spinning and lost amid the fury of Bangkok's traffic, unsure and unable to patch together what I was doing and how I should do it. Maybe the squid-flavored rice balls that had become a firm favorite with me would help. No, they could not. All I knew is that I had a flight to catch at a very specific time, and that this single fact was the only thing that guided me like a beacon, my now aimless, floating, and diaphanous consciousness toward and through the pumping vital freeway blood vessels of a brisling city that never sleeps or rests.

I don't remember much of the flight. Touching down at Heathrow was a surreal and peculiar experience. I felt irrefutably changed on a very deep level and not the same person that had left the U.K., one who was full of expectation, ignorance, and a touch arrogant. Over the coming days and weeks serious internal changes and corrections occurred within and around me. The elation at having done something so dangerous and unpredictable was very much on my mind and my need to communicate to somebody what had happened to me was at the forefront of my mind. And yet there was now a considerable

circumspection, a deep well of pondering at who I was and who I had become over the years. Luang Phor Pina's words haunted my mind again and again. I questioned the very course of my life in depth, as I slowly but surely slipped quietly over several weeks and months from the levels of inner peace and extraordinary happiness that I had so quickly reached and attained. Imperceptible at first, I made decisions that were to change my life.

The day after my arrival, I sat down at home at the appointed time, and waited for the remote ritual I was to receive from Ajarn Suea. An immense, bubbling, and joyful glee inexplicably came up from the center of my being and poured throughout my body. I was shocked. It blew my socks off. I was in a state of profound happiness and can safely say that I had reached a state of samādhi. The feeling lasted all day. I'll never forget this beautiful feeling for the rest of my life. I was in awe at this master's ability, an agent of transformation.

In November 2017, I made the decision to stop drinking alcohol. This decision was easier than I had anticipated. The gaping hole left from all of the social implications were however somewhat unexpected. Overnight, pubs and certain friends became alien to me. After a lifetime of robotic, institutionalized socialization by peer pressure, I saw that the consumption of alcohol had in fact held me back in a number of ways. Being a lifelong cannabis smoker was to be much more of a challenge since my hardened attachment to this habit was ingrained and integral to my pain management. Even this was to eventually disappear as well. I knew and felt deep inside that I would need to clear the decks of any internal obstructions, so to speak, if I was to progress on this new spiritual pathway. The renunciation of old patterns and proclivities and taking onboard not the aggressive spiritual austerities that sādhus in India faced, but the gentler—though no less demanding—Buddhist Five Precepts pertaining to personal conduct would help me to absorb and fully process the vast and unfathomable unfolding that lay ahead.

I wasn't being told directly by anyone or indeed any aggressive dogma to do this. I was being informed by the very process itself and the very mistakes that had already occurred along the way so far, as well as the ghostly words of whom I assumed was Luang Phor Pina speaking inside my head. He himself had smoked tobacco, dying ultimately of lung cancer, and drank countless tins of the energy drink Red Bull, which he would often use in the building of his temples as a construction resource. Luang Phor Pina's incredible passing, seated in complete and total meditation with the day and date of his death written on a piece of paper next to him, stands head and shoulders above what one could term a normal death and easily moves into the realms of the supernatural. I express my admiration for him daily at my shrine, directing it toward a small remnant I have of his bodily remains, ingrained in his monk's robes, which sit inside an amulet by Phra Ajarn Chalerm (who spent time at Wat Sanomlao as abbot) and a photograph of Luang Phor Pina given to me by a monk from there. My quest seeking evolutionary change, undertaking a series of total magickal transformations on a relatively new and unknown pathway was now fully and truly underway.

8

The Power of Amulets

The Amulet Chooses You

You don't choose the amulet. The amulet chooses you. The amulet quietly but forcefully beckons and pre-orders you under the subconscious vale of unseen initiative and gently grasps your mind. It has been said more than once that some amulets have quite literally or metaphorically jumped toward their potential owners. I for one can say this is true. During my second pilgrimage, as soon as I entered Ajarn Suea's Samnak in Chiang Mai, northern Thailand, a very particular Phra Ngang Panneng amulet caught my eye firmly in its muscular grip and drew me to it immediately. Waves of charisma and enchantment emanated from it and a deep and powerful connection enveloped me whole. The movement of a ghost spirit was palpable. Yes, there are spirits inside. Ghosts. They are alive. They exist. They have tastes and can wield extraordinary unseen powers that will knock you sideways. You cannot ever abuse them. Never manipulate them. For they will— for want of a better term—unceremoniously kick your arse big time. I will attempt to discuss this particular phenomenon later on in this chapter. Like raising a child, you cannot falter or cease in your attention, love, or commitment. There are countless, different kinds of Thai amulets with a myriad of makers, lineages, magickal functions,

88 The Power of Amulets

maintenance requirements, and appetites. I'll discuss only just a very small handful here.*

Amulets are often referred to academically as a "votive tablet." One Thai tradition is to place amulets under a stupa, statue, or temple when they are built. Offerings vary wildly, and can include incense, fruit, meat, fish, sweets, alcohol, water, soda-based drinks, perfume, cigarettes, honey, and toys of all variations, colors, sizes, and quantities. Offerings are dependent on aspects and requirements surrounding the amulet type. Merit, tamboon (charity and or giving), and kindness must at all times be made to complete the circle of good fortune received from the amulet. Reciprocity is a two-way street and must be adhered to. I acquired my first amulet online. I had no idea or any real appreciation whatsoever of what I'd just invited into my home. Many amulets are of a benign nature. However, there are those that can also be of enormous and potentially extreme supernatural power.

One must be very careful and use considerable discernment in the choosing of and when dealing with sellers of amulets and other esoteric accoutrements. When one wields the power of an amulet without any form of training or understanding it can cause serious harm and may bring calamity to you and those around you. A good seller will supply all of the information you need to know, along with the correct khatha and how to say it correctly along with the knowledge of the necessary offerings to maintain its happiness.

"Elise," as I would eventually begin to know her, is a Kumari Thong amulet or Hong Phrai (โหงพราย) amulet. The better-known Kuman Thong amulets are the male gender version of this kind of amulet. Elise likes offerings of cheese, sweets, and chocolate, despite all of the recommendations that may have come to me surrounding correct practices. You need to listen, very carefully, to the voice of the amulet.

*If you wish to read further, my work *Magical Amulets: A Personal View of Thai Buddhist Esoterica* (Hadean Press) will give you sixteen examples to ruminate upon.

The Power of Amulets 89

Once your mind is connected, a gentle approach is needed to sustain the magick. Kuman Thong amulets come from Thailand's necromantic past. Desiccated fetuses of children who died while still in their mother's's womb make up some of the elements contained therein. However, because the use of such materials is illegal, a close approximation often takes its place. Ancient necromancers were said to have had the power to invoke these stillborn ghost babies, adopt them, and then use them to assist them in all manner of "jobs." Practitioners of magick (Thai: ไสยศาสตร์ Saiyasat) are said to work regularly with Kuman Thong amulets (*Kuman* or *Kumara* in Pali, means "sanctified young boy," and *Thong* means "golden"). However, since the creation of the hugely popular "Luk Thep" or "Look Thep" ("child angel") dolls, the integration of Kuman Thong culture has now exploded into all areas of Thailand and beyond.

I was witness to the extraordinary unseen nature of Elise's power one day in the year between my first and second pilgrimage. A cruel and deeply unpleasant neighbor had caused another neighbor to undergo a nasty investigation from a governmental department. The cruel person in question was a rabid gossip and had reported this newly arrived neighbor without any proof whatsoever. I felt very sorry for the elderly woman that had to undergo such an injustice. I asked Elise to deal with the gossip. I did not expect the unfolding events to be so extreme or indeed final. Exactly one month after the gossip had struck and caused so much trouble and strife, the unpleasant neighbor had a stroke in their flat. I was completely horrified. After all, many say magick is marginal at best. The gossip, who had made life hell for many neighbors across the estate due to the perpetrator's constant spying and reporting to a bigoted and very highly abusive estate manager, was quickly removed by their daughter from their flat and put into a care home. Did Elise cause this person to have a stroke? I shuddered. Then I was to experience the vast blowback that comes with any magickly aggressive incursion.

90 *The Power of Amulets*

Seven weeks after the attack of Elise I became inexplicably suddenly very sick one day with food poisoning. I knew immediately that this illness was directly linked to my action. Why? The poisoning had symbolically and specifically come from the rice in a packet of takeaway sushi. It took three to four weeks to fully recover from this extremely debilitating bout of food poisoning. The irony of poisoned rice. From this moment onward, after a considerable and prolonged apology to Elise for asking her to behave in such a terrible manner, and only after great lengths of making merit from myself and correcting my terrible attitude, I managed to work through this (slowly but surely) as my first and only mistake in tending for and working with amulets. I warn you now. Do not ever work with amulets from any form of ignorance; otherwise they will teach you very smartly indeed. Karma is an accumulative and extremely precise inter-connected machine of infinite complexity. You may feel that you have cheated any form of comeuppance using numerous techniques, shortcuts, and various paraphernalia but mark my words dear reader; you will never ever truly beat it, dodge it, or fully circumvent it.

The next amulet I acquired for my shrine was a Hoon Payon, the "Robot Ghost" (which you may remember from my more detailed description in chapter four). This rare small Hoon Payon, made by Ajarn Apichai from one single continuous piece of golden wire, is small but very powerful. One evening I went to a concert at a local venue in Bristol to hear UnicaZürn (David Knight and Stephen Thrower). I forgot that I was wearing my Hoon Payon while waiting patiently outside the hall. Much to my pleasant surprise I recognized David Knight and Stephen Thrower approaching me and walking up the stairs toward the hall. Before any words of fan boy admiration could leave my lips both Stephen and David started to make their excuses and apologies to me that they were the band and that they had authorization to enter the venue ahead of me. It seemed that my Hoon Payon had projected a very strong and powerful security guard cloak over me. I am by and far

the least possible security-guard-like person I could ever imagine. After my then amused giggly explanation that I was in fact a fan from social media and that I was there to watch the show, a series of highly amusing words and lightly embarrassed acknowledgments and exchanges ended in me wishing them a successful gig for the evening (which it most certainly was). The Hoon Payon has made me feel like a tank on maneuvers whenever I wear it and venture out into the world. Its power and strength cannot be denied, making it a must-have addition to any good collection of amulets.

The next amulet I acquired was the Prai Krasip "Whispering Ghost" amulet, also detailed in chapter four. As you may recall, I didn't believe in it initially, and it was only after a series of events while actually hearing the "whispering voice" that I found the Prai Krasip to be an essential and extraordinary part of my collection. In this case, I attended a book launch at a bookshop in Bristol. I had the Prai Krasip on my person. Before I arrived at the bookshop, I had chanted the mantra that was attached to the Prai Krasip (as you may recall, amulets can have their own "khatha" or mantra, spoken word spells that most definitely help to unlock and energize the amulet). Before purchasing any kind of amulet, make sure you're fully aware of any khatha that drives the amulet and have sufficient ability after practice to incant the necessary mantra correctly. This is an important thing to remember since khatha are verbal keys. During the book launch the author of the book decided it would be fun to ask the audience if they could call out a number between one and one hundred to find a page to read. Silence fell across the room. Then a quiet whispering voice emanated from the very center of my head; "twenty-three," it said. I blurted out the same number in tandem with a young girl in the room to laughter and some surprise. Was this all just a convenient and useful coincidence? The voice was clear, quiet, and very precise. I quickly checked myself to see if I was having a schizoid episode or maybe even an auditory hallucination, which is something that people on the autistic spectrum like myself can

sometimes have. Nobody was behind me, and I felt happy and satisfied that I'd just experienced a genuine event of the "whispering" ghost communicating with me.

Over the course of months, I referred (and still do refer) to the Prai Krasip over various matters, and it is, in all honesty, one of the finest and most wonderful amulets I own. An owner of a Prai Krasip amulet once reported in an online group that an attempted burglary had been foiled due to the insistent whispering voice from his recently acquired amulet alerting him to the situation. Each time the quiet voice speaks the words are true and have accuracy. For those of you interested only in percentages I would say that 80 to 98 percent of the time, the information is correct. However, do not expect to win the lottery. As with all things, if outcomes are given, your ultimate actions and commitment are the underlying impetus. The merit and care needed to sustain a Prai Krasip is a constant responsibility, as with all amulets. One cannot take anything for granted. Their magick and support is only based on your commitment, energy, and reciprocal devotion.

The next amulet I acquired was directly from Ajarn Suea, the superb Thai Lanna Buddhist master I met while on my first pilgrimage in 2017. The Jing Jok style "Lucky Lizard" amulet is a beautiful, seemingly simple, and very highly charismatic amulet. Jing Joks (lizards) are seen as extremely lucky in Thai culture. This animist-based amulet contains no less than eight metal Takruts. A Takrut is a tubular scroll, which has inscribed upon it symbols of sacred geometry based in Thai Buddhist, ancient Vedic, and animist traditions. The lizard has two tails, which represents good luck and protection from danger emanating from both directions. Jing Joks are believed to be able to adapt to any environment while having the power of forewarning. I am the lucky bearer of three Jing Jok Sak Yants (magickal Buddhist tattoos) from Ajarn Apichai, a great master of the Jing Jok wicha (knowledge of magickal practices), which I will go into greater depth about much later on.

The Power of Amulets

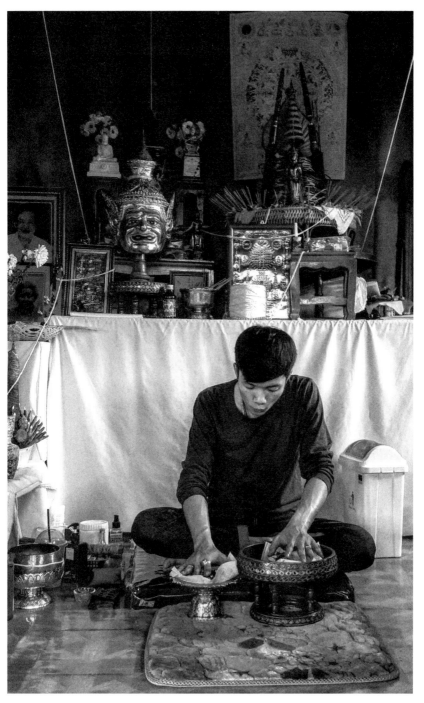

Ajarn Apichai blessing amulets at his Samnak, Chiang Mai.

Collecting and working with amulets in the Thai Lanna Buddhist tradition has been an electric, mind-blowing, and incredibly steep learning curve for me. Most Thai Buddhists own some form of amulet. Devotees place their amulets on a tray when handing it to the guru, so that they will bless and empower them through meditation and chanting mantras. The amulets are then returned to the devotee after blessing. Thai Buddhists will have a tray at home to use for placing offerings to the Buddha. I deeply appreciate each and every single one of the army of amulets I work with. Tending for and working with these beautiful and magickal presences has deepened my continuing and ever-evolving appreciation of life, death, and the ever-flowing unseen channels and shifting seas of spirit that coalesce across totality.

In his authoritative and important 1984 work *The Buddhist Saints of the Forest and the Cult of Amulets*, Stanley J. Tambiah identifies an amulet as, "khrūēang rāng khāūng khlang, khāūng khlang meaning an object having sacred or supranormal power; khrūēang rang meaning amulet."

One can further identify the unending esoterica associated with Thai Buddhist amulets as to be something of a cult, a craze, an industry, and indeed a deeply fetish-driven wormhole. In Thailand the acquisition of powerful magickal technology is often associated with supporting charitable aims, temples, and events. Amulets in Thailand are fetishized as much as fashion brands are here in the West. These extraordinary power objects can subliminally affect you and—as I mentioned previously—have very often been known to choose their owner. I have on occasion, while visiting Ajarns in their Samnaks (the holy and consecrated place of work specifically set up for the application of Sak Yant and other magickal rituals) felt myself inexplicably drawn directly to certain items, seemingly and completely helpless to their tractor beams of enchantment and alluring gravitational qualities. You don't choose the amulet. The amulet chooses you.

9
The Second Pilgrimage
Lost in Exotic Pastures

On the fifth of September 2018, roughly one year after my first pilgrimage, I arrived at terminal two at Heathrow Airport once again, with my copy of *Siddhartha* by Herman Hesse firmly in hand. However, this fine and beautiful work could not in any way support or illustrate the very different and specific journey I was taking. The autumnal leaves were beginning to fall, as I watched dead worlds collapse inside me and outside of me. The old dead ideas and assumptions began to fall away into nothingness. I was slowly but surely becoming transformed. Into *what* exactly, I was not sure. An unfolding of renunciation and previous patterns of personally destructive behavior and associations, like a glacier moving imperceptibly, taking its own time and space to transpire.

The year running up to this second pilgrimage was spent processing and digesting all that had happened during my first visit. As you may recall, I had been very interested and somewhat intrigued by Buddhism since my late teens. At this point in my life, I was now very firmly beginning to shift away from simply being *interested*, into manifesting all-consuming devotional aspects in the form of daily rituals and very specific precepts. Chanting, which had been very

much a baseline for me throughout my life, was now increasingly augmented by other processes. There was a deep feeling inside me that I could easily fall off the edge of this world into complete and exclusory immersion and it continued to haunt me. Things had changed and shifted. Ronnie had moved from Bangkok up to Chiang Mai and had left his life there, moving closer to the Ajarns. On my first visit to Chiang Mai with Ronnie I had gone with him on a short reconnaissance along with a friend of Ajarn Daeng to visit potential places to build a house. Traveling the backwaters of rural rice fields, stopping occasionally down long and endless dirt roads to look at various sites, was breathtaking, all moments that inspired my piece "Lost in Exotic Pastures." This twenty-minute, thirty-six-second experimental electronic ambient piece of sound art, constructed out of a series of soundscape field recordings I had made in the environs of Bangkok and Chiang Mai, embraces various field recorded textures and electronically sourced sounds. Ebullient natural wildlife, rippling subtropical heat, incessant buzzing insects, lush dense vegetation, and labyrinthine city realms seamlessly collide while the looming presence of this vast and enigmatic country haunts the background throughout this robust audio collage. The juxtapositions of feeling lost and found, the known and unknown are explored and beckon the listener to submerge and journey into this multitudinous recording.

As Ronnie and I discussed the itinerary of my second pilgrimage via email, he seemed determined to persuade me into having a Takrut needle inserted into my forehead. Takrut needles are yantras that have been inscribed onto metal sheets made from ultra-fine hammered metals. Inserting Takrut needles into the human body is an ancient practice. The needles are inserted under the skin into various parts of the body where they sit and from there exude the spell they are encoded with, be

it attraction, protection, or any number of magickal attributes that the holder would like to have. The Takrut needle itself would need to be made from 100 percent gold to ensure that no bodily infections would occur.

Ronnie told me that Ajarn Apichai could insert a Takrut needle into my forehead for what would be "superstar maha saneah," meaning charm, charisma, attraction, and authority that went into the realms of being an A-lister. If my memory serves me correctly, Ajarn Apichai had told Ronnie that he had 108 Takrut needles inside his skin and across his body. On our first visit Ajarn Apichai had invited Ronnie to touch an area under his left arm where a single Takrut needle resided. Ronnie reported to me that he had got a short electrical charge in his finger when he did this. It seemed that Ajarn Apichai had created a force field of energy using Takrut needles around his body at various points.

Despite this intriguing and fascinating idea, I still wasn't quite sure about going down this particular route. I took my time to do some much-needed research on this highly unusual idea and was slightly disturbed to see that this practice could possibly have some unwanted consequences. I read horror stories online of devotees having their Takrut needles move in an uncontrolled way around their body over time, and in some rare cases being totally expunged at various points and popping outside. The human body is a moving, ever-changing entity, one which—over time—can evolve into numerous permutations. Of course, these negative experiences were limited to a small percentage of certain devotees working with practitioners who were not professional or qualified to carry out this kind of procedure. I still felt unsure, however, and told Ronnie—who did not have any inserted Takrut needles of his own at the time and whom I imagined merely wanted to use me as some form of guinea pig—that I would gently pass on this very specific and extreme form of body modification and leave that for other travelers who have a stronger stomach for such things.

My attention was instead almost obsessively drawn toward the philosophy surrounding Sak Yants. My first experience had been such an incredible and revelatory experience, pushing new and profound boundaries, that I felt needed further and deeper investigation. This came not from a sense of being attracted to self-adornment, modification, or personal beautification, but from the underlying pull that placing onto my body the undeniable power and majesty of yantra and the sublime magickal effects that would accompany it had. An Ajarn delivering Sak Yant to a devotee would be akin to a bishop tattooing a parishioner with the very word of God.

I chose two very specific Sak Yants that my intuition had resonated with. The Sak Yant tattoos of Thailand dispatched by true and authentic practitioners are manifestations of magickal entities and are powerful, life-changing gateways to new realms of being. Their placement, direction, and arrangement can have very serious underlying changes and transformations within your psyche. As my flight coasted slowly over the Black Sea, visions of golden temples and vast temple spaces with overwhelmingly sized Buddhas flashed inexplicably through my mind. I wondered what all of this meant as I returned to sleep in the air-conditioned ambience of an aircraft at thirty-five thousand feet, slipping and cutting through the atmosphere toward Thailand for a second time. This time I'd packed more insect repellent and my recording equipment as before. I wondered what it would be like to spend eight days meeting three extraordinary Ajarns: Ajarn Suea, Ajarn Daeng, and Ajarn Apichai.

The journey of my second pilgrimage was distinguished by the fact that I was to pass directly through Suvarnabhumi Airport in Bangkok to

Chiang Mai International Airport, landing on the sixth of September, 2018, via a connecting flight. The timing I'd been given by Thai Airways for getting through Suvarnabhumi Airport to my connecting flight was roughly one hour, which passed much faster than I had imagined. Simple and seemingly small things—like not completing your visa card on the aircraft—added time to moving through numerous checkpoints. Slightly flustered, I reached the connecting flight just as the airline staff was finishing the boarding procedure. One more final push and I would be in northern Thailand, a vast and amazing countryside that beckoned with rich and untold treasures.

Ronnie, who met me at Chiang Mai International Airport, had kindly arranged for me to stay at the same B&B where we had both stayed on our first visit there. Jet lag aside Ronnie suggested we immediately strike the day and visit the Chiang Dao Caves. All the while my body and mind were saying, make your bloody mind up is it day or night, night, or day? I agreed, as I felt strongly that all of my time here should be spent exploring and experiencing this extraordinary country. Stopping off at a Café Amazon to partake of some seriously caffeinated drinks, which would become a familiar and much beloved routine during my time in northern Thailand, we continued with vigor to Chiang Dao Caves. On the way to these famous caves the stark reality of Thailand's military rule was fully drawn to my attention. Having to stand up under the rule of law during the Thai National Anthem before watching an IMAX film in Bangkok was nothing compared to the experience of being stopped at a military checkpoint.

The Chiang Dao Caves are only forty to fifty miles from the border between Thailand and Burma (now called Myanmar), where from 2010 to 2012 there were clashes along this border between the Myanmar Army and the Karen National Liberation Army. As we approached the checkpoint, Ronnie instructed me to look directly at the soldiers and remain calm. The soldiers—heavily armed with automatic weapons—scanned both of us with dark, dangerous, and piercing eyes. The tension

100 *The Second Pilgrimage*

was palpable as we waited for the soldiers to decide on whether or not to let us through onto our destination. Ronnie, who had lived in Thailand since the 1990s and was proficient in the Thai language, navigated this potentially explosive situation with his usual charm and gentle persuasion. Eyeing our Thai Buddhist amulets, the soldiers eventually let us pass, nodding and waving us on unmolested. As we departed, I gave the soldiers a "wai," the traditional respectful greeting in Thailand when meeting, saying goodbye, or simply showing respect. Many people in Thailand will wai when passing spirit houses, temples, shrines, or anything in regard to the monarchy. Many Thais will wai Buddhist monks, although the monks are not obliged to reciprocate.

At last, we arrived at the Chiang Dao Caves, which did not disappoint whatsoever. As quintessential locations for meditation and deep spiritual detachment, hermits and caves have a long-standing association stretching far back into pre-Buddhist history. Any cave that is noted as a place where a succession of hermits have lived is called Tham Russi, Lersi, or Ruesi (The Hermit's Cave). In some cases (where merit is due) statues are raised to note a specific yogi. The Chiang Dao cave system is magnificent, and possibly the most stunning meditation caves I've ever beheld; a limited description cannot possibly do it justice. The seventh longest cave system in Thailand, it goes on for some 3.22 miles into the very heart of the mountain, so wearing sensible footwear is a prerequisite, despite the cave system being fully kitted out with an electricity supply in certain caves and an ample supply of food and drink at an outlet nearby. A complex network of numerous interconnected passages (many which are dead ends), unaccompanied forays are strongly discouraged as—even though this system of caves has been heavily surveyed—it's highly likely you'll get lost. (See color plates 1 and 2.)

In the Chiang Dao cave system, there are four caves worthy of note:

1. Tham Phra Non (The Sleeping Buddha Cave)
2. Tham Nam (The Water Cave)

3. Tham Maa (The Horse Cave)
4. Tham Kaew (The Crystal Cave)

The chthonic liminal spaces within the caves hold numerous nature spirits and wildlife that accompany and complement the Buddhist state religion. The rich and diverse variety of wildlife inside this cave system includes crabs, millipedes, spiders, springtails, bats (and bat guano), and all manner of microcrustaceans, so if you are averse to such things consider yourself warned! The ancient Chao Luang Kham Daeng spirit cult of the Tai Yuan people in Chiang Mai and Phayao provinces believes that the Chiang Dao Caves are home of demonic giants or "yaksha" who were ruled from within the cave by a noble king. Chao Luang Kham Daeng was a prehistoric figure before King Mangrai founded the city of Chiang Mai in 1296 BCE. In several versions of Chiang Dao legends, it's claimed that Chao Luang Kham Daeng was the Lord of the Ogres, guarding treasure deep inside the Chiang Dao Caves.

Many spirit mediums in northern Thailand believe that the spirit of Chao Luang Kham Daeng was the greatest among all the spirits of Lanna. Indeed, the Chao Luang Kham Daeng spirit is praised and was, at one point, promoted from a spirit of the Lua Indigenous group to leader of the Chiang Mai guardian spirits. Villagers of Chiang Dao say that an annual spirit-offering ritual at the Chao Luang Kham Daeng shrine is traditionally held in the ninth month (June). Caves in Thailand are ultimately extraordinary locations of hybrid belief fusion that offer protection, danger, devotion, and meditational retreat, all in equal measure. Rituals and offerings from the mundane (such as sweets and flowers) to the extreme (such as ox blood, raw meat, and pigs's heads) to show respect for the caves and appease any perceived entities viewed to dwell within them, are essential components of any considered approach.

102 *The Second Pilgrimage*

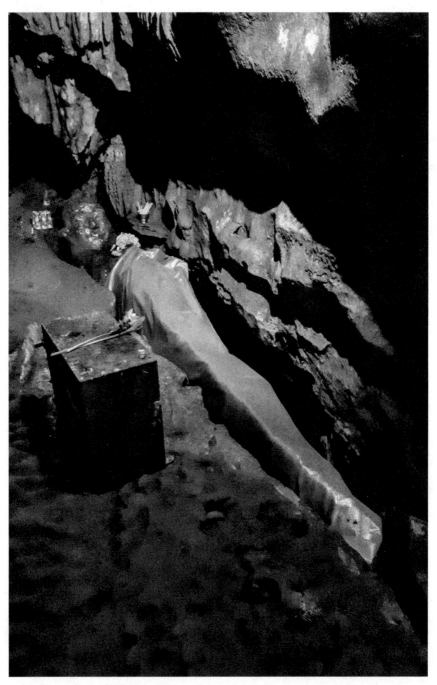

This rock formation at Chiang Dao Caves is praised as an animist female deity. She is offered flowers, dresses, and incense.

Chamber after chamber at the Chiang Dao Caves yielded spectacular statues of numerous Buddhist and Hindu deities and various points of worship. The whole of the location in fact is adorned with many beautiful and awe-inspiring buildings, statues, and shrines. Caves and the spirits that dwell within them are a very serious business and point of devotion in Thailand. An outcrop that was a long and thin elongated shape on the cave floor had been identified, recognized, and blessed as a female Ogre. This female Ogre had a full clothes rack of beautiful dresses as offerings next to it. Each and every important auspicious time of year would merit a fresh change of clothes, with each change accompanied by other offerings such as food and drink.

When we entered the final chamber, Ronnie and I experienced a depth and weight of silence that I did not think was possible in nature. Only the sound of air being pushed from a bat's wing gently brushing the glacial texture of the chamber's vault broke the profound silence. I pondered at the infinite calm and vast serenity that one would acquire here, sitting in meditation for a few days. Monks would stay there, for a period of one month, their meals brought to them as they sat and meditated. Some advanced practitioners have even managed to meditate in deep caves for three years and three months. Psychonauts from deepest of inner space, their return to surface level celebrated by the local populace as if they were returning from outer space.

Before leaving the caves, Ronnie and I walked along a consecrated shrine area that featured a different Buddha for each day of the week. I was born on a Wednesday (Rahu's day). It was customary to put into the shrine an offering of money no matter how small to make merit for the Buddha of that specific day. I did so, leaving the Chiang Dao caves happy in the knowledge that I had made merit and encouraged good fortune to smile upon me while I traveled. (See color plate 3.)

10

Thursday Is Lersi Day

Serm Duang Ritual Bath and the Second Sak Yant

You might remember that during my first pilgrimage, it had been arranged for me to have one of Ajarn Suea's legendary Serm Duang ritual baths, which literally realigns the paths of fate to be more beneficial and helpful to the person being bathed. But because the astrological alignments were not auspicious (and he did not see any good coming from it), the Serm Duang ritual was aborted on this first attempt. As mentioned earlier, such is the depth and voluminous mastery these Ajarns employ and fastidiously follow. Their worlds are run not by commerce or other such shallow considerations. This time around I was in luck. The timing and alignments were auspicious.

My heart sang upon meeting Ajarn Suea once again. When Ronnie, Jaran (Ronnie's partner), and I entered his Samnak, he recognized me instantly. We all sat down around him, surrounded by glass display units packed with amulets, potions, and various statues to numerous deities. I sensed that this time there would be some hard truths and the acquiring of essential magickal supplies. Ajarn Suea has an innate gift. He studied magick from a very early age, living in the temple of Kruba Duangdee while studying with local magicians in the

district of Ban Fon near Chiang Mai. He can read the upper arm—usually the left—of any person and make pertinent statements about them and their character. Although this usually happens after a card reading using Western tarot, the meanings, methods, and techniques Ajarn Suea uses in no way resemble anything I have ever witnessed in the West.

I drew the Three of Swords. Traditionally, the Three of Swords has numerous meanings: terrible heartbreak, rupture, absence, separation, dispersion, emotional pain, sorrow, grief, and hurt. In *The Pictorial Key to the Tarot*, A. E. Waite adds, "all that the design signifies naturally, being too simple and obvious to call for specific enumeration." Ajarn Suea pointed to the card and made his interpretation, which Ronnie's partner Jaran translated to indicate that I was something of a "cry baby." I didn't like being called a "cry baby." A "cry baby" often denotes someone who is spoiled, and this translation implies that I am a whiner and immature. Although in retrospect I now think this label was essentially unfair and unkind, I also know it is not completely without merit. Up to that point I had indeed wept more times than I could possibly remember. As an autistic, pansexual man with weaponized genetics (namely a genetic family lineage on my father's side of bipolar disorder, schizophrenia, and a strong predisposition for occult practices) who has suffered from post physical abuse PSTD from an early age, I couldn't help but live in a near-contsant state of heightened and fluctuating emotion.

Over the years, however, I've managed to master my chaotic and whirlwind personality, with its untethered wildness, and channel that energy into being an empathic, intuitive, and exceptionally detail-oriented person, and my emotional, hair-trigger personality proved to be a safety latch for me over my successive pilgrmages. Tina Marie—something of a body modification legend in these circles and one of the first women I'd met to have had her labia pierced numerous times—once even made me "an honorary woman." She said I could

easily pass as a woman based on the fact that I feel and experience things so deeply. Personally, I find the word *sensitive* to be a better fit. I am not special. I am just a specialist. Labels are so easy to slap onto something that you basically don't understand. Labels are for food. Labels are not humane.

When the Three of Swords turns up in a tarot card reading, it can often symbolize deep hurt. It depicts an image of the human heart being pierced by three sharp swords, which can represent words, actions, or intentions. Which, in turn, can inflict intense emotions of pain, sadness, grief, and heartbreak. As such, this card turned out to be spot on. My life up to this very point had been a littered and cratered doom-field of disappointments, setbacks, loss, and failures (both romantically and in business), accompanied by sorrow, conflict, unrelenting grief, and mind-crippling depression due to deeply rooted personal family issues. My father's death one year prior to the reading had brought to me the ultimate realization: not once during my life had he ever told me that he loved me. Although the work to reconfigure (and in a way rewrite) the hard drive of this downward spiraling trend had already been initiated in the previous year's pilgrimage, I hoped that Ajarn Suea's purifying and deep cleansing bath would flatten this undesirable pattern and any accrued defilements I was still carrying.

As I sat cross-legged in front of Ajarn Suea, he burned wax into a prepared bucket filled with water and numerous herbs, flower and plant pods, and potions. He chanted in his strong and powerful voice, the burning wax dripping slowly into the bucket. I was then asked to undress down to my bathing trunks in his bathroom. I met him and Ronnie outside his Samnak where I then sat down on a chair. It was slightly peculiar because although there was a large stunning cloth backdrop of two Ganeshas behind me, I was facing the main road and its busy traffic. I was told to assume the wai position (the palms of my hands facing inward in prayer) and close my eyes. Ajarn Suea began to chant again.

Then it started. Ajarn Suea scooped the mixture from the large bucket that was now on the floor next to me and poured it completely over my head. The initial shock completely blindsided me. I was not prepared in anyway whatsoever for the brick wall impact of blessed holy water packed with numerous magickly active compounds and melted magick candle wax cascading over and down upon my body. I was unable to speak or move. The feeling was profound. I felt the pods roll down my head and body. Each and every single ingredient in this jamboree was akin to a spiritual revolution in a bucket.

Ajarn Suea continued to chant. Wave after wave of each icy ladled scoop was pounding my head and body in an unrelenting onslaught and bombardment of cleansing. When it ended finally and the chanting had stopped, I felt as though the person I had been up until then had been stripped away like the thick layers of an old toxic onion and all that was left was the gleaming glowing child that had been trapped inside. If one could hit the factory setting button on the human body and mind, this was it. Never in my life I had felt so unburdened and relieved. A weight had once again been lifted and my mind soared open to the beauty of everything around me.

It was Thursday, the sixth of September 2018. Thursdays in Thailand are traditionally known as Lersi Day. The veneration of Lersi—a most important and foundational figure—is a notable and important practice in Southeast Asian Buddhism. Affectionately known as "Grandpa," or Ruesi—the mystical, secretive, hermit sages, healers, preachers, and practitioners known for their mystical and supernatural practices and spiritual teachings—Lersi are often depicted as ascetic figures living sequestered in seclusion and isolation in a variety of locations such as caves, jungles, woodlands, and hidden places of worship, and have historically played a significant iconic role in the spiritual and cultural

landscapes of countries like Thailand, Cambodia, Laos, and Myanmar. The appearance of the Lersi in any form, be it physical or in design, is often linked with spiritual and meteorological phenomena. Luang Phor Thongdam, a sublime practitioner, is one of the many guru monks who have created what is called the "9 face Lersi Roop Lor Nur Ngern." This strictly limited small statuette—in silver, gold, and bronze editions— has the faces of nine Lersi, which are at the central core of practices in Thailand and could be called the most popular and powerful Lersi deities, are as follows:

1. Lersi Parotmuni or Por Gae: Many pray to him in Thailand because Phor Gae is seen as a sage, secretary, and or scribe who is able transmit knowledge to the world and enable trance states.

2. Lersi Narot: A truly sublime guru of occult science, supernatural knowledge, astrology, musical instruments, and due to his connection to his Indian counterpart Narada, music and singing. Some legends say Lersi Narot was born from the forehead of Brahma, the Hindu god, referred to as "The Creator" within the Trimurti, the trinity of supreme divinity that includes Vishnu and Shiva, which is why they call him "Son of Brahma."

3. Lersi Narai: A truly great and powerful wizard. Practitioners would be wise to respect him, not only in the fields of "black magick" or traditional medicine but also to grant influence and authority.

4. Lersi Tafai. Another powerful ascetic who achieved success in the Jhana meditation method of Fire Kasina. He is the strongest in supernatural powers and authority, and very good for ceremonies and rituals. His purpose is to inspire practitioners.

5. Lersi Tawa. He has achieved success in the field of alchemy, blessing alchemists and the holder of ancient knowledge in the creation of powerful occult metals and mixtures of therein.

6. Lersi Ped Chalugan or the Bull-head Lersi. This Lersi possesses supernatural powers and knowledge and is believed to be the

first incarnation of Pra Narai or Vishnu, thus granting supernatural powers and high influence.

7. Lersi Pujow Samingprai or the Tiger-faced Lersi: The expert in the suppression and subduing of enemies, leading and governing followers, and bestowing authority. He is also said to be in charge of necromancy. He can offer protection from evil spirits, black magick, and keeping your prai magickal items in line and granting you authority.

8. Lersi Promma Paramit. His supernatural powers are on par with all Lersi and possesses Metta (loving kindness and compassion) despite being fierce and speaking with a booming voice. He is Lersi Brahma with four green faces and eight arms, very huge and tall. Purpose is also for granting influence.

9. Lersi Chiwok or Jīvakal. This is the great physician who cared for Buddha during his life. He is an expert in medicine and grants good health.

In the documentary *The Lost Wizards of Thailand*, Ruesi Ketmunee, Ruesi Phuttavet, Ruesi Chaichatri, Phra Pattarayano, and Phra Jakkrit discuss and speak openly about their present and former lives as Ruesi. Ruesi Chaichatri draws a clear line of lineage from the Ruesi or Rishi (pronounced "Ruesi") of India to the Lersi hermits of Thailand:

Where does magic come from? It comes from Hinduism. There was magic well before the time of Buddha. You know the Ruesi in India? Stay underwater. All day! Those Ruesi turn to stone for years and come back as living people. They live deep in the forest, some don't wear clothes and live in the caves. We don't know how many hundreds of years old they are because they stay hidden. Magic, it doesn't exist to deceive people. No . . . the reason it exists is to share and help others. But how is it used in the wrong way? It gets lost in personal practice used for selfish reasons.

110 *Thursday Is Lersi Day*

The Ruesi of Thailand however can be traced as far back to the Ruesi of India, the poets of the hymns of the *Rigveda*. The Ruesi, Rishi (or ṛṣis) were male and female poets who composed hymns to the deities (Vedic gods), praising sponsors, noblemen, and chieftains, who in turn rewarded the Rishi with cattle, gold, and occasionally the odd household slave. The Rishi were not merely the "hearers" of the eternally existing Veda (śruti, revelation), they were "active poets" (also called brahmán, vipra, and kavi). Found in clans and families (the most prominent ones known as the "seven ṛṣis") the Rishi have been identified with the seven stars of the Big Dipper from Ṛgvedic times onward. The influence of Hinduism, despite being viewed through Buddhist optics, can be seen in carvings at Wat Phra Chetuphon, with scenes from *The Ramakien*, an important part of the Thai literary canon, with Phra Ruesi Narot giving advice to Hanuman.

The Ruesi/Lersi of Southeast Asia have characteristics that have been inherited across history: a tiger skin robe and hat, prayer beads, a white beard, a prominent third eye. Since Vedic times there has been a belief in India that the eyes of holy men were powerful, due to their ability to gaze deep into reality. From this it is further believed that such practitioners could, in effect, transmit their power to others. To be gazed upon by a Lersi was considered to be very auspicious. Ruesi and Sadhus are both seen as holy men. In 6:4 of the Therīgāthā (*Poems of the Elder Nuns*—seventy-three poems attributed to early members of the monastic Saṅgha), Sujātā Buddha is referred to as "the One with Eyes." Phra Ruesi, Lersi, and Rishi overlap in some—but not all—cases and lack any consistent regular standardization. Links between Thai hermits, Ruesi, Lersi, and the Indian Rishi can sometimes be idiosyncratic, localized, and highly complex. It can be said however with some level of certainty that there are four main types of Lersi in Thailand—Racha Lersi, Phrom Lersi, Taep Lersi, and Maha Lersi—each with their own level, expertise, abilities, and accomplishments. Each of the four categories then subdivides into eight further types: Pra Sitaa, Pra Yokii

Thursday Is Lersi Day

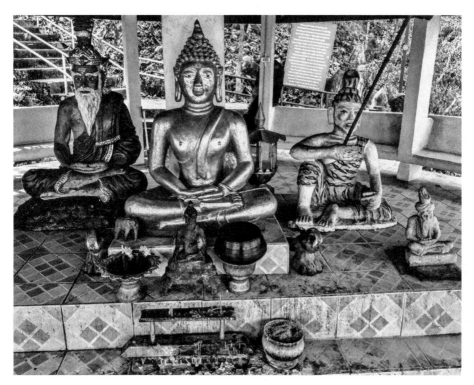

Lersi and Buddha statues outside a shop at
Wat Mahawan Woramahawihan, Lamphun, Thailand.

(Yogi), Pra Munii, Pra Dabos (Dabasa), Chadin (Chadila), Nak Sit, Nak Prot (Paratha), and Prahm (Brahma).

Phra Lersi Narot is known as one of the most powerful Lersi of the Thai occult world and is seen as a fascinating emanation of Narada, or Narada Muni, the famous Hindu literature sage-divinity, traveling musician, storyteller, news vendor and wisdom soothsayer, and one of the mind-created children of Brahma, the creator god. Phra Lersi Narot has many identical attributes to his Indian counterpart Narada, including his known magickal abilities at changing gender. Narada experiences the ability to transcend gender by becoming a woman as told in the Devī-Bhāgavata, one of the eighteen Mahapuranas of Hinduism. The resonance of androgyny and shifting sexuality sits well with the magickal powers of the Lersi, the angelic, shape-shifting, and sorcerous

112 *Thursday Is Lersi Day*

being, who ultimately sees the irrelevance of gender and whose own supreme form as consciousness remains without gender, in the cradle of the non-substantiality of their own sexual identity.

It is said that there are 108 various emanations of the Lersi hermit sages that are currently recognized in Thailand's incredible pantheon. The number 108 however does not literally mean or relate to the actual number itself. It is a number that is used to indicate a large inconceivable amount and not an actual amount. One hundred and eight is in fact a sacred and mystical number that has an endless depth of meanings within the Buddhist tradition. One hundred and eight is regarded as an example of harmony because of the wide set of mathematical combinations and calculations that would lead to 108. Bhante Gunaratana's *The Four Foundations of Mindfulness in Plain English* clearly states:

> As the Buddha explained, when we consider the five types of sense consciousness and the objects they perceive—eyes and forms, nose and smells, ears and sounds, tongue and tastes, and skin and touches—we can distinguish fifteen types of feelings: pleasant, unpleasant, and neutral feelings linked to each sense. We can also add a sixth sense, mind and mental objects such as thoughts. Memories, imaginings and daydreams. These can also be pleasant, unpleasant, or neutral. So now we have eighteen kind of feelings. When we consider that each of these eighteen kinds can arise as either a physical sensation or an internally generated emotion, we have thirty-six. Multiplying these thirty-six by past, present and future, we can distinguish 108 kinds of feelings! . . . Only through practice can we distinguish among all 108 categories.

The Lankavatara Sutra, a prominent Mahayana Buddhist sutra, has Bodhisattva Mahamati asking Buddha 108 questions with corresponding 108 statements in answer to these. In Hinduism the Mukhya Shivaganas (attendants of Shiva) are 108 in number. Beads on strings of

prayer beads are usually 108 in number. 108 is inundated throughout Buddhist and Hindu spirituality as a number of sacred resonance. The astronomer Vara Mihira, a contemporary of the Bodhidharma, thought that Zodiacal man* had 108 padas (feet or extremities).

Relationships between various astronomical concepts pointed toward the harmony of 108. One hundred and eight eclipses constitute a complete cycle in Buddhist and Hindu worlds. In the Indian epic *The Ramayana*, there are 108 offerings that Ram was supposed to make, and the earlier orally transmitted Ramayana through disciplined oral transmission is three thousand years old. The Sudarshana Chakra is a divine spinning, discus weapon with 108 serrated edges, generally portrayed on the right rear hand of the four hands of Vishnu. In the *Rigveda*, the Sudarshana Chakra is stated to be Vishnu's symbol as the wheel of time. According to Marma Adi (an Indian traditional art of pressure points) and Ayurveda (the pseudoscientific alternative medicine system with roots in the Indian subcontinent) there are 108 pressure points in the body, where consciousness and flesh intersect to give life to the living being. Coincidentally, the Chinese school of martial arts is also in agreement with the Indian school of martial arts on the principle of 108 pressure points. Finally, 108 has an important place on the number of defilements that are recognized in the major schools of Buddhism. It has been suggested in various commentaries referencing scripture that the Buddha himself was a Lersi. Some of the earliest lists of Lersi or Ruesi are found in Jaiminiya Brahmana verse 2.218 and Brihadaranyaka Upanishad verse 2.2.4.

*Called also *Kalapurusha* or the "person of time." In Hinduism the Rishis revered time as Kalapurusha (the embodiment of time), giving him five limbs (the foundation), with the cosmic mind of Kalapurusha being the moon. The universal form of Vishnu can also be divided into five parts, each associated with one of the five Tattvas or states of energy and matter.

Back inside Ajarn Suea's Samnak, my eyes were automatically drawn to numerous objects. They literally grabbed my eyes and forced me to walk over to them. They had indeed chosen me, and I would be taking them away with me. Firstly, a Phra Ngang Panneng amulet. This large chunk of human skull was cased and had various elements encrusted on the back; a Takrut, a couple making love, jewels, a small bottle filled with spiritually active ingredients, and two apparently surgically accurate large glass eyes, all submerged in a black oily matrix. The front had a beautifully painted representation of Phra Ngang surrounded by numerous yantra script.

Next a black, red-eyed Phra Ngang, varnished with yantra script including purple yantra script on the back. And finally, a Pujow Samingprai tiger-faced Lersi bucha, made using lightning wood and supported with a large piece of bone shard underneath, fixed into the base. Trees that are struck down and destroyed by lightning are believed to have been touched by a supernatural force, a force that has come directly from a god or deity. Such trees are highly prized for use in amulets, magickal knives, and buchas. Lightning wood is deemed to have highly protective values. The trees used must be seen to have died in a way that was not forced or deliberately harvested by human hands since this considerably reduces and diminishes its efficacy and power. Ajarns cannot just go out into the world and take exactly what they want. An Ajarn will often have numerous helpers and suppliers who are seen to be trustworthy and follow to the letter the prerequisites that dictate Buddhist protocols for obtaining such things.

When an Ajarn creates a bucha of a deity using very specific wood it is believed that the supernatural attributes of that wood are transmitted into that bucha or statue. I made the requisite donation to secure this stunning bucha, but unfortunately, I could not take it with me there and then. Ajarn Suea stated that it would first need to be consecrated, a process that would take a period of days. Fortunately for me I had days to wait and would be able to collect this magnificent bucha just as I would be leaving Thailand.

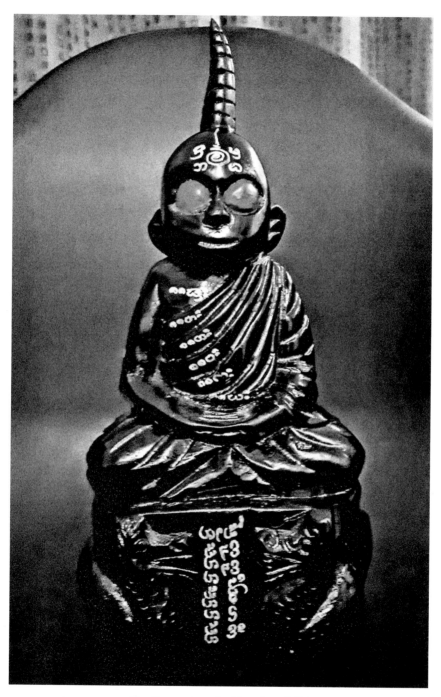

Phra Ngang statue by Ajarn Suea, 2017.

I bowed to Ajarn Suea and left his Samnak in Ban Fon filled with admiration, respect, and a touch of awe. Ronnie and I then departed for the next part of this momentous pilgrimage. I wondered what on earth would happen next. It was only the second day of roughly one week and I already felt as if I'd spent an eternity traveling in this mystical and deeply time-dilated world, a psychonaut carving out meaning, divinatory fluctuations undulating, lapping, and washing upon the shores of my slowly expanding consciousness. The next visit however would find me moving from this enchanted realm into something more along the lines of an ordeal.

Friday the seventh of September saw the second of what would ultimately become in total seven separate Sak Yant rituals during my three pilgrimages to Thailand. The first, with Ajarn Nanting, was without ink using only herbs, translucent oils, and some other secret ingredients. This second Sak Yant ritual was more highly visible and done in Chinese ink. I had chosen two designs prior to our meeting that had after some considerable contemplation and rumination resonated deep within me. First the Yant Phra Lak Na Thong (also known as Lakshmana who is described as the incarnation of Shesha, the thousand-headed Naga upon whom rests Lord Vishnu in the primordial ocean of milk (Kshirasagara), a powerful warrior (or The Perfect Man as personified by Rama)) and second, Yant Takaab (or "Centipede of Luck" which refers to the local belief that centipedes bring luck, protection, and good fortune).

Sak Yant has an animist substratum with a full and total integration into Buddhist practices. An Ajarn will draw upon his knowledge (his wicha) from an unbroken lineage of masters to deliver these magickal yantra ink spells. The Ajarn's knowledge of spirits (phee) and body souls (khwan) works in tandem with his ability to incant

the correct khatha during the implementation of this sophisticated magickal geometry. Ink preferences can vary among devotees. Meuk Boraan (traditional ink) is made by hand from burnt coconut husk and then mixed with coconut oil along with other organic ingredients. Although the color variants of this particular ink are said not to make a strong, deep pigment, its spiritual power is viewed as being very strong indeed. Ajarns are known to often mix the two. However, the foul-smelling stench of Meuk Boraan persuaded me that Chinese ink was the way to go.

Before entering Ajarn Daeng's Samnak I took my shoes off outside near the shrine dedicated to Ganesha. His place of work and worship is similar to any shop. If you didn't know it was there you could easily miss it. Upon entering, the familiar smell of incense filled the air. The atmosphere was rich and swirling with spirit. The Samnak's layout was along the lines of a seated waiting area near a glass-cased counter at the front next to the consecrated fully functional shrine where numerous Lersi, deities, and Buddhas were displayed. Many Pha Yants, blessed wall hangings, were hung throughout the Samnak. The offerings there were many and clustered the shrine like a beautiful garden. This place was completely unlike any tattoo shop in the West and as far removed as possible even from the idea.

 I sat down in the waiting area and then began to get a little nervous. Green tea was kindly served by his Luksit (an apprentice). Ajarn Daeng's head momentarily popped up from what he was doing to acknowledge both Ronnie and myself. He was just finishing off a client's Sak Yant, approaching the blessing stage where he doused the head and body of the devotee with blessed water using a bunched blessing rod, chanting the finishing verses. The young man left happy. He had received a Sak Yant on his throat, a very painful place to have such a thing. This small

but very specific Sak Yant would aid his ability to articulate and produce refined speech, helping him with any form of public speaking or spoken communication in general.

Ajarn Daeng then motioned to Ronnie and me, and I was asked to step over to the shrine where a cushioned seat was situated. I was asked then to remove my T-shirt and describe the Sak Yant I would like. Ajarn Daeng is a remarkable and very much respected purveyor of Sak Yant. His superb and almost laser guided services are very highly sought after by practitioners, temples, and students alike, all of whom regularly go to him with requests for devotional design work. He had become a temple boy aged twelve, followed by almost a decade spent as a novice monk. He has spent his entire life absorbing and learning Sak Yant, spells, and incantations from numerous masters. Very recently he received the accolade "master of masters."

After some creative discussion between Ronnie and Ajarn Daeng as to the exact location of these two Sak Yant, the process of templating the first design onto my upper right arm began. A drawing was placed on my upper arm and a faint guiding line was dabbed carefully into place. When the drawing was finished, I was then asked to look at the Yant Phra Lak Na Thong template in a long mirror to the side of the room. I looked at the Yant Phra Lak Na Thong. It was perfectly represented on my upper right arm, directly transferred from the ancient and sacred design of some several hundred years or so. I was transfixed by it. Sitting back down I then began to watch my breathing and entered into a lower state of samādhi. Even though Ajarn Daeng was not using the traditional Sak Yant rod, but a bespoke tattooing gun that he himself had devised and built with his very own personal upgrades, I still quietly braced myself for the ensuing and inevitable pain that would follow. Much to my surprise there was nothing that I could not handle, at least not initially. The levels of pain were reasonable. Certain areas of the Sak Yant were highlighted red ink. Ajarn Daeng then said something that was then translated by Ronnie for me: "The red pres-

Thursday Is Lersi Day 119

ents regeneration. This Sak Yant and its magickal power will constantly regenerate for you without end. Always. Even in death." I was in awe when he said this.

As the Sak Yant slowly took form, the yantra script appearing around, in, under, and throughout the design, a strange and definite feeling passed through and into my body. A surge of power and energy rushed down and through my right arm. I wondered how this Sak Yant would change me and what kind of attributes it would ultimately bring. As the process continued, I noted that I had passed into and in and out of various trance states, some lower, some higher. This is called Khaung Kheun (or "stuff rises"), which refers to Sak Yant–related trance states. Ajarns are able to *Pluuk Sehk*, which means to literally "plant spiritual power" in the Sak Yant through ritual and khatha. *Sehk* comes from the Sanskrit term *Abhiseka*, which relates to a ritual, or a devotional activity associated in the rites of passage in Hinduism, Jainism, and Buddhism.

The Sak Yant finished, I was invited to stand up and look at the finished result. The Yant Phra Lak Na Thong glowed. It shined as if touched by a holy spirit. My jaw dropped at the total beauty and overwhelming charm of this immense Sak Yant. It was hard to pull away my focus from it. It seemed to be alive; it moved and danced in the light of the Samnak, a brand-new entity birthed and existing in two dimensions on my upper right arm. Then Ajarn Daeng asked me to take the seat again. Next was the Yant Takaab or the "Centipede of Luck." Before he started, Ronnie and Ajarn Daeng had a quiet discussion with each other. It was mutually suggested by them both that the centipede head could start on the upper left side of my chest, move over and behind and across my back, and then stop on the right-hand side of the back of my shoulder. This would give the impression that the centipede would be traveling across my back and appearing over my shoulder. Although it was highly unusual for a third party to influence the Ajarn's placement of the Sak Yant, I agreed with them that this would be a marvelous idea.

120 *Thursday Is Lersi Day*

Ajarn Daeng then set down to begin. In this instance, a template was not used. Instead—using only his hand as a guide—Ajarn Daeng very carefully sketched out the long and writhing body and tentacles of the centipede, which took quite some time to do. After he was done, I was allowed to look in the mirror at the finished guidelines. I was impressed with Ajarn Daeng's almost laser-guided skill at line drawing freehand. I thanked him and then sat down again to proceed with the process of the inking of this stunning animist Buddhist creature upon my upper body. So far, my experience with Sak Yant had not included any real severe pain or discomfort. This was about to change. The upper chest is a particularly sensitive area. The combination of long strokes of centipede tendrils and the intricate Buddhist scripture created an intense and lasting pain that I had now committed myself to endure.

As Ajarn Daeng's tattoo gun hammered across my upper body, each twist and turn of the design danced in a Khaung Kheun garden of endorphin euphoria. Wave after wave, the threshold of my pain levels shifted and raised, my internal state gearing up and up into a cloud-drenched plateau. Behind closed eyes I breathed in each single skin puncture, my nervous system electric and dizzy with signals, my ordeal elevating me to a brand-new realm. I felt the centipede's many legs undulating across my back and shoulders, the Buddhist scripture underscoring this newly birthed creature's presence. I was now in a symbiotic union with the centipede, its tentacles, legs, and tendrils caressing, informing, and moving upon my body.

Ronnie stood by and witnessed the ritual. The pain began to become unbearable. Ronnie saw me becoming overwhelmed and spoke to me in an attempt to guide me. He said: "Take your middle finger and thumb and press them together, tapping them together while slowly breathing in and out. This will help you to circumvent some of the pain." This actually helped. I was surprised that such a simple displacement activity would work. Further along, as the final tentacles were hammered in, the

middle finger–thumb exercise ceased to be useful or indeed helpful in any way whatsoever.

Fortuntely, by this point the design had been completed. Ajarn Daeng then proceeded to bless the Sak Yant, sprinkling blessed water over and onto my head in front of the shrine. Ronnie took out his camera and shot some video of my Sak Yants, right to left, from the Yant Phra Lak Na Thong all across and along the many legged and tentacled Yant Takaab. The designs looked crisp, fresh, raw, and hyper-real, their energy and supernatural power shining like a Buddhist version of the illuminated *Book of Kells*, the extravagance and complexity of these ornate and swirling motifs now permanently merged onto my upper body. My body had now become and was in the long slow process of becoming a living embodiment of text and image, my years of chanting and visiting temples all culminating to this point of my body becoming text, text of Buddhist scripture, the rituals of Sak Yant and the forms that the body takes in these intense rituals opening up to a kind of knowing, this completely profound and totally transformative practice, this bespoke little needle gun and ink ritual now becoming inseparable from visionary experience itself, the body becoming very much alive with the universe within it, outside of it, and beyond it.

11
Wat Phra That Doi Saket Jing Joks

Trapped in a Strange Unending Time Loop

It would be an act of extreme folly not to visit as many temples as one could safely manage while on pilgrimage to Thailand. There are countless temples, sacred spaces, profound geological formations guarded by spirits, monks and monasteries, and numerous diverse holy shrines to visit and pay your sincere respects to. The day after the Sak Yant ritual with Ajarn Daeng both myself and Ronnie went to visit Wat Phra That Doi Saket, in the Doi Saket district, just outside the city of Chiang Mai. A *wat* is a Buddhist and or a Brahminical temple. *Wat* is a Thai word borrowed from the Sanskrit word *vāṭa* meaning "enclosure" and or a sacred precinct with quarters for bhikkhus, temple, an edifice housing a large image of Buddha, and a teaching area. This can vary from place to place although—as I was to discover—the underlying principles of Thai temple structure are fundamentally the same.

A Thai wat consists essentially of two parts: the Phutthawat, which is the area that is dedicated to Buddha and contains several buildings, and the Sangkhawat, where the monks live within the walls that sur-

round the temple compound. In the Phutthawat are the chedi or stupa, a bell-shaped tower containing a relic chamber; Prang Thai version of Khmer temple towers; an Ubosot or Bot, an ordination hall; and—one of the most sacred areas of a wat—Eight Sema stones marking the consecrated area; the Wihan, a shrine and assembly hall of Buddha images where monks and laypeople congregate; a Mondop, a square- or cruciform-shaped building or shrine that houses relics, sacred scriptures, or can act as a shrine; and the Ho Trai, the temple library or depository housing sacred Tipiṭaka scriptures.

The second element, the Sangkhawat, contains small structures called Kuti, literally a room built on stilts, designed to house just one monk in a space officially measuring 4.013 by 2.343 meters. Wat Phra That Doi Saket holds much to be admired, including some very fine examples of modern Buddhist art as painted by Thai artist Khun Chaiwat Wannanon, commissioned in the 1990s. This beautifully shaded and prayer-flag-clustered, Bodhi-tree-enshrined temple on a hill has gorgeous Nāga serpents in vibrant colors, highlighted in golden paint wrought in stone masonry standing outside to greet you.

We lit incense and candles before we entered the breathtakingly striking interior of the golden chedi, a high golden metal speared fence surrounding a golden inner temple. Outside a row of exquisite and perfectly scaled and carved wooden monks wearing robes sit in meditational posture. At every single point of this very noteworthy temple is a statue, shrine, and outer temple building that ravages the eyes while a gentle shushing and hissing ambience of trees and subtropical birds caresses the ears.

This was a deep healing balm after the ordeal that my mind, arm, and upper body had met. After this extremely pleasant and hypnotic experience, we traveled south of Chiang Mai to visit another temple. Wat Phra Phutthabat Huai Tom is said to house the ageless, non-decomposing body of the monk Kruba Wong. Monks meditating into their own death is an ancient practice. *Tukdam* is a very rare spiritual

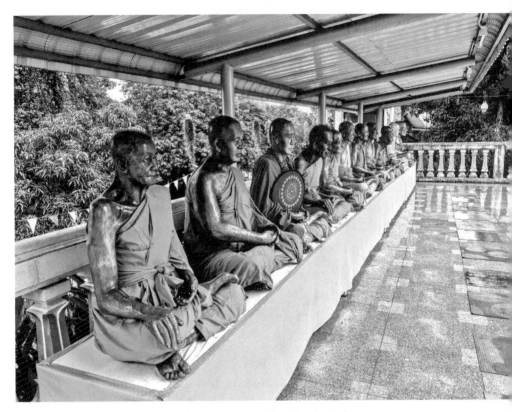

Monk statues at Wat Phra That Doi Saket.

state of meditation, which literally means "the integrity of the mind and heart" and refers to a very specific meditation practice. Dying is considered to be an important process because it gives an opportunity to become fully enlightened in a meditative state. An experienced meditator such as a Buddhist monk with a complete insight into emptiness will be able to hold that moment, remain in that state, and merge with the Dharmakāya, the innate nature of reality or Ground Luminosity. Reaching the state of Nirvana represents the achievement of a state of perfect quietude, euphoria, and liberation from the repeating cycle of birth, life, and death. The meditator neither eats nor drinks during this sacred time, and they are not to be moved nor touched until they arise to this specific state on their own. When a master senses that his own

death is approaching, he will engage in Tukdam until point of death, at which time the body is left undisturbed for three days, so that the consciousness can fully exit the body.

In Tibetan Buddhism the book *The Bardo Thodol*, commonly known in the West as *The Tibetan Book of the Dead*, is read in full near the corpse, which is then untouched for forty-nine days in order for consciousness to exit the body. This bliss state is often imprinted onto the body of the meditating monk. Examples of monks three, four hours—or indeed many years—after their death are seen to be in an unexplainable state of non-decomposition, sometimes with a smile fixed onto their face as was seen on the body of the revered Thai Buddhist monk Luang Phor Pina. He had been dead for over two months but when his body was examined it had mysteriously not decayed, a gentle warm smile upon his face.

On the morning of Sunday September 9, 2018, at 9:17 a.m., before beginning what would turn out to be an epic journey, we stopped at Nana Bakery for breakfast. Ronnie had previously told me about something that I should definitely try. I wondered what on earth it could be. I imagined that some form of exotic Thai delicacy would be offered to me as a highly unusual breakfast option. No. It was just simply a very fresh, warm, perfectly baked small mini quiche, or as we would then begin to call it, "little quiche." This may indeed sound a bit odd and maybe a touch peculiar but believe me it was one of the most gorgeous quiches I had ever eaten. With an excellent cup of coffee from Café Amazon it was quite simply the breakfast of champions.

Traveling down to Wat Phra Phutthabat Huai Tom in Lamphun Province, which has a settlement of more than 17,500 Karen tribe members originally from Karen State in Myanmar, was relatively an easy and straightforward journey. Kruba ("venerable teacher") Wong, who

ceaselessly worked to liberate the Karen from animal sacrifices, poverty, and opium addiction, converting them to Buddhism, pacifying strong, local evil spirits around an old chedi, established Wat Phra Phutthabat Huai Tom in 1970. Kruba Wong led the Karen to stop raising and killing animals, become vegetarians, and bury their weapons and tools for sacrifice under the chedi. Alcohol, gambling, and drugs were banned, and the Karen were instructed to follow the Five Buddhist Precepts to obtain protection from sufferings. In 1973, Bhumibol Adulyadej, the king of Thailand, visited Huai Tom and urged Kruba Wong to continue helping the Karen.

After a roughly two-hour-and-forty-minute journey, Ronnie and I reached Wat Phra Phutthabat Huai Tom, whose sublime beauty opened up and spread out before us. In the searing and stifling heat, we entered the ornate gold and emerald-encrusted, nāgá-flanked temple-hall, outside a magnificent golden statue of Kruba Wong in seated meditation posture. The temple-hall is named Wihan Phra Muang Kaeo. We both gazed up high onto the altar at Kruba Wong, now lying in a remarkable leveled jewel-studded seventeen-million-baht (as of 2022 roughly £384,341 GBP) glass coffin, embalmed, and covered in gold leaf. (See color plate 8.)

Bowing and prostrating on the floor while giving obeisance in front of this extraordinary shrine was a humbling and strange experience. I experienced what can only be described as an unusual spiritual phenomenon. Maybe it was a combination of the heat and the sensation of being overwhelmed. Flanking either side of the shrine were two white Buddhas. My head while coming out of bowing caught sight of one of the two Buddhas winking at me. This bizarre moment seemed correct to me at the time as I couldn't imagine anywhere more sublime or indeed anywhere more blissful than this very place and time. Blinking and slightly rubbing my eyes, I looked again. The statues were still and completely unresponsive and enigmatic. Outside, I placed a five-hundred-baht note into the money tree on the steps. Ronnie caught

my eye to show me an elderly gentleman was offering a wai to me, grateful and very pleased by my donation to the wat. I offered a respectful wai back. Ronnie and I then walked farther into the grounds. I became enchanted and enthralled, disappearing into the extensive and richly colored corridors of wall murals, stunning architecture, and exquisitely decorated buildings. I entered into another vast shrine where numerous Buddha statues, some huge and some small, all sat beneath an enormous representation of the Bodhi tree. (See color plate 9.)

Even though my time at Wat Phra Phutthabat Huai Tom totaled in reality just over two hours, it seemed to me that I had quite literally been there all day. The depth and stretch of time dilation experienced here was very considerable indeed. I remember experiencing a similar phenomenon when I entered Chiang Mai for the very first time in 2017. Now in 2018, here at Wat Phra Phutthabat Huai Tom, time stretched and elongated into hours and hours. I knew that this temple was exerting some force into the world around it. Like a vortex of extended space-time, the temple had stretched time and created a form of timeless island. I felt perplexed and somewhat startled by this incredible and disconcerting feeling.

Before visiting the temple shop, I spent some quality time with a local temple cat who seemed to be so relaxed that he melted in floppy fur shapes under our gentle attention. Gratefully, under the shade that the temple shop afforded, we bought some items before leaving. I acquired a lovely enamel amulet with Kruba Wong himself on the front, a square piece of his monk robe on the back, and a set of pure white prayer beads.

After leaving the sublime Wat Phra Phutthabat Huai Tom, on the road toward Chiang Mai the high and inexplicable weirdness then began. It didn't start off immediately, just gradually. The journey down as I've mentioned previously was roughly two hours, forty minutes. Along the

way I took the odd photograph of our journey back. The countryside was lush and beautiful. An abandoned fuel station with an overgrown forecourt caught my eye. On a hill overlooking a lush valley a stunning temple slightly obscured by jungle peaked over the top. Mile after mile of road dragged on.

Then, Ronnie's iPhone map failed. The connection was lost, but we continued on our way, in what we seemed to think was the proper direction. An hour passed. Ronnie noted that we had seemingly not progressed. Had we taken a wrong turn? We backtracked to a point and tried again to make progress. Again, confusion as another hour passed and no progress was made. We were lost.

Ronnie was an extremely capable and clear-minded organizer when dealing with traveling, reading road signs, and had an innate sense of direction. He even once worked as a road tour manager. He became perturbed and exhibited an unusual resignation that we were indeed lost. We turned back and passed by the same roadside 7-Eleven again, stopping for a toilet and coffee break. Time stretched, and the same weird and peculiar feeling that had filled me back at Wat Phra Phutthabat Huai Tom engorged my senses once again. Had land spirits colluded to play with us and our perceptions of direction and time? This strange thought was not without merit as we once again tried to forge ahead in Ronnie's car on a road and its hidden spirits that seemed to want to keep us firmly in the Lamphun Province.

Since this trip had now extended into an ordeal that Mad Max would find testing, a road that consistently decides to reset itself, looping its travelers over the same road again and again and again. For over six hours, we attempted to wrestle the vibratory vortex clutches of the road from Wat Phra Phutthabat Huai Tom to Chiang Mai. In the end, our return journey took more than double the time it took us to get there. Road weary and greatly relieved, we entered the outskirts of Chiang Mai, passing by two trucks heavily laden with wooden planks on their way to one of the many woodworking shops and factories based there.

On Monday, the tenth of September, at 6:09 a.m., we hit the road again. I was refreshed and reenergized after a good meal and a good night's sleep in an air-conditioned room. The next port of call on this second pilgrimage was to meet Ajarn Apichai, who now resided in the city of Phitsanulok (Vishnu's heaven), a 249-mile drive from Chiang Mai. We had organized a one-night stay in a hotel called the Dragon River Avenue Hotel. Founded over 600 years ago, Phitsanulok is one of the oldest cities in Thailand, and acted as a provincial center of the Khmer Empire during the Angkorian period. While organizing the itinerary I had talked to Ronnie about the possibility of acquiring some Jing Jok (lizard) Sak Yants. Jing Jok Sak Yants fascinate me, and Ajarn Apichai had just completed seven years of training surrounding the wicha of this very unusual and particular form of Sak Yant. Since the subject has such a vast content of both animist and Buddhist knowledge within it, one could write an entire work based on the depth and culture of Jing Jok Sak Yant.

In the canon there are an original nine Jing Jok designs, which then evolve into a further 108 different designs and permutations. Each design has a specific functionality and magickal purpose. The tattooing of animals in Thailand is seen as a magickal way of capturing and embodying the very characteristics of that animal or creature. Once one has the Sak Yant of that animal, it is thought that one is able to acquire the supernatural qualities and even go into a trance state to literally become that creature. The folklore of people in Thailand has evolved to believe that Jing Joks (geckos) bring charm, good fortune, and luck. If a Thai person hears the crying of the Jing Jok as they leave their home it is seen as an omen of bad luck or foreboding. If the Jing Jok greets you as you leave your home it is seen as a good omen. Jing Joks are flexible and highly adaptive creatures that can live in almost any environment successfully. They can go so far as to

camouflage themselves completely by changing their color, and can evade almost any danger, even if it means regrowing their own tail after a close escape. These qualities are very much admired and revered by Thai people.

Jing Joks are seen as a prai spirit animal which must be brought into the home using the same method of invitation as other prai devas and spirits. Before inviting the Jing Jok spirit into your home, five incense sticks must be lit. The local spirits must be informed of the arrival of the Jing Jok as a member of the household. A further sixteen sticks of incense are then lit so that the Higher Celestial Guardian Devas are also then informed. Jing Joks are said to be gifted with the ability of foresight. Its cries are duly noted by Ajarns during any form of important ritual or ceremony as this can further illustrate the auspiciousness of such events.

As we drove, a heavy morning mist shrouded the mountainous valley that cradled Route 11 down toward the Doi Khun Tan National Park. A huge golden statue of a monk atop a hill looked down upon all who traveled this stretch of road, a gleaming serene sentinel resting in the higher realms, barely visible. This time the drive was sleek, fast, and almost express-driven, our progress seemingly fueled and guided by invisible wings hurtling us toward our final destination. Gradually, the landscape opened up into vast sprawling plains, the early mists burning away into blue sky and bright sunshine, fluffy white clouds coasting like candy floss. To each side of Route 11, the luscious and green undulating contours rolled. I marveled at mile after mile of thick jungle, watching intently at any clearings and openings to see if I could spot any of the teeming life that dwelled within.

Before we arrived at Ajarn Apichai's home, we stopped off at a chemist. On the previous evening we had gone to a roadside restau-

Wat Phra That Doi Saket Jing Joks 131

rant in a small stretch of jungle. While feasting on numerous chunks of well-done meat, in spite of spraying what I would call an adequate amount of insect repellent, the local population of blood-sucking creatures decided that this would be no deterrent or block to chowing down on a prime piece of juicy foreign leg, namely my lower left leg. It cannot be overstated that precautions when traveling to and inside Thailand need to be taken very seriously indeed. Having a rock-solid travel and health insurance plan (I included natural disasters as an extra upgrade on mine) is essential. Also essential is enough insect repellent and any of the necessary items one would need to take when journeying in a swelteringly hot subtropical country.

My lower left leg had reacted badly to the biting and sucking and looked to be in bad shape; it was swollen, my shin now speckled with infected red bites. Ronnie—who had more experience than me in this area—told me I needed some hydrocortisone, strong plasters, and some anti-itch rash cream for good measure. While waiting for the chemist to open, an elderly and kindly Thai gentleman approached us and began to talk to us. His English was remarkable. He took time to hang out with us, expressing interest in where we were from and why we were there. I was very impressed with the level of his spoken English and wondered, if this situation were reversed, how good an English person's Thai would be. Even in the most casual of encounters with the people of Thailand, I regularly felt an underlying kindness and thoughtfulness. After tooling up my poor left leg with the newly acquired medication, we said goodbye to our new friend and continued onto the final stretch.

Our car now pulled into a wide and long street flanked by a row of identical raised bungalows on either side. As we parked I noticed a series of clothes racks, very much like a yard or tag sale, outside Ajarn's home, each filled with a variety and assortment of clothes and toys, for both children and adults. One or two folks were there examining the racks, occasionally picking out something. After spending time in Thailand, I

now understand Thai people as highly entrepreneurial, engaging in the daily hustle of buying and selling in order to generate enough income to keep at bay the wolf at the door.

We entered and were then led across a tiled floor into Ajarn's Samnak, a smaller square room than the one I had first met him in Chiang Mai, with a shrine and various rod instruments on a rack pertaining to the art of Sak Yant. But before we began some intense business ensued. It seemed that an order for a Kom curse ritual had been placed through Ronnie for Ajarn Apichai to execute. Ronnie passed a photocopy of someone's driving license over to Ajarn Apichai and after a prolonged discussion, they reached a final agreement. This was the beginnings of what is called a "Kom" curse ritual. Kom rituals traditionally were meant to realign balance within personal relationships. This ritual entails an Ajarn collecting a target's details (birth date, photograph, and full name) and then, through the use of astrological tables in tandem with the target's details, triangulating a date. Since the nature of the ritual is to draw and invite ghosts or for a specific ghost to hit a target person, putting them down hard and subduing them, graveyards (the more spirit infested the better) feature as the best location for this ritual. Other items such as clothes worn by the target, bodily fluids, and hair are also much appreciated in the instigation of this curse, all of which help to magnify the strength of the ritual. The effects can begin almost immediately and can last up to six months. I later heard that the subject of this particular Kom hit curse felt the effects within a period of twenty-four hours. Some targets of this dark form of work can feel as if they have been metaphorically hit with a baseball bat and feel the effects for considerably longer (as it happens, this particular target was seriously floored for months). Depression, deep inner sadness, paranoia, and confusion often manifest in the victims of an effective Kom hit curse ritual. These rituals are so effective that even corporate America has engaged in this service. The target I heard from a third party was seriously floored for

many months (bosses beware; the next time you are cruel or aggressive toward a subordinate be very careful indeed, they may well invest a few hundred bucks for a Kom hit to put you down).

I hope all of this serves as a warning, dear reader: When considering being near, in the general proximity or even employing violent magickal forces and spirits of a dark or black nature, no matter how much preparation you take or how friendly, kind, or seemingly approachable these forces are, you will inevitably, in at least one instance, be bitten cripplingly hard by a small, rogue, single, and irritatingly persistent bloodsucking tick from the inevitable karmic whiplash blowback blast. What goes around does indeed invariably (and ultimately) come around, no matter how hard you try to hide.

Ajarn instructed me to sit down on the cushion before him on the floor. He showed me a design menu of Jing Joks, nine of them, all surrounding a central Jing Jok design. We discussed through Ronnie the meaning and functionality of each design. I looked carefully and decided on which ones I would like Ajarn to give to me:

1. Jing Jok Petchaleek has a single body with two heads and two tails. This Sak Yant is for protection from any form of danger as the Jing Jok can see in both directions while having a double body. This extra Jing Jok body acts like a second self, so that it can be attacked instead of the bearer, much like a doppelgänger, absorbing all of the bad luck and negative effects directed to you from any life events.

2. Jing Jok Kharp Thong Chai has two unfurled flags being held in its mouth and resting in front on either side of its head. The flags denote victory in many (if not all) aspects of life. This includes any working and business relationships, while also aiding in all forms of promotion and your position in society. This particular Jing Jok is favored by civil servants, the police, and those attached to the army.

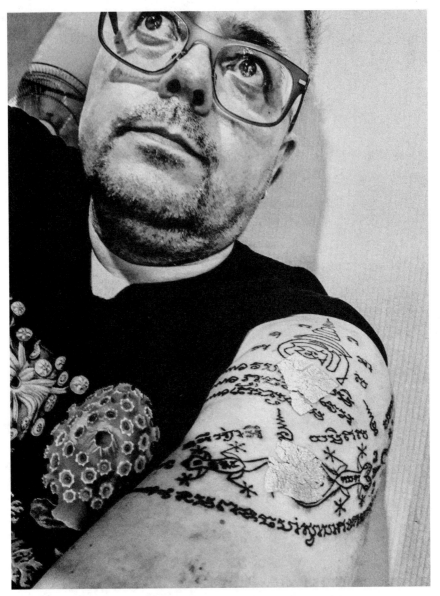

Gold-leaf-blessed and finished Jing Jok Sak Yants on my arm by Ajarn Apichai, 2018.

3. Jing Jok Satru Phai is a Jing Jok lying on its back with an unalome yant coming from its mouth that looks like a flame. This Sak Yant helps the bearer to knock any malicious thoughts or gossip about them directly back to the person making it. It acts

Wat Phra That Doi Saket Jing Joks 135

like a mirror, if you will, reflecting all negative energy back to the source. It also knocks back any curses and other forms of harmful magick.

I felt very happy and satisfied about my choices, knowing these three powerful Jing Joks would work in tandem and complement each other. Ajarn Apichai saw that these three Jing Joks would leave extra space for some other more personal bespoke touches that he would add and embellish upon as the process of the ritual unfolded into the afternoon.

The jump from Ajarn Daeng's personalized tattoo gun to the traditional Sak Yant rod was something of a shock. I had experienced Ajarn Nanting's Sak Yant rod on the first pilgrimage but had quickly forgotten how much of an extreme experience it is to have Sak Yant done in the old way. Ajarn Apichai had made marks at various points on my arm to centralize where he would begin and exactly where the Jing Jok would be placed. His focus was like a bench vice grip, locked on with the jaws of his intention; the Sak Yant rod repeatedly speared again and again slowly forming each and every single Jing Jok in a specially prepared dark blue ink. Ajarn Apichai has on occasion appeared in advertisements and events to support the hygienic and correct procedures that surround the implementation of Sak Yants. His reputation is high surrounding not only his technique but also his overall attitude toward the craft and artistry of Sak Yant.

Throughout the ritual my body failed to deal with the overwhelming double whammy of prolonged cushioned floor sitting and absorbing the business end of a Sak Yant rod. I was surprised by these new levels of discomfort, leg pain, and stress. It is these very emotions and feelings of pain that make up the core constituent parts of the Sak Yant ritual. Your ability to cope and your humility during this harsh ritual is tantamount to making it a successful experience. From the constant application of metal rod and ink, one is forced to go inside and visualize one's way through and beyond the ordeal. A trance state is reached

whereby you meet inside higher realms the entities that dwell there, offering them your total devotion for safe passage through this trial. At various points I had to change my position as my legs grew numb under the lack of movement. Ajarn was patient with me. He could see that I was struggling to take on board and carry the ordeal through to its final conclusion. I paused for some water and then saddled the ritual once again, my bull-horned willfulness edging closer and closer to the finishing moments.

After finishing off the three beautiful and perfect Jing Joks, Ajarn added a heart khatha yant and then three single lines of Khom script underneath. The ritual was then finished off with chanting and the blessing of gold leaf being placed onto my upper arm and blessed water. I felt myself come back to myself after a few minutes. Ronnie, who had been taking various shots with his camera of this profoundly painful ritual, smiled and asked: "What was the most painful part?" Swimming high as a kite from the huge of bomb of endorphins that had just been detonated inside my brain and body, I replied: "The last three lines of Khom script. Excruciating beyond words."

Everything was gently swirling. Not in a seasick sort of way. It was the aftermath of raw and powerful magickal energy transmission, powerful animist yantras now scuttling up my left arm, dynamic and resplendent on my skin, finished off with three large squares of gold leaf. I became aware that I was right there and then transforming into someone and maybe something else. It was a strange feeling, seeing the old self literally becoming tattooed out of and then into existence.

My view of permanent tattoos before this second pilgrimage was one of nonattachment. Although I had a background in the arts studying drawing and painting, I had no view or previous desire to acquire such things. I had not hitherto considered the connection however extending the arts onto my very body and skin, which from the excavations of ancient fossilized human skin, we now know as the first true canvas. Was this art or magick? It seemed to be both and then some.

As the days and months passed from its epicenter, the ritual radiated like a bomb of light and enchantment, its grip sculpting itself firmly across many situations and events. Countless times I would see the image of the Jing Jok appear in art, literature, film, and photography, reminding me of my connection to this highly adaptable creature and its overwhelming ability to exist in almost all situations. No, I didn't grow a forked tongue (or wish to have mine surgically altered) but I did feel the magick and strength of the wicha guide, informing and assisting me in almost all things in my newly evolving animist driven consciousness. There before me, near Ajarn Apichai's shrine, was a Pha Yant design he had drawn. It was of the essential nine Jing Joks.

Pha Yant are variously sized cloth pieces that are inscribed with yantra. The direct translation of Pha Yant is *Pha* meaning "cloth" and *Yant* for "yantra" which is derived from Sanskrit language and describes the sacred geometrical designs printed on the cloth. They can be printed and hand drawn. I asked if I could acquire this last Pha Yant he had of his newly acquired Jing Jok wicha. I donated an extra amount along with my donation for the Sak Yants. He very kindly blessed and signed the Jing Jok Pha Yant there and then. I was thrilled by his kindness and subsequently got the Jing Jok Pha Yant framed when I finally returned home. It now hangs on my wall near my shrine, exuding all of the energy only a strong and heavily blessed item such as this can radiate. Pha Yant can alter the room in which they hang and the person that dwells there.

I now have four out of the nine original Jing Joks in a clockface-like layout near my shrine: A Pujow Samingprai Tiger-Faced Lersi riding Rahu; a black and gold Rahu; the lineage of Ajarn Nanting's masters and teachers; and now the Pha Yant. The power that these Pha Yant emanate is unmistakable. Pha Yant are magickal talismans that underscore my daily life and the rituals I undertake at my shrine.

They are in my wallet, on my wall, and on my mobile phone in sticker form. These two-dimensional visions are emanations of consciousness in of themselves and exist as magickly functional totems. A common phrase that is used the describe Pha Yant in Thailand is "Bong Gan Pay" meaning to "protect from danger or harm." There is a strong belief in ghosts in Thailand, so many believe that Pha Yant will keep you safe from evil spirits. Others are of the opinion that it will boost your business, provide charm, or even help you to find love. Pha Yant have sacred yantra geometrical designs and animist-based designs, which can incorporate Buddhist psalms, magickal formulas, and symbols for protection and blessings. Suea Yant (Yant shirts) are worn under clothing close to the skin. Ancient warriors wore them in battle to ward off blows from sharp weapons. Pha Yant that are small enough can be either kept in the pocket or the design can be written on the undershirt to protect soldiers and cast spells on the enemy. It is said that even touching or rubbing Pha Yant onto your skin can have magickal effects upon those that touch them, such is the highly potent nature of these remarkable and outstanding items in Thailand's magnificent and sublime culture.

12
The Acquisition of the Miit Mhor

Lek Nam Phi, Akhara Script,
and the Keris Blade

Leaving Ajarn Apichai's Samnak and driving into the setting sun, Ronnie and I made our way to the Dragon River Avenue Hotel, which sits by the snaking Nan River and faces the Chan Royal Palace, in downtown Phitsanulok. Pulling up to the hotel, a strong atmosphere hit me directly and a confluence of spirits engorged all of my senses. I knew around and underneath my feet of this seemingly modern contemporary hotel with its neon dining balcony, minimalist interiors, and wooden flooring, forces writhed, awaiting any opportunity to exert themselves. I felt as though I was being watched. Not even the two floppy, oversized teddy bears that sat on each end of the sofa in the downstairs check-in waiting area could dampen this persistent feeling. The clean white décor only accentuated this underlying feeling.

Before we sat down for dinner, I went outside and took some photos of the gardens. Two things caught my attention. Firstly, I noticed an underlit Hello Kitty statue that looked strangely menacing in the dark. Secondly, I saw two beautiful tall ornate spirit houses (one with a ladder) fully blessed with generous offerings that shone a golden hue in the surrounding sympathetic lighting.

After an uneventful night's sleep in our respective rooms, Ronnie and I went down to breakfast, which was served in a large area that looked like it could double as a conference room. The eggs were oily and slightly rubbery. Although the rest of the breakfast fare was of a reasonable standard, I still hadn't got use to the idea of having rice for breakfast. On my very first pilgrimage Ronnie had taken me to a small bustling restaurant underneath the BTS Sky Train bridge in Bangkok. Completely covered in white tiles, this restaurant served nothing but chicken and rice in various forms. The chicken consommé that was served along with the meal was the most extraordinary chicken soup I had ever tasted. It was a beautiful, extremely cheap, and incredibly delicious meal. In spite of this experience, this was the only time while traveling in Thailand that I ventured into having chicken and rice as a breakfast option. I recall this here and now to demonstrate the benefit of having an open mind, open palate, and open heart, when visiting Thailand. I initially considered refusing such a meal so early in the morning but now feel that the experience, which has since implanted itself firmly into my consciousness, remains as something now deeply cherished and much beloved. It's the seemingly small things that inexplicably tuck themselves into the mind and quietly but firmly take up residency, exuding a nostalgic light of enchanted remembrance that can be so evocative and persistently haunting.

Back inside my hotel room, while packing up my overnight bag for checkout, a sudden and total panic hit me like an electric spark: I had lost my phone charger cord. You may find this incident a trivial matter, and indeed, in any other locale, this would probably be true. Traveling in Thailand however without any means to charge your phone is a more troubling affair. My phone required a specific charging cord I couldn't borrow easily. I knew that the current battery level would last for at

least a few hours if I economized, so I would have to carefully manage my usage until I could find somewhere to buy a replacement.

Where on earth had the cord gone? I went inch by inch through every single possible place in my room. I was perplexed and slightly freaked out. I knew that the cord had been in my bag and that is where it lived. I was flummoxed and although I couldn't offer any definitive reason for its disappearance, I had two possibilities in mind. The first was that Ronnie, who had borrowed my phone cord in the evening had failed to return it to me even though he explicitly insisted otherwise. I entertained the possibility that Ronnie had somehow carelessly ditched my cord in his room—thus preventing me from recharging my phone— in a subconscious attempt to prevent me from taking photographs, which seemed to be an underlying obsession with him. For some reason, he disliked me taking photos of the two of us together and appeared to be strangely threatened by my documentation of my pilgrimage.

The other (more surreal) possibility that a mischievous and untoward spirit had hijacked my phone cord crossed my mind. I considered the distinct possibility that a taunting and unpleasant spirit had taken some offense at my presence here in Phitsanulok. Perhaps it had even possessed Ronnie. I had taken the liberty of photographing a spirit house outside The Dragon River Avenue Hotel. This can be, if the approach is not correct and reverential, a bad idea since spirit houses are the homes of spirits.

Spirit houses (such as the ones in the gardens of the hotel), intended to provide a shelter for spirits who can cause problems for people if they are not appeased. Most houses and businesses including corporate headquarters have a spirit house placed in an auspicious spot, most often in a corner of the property. The location is chosen after strict consultation with a Brahmin priest, a monk, or an Ajarn. Somewhere along the line, a maleficent form had sequestered my phone cord down some infernal wormhole. Alright then, game on. Let's see who will win this cat and mouse game. I strictly managed my slowly emptying battery life and

waited to see if this little invisible spirit menace would eventually show themselves to me.

Once again we were heading north toward Chiang Mai. We had discussed previously the option of a turn off and visit to the Lek Nam Phi Iron Ore Mine if time allowed us this luxury. Fortunately, we had made very good time despite the odd spirit attack and now made our way to a special and unusual place in Thailand's history now preserved as the Bor Lek Nam Phi Folk Museum. It seems that from the offset you are in a strange and peculiar way dissuaded from visiting this magickal and special place. The road signs themselves are not helpful in any way whatsoever and tend to baffle even native travelers. I feel that this gentle wall of impenetrable chaotic confusion magick is an inexact way of protecting this profoundly important location. Powerful spirits dwell here, and their presence transpires into this place of existence in many inexplicable ways. Ronnie's GPS (a tool I highly recommend you use when attempting to find this place) and his prior knowledge from previous visits did much to help us access this historical folk museum and essentially sacred location. It was here that Ronnie had, over time, acquired numerous Miit Mhor, a spiritual ritual knife that is used for various magickal acts such as breaking bonds, binding, and creating an area of protection.

I had it firmly in my mind to acquire a Miit Mhor here but first it was important to pay my respects at the inner hall of the shrine of the Guardians of Bo Lek Nam Phi. Attempting to take a photograph of this shrine, I noticed that try as I might I couldn't get a totally crisp image. An invisible fuzzy field seemed to radiate from this place. I lit incense and bowed gratefully to the three Guardians, their omnipresent visages looking upon me with a mixture of bemusement and quizzical perplexed concern. This early open morning butterfly enchanted visit

had a high feeling of serenity and peace as Ronnie and I walked up the pathway toward the mining areas where countless butterflies nuzzled the sea of blooms that drenched and surrounded this sublime place.

This ancient site has been a source for Lek Nam Phi, the highest grade of metal ore that has been used in countless steel magickal weapons such as swords, scorcer or shaman knifes, and spears for centuries. There are several mines here rich with the magnetic Lek Nam Phi and I went magnet "fishing" in one of the wells. I was blessed with a small bag for my troubles.

The Phra Khan well is considered to be the finest well since the royal blacksmith of old had exclusive access of this mine to acquire ore for the smelting of all royal blades. The name of the well Phra Khan also translates into a name for a royal Keris-like weapon. Keris or kris blades originally derive their name from the Old Javanese term *ngiris*, which means "to slice" or "wedge," though this particular blade has deep roots in Indonesian and Malay culture as well.

After a weirdly pleasurable visit to a large army of rooster statues that were arranged and stationed underneath what seemed to be a bandstand roof it was time to visit the museum shop to acquire my Miit Mhor. Throughout this unusual place there are various little shrines and places to honor. I would sincerely recommend being very attentive indeed to each and every one since it is always pertinent to pay attention to such seemingly small details. (See color plates 23 and 24.)

Within the Satsana Phi belief system ("religion of spirits"), which is an animist Thai religious belief intermixed with Buddhist beliefs, supernatural deities or gods can sometimes inhabit buildings, territories, natural places, or all manner of things. What may seem to be a large army of rooster statues to me may be a sea of spirits to another. In whatever frame of mind you may find yourself it's always good to cover your bases and honor that which is before you. Walking around the Bo Lek Nam Phi Museum Shop, I slowly took in the vast and almost overwhelming array of blades, swords, and steel weaponry that

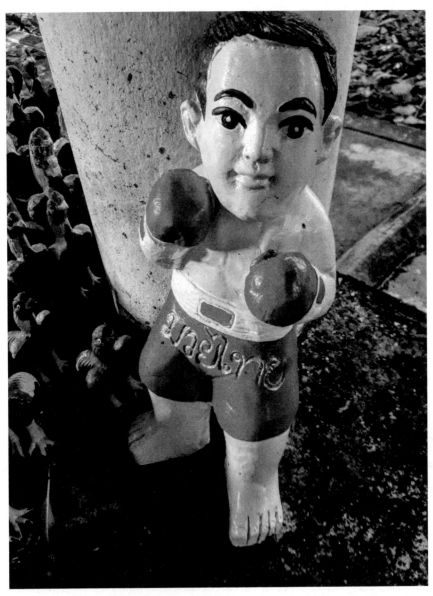

Muay Thai Fighter Spirit at the Bor Lek Nam Phi Folk Museum.

one could imagine. The Miit Mhor ritual knife is a magickly empowered tool that is akin to the magick wand in various traditions across the world. These knives, forged at astrologically auspicious and significant times, repel all negative forces and the techniques used to forge

The Acquisition of the Miit Mhor 145

these unique blades are varied and many, often alchemically forged, and sheathed. They can take up to two months to make (maybe even more depending on whether the knife has been created specifically on your astrological birth map). The practice of utilizing sacred metals for forging into blades has had a very rigid set of rules and formulas for many hundreds of years. Metals are chosen for their magickal values with stringent ancient formulas on how they should be mixed, blessed, and empowered.

The Miit Mhor can be seen as a scepter of command, a very powerful magickal tool that is capable of controlling spirits and ghosts, a ritual and spiritual weapon that is able to banish evil spirits and also to nullify curses. The Miit Mhor requires an altar or the very least a very specific sacred place. In the Thai Lanna tradition, the Miit Mhor is known as a "Meed Haek." The word *Haek* means "to scrape, brush or stroke". The Meed Haek can be used for healing illnesses, ailments, and exorcising demons. If the Meed Haek blade is not metallic, it has been known to be created from other animal or plant substances such as tiger, bear, monkey, crocodile teeth, wood, coral, ivory, boar tusks horns, antlers, seashell, or bones. The Miit Mhor inside the Bo Lek Nam Phi Museum Shop were all metallic and highly detailed in their construction.

As I circled the shop again and again one blade kept catching my eye. I felt this was a good sign. It was a sign that the blade was calling to me. I answered its call. I picked it up and held it in my hands. I studied its simple, crisp, and yet highly effective construction and marveled at its beauty. This knife was the only keris-style blade made from Lek Nam Phi in the shop. This Indonesian and Malay dagger, famous for its distinctive, wavy blade, is one of the weapons commonly used in the Pencak Silat martial art native to Indonesia. The number of curves on the blade (known as luk or lok) are usually always odd. Common numbers of luk range from three to thirteen waves, but some blades can have up to twenty-nine. This keris (that I ended up purchasing) had a total

of three waves along its blade. According to the Javanese Kejawèn religious tradition, which contains animistic, Buddhist, and Hindu aspects, keris are meant to contain all the elements of nature: tirta (water), bayu (wind), agni (fire), bantolo (earth, also interpreted as metal or wood, the sheath and hilt on my blade was made from this), and aku ("I" or "me," meaning that the keris has a spirit or soul). The blade's wavy lines are associated directly with the Nāga serpent or dragon, which also symbolizes the irrigation of canals, flowing rivers, freshwater springs, wells, waterspouts, waterfalls, and rainbows; the very movement, energy, and dynamism of the Nāga serpent. All these elements are present during the alchemic forging of keris blades.

Akhara script was carved along the full length of this particular blade. *Akhara* is a gender-egalitarian term, which means "circle" or more precisely "the spiritual core". The blade's script then goes on to describe the place where the blade was forged, in this case, Bo Lek Nam Phi. The Akhara script in essence establishes the Miit Mhor keris lineage, purity, and authenticity. Akhara script on Miit Mhor blades is a hallmark of fine craftsmanship and the highest possible standards of ritualistic magickal precision in its creation. If you are interested in further reading on the subject of keris blades, the book *Keris and Other Malay Weapons* by Gerald Brosseau Gardner (founder of the tradition of Gardnerian Wicca) is a good place to go.

Back on Route 11, two strange and significant events occurred before we reached Chiang Mai. The first was we nearly ran out of petrol. This bizarre occurrence was an oversight by Ronnie who had up to this point been pretty solid dealing with the tour management side of things. The level on the gas meter had gone below the final marker and we were literally cruising on fumes at one point.

We managed to pull into an isolated restaurant for directions to the

The Acquisition of the Miit Mhor 147

nearest petrol station. Outside this lonely place was a giant-sized mushroom and strawberry. I'm not sure if this was a statement of intent or just the usual random crazy Thai cultural motifs that make life just that little bit more interesting. We were informed that a PT station (a brand of Thai gas station) was just a couple of miles down the road. A beautiful blue skies and fluffy-clouded day made our predicament seem a little less perilous than it actually was. Crossing the road into the forecourt of the petrol station, I hoped that my quiet and continuous chanting of Namo Dtassa Pakawadto Arahadto Sammaa Samputtassa (the Thai phonetic pronunciation is slightly different from Sri Lankan Pali of Namo Tassa Bhagavato Arahato Samma Sambuddhassa) had, in some small way helped our vehicle over the finishing line before shuddering to an empty halt. While we were filling up I took a photo of the PT station's spirit house, which was directly underneath the tall signage. As mentioned earlier, even in the most isolated of places, spirit houses in Thailand pervade every auspicious corner. Relieved, fueled up, and armed with drinks and snacks we went onward. It was while on the road to Chiang Mai that the second strange thing happened.

In the midst of a conversation, Ronnie and I had a brief argument. Maybe this had been sparked off by my photograph of the spirit house at the PT gas station.

It seemed that Ronnie's mentor and friend would be visiting Thailand. Ronnie was excited that he was coming over and shared with me how his mentor had guided and supported him through what I gather were dark times. Ronnie then stated that at one point his mentor had hit him. Upon hearing this I had very mixed feelings indeed. In Zen Buddhism during Zazen, which is a form of seated meditation and ultimately the practice that allowed Buddha to attain enlightenment, it is critical to stay focused and allow balanced relaxation in the vertical position of the body. This is the heart of Zen Buddhism, when attention is placed on the exact alignment of the posture, flow of the breath, and the rise and fall of thoughts. I have

148 *The Acquisition of the Miit Mhor*

read accounts in Zen literature of sensei hitting students with a stick if their discipline and focus wander even one iota off course. This may seem extreme, but I understand that some discomfort is required to attain anything that carried any form of high spiritual value.

When Ronnie told me about this experience, I was naturally concerned and responded in what I felt was an appropriate manner, "I do not condone in any violence whatsoever whether it is meant to be helpful or corrective." I was surprised by Ronnie's angry response when he shouted, "What fucking business is it of yours anyway?" The conversation quickly spilled into a full-scale argument in which I had to shout my neutralizing counterpoint over his loud and angry missive, "I respect your experience!"

After this incident, the car fell silent for a good few miles. I had known for some time about Ronnie's hair-trigger anger and that he was prone to volatility. I did not find these outbursts constructive or welcome. Ronnie had what I would call (and what he actually said to me at one point) a "I don't give a fuck what you think" attitude (unless of course he was after something), and a tempered, under the surface, belligerent attitude that indicated he didn't suffer fools (intentional or unintentional), authoritarian figures, or arrogance in any way at all. I found this ironic, since sometimes Ronnie himself displayed these very same qualities. His brusque and extremely blunt and messy approach served and hindered him in equal measure. This hard edge was counterweighted by his charm, physical discipline, and—at times—almost inexplicably overwhelming generosity. He labored to tell me once that "kindness" was important, something I believe to be true. However, a story Ronnie told me about canceling a devotee's trip due to a minor infraction made me feel I was walking in a minefield of petty and childish preferences.

While I understand some car owners can be aggressively protective of their vehicles, in this case I believe it was the devotee's disrespect and contempt that really irked Ronnie. He expected high standards of

behavior from those around him, even while sometimes exhibiting traits of flakiness himself. In terms of astrological characteristics, Ronnie was a balls-heavy Gemini with the changeable, idiosyncratic, and elemental air-based fluctuations that people with this zodiacal sign represents. All of this interplay and banter ending in the term *kráp* (added to the end of sentences in Thailand for courtesy and softening the impact of a sentence) between myself and Ronnie in person, and via social media, tons of email exchanges, and messages, however was to come to an abrupt end some four years later after this major tiff on Route 11 while on our way back to Chiang Mai.

Back in Chiang Mai Ronnie and I went to pick up the now fully consecrated Pujow Samingprai Tiger faced Lersi bucha that I had acquired at Ajarn Suea's Samnak. Ajarn was seated cross-legged on the floor near his shrine where he was putting the final touches on the three bucha in front of him, placing yantra at certain points on the bucha. Pujow Samingprai Tiger-faced Lersi bucha all shone with a life force that was not previously present. His powerful incantations had the very breath of life within them. I picked up the bucha and felt that I was picking up a small deity of light. I was taken aback at its aura and the pulsing emanations that emanated from within it. I knew that I would have to very carefully transport this precious and now consecrated sacred altar piece back to my home over thousands of miles and was grateful I didn't have to make this journey using a camel and star maps.

After checking out for the second time from the B&B and heading for the Chiang Mai International Airport, I had the strong and unmistakable feeling that I would be visiting again at some point in the future. The feeling was inexplicable with no reason behind it. I just knew that I would be coming back one last time. Maybe two. It had taken

150 The Acquisition of the Miit Mhor

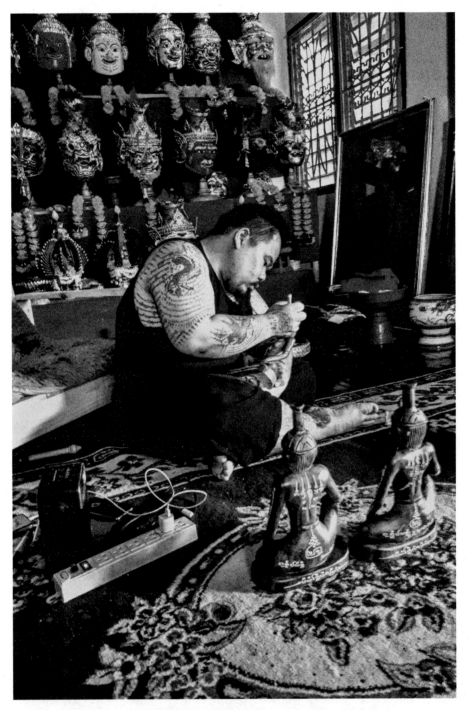

Ajarn Suea inscribing his Lersi Pujow Samingprai statue with yantra.

considerable funding and resources to make this second pilgrimage, and yet the feeling that another pilgrimage was coming was firmly inside my bones.

In a synchronous event at the departures area Ronnie said his goodbye. He held out his hand and gave me a gift. It was a beautiful bronze Pujow Samingprai Tiger faced Lersi amulet by Ajarn Tay. Once again Ronnie perplexed me with his unpredictable generosity. I immediately put it on around my neck. It had an adjustable cord, the kind that I liked. "You look younger. It's actually made you look younger," Ronnie said. Although I knew embracing Lersi magickal technology can have numerous effects, this one was surprising to me. Since Ronnie wasn't one to readily hand out compliments, I took this as a sign that some form of shift in my appearance had indeed occurred, even if it was just a cloak that had dropped a few years off my visage.

At the airport, it was time to solve that troubling issue that had surfaced its ugly head at The Dragon River Avenue Hotel in Phitsanulok and plagued me ever since—replacing my missing phone cord. The airport departure lounge was an endless mile long, filled with numerous kiosks. Finding the right cord seemed almost impossible as I made ridiculously repeated visits to every single kiosk, even purchasing and returning the wrong cord at one point. Exhausted from this absurd escapade, I finally managed to find the correct cord for my phone, finally outwitting whatever spirit may have caused it to disappear. The price on the till lit up in neon red . . ."555 baht." In Thailand, the prefix "5" is used when texting or emailing to indicate and simulate laughter. The demon spirit was laughing scornfully at me. Ha, ha, ha indeed.

Back home, I slowly but surely unpacked the new treasures from my second pilgrimage and began to install the upgrades to my shrine, namely the black Phra Ngang and Pujow Samingprai Tiger faced Lersi bucha

The Acquisition of the Miit Mhor

from Ajarn Suea, and a pedestaled Rahu gift from Ronnie. These now stood aside the gold-hatted Phra Ngang and Sihuhata (Five Eyes Four Ears) and Luang Phor Pina Rahu bucha from my first pilgrimage. For the next year I performed my daily practice without fail. Blessings, offerings, chanting, meditating, and working with necromantic magickal tools and undertaking the odd operational bespoke ritual. I prepared myself for the coming third pilgrimage.

Unbeknownst to me, my next pilgrimage would entail a major set of ordeals and serve as another stage of a magickal transformation that had slowly but surely been unfolding over the last three or four years. Following a pathway, any pathway—be it magickal, spiritual, or any form or emanation you wish to subscribe to or if you really want to create yourself—is a harsh, difficult, and at times painful undertaking to devote oneself to. Practicing nonattachment, undertaking a daily practice at a shrine, renouncing former behavior patterns and associations, devoting yourself to new pathways of becoming, all take the will, surrender, and focus of your mind and heart to accomplish. Everything must go. It is the ultimate fire sale of the soul. The higher you go, the thinner the air and the more exposed to the currents you become, the deeper the silence you will encompass and embody. My pilgrimage of January 2020 would sit nestled and teetering on the edge of an apocalyptic worldwide event that would change everything, sustaining and ultimately transforming me forever.

13
The Year between Pilgrimages
Transformations and
Processing Magickal Rituals

In the year leading up to my third and what I thought would be my final pilgrimage to northern Thailand to meet and undergo rituals with the Ajarns, a number of notable things occurred. The shrine that had already been established at my home for a number of years was now, slowly but surely, growing in size and stature. My deep involvement and merging with Thai Buddhism and its practices had clearly had a strong impact on me, and my daily routine changed and mutated accordingly. My daily practice now consisted of meditating with necromantic items, making regular offerings to the deities and spirits, chanting numerous mantras, making merit to those around me (both privately and publicly), and burning incense and paying homage to Buddha and all manner of deities, monks, and spirits. Black Phra Ngang, Tiger faced Lersi, Rahu, Gold hatted Phra Ngang, and Five Eyes Four Ears all stood resplendent with offerings and a presence that was undeniable. I had also established a separate area that held a shrine dedicated solely to Buddha with a number of antique Buddhist items.

Assimilating and processing what had happened to me in the second pilgrimage took months for me to fully digest. The immediate aftermath

154 *The Year between Pilgrimages*

was the usual high followed by a slow comedown, and then entering into a phase in which I found certain aspects about myself and my connections to associations changed. This change in perception was not ego-driven or contemptuous in any way whatsoever. It felt more like leaves when they cease to be alive gently fall from the trees' branches. Old ideas, dogmas, associations, and attitudes shifted and moved.

One such change—a major turning point for me—was the cessation of my cannabis habit. I had smoked cannabis since the age of eighteen. Now, in my early 50s, I decided it was time to say goodbye. I thought this decision would be extremely difficult for me to handle. It was easier than I thought. My mind was now in such a place that I was permanently in a state of raised consciousness, and that anything less than this would be incongruous to my feelings and my daily practice. Even the idea of taking a single puff of a vape didn't appeal to me. It was as if I had just turned away from this gently and naturally without any fanfare or struggle. It just happened. Transformational magick just happens. It creeps up oh so quietly and then, before you know it, you are changed. Magickal transformation, whether personal or general, doesn't need to be a theatrical Broadway event. So long as you are earnest and devoted in your quest, it will come. I just finally knew that repeatedly taking the same pathway would result in the same outcomes. Like Neo in *The Matrix*, I didn't wish to go down the same road again.

Another habit I ended (within mere months of arriving back home after my first trip) was the cessation of biting my nails. This entrenched habit, which had been with me since childhood, phased itself out. I nearly didn't notice it happening. This terrible affliction had been a bane in my life and had made me ashamed to show my fingers in any form of photograph. Now this habit had been silenced. The nervous and anxious trouble of nail biting had finally gone. I knew that this new pathway of experience would be of great benefit for me personally and help to promote inner peace the likes of which I had not known before.

In November 2019, I did a radio interview with Alex Hawkins for his show *Homely Remedies* on Frome FM. A kind and generous supporter of my work over the years, it was a great pleasure and delightful surprise to receive another invitation from Alex some three years after our interview back in 2016. This interview was a longer and more in-depth chat. A lot was discussed over those fifty-seven fully caffeinated minutes: my beginnings and continuing journey in music, living in Los Angeles, my pilgrimages to Thailand, and my strange and delightful encounter with Jenny Tomasin, an actor who portrayed the character of Ruby in the ITV show *Upstairs Downstairs*. Jenny wasn't just an excellent performer but also a highly experienced medium and practitioner of psychometry.

When I met Jenny, I was living at Swiss Cottage in London, where I used to take walks to the weekly market. On one such excursion, I noticed a handwritten notice on a message board across the road from the Swiss Cottage Community Center advertising tarot cards and psychometry readings by "Jenny," along with the price and address. At the time, a thought passed through my mind. "I should go and do this," I thought. I followed my intuition and ended up at a small sunlit room facing Jenny Tomasin. What impressed me the most was the psychometry reading she gave me, probably one of the most powerful experiences I'd had in occult circles up to that point. Psychometry is also known as token-object reading, a form of extrasensory perception in which objects are believed to have an energy field that transfers knowledge regarding that object's history.

Jenny requested an item from me. I handed her my watch. Over the next several minutes she held my watch and focused upon it. Jenny then described to me something that only in retrospect could I fully understand and comprehend. She carefully described a pattern of movement. Pointing to the table she said: "You will first go here, and then back, and then go back there and then back again, and then go there

again, and then come back, and then go back there for a long while and then finally leave and come back here for good." At the time, I couldn't understand what on earth she was talking about. It was only years later, when this important meeting popped back up into my mind, that I suddenly realized what she had been telling me. Jenny had accurately described my three initial visits to the United States, followed by my full migration there, followed by my return back to Britain. Jenny had described my movements of a period of just over ten years. Jenny Tomasin wasn't just an excellent character actor, she also had a profound, remarkable, and generally unknown hidden gift.

Given its significant role in my life, it is not surprising that music also played a significant role in helping me process my experiences. In February 2019, I released the album *Thai Occult Road Trip*, a panoramic audio celebration of my fascination with and admiration of the magickal occult system of Thai Lanna Buddhism. An integration of electronic and organic sounds, this sonic travelogue expresses and crystallizes incidents and remembrances that I had experienced during my pilgrimages. One track, entitled "Kom Hit Target," is a crushing and relentless dirge that expresses the slow and frightening progression of a ghost creeping up on its intended victim and haunting them. While meditative and circumspect, this album of four deep tracks attempts to be a highly danceable yet chimeric experience of experimental electronic music, while integrating the nature of Thai culture. Music magazine Compulsion Online captures the essence of the album perfectly when they say: "Not since Peter Christopherson released *Form Goes Rampant* under the name The Threshold HouseBoys Choir has any electronic musician captured the sacred nature of Thai culture so beautifully."

In October of that same year I contributed to an exhibit at Bristol Museum called "Do You Believe In Magic?" In response to the muse-

The Year between Pilgrimages 157

um's open call to the public for submissions of photographs of magickal objects accompanied by a short description, I sent the museum my photograph of and commentary about a Phra Ngang Bucha,* a magickal statue with spiritually active elements made by Ajarn Suea. The museum replied to me to say they would be using my story in the exhibition, but not the photograph of the object that the story was about.

While visiting the exhibition I saw that the description they had installed on the plaque was not accompanied by the photo it referred to. Instead, a different photo was on display. For me, Phra Ngang is an object of veneration. I had sent to the museum my own personal photograph of the original image of the statue (or Bucha), which I had acquired directly from Ajarn Suea himself during one of my pilgrimages, and the accompanying descriptive text so that Phra Ngang, one of the deities I now worship and respect daily, could be correctly beheld and admired in his true and beautiful glory. By not using the photo associated with its accompanying description, the museum had made such a thing impossible.† For me, Phra Ngang represents a real and living presence and is a symbol of growth, life-force, and personal evolution. Carl Jung (though crediting it to Lucien Lévy-Bruhl) articulated this dynamic—identifying and merging unity with an object—as "participation mystique."

Another section in the exhibition was dedicated to the practice of tarot. Readings of tarot can only be accurately made if the connection between the medium (the tarot cards) and the tarot card reader/owner is unbroken and within close proximity of its owner's energy, integrity, and spirit. In fact, magickal objects of *any* kind—such as wands, cards, statues, or instruments—can only be effective if the person that owns and is deeply connected with it is the only one allowed to wield it.

*As stated previously, Phra Ngang is an animist nature deity or demon that is said to reside on a mountain.

†The museum later contacted me and apologized for their error. I then re-sent the correct photograph to them and they redesigned a plaque with my original description to attach to the proper photograph.

158 *The Year between Pilgrimages*

As I sat at the tarot table some folk approached me and asked me about the Khun Paen amulet (made by Ajarn Apichai) I was wearing. For a brief moment I felt as if I had dissolved and become a part of the exhibition, which was like a flashback of my time working at The London Dungeon as a Warder and a brief stint working in the slides department at the Victoria and Albert Museum.

Before my evening private viewing that night, I dined at one of the best kept secrets in Bristol, the wonderful Brisnoodles. Here I sampled their fantastic Jasmine Tea and exquisite and generous Mixed Seafood Hot and Sour Noodle Soup, likely one of the finest and excellent bowls of noodle soup I've had in recent memory. Do you believe in magick? I do. Indeed, my evening progressed from my fine meal to what was to be the highlight of the evening for me. While waiting in queue for the exhibition to start, I met with the one and only Adrian Nooke, counselor, healer, Druid, and member of The Order of Bards, Ovates, and Druids (OBOD). I warmed to Adrian's open-hearted, wise, approachable, and friendly aura almost instantly. He told me that he was one of the exhibitors at the exhibition and then introduced me to his lovely partner. Both exuded an intense, bright, funny, self-effacing yet rich energy I found both enchanting and charismatic. I met Adrian again inside the exhibition, where he kindly discussed at length with me his practice and pathway. It is extremely difficult to fully do justice to a thing like magick, a subject that is oceanic and vast. Although Bristol Museum made a fascinating and outstanding stab at this subject, I continued to have other small reservations about some of the decisions they made.

With over two hundred exhibits the exhibition felt like a shop of curiosities, containing many items and much to dwell upon. There was also no mention at all in fact, of black or dark magickal processes. Although there was a "dried out cat" in the exhibition there was no mention of Crowleyan ritualistic cat killing. Nor was there any mention of Santeria, Voodoo, Judaism chicken sacrifices or Aztec human

The Year between Pilgrimages 159

heart sacrifices. Admittedly, I would personally not wish to see such things. However, I am clearly and highly aware of their place in human magickal history. Out of light comes darkness; out of darkness comes light. In a nudge wink moment to the visitor, the smartphone was mentioned as a magickal device though there is no mention of the suffering of the children enslaved to obtain the tightly controlled conflict minerals that run these pieces of modern technology. One practitioner who was included in the exhibition was occultist, psychonaut, and writer Julian Vayne, who spoke about his experiences via a small flat screen. Just below this was a cupboard that visitors were invited to open in order to smell the magickal herbs inside. Gorgeous artwork from various tribes adorned the walls and insides of glass cases, supplemented by plenty of textual information to read and absorb. Meeting Adrian Nooke in person next to his enigmatic video exhibit was a wonderful experience. Adrian spoke to me directly outside and beyond the video about the meaningful and resonant images that were emblazoned upon his shamanic drum, his love and reverence for the planet (which I wholeheartedly share), and his practice of visiting a local stone circle at full moons and sunrises, to sing incantations, and raise spirit. Once the video of Adrian had finished it became apparent that the curtains that the video was being projected onto covered a doorway from which another area could be accessed. Some exhibition workers came through carrying a box of items. "It looks like there's a doorway hidden behind me," said Adrian.

I took this statement to mean something beyond its initial mundane meaning. We are indeed all doorways to other realms. *Magick* or indeed *magic* is a term that is allegedly derived from the Old Persian *magu*, a word signifying a recorded designation of social class or priests of all western Iranians during the Median, Achaemenid, Parthian, and Sasanian periods. Beginning in the fourth century BCE, the use of the term *magus* was used to designate conjurers, sorcerers, and soothsayers, the very same word used for designating wise men—like those

who arrived "from the East" (Matt. 2:1) with the offerings to the infant Jesus Christ, the same Christ who is now seen as possibly a sorcerer himself due to his magical practices in the New Testament. The historian Owen Davies stated that the word *magick* was "beyond simple definition" and had "a range of meanings." I concur with this statement. Like a shape-shifting deity the word *magick* or *magic* has changed at every twist and turn it meets.

The preparations for my third pilgrimage to northern Thailand in January 2020 started in October/November 2019. Even as Ronnie and I discussed rough ideas for my itinerary, by that time I had a clear, underlying, and strong focus on one thing and one thing only. Since my initiation back in 2017 into the devotional ways of Mae Surasatee via Ajarn Nanting, I had felt over time a strong undeniable urge building up inside of me: I wanted to crown my deep love and devotion to this sublime deity by acquiring a fully consecrated bucha of her for my shrine. To that end, Ronnie suggested we travel to Mae Sot, a city on the border of Thailand and Myanmar, where he told me many items such as this could be easily acquired. However, what would actually transpire and occur during my next pilgrimage would be a profound, remarkable, and life-changing series of episodes that still resonate within me to this day.

14
The Third Pilgrimage

*Personal Revelations and Reaching
the Golden Temple*

On Monday the sixth of January 2020, I entered the terminal at Heathrow wearing my muted silver Paco Rabanne combat jacket and my Ong Kru Khun Paen amulet by Ajarn Apichai. I had the determination of a man on a mission. Consisting of over 20,000 couplets, "Khun Paen" comes from the epic Thai poem "Khun Chang Khun Paen," which in turn comes from a Thai folklore legend. Khun Chang and Khun Paen are the male characters within the text. "Khun" is a junior feudal title given to male commoners. Existing purely as an orally transmitted poem sung by Thai troubadours, the poem was eventually transcribed into text and published into printed form in 1872.

Khun Paen is viewed as the perfect Thai magician, schooled in the "inner ways," capable of remarkable feats of magick, sorcery, and cunning. Khun Paen also has an army of spirits at his command who defend him against enemy spirits, act as spies, and transport him at speed. In a well-known passage from the poem, Khun Paen acquires an extremely powerful spirit from the stillborn fetus of his own son. This spirit is known as a Kuman Thong, the golden child. The Ong Kru

162 *The Third Pilgrimage*

(Master Version) Khun Paen amulet by Ajarn Apichai that I had chosen as my amulet of travel was one of only five made. Blessed a total of nineteen times, Ajarn Apichai had created an amulet of awesome power and depth. On the front of the amulet sits a seated Khun Paen. On the back, an array of takrut and a vial of spiritually active items gives the amulet considerable weight and energy. The matrix of the amulet body was constructed from a mind-boggling twenty-three various ingredients, all of them organic and necromantic in origin. For the granular among you, here is the complete list:

1. 108 magickal plants
2. Waan Sow Long
3. Three types of Waan Saneah Jan
4. Khrua Khow Long
5. Waan Dok Thong
6. The powder of Rak Sorn Flowers
7. Powdered flowers that have been given to the temple
8. The peak of an old Chedi ground to dust
9. Earth from eight graveyards
10. Earth from eight temples
11. Earth from eleven markets
12. Earth from eleven fields
13. The bone ashes of four female Tai Hong
14. Powder from the Panneng of four babies
15. Powdered Luk Krok
16. Ashes from a man who died on a Saturday and was cremated on a Tuesday
17. Nam Man Prai from many old Ajarns
18. 108 Nam Man Waan oils
19. Three types of Nam Man Jan oil
20. Nam Man Waan Sow Long oil
21. A rare type of Yaa Faet
22. See Pung Saneah Jan
23. The very hair of Ajarn Apichai himself

To say that I felt like a Jedi on steroids walking around Heathrow would be an understatement. I passed effortlessly through the security, through baggage and all manner of checkpoints. I felt the slipstream of

divine magick caress my entire body in the darkness and fluorescent sections of terminal two. So far, my third pilgrimage felt completely different from the first two. Very different indeed. Like Khun Paen himself, I felt I was being transported into the waiting aircraft without friction or event, the amulet acting like a paranormal key card. I was able to draw strength from the male, female, and child sources of necromantic ingredients inside the amulet for various specific requests. From the male source I could ask for protection. From the female source I could ask for attraction and good fortune. From the child source I could ask for wishes to be granted.

This time around, I felt that I had now finally merged with the system of magick that I had been studying and practicing for the last five years. This third pilgrimage was to be the crowning achievement upon which my devotion and consistent discipline would sit. I had no ulterior motives other than to heal, grow, and hopefully transform into a more beneficial and optimal version of myself, which up to now, had been woefully ill-equipped to manage any form of stability in my life. Although anger can be a motivator for a lot of people, it was not what was driving me. Yes, like anyone I have experienced anger in response to personal events and occurrences that have either damaged my life, destroyed my expectations, or crushed my hopes and dreams. It seemed to me that many people approached Ronnie with a thirst for power and control, and even though Ronnie had mastered the art of the illusion of being able to supply it to them, he himself was also thirsty for it. Power and control are never acquired. They are created if a series of prerequisites are met, fulfilled, and are consistently supported. If power is simply taken, when it was never given in the first place, then it can ultimately be taken away. Simon Leys in *The Halls of Uselessness* said: "Cultural initiation requires metamorphosis, and we cannot learn any foreign values if we do not accept the risk by what we learn."

Facing yourself in the mirror of rituals, initiations and life-changing

experiences can be frightening for many. My quest for self-realization and enlightenment was the impetus for me to take four pilgrimages in total to Thailand. I entered, I was then entered into, and then finally I merged with an entirely new pathway. Losing what you perceive to be yourself and selves can be a terrifying thought. What I find even more terrifying is not to know, not to understand, and not to evolve. For it is the lack of any progress and development within your spiritual life—if you have one—that manifests a life of shallowness, emptiness, and oblivion. Cultivating my inner spiritual life acted as a much-needed counterweight to a deep sense of absence that had haunted of me for so long, a sense that ultimately had to be visited and examined carefully, the internal crash site cordoned off and forensically examined. I knew it would take enormous courage to face the pain and undergo the difficult rebirth I so desperately wanted. Mine was not a quest to get closer to God or a god. It was to see how many different gods I could find and find out for myself whether or not they were real, authentic, and had a sincere place in my world. It was a quest to pay homage to Buddha, to his temples and all the Ajarns. It was a quest to magickly transform myself for the betterment of not just myself but for everyone around me. To be my best self would take work, sacrifice, and devotion. To be my best self would take discipline. Throughout these pilgrimages I had been moving from one realm to another. The spiritual elevator in this third pilgrimage however was about to reach another floor. As I embarked on my third pilgrimage, the image of Ken Kesey's famous school bus *Furthur* came into my mind for some peculiar reason.

I arrived in Chiang Mai International Airport on the seventh of January 2020 at 6:30 p.m. and met up with Ronnie who was kindly waiting for me in the international arrivals lounge. As per usual, I was grateful to him for picking me up and driving me to my hotel.

Acclimatizing once again to the thick and warm subtropical heat, replacing and balancing out my loss of bodily fluid was a slow and sticky effort. Anyone who doesn't enjoy living inside fan ovens with the occasional respite inside ice boxes disguised as 7-Elevens, hotel rooms, and restaurants, should think twice before visiting Thailand. Due to some various unforeseen circumstances, my itinerary for the next few days was to change. As it turned out this was to my advantage. As with my previous pilgrimages I had arranged with Ronnie a daily fee for his services as driver, guide, and translator, although his partner accompanied him during certain meetings requiring a depth of translation that Ronnie felt he couldn't deliver. Even though his Thai was adequate enough, he felt that the finer points in important conversations that necessitated detail (such as the information from divinatory dialogues) required a slightly more tuned ear.

In preparation for this trip, I had come up with what I believed to be a reasonable budget, one that I hoped would cover all my needs during my seven days in northern Thailand. On the morning of Wednesday the eighth of January 2020, I awoke feeling refreshed and eager to start the day's itinerary. Ronnie suggested we go to Wat Phra That Doi Kham (Temple of the Golden Mountain) early in the morning to meet the sunrise, an idea that appealed to me greatly.

In the yawning, muted early light of dawn, we approached Wat Doi Kham. This sublime temple is very beautiful beyond measure. Wat Doi Kham or Wat Phra That Doi Kham, otherwise known as The Golden Temple or Temple of the Golden Mountain, nestled high on top of a hill at Doi Kham in the backwoods of the Royal Park Rajapruek, about ten kilometers southwest from the city. The views from the top of Wat Doi Kham are stunning and panoramic, as you can see both the city of Chiang Mai and also the rolling mountains at the back of Doi Pui

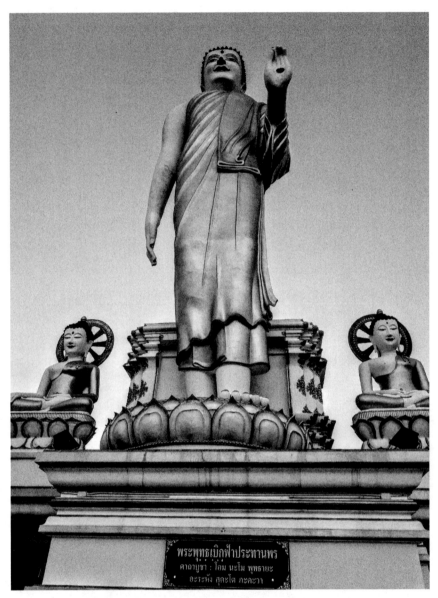

Standing Golden Buddha at Wat Phra That Doi Kham.

Mountain. A seventeen-meter-high image of a sitting Buddha, decorated in gold, lends to the temple's nickname "The Golden Temple." (See color plate 5.) There are a number of approaches to Wat Doi Kham. We took the staircase.

It was very early in the morning. A cacophony of dogs and cockerels barked and crowed as we climbed a high gradient, wooded, steep, and considerable hillside pathway up toward and before the final three hundred steps from the very bottom of Wat Doi Kham to get to the temple. The heavily wooded, tree root entangled hillside before the nāga serpent stairway is deceptively steep and you may be exhausted from the double climb of this challenging and harsh gradient. This ascendant ordeal was in fact an act of devotion and physical magick in of itself, the calm and warm subtropical air forcing sweat out of my body, our calf muscles quietly protesting the repetitive angular tension required of them to make the climb. Indeed, I would need to visit a local masseur to ease my left calf muscle, which became bunched and rock solid tight, and was unbearable to walk on after this climb. The staircase is decorated with magnificent nāga serpents on each side winding down the mountain. At the top one is literally transported into a vista from heaven. Small inner temples, statues, and a vast collection of Buddhist gongs populate this transcendentally beautiful Buddhist temple.

The temple is assumed to be well over 1,300 years of age and is the location of the pagoda Phra That Chedi, where the Buddha's hair relics are enshrined. Every year on the seventh or eighth of May, during the waning moon following Visakha Bucha Day, water is sprinkled onto the Buddha's hair relic. At one point, we tapped a vast ceremonial gong at Wat Doi Kham. The sound of this massive gong—which I recorded on my phone—had a depth and resonance that stirred the very spirits of the mountain. The overall atmosphere at this time in the morning was extremely dreamy and completely sublime. The experience of visiting this profoundly magickal place left me feeling energized and filled to the brim with a deep swell of internal calm and inner tranquility, despite my lower left calf muscle trapped in a tightly clenched, painful spasm. Such is the cost of not physically warming up before attempting to hike a stiff gradient in an early morning chill.

After our trip to Wat Doi Kham, we went to visit Ajarn Suea. I was to receive one of his legendary Serm Duang cleansing baths, and had packed a towel and bathing trunks in anticipation. As I entered Ajarn Suea's Samnak I had the feeling that this would be an extraordinary meeting. I bowed to him, and he acknowledged my presence. In the two previous meetings we had established a rapport, and by this time, I felt very comfortable and held considerable admiration and love for him. Glancing around his glass presentation cabinets three amulets jumped out at me, their power and beauty demanding my attention and eventual purchase. These scorpion, centipede, and ouroboros animist amulets vibrated an immense energy that was undeniable. I marveled once again at Ajarn's craftmanship, skill, and ability at creating such incredible magickal amulets that have a life and potency that are difficult to beat. My heart swelled. I was intoxicated by these treasures, elated to have such sacred items in my possession.

After acquiring the amulets, I changed into my bathing trunks inside his bathroom. I then went outside to the chair that awaited me, the one in which I would receive one of Ajarn's legendary Serm Duang cleansing baths, a shocking and powerfully revitalizing ritual that would reset me for the next part of my visit with Ajarn Suea, one that would ultimately blow my mind. Ajarn Suea, as was his technique, asked me to sit down next to him with my right arm facing him so that he could feel the upper arm carefully and methodically. What came from Ajarn Suea next almost knocked me off my feet. He said: "You have been able to have precognitive insights throughout your life have you not? You have known when things would happen, and their outcomes haven't you?"

Ronnie looked at me with a stunned face as I replied, "Yes, Ajarn. I have."

"You have had a Guardian Angel guiding and helping you through-

out your life. They have taught and guided you all that they can, and they will now move on. It is important that you give tamboon to them. I will perform a Satuang Ritual for you. You will need twenty-one fish to empty into the river in order to give thanks to them," Ajarn Suea said.

I was stunned, and sat in a state of shock at what he had just said to me. The ritual would need to take place on Friday evening on the tenth of January, which would be during a full Wolf Moon. I couldn't get my head around the logistics of buying twenty-one fish (in this case, twenty-one very muscular catfish) and then transporting them to Ajarn Suea's Samnak for the ritual to take place. To my relief, Ronnie seemed clued in. He told me it would be fine; he not only knew where we could buy the fish but also how to transport the newly acquired shoal.

The next thing that Ajarn Suea said would be something that would change my life forever. Ajarn Suea closed his eyes and appeared to go into a trance state. Then, in a slow and dreamy voice, he said: "I have seen you with a Sak Yant. You must have the three-lined Yant Soi Sangwan on your chest." As with everything that had come from Ajarn Suea's mouth at each of our three meetings, this was not what I expected to hear. I was dumbfounded, and felt a quiet but restrained panic rising inside me. I knew from the start that a chest Sak Yant would be—at the very least—an extremely painful and considerable ordeal to endure, as all Sak Yant invariably are. I even imagined myself passing out during the ritual. *Yant Soi Sangwan* (or Soy Sung Warn—I have seen various spellings) roughly translated, means "necklace." Yant Soi Sangwan is said to have many functionalities the main one begin invincibility. This particular Sak Yant is of an ancient design. Warriors and fighters across time in Southern Asia—right up to and including the Muay Thai fighters—wear this Sak Yant. Usually tattooed along the upper chest, this Sak Yant dips down, mirrors the pathway of the clavicle bone, and meets at the center of the sternum.

Often selected by mixed martial artist fighters for its ability to make them feel invincible without indulging in the urge to completely destroy their opponents in any given match, this particular Sak Yant is a good choice for a fighter who finds themselves getting overtly or emotionally carried away during fights and wishes to remain in total control of their rage and violence, able to show mercy to a defeated fighter when needed. It is believed that no weapon can harm, puncture, or hurt the body, so long as the bearer of this Sak Yant upholds the Five Precepts.

Ajarn Suea himself had an eight-lined Soi Sangwan upon his chest which was a marvel to behold. I myself was now tasked with obtaining a three-lined Soi Sangwan, each line of which has its own very specific meaning as follows:

1. A virtue of great mercy
2. Great power and prestige
3. Invincibility and being able to avoid all danger

Ajarn Suea's eight lined Soi Sangwan relates to greater protection, higher attainment, and wider functionality of magick. There is a phenomenon that has been observed when corpses with Sak Yant upon them have been dug up for relocation. On the areas of skin that have Sak Yant upon them no signs of decomposition have seemingly occurred. Here the protective power of Sak Yant are given the special designation of *Mai Nao* meaning "*does not rot.*" It is important to understand that the seemingly mixed and compartmentalized influences informing Sak Yant are by no means separately walled off areas of animism, Hinduism, and Buddhism. These sacred symbols are essentially short Buddhist formulas, some of which are possibly of Hindu origin, but always act in a harmonious combination. Some aficionados say that having Sak Yant done by a tattoo gun is a bad thing to do as it can bring misfortune upon both the Ajarn and the

The Third Pilgrimage 171

devotee. Intuitively, I feel this is not accurate. Both the rod and gun are acceptable methods of application. What is of paramount importance and completely critical to this ritual is that the person applying the Sak Yant is firstly a fully trained authentic master in possession of an entire lineage of knowledge behind them and secondly that it is performed in a consecrated space. While I have undergone Sak Yant there were sublime unspeakable moments in which I could see the many hands of various past masters, all within a single hand holding the Sak Yant rod. One after the other, these hands formed an unbroken line of wisdom and spiritual transference of the teachings, all of them present in the now of doing. There are of course thousands of versions and adaptations of Sak Yant designs with equally as many countless interpretations of them. It is safe to say however that the inked lines drawn within the architecture of Yantra designs ultimately represent the very umbilical cord of the Buddha and are traditionally known as "The Bones of the Yant".

An authentic master will have many books, designs, and paper templates with numerous variants and countless designs. As mentioned earlier, Ajarn Daeng has been known to use a bespoke tattoo gun made to suit his purposes. A revered master of Sak Yant (recently given the honorific "master of masters"), many devotees, monks, and monasteries come to him for his designs and beautiful, exquisite work. With his kind and pure light filling the room, each time I've gone to him, it's been a humbling experience, and I've had nothing but good experiences with him.

Ajarn Daeng (or indeed *any* Ajarn) would not apply Sak Yant if anyone entering their Samnak was dirty, drunk, or behaving erratically. Breaking the guidelines or the Rules of Sak Yant as dicussed in the first chapter would necessitate the devotee returning to the Ajarn's Samnak, which authored the Sak Yant, making an offering, and then being bathed in Sompoi to clear the Yants of any accumulated defilements. Chanting Namô Tassa Bhagavatô Arahatô

172 *The Third Pilgrimage*

Sammâ-Sambuddhassa (*Namô*—"I pay homage;" *Tassa*—"to him;" *Bhagavatô*—"to the Exalted One;" *Arahatô*—"to The Worthy One;" *Sammâ-Sambuddhassa*—"to The Fully Enlightened One") three times is also seen as a potent way of cleansing any defilements. These defilements can appear in numerous—and what could be seen by non-practitioners as bizarre and highly superstitious—forms such as: spitting in the toilet bowl, eating at a funeral, eating left over or praised food, or breaking any one of the Five Buddhist Precepts. "Not spitting into a toilet bowl" was a surprise for me, but then, when I caught myself just about to do it once, I realized that it was something that I must have been doing long before my immersion into this philosophy. Now, I no longer do it, and strangely, I have found there does seem to be a benefit in my cessation of such a habit.

One important thing to remember is that Sak Yant have got to be applied inside an actual Samnak. While I understand that Ajarns may travel abroad, see many devotees, and set up their working space in a variety of places that they then consecrate in order to conduct their work, my personal feeling is that the Samnak cannot be completely replicated. Its precise physical, geographical location—imbued with the energy of land and air spirits—is the very thing that gives them their power. In *Language and Power: Exploring Political Cultures in Indonesia*, Benedict Anderson describes the potency of cosmic energy in divine places, seemingly rich with hidden spirits:

Power is that intangible, mysterious, and divine energy which animates the universe. It is manifest in every aspect of the natural world, in stones, trees, clouds, and fire, but is expressed quintessentially in the central mystery of life, the process of generation and regeneration. In Javanese traditional thinking there is no sharp division between organic and inorganic matter, for everything is sustained by the same invisible power.

The Samnak is akin to a temple and it is to be seen as sacred, holy, and consecrated ground. Traveling to Thailand and actually being there with the Ajarn inside his Samnak is an experience rich in spiritual depth, import and feeling, all tied with an authentic significant meaningfulness. It simply cannot be casually replicated elsewhere. The pilgrimage itself is significant, as the entire process of traveling to a sacred space in another part of the world has its own very definite and specific flavor. This significance should be a significant consideration to anyone thinking about approaching an Ajarn, whether for a ritual, guidance, amulets, or any form of Sak Yant. Questions to ask yourself are: Are you prepared to leave your safety zone, and travel great distances to acquire the magick you seek? Are you prepared to put yourself into possible danger? The profound ritual of Sak Yant is ultimately a holy act executed on holy ground undertaken by a master who is a representative of the faith. If you commit yourself to the spiritual, physical, and sometimes difficult and uncomfortable process of making such a pilgrimage, the encounter—no matter what affiliation you do or do not hold—will be a life-changing and permanent experience.

Fortunately for me I had invested in a fine piece of magickal technology, one created by Ajarn Apichai. The Gan Suam Takrut is made from a very thick plate of lead inscribed on both sides with Yants, namely the Yant Song Tripot and Yant Gaa Sathorn. It also contains an attribute called Gan Suam that directly prevents loss of magick from any Sak Yant and amulets. The Takrut also assists in reflecting bad luck, curses, and black magick back to the person who sent it. When I first put the Takrut close to my skin I felt a strong wave of expansion in my consciousness, which leads me to believe that this oil-soaked Takrut may be psychoactive. I now carry it in my pocket inside a custom-made velvet bag. Having this remarkable form of protection on my person at all times is one of the many aspects that I love about Thai occulture and the extraordinary beliefs surrounding Sak Yant, which have got to be applied inside a Samnak.

15

The Ouroboros Effect

Muang On Caves and the Hair of the Buddha

Leaving Ajarn Suea's Samnak, I left a dizzying array of feelings, and I wondered how I would manage to process all of what I was experiencing. I now carried with me three incredible amulets that each had their own power, strength, and functionality:

1. The Scorpion amulet, which has the power of authority (Maha Amnat). Scorpions in Thailand are a source of food and cannot be killed intentionally for use in amulets. The deaths of scorpions used in amulets must be accidental and completely unintentional.

2. The Centipede amulet, which has the power of both black and white magick, and can protect against evil spirits and any form of spiritual attack. The Thai ethnic group called the Mon people, who originate from Southern Burma, hang centipede flags during the Swan and Centipede Festival. Thirty provinces around Thailand have Mon communities, including the the Samut Sakhon Province, the Phra Phradaeng District of Samut Prakan, and the Pak Kret district in Nonthaburi. The centipede is a symbol of the Buddhist faith and moral precepts,

comparable to the proportions of the various organs of the centipede, with the claws signifiying that Mon people will never fear their enemies.

3. The Ouroboros (a snake eating itself) amulet gives its owner the power of evasion from dangers, good fortune, and good business luck through the recycling of energy. Ajarn Suea used a rare wicha to create it, which enabled its wearer to experience a renewal of new energy and new opportunities every day. This renewal process and recycling of energy is best described by Carl Jung, in his *Collected Works, Vol. 14: Mysterium Coniunctionis*, who said of The Ouroboros:

The Ouroboros has been said to have a meaning of infinity or wholeness. In the age-old image of the Ouroboros lies the thought of devouring oneself and turning oneself into a circulatory process, for it was clear to the more astute alchemists that the Prima Materia of the art was man himself. The Ouroboros is a dramatic symbol for the integration and assimilation of the opposite, i.e. of the shadow. This "feed-back" process is at the same time a symbol of immortality, since it is said of the Ouroboros that he slays himself and brings himself to life, fertilizes himself and gives birth to himself.

The ouroboros entered Western tradition via ancient Greek and Egyptian magickal traditions. In the "Aitareya Brahmana," a Vedic text of the early first millennium BCE, the nature of the Vedic rituals is compared to "a snake biting its own tail," while the medieval *Yogakundalini Upanishad* describes this energy signified by this image as "divine power, Kundalini, which shines like the stem of a young lotus; like a snake, coiled round upon herself she holds her tail in her mouth and lies resting half asleep as the base of the body."

176 *The Ouroboros Effect*

After a much-needed coffee break in a beautifully air-conditioned café, we then traveled to Chiang Mai, to visit the Samnak of Ajarn Apichai. Ajarn Apichai had moved from Phitsanulok to reestablish his Samnak in Chiang Mai, a city which—with over three hundred Buddhist temples located in its environs—is considered to be a major center for Ajarns. It made perfect sense therefore that Ajarn Apichai should be here. Ajarn Apichai requested a very specific Sak Yant for me. I went up a flight of wooden stairs to an apartment space on the first floor of a building which had a wooden-floor-effect linoleum. I was to receive the Khun Paen Khrong Muang Yant (Khun Paen Rules the Land and City Yant), which comes from the knowledge of Luang Pu Suk, one of Thailand's most legendary ancient guru monks.

Widely accepted as an Accomplished Grandmaster of Wicha (magickal knowledge) and Saiyasart (dark occult knowledge and the science of influencing life through unnatural and supernatural forces), one of Luang Pu Suk's supernatural powers and psychic attainments (*abhiññā*) was the ability to change the shapes and sizes of objects from one life-form to another. The Gan Suam Yant and Gan Kom Yant, which were applied either side of the Khun Paen Khrong Muang Yant, both wield incredible magickal weight and power. The numerical value of the number three appears throughout designs of Sak Yant tattoos. This represents The Three Jewels of Refuge, that being Buddha, Dharma (the teachings), and Sangha (the Buddhist community) along with the Three Higher trainings of morality, concentration, and wisdom. These last three Sak Yants Ajarn Apichai insisted that he give to me specifically because they were his Yant Kru, which means that they are his Master Yants or central controlling trademark yants. This is regarded as a very powerful Sak Yant to have from any Ajarn and will protect you in many unseen ways. By having an Ajarn's Yant Kru you show respect to the master that has bestowed it, and you become a disciple of that master. The execution of these Sak Yant were quick, detailed, and almost without any pain whatsoever since they were along

the upper back thus there being sufficient flesh for the designs to be popped onto. As he dispatched the Yant Kru, Ajarn Apichai's samādhi was total and complete. *Samādhi*—means "calmness" or "stability of heart". The book *Forest Dhamma: A Selection of Talks on Buddhist Practice* by Ajaan Maha Boowa Ñanasampanno describes three different kinds of samādhi:

1. Khaṇika Samādhi—in which the heart becomes unwaveringly fixed and calm for a short time after which it withdraws.
2. Upacāra Samādhi—which the Lord Buddha said is almost the same as, but lasts longer than, Khaṇika Samādhi, after which the Citta (mind) withdraws from this state.
3. Appaṇā Samādhi—a samādhi that is subtle, firm, unwavering, in which one can remain concentrated for a long time. One may choose to remain concentrated in this state or may withdraw from it as they wish.

Although my time spent at Ajarn Apichai's Samnak was only an hour or so, I felt, once again, that time had somehow dilated and shifted. At the end of the session, I posed for the obligatory photo with Ajarn Apichai. In it, we both looked happy and pleased, my eyes only just slightly hooded due to the heavy jet lag that was now gently kicking in my brain.

After another deep and replenishing sleep, I woke up Thursday the ninth of January to what would be essentially a gentle day with a fascinating interlude of ordeal and danger. Meeting Ronnie at my hotel, we drove off and proceeded to a shopping mall called Promenada Chiang Mai for lunch at a cool Japanese eatery. The main reason Ronnie brought me here was to observe a huge hive that bees had managed to establish

outside a picturesque window overlooking the city. It hung precariously on an anti-pigeon spiked beam hanging down by at least six feet in size. I saw this as a metaphor of our lives, Ronnie living in Thailand and myself caring full-time for a disabled elderly mother, somehow existing in the most impermanent of situations and yet still managing to dwell so far without falling into oblivion.

The plan for today was to visit a set of limestone, stalactite-filled caves deep inside a hill within the temple of Wat Tham Muang On. The Tham Muang On Caves (or just Muang On Caves) are located in the district of San Kamphaeng, about ninety minutes (by car) from Chiang Mai. The caves are reputed to have been visited by the Buddha and his disciple for three days and three nights, and as such, objects connected to this are treated with the utmost sanctity. This includes a stalagmite in the caves, which is said to contain a hair from the Buddha. The stalagmite is fenced off, with a monk's robe placed around its circumference. (See color plate 4.)

Since access to the caves at Tham Muang On is dangerous (sometimes even fatal), caution and good judgment must be used by anyone hoping to plumb their depths. Located deep inside a mountain, the Muang On are less of a cave, and more an ancient, downward eroded cavity. After a drive up a mountain forest pass road, we arrived at a small area with ample parking, a gift shop, and a café. After being greeted by a copious amount of monkeys begging for food in the parking lot, we were faced with the task of navigating a crazy stairway, one longer, steeper, and more winding than even the Nāga serpent stairway at Wat Doi Kham. After making various pleasing stops at charming and beautiful shrines up along the ascending stairway (I strongly recommend doing this as I believe it to be integral to the devotional act of visiting this sacred site) we finally made it to the top. There, we approached the entrance, located in a small area carved out of the side of the mountain. There stood an innocuous green painted doorway leading into the caves.

The Ouroboros Effect 179

As soon as we entered, we were faced with what can only be called an ordeal, not for the vertiginously faint-hearted, heart troubled, unhealthy, poorly foot-shod, or chronically ill. My own sense of balance and discipline was sorely challenged. The gradient is radical and frightening, and the stairway down is as close to resembling a straight down ladder as one can get. At first, I stood there puzzled. I thought that perhaps it was some kind of access point, meant for maintenance contractors only. Not so. This was, indeed, the main public entrance! I couldn't imagine for one moment anything like this being allowed to remain open in the United Kingdom. In fact, if you tried to establish a set of caves like these as a tourist attraction there, the health and safety officers would—without pause or provocation—shut it down immediately. This wild, crazy, and almost insane location was supported only by the bare minimum of modern facilities and safety observances.

I slowly traversed down the vertical concrete and thick chrome banister stairs that led deep down into the caves. An outcrop of solid rock bowed sharply and loomed down upon me as I descended, backside first, down each and every single stair for at least fifty feet or so. Just beside the vertical stairway, I could see the original method of entering these caves—broken and rotten original ladders now abandoned. I was stunned. I had never in all of my life gone down such an insane stairway. Ronnie was waiting for me on the first landing point. He gestured to me to let me know he was going to go forward into the first chamber. I gestured back. Finally, after what seemed like an eternity, I met up with Ronnie and we walked through the first chamber. On each side of the first cave there were sporadic gatherings and clusters of numerous small statues, strange stone arrangements, and mini shrines of surreal stone god deities that had taken up residency in the caves.

Coming to the end of the first chamber another bizarre and surreal sight met me. A Buddha fortune-telling machine with a sundial light bulb wheel and a Buddha inside the middle, plugged into the wall of the cave. This perplexed me greatly. How on earth had anyone managed

180 *The Ouroboros Effect*

to drag this machine down into this most chthonic of realms? And how was it being powered? I followed the instructions, put in some money, and waited. A Thai voice chanted, pinging bells rang out. This was followed by circular, multicolored lights circling around the clock face, finally resting on the number seven. On the wooden shelf next to the machine, a piece of paper with the number seven was spat out. The fortune on it was in Thai, Chinese, and English and read as follows:

Though misery is through, your family and comrades are all happy, but you yourself still feel uneasy. Merit making and alms giving will fulfil you. Don't be greedy, if you grasp all, you'll lose all. Be patient, like an archaism (I imagine they meant to have said "ancient" at this point) said that after planting a tree, you have to wait a while for its fruit. You'll have good fortune and find your lost treasure. Asking of a spouse, you're likely to find a good one. For you who are sick will get better. For other matters, all seems to be good too.

After all the struggle I had endured to get to this place, I found this news heartening. Indeed, there had been a history of considerable "misery" in my family. Ronnie and I pushed on to the next set of stairs down into the final chamber where a collection of astounding statues resided. As I noted earlier, it is written that Muang On caves have a hair relic of the Buddha inside. This particular area is called Phra That Nom Pha. It is believed that the hair relic is embedded into a limestone itself, in the form of a stalagmite, which is unusual considering how most Buddha's relics are usually held in chedis across Thailand.

The second chamber floor had an impressive array of features; the huge stalagmite dressed in robes, a ten-meter reclining dressed Buddha and seated dressed Buddha called Pang Samathi and Pang Sai Yad (respectively), and a large, fossilized dinosaur skeleton. (See Plate 4 in the color insert.) This cave was once the meditation place of Khruba Siwichai, a Thai monk of considerable renown. Born on the eleventh

of June 1895, in Ban Pang, Li District, Lamphun Province, he had great reverence toward the science of magick and spells, and gained a reputation for his asceticism, charisma, and rebellious personality. He became the abbot of Wat Ban Pang after the former abbot, Khruba Khattiya, passed away.

The atmosphere of these caves was immense; one can imagine reaching fathoms deep into yourself while meditating in this vast chasm of underground delights. The silence, as with all sacred places, is voluminously unending and tectonically robust. Inside this solid church of rock and stone, silence is most definitely required; indeed it is the only way to absorb—as if through osmosis—the mountain spirits who reside here. When I entered this magnificent cave system, I was plunged immediately into a dream pool of darkness, twilight, and rich history. Leaving is another matter altogether. Reversing direction, returning upward through the aircraft hangar–sized grottos of phantasmagorical sculptures, and climbing up the long and seemingly unending tunnel toward the light at the beginning—with spirits and all manner of ghosts rushing through you up and up, into the broad daylight of the dense, sweltering subtropical forest above—one is literally reborn.

Finally outside the cave, the forest began to rain down an avalanche of dried brown leaves. They made a crackling sound, punctuated by the occasional whoop of a monkey sounding off. As I looked down at the steep forest hill of thick vegetation while bathing in the high-pitched muggy ambience of insects, I wondered how monks must have felt upon exiting the confines of the caves to experience the outside for the first time in months, maybe even years. I was soon however to experience a small but hauntingly pertinent incident that would etch this profound experience of rebirth into my mind.

When Ronnie and I drove away from our visit to the caves, he turned on the car stereo to play some music. He had a wide selection of musical tastes, reflected by a vast library of music that contained a variety of different genres. And yet, when he turned on his car stereo,

the first song to play randomly was a track by Coil called "Everything Keeps Dissolving." "It's strange but I haven't heard this is in quite a while," Ronnie remarked. As a deep drone emanated from the speakers, I clearly remember a feeling of awe and surprise. The track filled up the car with its immense vibrations as I remembered Coil and their music once again.

I took a photograph of the player as the track played. I felt, quite vividly, the presence of Peter Christopherson's spirit with us there inside the car at that very moment. As the track played on, I became increasingly aware of what could only be referred to as a melting away of boundaries. I felt a divine emptiness swallowing whole everything that could have or used to be the "me" I had always considered myself to be. It felt like the old me was vaporizing, dissolving into the humid, intense, and subtropical heat of the jungles of northern Thailand. This slow labyrinthine unfolding pathway I had traveled ever since I first heard "The Wheel," the song that had sealed the deal on my interests in Buddhism, right through to this moment inside the car, which told me that—as John had sung so long ago in my speakers—the wheel had indeed been turning, and would continue to do so, without end, as I slowly but surely continued my climb up the cosmic gradient of this endless and panoramic helix called Coil.

Friday the tenth of January 2020 dawned, the day that would mark my final initiation not only into the cult of Mae Surasatee by Ajarn Nanting, but the undertaking of the Satuang ritual by Ajarn Suea. In the first case, I was to receive two Mae Surasatee Sak Yants and, thanks to Ajarn Nanting's kindness, acquire a rare and sacred bucha of Mae Surasatee herself. In the second, I would liberate twenty-one sentient beings (in this specific case, catfish acquired from the local wet market) in order to give tamboon—the act of making merit or giving through

offerings and kindness to my Guardian Spirit—during the full Wolf Moon. For some reason, I felt that these rituals would be major points in my life. I knew that the Satuang ritual was very important. Ajarn Suea stated that up to this point the spirit had given me flashes of prophecy throughout my life and now they had taught me all that they could offer before moving on to another soul to guide.

Throughout my life there had indeed been countless inexplicable (and what one might call esoteric) experiences relating to otherness that had led me to this point. I now work and commune with over thirty to forty spirit entities. My kind, loyal, and long-standing Guardian Spirit was now leaving the party with a full room. It was time to say goodbye and honor them.

Our plan was to acquire the catfish, travel to Ajarn Suea's Samnak, and, after finding a location to deposit the catfish, travel to Ajarn Nanting's Samnak for the Sak Yants. We would then return to Ajarn Suea's for the Satuang ritual. I felt a sense of trepidation as we commenced on the first part of our extraordinary day. I knew inside that something remarkable and once in a lifetime was about to happen.

The business of buying twenty-one catfish is not easy or without incident. At the time I was completely unaware of the impending viral holocaust that had recently exploded next door in China, and the simple idea of going into a Thai wet market did not engender in me any feelings of danger or unseen calamity. At 12:25 p.m. Ronnie finally found a local market. Thai markets can be a wild and somewhat shocking affair; I was not prepared for what I encountered there: frogs, fish, and numerous varieties of living creatures all writhing and thrashing together in a hubbub of animal agitation. As someone prone to waves of extreme empathy, I found the combination of the sound of animal chaos, human interaction, and Thai music piped into the hustle and bustle unnerving. We paid 530 baht (roughly £13 GBP) and the twenty-one slippery catfish were placed into two large plastic bags filled with water. As Ronnie and I hurriedly walked to the car, on our way to quietly liberating these

beautiful, elegant fish from their inevitable deaths, my arms strained carrying the weight of the two writhing plastic bulbs of energy. I felt humbled. I sat down into the passenger seat, and gently placed the two bags by my feet, where they remained at arm's length for the duration of the journey to Ajarn Suea's Samnak. Catfish are long, solid, pounding beasts of hardened muscle. I couldn't help but notice and admire their backbones, a true marvel. According to a study conducted in Japan, catfish can predict strong earthquakes. This comes as no surprise. The energy released by these extraordinary creatures is considerable.

When we arrived at Ajarn Suea's Samnak the fun and frolics began. As we looked around his property for an appropriate receptacle in which to hold the twenty-one catfish, a series of embarrassing, comedic scenes ensued. Like rabid Olympic-trained salmon leaping upstream, two catfish, first one and then another, launched themselves up and out of the large black plastic bucket we had found at the back of Ajarn Suea's home. Off went the first catfish, jerking itself down the pathway toward the road. I managed to grab the writhing creature and put it back into the big black bucket. Then, off went the second catfish. It wriggled down the pathway and toward the road before it too was apprehended. Finally, we managed to find a lid for the big black bucket and put an end to this embarrassing escapade. Fortunately, Ajarn Suea was not present and did not witness this spectacle. He had told Ronnie that, astrologically speaking, the best timing for this ritual was around six o'clock in the evening, which left a nice window of time to complete the next part of the day's itinerary.

In the searing heat, we pulled up to Ajarn Nanting's compound. There in his garden I could see a variety of magickal plants, with one in particular catching my eye. A distant relative of ginger, and a member of the amomum family of zingiberaceae, Waan Sao Long is known as *Amomum biflorum* in the West. Many of this family's species are important ornamental, spice, or medicinal plants. It was first described in the West by William Jack, a noted Scottish botanist and medical

practitioner. In 1818 Jack accompanied Stamford Raffles—a British statesman best known for his founding of Singapore and the British Malaya—to Sumatra, where Jack extensively documented the rich flora of that region until his death in 1822. *Amomum biflorum* is on the International Union for Conservation of Nature Red List of Threatened Species. Apart from being good for the heart and general blood circulation it is also thought to bring good fortune and strong attraction in Thai society. The perceived health benefits include: improved blood circulation, reduction of muscle tension and body aches, relief of numbness and inflammation of muscles and tendons. It has a unique and very uplifting aroma.

We approached the shrine to the Burmese deity Mae Surasatee and gave our obeisance by bowing—first flat onto our stomachs, then onto our hands and knees—to this beautiful and magnificent shrine. In Thailand, one must honor shrines in the proper manner, with the utmost attention to detail. One hair out of place could start an incident. Much like being in a church, certain behavior protocols are not only expected, they are demanded upon pain of death. I learned this the hard way. I say this because Ajarn Nanting, a sorcerer and realized master of Tiger magick, has the abilities and characteristics of a tiger. His stealth and mastery are a terrible and horrible thing to be on the wrong side of. This supreme master does not suffer fools gladly and I have made note of countless times when his fury and rage have been meted out to those souls who have unfortunately crossed his razor-pawed clutches.

During some casual research between my first and second pilgrimages I noted that the Indian deity Saraswati, the Hindu goddess of knowledge, music, art, speech, wisdom, and learning who is one of the Tridevi, along with the goddesses Lakshmi and Parvati, had a passing but very noticeable resemblance to Mae Surasatee. I studied these two sublime deities carefully and saw that Saraswati rode a white swan. Mae Surasatee also rides a white swan though in Burma this vehicle becomes a duck. I noted my observation in—what I thought was—an

innocuous Facebook post. Unfortunately for me, when Ajarn Nanting saw this post and immediately unfriended me, I realized I had made yet another faux pas. In a deeply concerned panic, I messaged Ronnie. I couldn't understand what on earth I had done to provoke Ajarn Nanting's ire, causing him to disconnect from me in this abrupt manner. After some considerable effort, Ronnie managed to calm down this storm in a tea cup with a dilopmatic personal message stating I was not being deliberately disrespectful to Mae Surasatee. I then sent another friend request to Ajarn Nanting once again in which he finally accepted.

Ronnie couldn't explain to me what had happened. After much consideration, my mistake became apparent: in openly noting the similarities between Saraswati and Mae Surasatee, I had unintentionally denied their indviduality, and thus their unique, respective powers. It is critical to understand that no sense of comparison or similarity be made between any deities in Asian belief systems whatsoever. I learned that each and every single form of god, goddess, or avatar must be categorically accepted on its own terms, without any censure or discrimination. Although I could see for myself the similarities between Saraswati and Mae Surasatee, my public declaration of such is what had caused offense. You are meant to adopt a humble attitude and accept teaching from an Ajarn in an open-hearted manner. A foreigner (a farang) displaying understanding of this level could easily be viewed by an Ajarn as being impertinent.

Upon entering Ajarn Nanting's Samnak we were greeted by the jocular and happily seated visage of the Tiger Master. He sat near his three-tiered shrine, the first tier composed of photographs of monks and masters, the second an array of Buddhas, and the third several Burmese Buddhist Weizza, including Bo Min Gaung, Bodaw Setkyar Min, and Bo Bo Aung followed up by a group of Tiger-Faced Lersi. In Burmese Buddhism, a Weizza is an immortal and supernatural mystic associated with esoteric and occult practices such as the recitation of mantras, practice of all forms of samādhi, engagement with mysticism,

and the undertaking of works in alchemy and rituals. The goal of this practice is to achieve immortality and the state of the Weizza, who awaits the appearance of the future Buddha, Metteya.

After removing our shoes we approached Ajarn Nanting and gave him the wai to show our respect. Facing a master such as this requires sincerity and respect. Because an Ajarn—who has X-ray vision on every conceivable level—is able to detect any trace of ego or personal presumptuousness, in order to meet one face to face, one's heart must be pure, without any hint of negative emotions that might indicate an agenda of any kind. This is because in order to indulge any thoughts of a pilgrimage, one's intentions must be pure. Although there were points during my process of consecutive pilgrimages in which I felt myself nearly go mad, it was not because I had an agenda or had some long-term plan to acquire power or gain some kind of edge over anyone.

Thai Lanna Buddhism is not like any other form of Buddhism I had encountered up to this point. The underlying impulse that had compelled me to make my three pilgrimages thus far was pure; I merely wished to submerge and embed myself meaningfully into a philosophical system, one that had resonated deep inside me—to a more or lesser degree—throughout my entire life. This edge of madness had visited me multiple times. It had come when the spirit of an arahant monk spoke to me from the other realm to voice their opinion of my conduct so far. It had come when a ferocious fireball created by a magician burst upon me while I hid under a cloth that had once been wrapped around a corpse. It had come when the repeated hammering of the Sak Yant rod delivered pain of such unimaginable levels that I wished I was dead. It had come when each and every ritual, cleansing, and personal revelation and realization stripped away yet another encrusted layer of my labyrinthian psyche. And I am not the only one.

188 *The Ouroboros Effect*

Over social media, I once chatted to an intelligent bilingual young man about his travels to Thailand to meet the Ajarns. He hailed from Nottingham and was candid about the mental suffering he had experienced. He candidly admitted he had experienced something akin to a complete nervous breakdown while pursuing his spiritual quest in Thailand. Even his firm grasp of the Thai language was not enough to shield him from the ravages of psychic bombardment one must endure during such an esoteric and challenging undertaking. As a person diagnosed with autism who suffers from PTSD, I empathized with him. His admission of anguish only stirred in me admiration of the great courage he possessed in undertaking his pilgrimage. I gently encouraged him to stay firm in his belief while staying as grounded as possible. His experience is yet another reminder that ritualistic ordeals such as these are not to be approached in a flippant or gauche manner.

Indeed, as I now faced Ajarn Nanting for the third (and possibly final) time, I was able to recognize that it was my own personal contemplation and years of practice that had brought me to this very point. Nothing and nobody—not even the odd body-shaming comment Ronnie doled out—would ever deter or shake me from the pathway of what I believed to be my final and eschatonic pilgrimage.

16
The Cult of Mae Surasatee

*In Praise of Twenty-One
Catfish and All Sentient Life*

As I sat cross-legged, facing the Samnak's open linoleum space in the humid, afternoon subtropical heat, Ajarn Nanting pummeled my left and right shoulders with the Sak Yant rod. His careful application of the Mae Surasatee template was followed by the mixing of ink and the chanting of mantras. The experience was electric and intense, identical to the first time I had surrendered to Ajarn Nanting's rod. With each and every single Sak Yant point—fish egg, fish egg, fish egg, fish egg, fish egg—the rod tip hit each one of its marks and the ancient and minimalist design of Mae Surasatee slowly materialized, her shape magically transpiring on the blades of each of my shoulders. Mirrored and elegant, with both movement and stillness, complementary to each other, each bestowing enchantment and good fortune, these ancient, symmetrical designs reflect numerous qualities that work together in tandem as a pair.

Ajarn Nanting followed his application of these Sak Yants with a blessing beneath a sacred cloth the color of deep red, rich with diagrams, symbols, and images dedicated to Mae Surasatee. Then a rather ornate and beautifully red initiation skull hat was placed on top of my

head, over the cloth. One of a kind headwear, the hat was adorned with red sequins and gold-trimmed lining, and featured a design resembling dragon's scales. Although much shorter and more highly decorated, it vaguely resembled Tibetan Lama Buddhist headwear. Elated, joyful, and in bliss, I felt as though I was gliding. A warm wave of feeling emanated throughout the room. It was as if a myriad of spirits and unseen presences were pleased and excited at the result.

Ronnie took photos throughout the process, and we all sat together as I composed myself after the ritual. Ajarn Nanting and Ronnie then had a conversation in Thai with each other. I could not understand what was being said. Ronnie partly translated. Ronnie said that it had been some time since Ajarn had done Sak Yant and that the experience had been just as pleasurable for him, to be back in the saddle so to speak. I smiled at Ajarn as he spoke about the process, filled with passion and love. At one point I recall Ajarn describing the action of using the Sak Yant rod: *"Pom! Pom! Pom! Pom! Pom! Pom! Pom! Pom! Pom! Pom! Pom! Pom!"* With each *"pom!"* I felt the puncture of the rod.

I now had the Sak Yant of a deity with whom I had become obsessed, possessed, and completely enamored with on all possible levels over the last three remarkable years. Looking back on this time I now see that I was in a state of madness that could be seen as both devotional and illogical. Frederick M. Smith describes this state in *The Self Possessed: Deity and Spirit Possession in South Asian Literature and Civilization* as an "exalted state of devotion," one that "retains an experiential component generally considered absent from the experience of samādhi. In the devotional experience of āveśa the experiencer is fully immersed in his or her beloved deity, yet still retains a relationship with that deity. This sense of separateness within immersion represents the paradox of āveśa as a devotional state."

I was fixated and somewhat possessed. As if on a mission, I knew I needed to acquire a bucha (a sacred statue with active magickal ingredients though this term does also initially mean "to praise or worship")

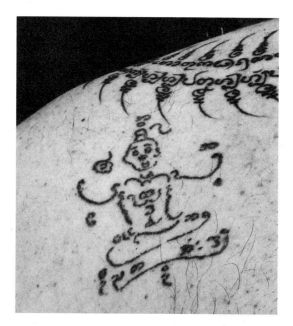

Top, Mae Surasatee Sak Yant by Ajarn Nanting on my left shoulder.
An identical Sak Yant appears on my right side.
Bottom, Mae Surasatee statue by Ajarn Nanting.

of Mae Surasatee. Ronnie and I had originally planned to drive to Mae Sot, a city on the Thailand and Myanmar border, to acquire the said bucha and to visit some very old shops that might yield some hidden treasures. But when it came down to it, I realized my budget had been depleted and would not allow me to complete this planned excursion. In what can only be called a serendipitous coincidence, I saw, underneath a glass case, on offer alongside other incredible amulets, perfumes, and a substance called See Pung (a form of enchanted magickal beeswax) that Ajarn Nanting had a Maai Panoo Mae Surasatee bucha, a small but extremely beautiful wooden and gold leaf–covered bucha to Mae Surasatee.

This bucha was a rare treasure indeed. It had been blessed many times by various Ajarns and venerated masters, including Kruba Pornsit, under whom Ajarn Nanting had served as a Luksit. Kruba Pornsit was one of the most important monks of the Serp Dtamnan, an organization born to preserve and keep alive the most ancient magickal practices of the Lanna people, to prevent them from being lost in time. A legendary master in possession of incredible abilities, including the ability to phase in and out of visibility using an ancient and rare wicha, it has been reported that while looking upon Kruba Pornsit his physical visage went fuzzy and faded, as if phasing in and out of focus. I am proud to have a beautiful Tiger Faced Lersi amulet from Kruba Pornsit.

The bucha was gently taken out of the glass case and when I held it in my hands, emotion welled up from deep inside of me and I very nearly cried. Mae Surasatee's countenance glowed and shone like the sun. The golden swan upon which she rode and the exquisite motifs that adorned this highly magnetic artifact swallowed me whole. I placed the requested sum into a donation bowl and commenced worshipping at Ajarn Nanting's shrine. The bucha had been created by Phra Ajarn, trained in the regional Tai Yai magick, the very same Tai Yai monk that had crafted Ajarn Nanting's Mae Surasatee. With only two versions in existence, this bucha was rare. On the back of the bucha was

a black lacquer (which contains herbs for great fortune) which appears to be eating the gold, which in the magick of the region means it will constantly give back to the owner. Each piece of the bucha was crafted at very specific astrological times and points. The fully fledged Thai Lanna Buddhist–style shrine in my home, where I performed my daily practices of meditating, chanting, and making regular offerings to each of the deities and spirits that I communed with, now included, in the central pride of place, this newly acquired Mae Surasatee bucha. Since my inked Mae Surasatee Sak Yants, she quite literally has my back. Her beautiful holy and sacred presence would now always be with me.

I now work with three Mae Surasatee amulets. One by Ajarn Nanting, specially created using a blend of magickal herbs and a Takrut. Another created by a sublime practitioner called Phra Ajarn O. Putthoraksar. This smaller and more compact amulet, composed of an original mixture of earths and plants, has gone through a secret process of creation, handed down through an ancient cult and Burmese lineage of Khru Surasatee. The third amulet is probably far more connected to spiritual possession in its scope and features an aspect of necromancy that Western minds may find somewhat disconcerting. The Mae Surasatee Panneng (third eye region of a human skull) amulet by Ajarn Tay is a remarkable and sublime amulet that I wear on a regular basis. It has four pieces of what is called a Phi Tai Hong female bone that surround two Takrut spells set inside a matrix of graveyard earth and bone powders. Appropriate offerings to Mae Surasatee include green bananas, unopened coconuts, pineapple fruit, and (once a year) an unopened jar of honey, all placed beside her. Sweet smelling flowers must also be placed near her, a task I undertake once a week. Perfume is another offering I regularly give to Mae Surasatee, one she enjoys and responds to. Invoking her spirit through such sensuous offerings increases levels of luck, pleasure, and good fortune, all of which emanate from one's devotion to her. Numerous requests can be made to her, ranging from success in love, an increase in wealth, assistance in improving studying

and intellectual pursuits, general overall improvement, the development of samādhi, and the granting of wishes.

Since my enchantment and initiation into the cult of Mae Surasatee I have become another person completely. Music has been the initial catalyst of this relationship and the deity herself has informed my music in kind. I have seen firsthand how persistent, selfless devotion to this magnificent deity has filled my life with remarkable inspiration and good fortune. I am completely devoted to her and praise her through my work as much as I can. Entering into a relationship with a deity such as Mae Surasatee is akin to opening a portal from which there is no return, and—if you praise her correctly—she'll bless you with her kindnesses and blessings.

After making some final acquisitions at Ajarn Nanting's Samnak such as some Mae Surasatee perfume (which has a Takrut inside that one is meant to spray around the bucha as way of pleasing and summoning her) and some quite extraordinary See Pung, Ronnie and I made our wai to Ajarn and walked out into the baking afternoon heat.

It was now onto Ajarn Suea's Samnak for an incredible Satuang ritual, which would end at the Ping River. Pulling up to Ajarn Suea's Samnak, I felt a shudder of nerves. I knew that this ritual was very important since it was honoring an unseen presence that had guided my life up to this point. Ronnie and I entered his Samnak, made our wai, and sat down on the floor. I was asked to sit in the middle of what I perceived to be a series of ornate boxes covered in what appeared to be palm leaves, filled with a large and amazing selection of offerings that were placed around me along with the now-sealed bucket of twenty-one catfish that we had stashed there earlier. At precisely sundown, Ajarn Suea began an incredible recitation of khatha that lasted thirty or so minutes. I was then asked to cup blessed water from a bowl and scoop it onto my head so that the

The Cult of Mae Surasatee 195

water fell into the boxes of offerings. Ajarn Suea then asked me to hold my head over the big bucket of twenty-one catfish. The lid was removed. It was instantly obvious that the catfish were in no mood whatsoever for this ritual. They writhed, jumped, and bubbled wildly. Much to my great relief, it was decided that I was not to hold my head directly over the livid crazy cauldron of sentient beings and that the khatha was to be chanted with the lid closed. After the ceremony, we carried the big bucket to the car in preparation for a trip to the Ping River. "I will see you again," said Ajarn Suea as we left. I respectfully bowed to him.

For the next forty minutes Ronnie and I drove around, navigating the frenetic Friday night traffic in Chiang Mai looking for a place to park and release the fish. This turned out to be an epic task in itself. When Ronnie spotted a hotel on the banks of the Ping River, he pulled up to it and parked. The Floral Hotel Sheik Istana is what one could easily call an exquisite and fully realized Arabian fantasy. Water features, beautiful multicolored tiles and gorgeous wall and sofa coverings colluded to create a location worthy of a film set. We walked with the large, black, plastic, two-handled bucket from the parked car to the hotel. We entered and headed toward the reservation desk. Nobody was there. We then walked toward the back of the building to access the gardens facing the river. Nobody was there. We walked down one way into the gardens and then another. Nobody was there. I imagine that the sight of us was amusing: two vaguely occult-looking blokes, wandering around a ghost hotel, preparing to dump twenty-one wild and (at times) rabid, Houdini catfish from a big black bucket into the Ping River.

Finally, I caught sight of a footbridge over the Ping River wall. Over we went. Down at the edge of the Ping River feelings of sadness, excitement, joy, confusion, embarrassment, and perplexed curiosity all spiraled under the full, luminous (and numinous) Wolf Moon that hung high up above bleeding like a sparkling silver plate in the evening sky. "Off you go. Goodbye catfish," I quietly muttered. After untying the twine sealing the lid, I carefully lowered the bucket and tipped the rim down

toward the edge of the river. The bucket acted like a cannon. With rambunctious gusto, the catfish exploded out, off, and down into the river. They were gone in an instant. Only the dark river sediment that had been churned up after their release remained, swirling and gesticulating countless patterns and permutations in the river's void. Goodbye and thank you, old friend. Then, like ghosts fading into another dimension, Ronnie and I disappeared into the night's humid, pensive cowl.

Back at the hotel, I felt lost inside, an expanding dream state now growing. Ronnie informed me that Saturday would be another day of intense ritual with Ajarn Daeng. I was grateful for some time alone to decompress. The day's events had finally caught up with me and I tried to process all that had happened. I decided that I should try to anchor myself in something simple, pleasurable, and mundane. I walked alone along Huay Kaew Road, around the corner from the hotel, looking for a small and unpretentious restaurant where I could eat as I ruminated on all that had occurred. I seemed to glide in. I chose from the menu and was served my food in a blur of compressed time at this charming place filled with locals. I stared happily at the beautiful bowl of soup with vegetables and small perfect mini pancake rolls with dipping sauce, accompanied by a garnish of salad and a mango smoothie before me and began to trip out into infinite deep space. I felt as if a galaxy were inside me, stars and planets in their trajectory with no separation in between.

On the eleventh of January 2020, at 11:06 a.m., Ronnie and I stopped at Café Amazon for coffee on our way to Ajarn Daeng's Samnak. Here, I filmed a pool of beautiful golden koi carp swimming in gentle and contented meditational circular patterns. I watched them burbling around, slinking through their small wet world, suspended in translucent liquid. I saw the shining fish and saw myself, and then

looked up and saw the sky, clear blue and wide open. Were the spirits of the higher realms looking down at me as I looked down upon these fish? Did I save the twenty-one catfish last night, like some aquatic Oskar Schindler, to thank my Guardian Angel? Or did these seemingly large and unnoticed sentient beings—in countless and impossible to calculate consequences—all pass onward into infinity, the repercussions of their saved lives untold and unknown? I pondered momentarily on the infinitesimal possibilities and then quietly girded myself for what I knew would be a painful and testing ritual about to come.

It was 12:05 p.m. when we walked into Ajarn Daeng's Samnak in the Yu Wa subdistrict of San Pa Tong District, in Chiang Mai Province. The shrine to Ganesha outside had offerings of flowers, fruit, drinks, and incense around it. Inside, a young man was having the final touches placed on a Sak Yant. We paused before entering, and completed the final blessing just before going inside. I sat with Ronnie in the waiting area and wondered what would happen next. I was slightly fearful, apprehensive of the ordeal yet to come. Ajarn Daeng had heard beforehand that I was to have the application of the Yant Soi Sangwan chest Sak Yant and had found a beautiful template for the central part of the three-line Sak Yant that was to sit right on the middle of my chest. I looked at its intricate beautiful lines and agreed it would be perfect.

The process of marking and setting up the template with small, marked areas to show where the lines would go across my upper chest took roughly twenty to thirty minutes. Finally, I was asked to look in the mirror. When I saw the template marked up on my upper chest, I realized this was the point of no return. Ajarn Suea had seen all of this in a vision and had guided me to go through with this highly unusual and challenging ritual. I was not one to question a great master such as

this; like Ajarn Suea himself, I wished to follow suit with my own Yant Soi Sangwan.

In my case, the Soi Sangwan Sak Yant would have numerous unalomes across the top of the design, which would run along the full breadth of my upper chest. The unalome symbol represents the path to enlightenment in Buddhist culture. The spirals symbolize the twists and turns in life, and the straight lines represent the moment of finally reaching the path of enlightenment, peace, and harmony. The longer you wander, the less wayward you become and the more centered as the loops tighten. The dots at the end of the symbol represent death, or the moment we fade into the nothingness of divine emptiness. The unalome symbol has important significance in ancient Hinduism. Considered to be the symbolic form for the third eye of Lord Shiva, it denotes knowledge or wisdom and the path to perfection. The swirling zigzag motifs symbolize that life is never easy and that there may be many missteps, lessons to be learned, and suffering before we ultimately become enlightened.

In some Buddhist sects, the unalome is also believed to represent the records of the lives of various arahants, which comes from the Pali word *arahati*, meaning "worthy" or "noble." It is also a title given to someone who has attained enlightenment and transcended "the round of birth and death, they have destroyed the taints, lived the holy life, done what had to be done, laid down the burden, reached the ultimate goal, destroyed the fetters and become completely free, liberated through final knowledge" (Majjhima Nikaya 1. 141).

During the ritual of the Soi Sangwan Sak Yant, I was transported into new realms of being, breaking through profound new thresholds of pain, endurance, and ecstasy. The outside sounds of the heavy traffic became an orchestrated mass of surreal dub soundscapes, throbbing and gesticulating as each and every single needle point penetrated my upper chest. The concussion of vehicles merged with the percussion of the needle. At one point I nearly swooned the repeated onslaughts of

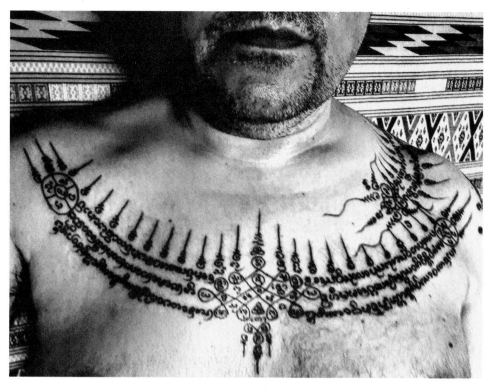

Yant Soi Sangwan with the Yant Takaab, the Centipede of Luck.

pain forcing my brain to expunge vast quantities of reactionary chemicals. Ronnie once again reached out, as he done so in previous Sak Yant rituals, and reminded me to tap my thumb and middle finger to ease the pain. This proved to be a pointless act.

Although I felt as though I was drowning, I also knew I must endure. The Sak Yant recipient must not falter in any way; any signs of fear or cowardice will make the experience much lesser and without merit. As Ajarn Daeng inked the design upon my chest bone, shockwaves of extreme agony fired a battery of nerve signals straight up into my brain and across my chest, a running stream of screaming death, blue murder missiles, and all manner of horrific anguishes all pounded away at my resolve and wall-crumbling endurance. Imagine a steel needle on your breast bone, going right through your skin, hitting the hard

surface of your skeleton. I was only just one of countless devotees who had all been here at this very moment and point in time. I only hoped that I could acquit myself in an honorable fashion with as much humility as possible. I knew I was not a warrior, but this harsh ritualistic process and transformation was making me one whether I liked it or not. My body took the pain again and again, as line after line of Buddhist scripture was slowly but surely embedded into my flesh, transforming my skin into a holy and sacred reflection of mantras, spells, and secret meanings.

The session for the Soi Sangwan Sak Yant ended at 1:35 p.m. I was high as a kite and spinning on the endorphins now pouring through my body. I stood up and was asked to look into the mirror. There before me was an elaborate, intricately inked necklace of scripture and design of profound beauty on my upper chest. I was taken aback at how stunning it was. I felt the charge and surge of some new force inside me. I felt like a warrior. For a moment my body merged with the visage of a myriad of ancient warriors, standing together, braced for action, energized and ready for battle. The vision was staggering. I realized then and there that I was one of them, ready to attack anyone and anything that dared cross me. I looked at myself and saw that another person had suddenly arrived, replacing the old self with a new and far more powerful self, a confident and authoritative new self, a warrior of spirit, magick, and energy.

Suddenly, from the deepest part of my being, a long, heavy, and vast monster-sized laugh rose up and released itself. Like waves of the ocean, the vibrations rocked upward and released themselves upon the shore. I was shocked. Who was laughing? What on earth had just happened? I stood in Ajarn Daeng's Samnak, a joyful being, full of bliss. After regaining my composure, I was surprised to hear Ronnie ask me, "Do you wish to continue?" I had completely forgotten that I was at Ajarn Daeng's Samnak not just for one Sak Yant, but two!

I wanted to proceed with the second Sak Yant, but my body was

The Cult of Mae Surasatee 201

exhausted from the intensity of the first Sak Yant. I knew I needed a break, and wanted to come back later for the second ritual. Ronnie seemed a little perturbed by this as he had made special arrangements with Ajarn Daeng to obtain a group rate for the two Sak Yant. Ronnie told me that not doing them both at the same time would be more expensive. I didn't mind or care. Indeed, I did not even have a firm grasp on my own mind at this point. I was floating in space, totally drained, and in need of a very serious time-out. I was still experiencing what seemed to be the aftermath of an army of ancient Thai warrior spirits passing through and into my body. The resonance of this ritual had been an earth-shattering and cosmic experience. I felt like I had been turned into a huge temple gong, struck with full force. I needed time to process what had just happened to me. I now understand that any empathic and psychic being undertaking such a ritual is likely to draw in all and any supernatural residue essences present, and that these forces will be transformative, resulting in nothing short of a rebirth right there and then. Not that I would wish to encourage the use of well-trodden, clichéd cultural icons to describe something so far beyond normal Western comprehension, but this fresh and brutally raw ritualistic episode was a little bit like a full-on regeneration of the kind depicted in the TV show *Doctor Who*, in which a character undergoes a transformation into a new physical form and different personality after circumstances that would normally result in death. Although I had not prepared for it, I knew right away that I must apply immediate self-care and cocoon myself to begin anew. I desperately yearned for the comfort of space, peace, silence, and the deepest of contemplation, and besides, the hotel and a hot meal was calling my name.

17

The First Hell Garden

Chiang Dao District and Offerings for Phra Rahu

Wearing a black T-shirt while sleeping was a wise idea. The day's previous ritual had left a design that was still fresh and ever-so-slightly moist on my upper chest. I didn't wish to mark the crisp white Egyptian cotton sheets on my bed with my Sak Yant and thanked myself for thinking about such details and saving myself an extra charge for doing the laundry. Indeed, I felt that today, Sunday the twelfth of January 2020, would be a good day to do some much-needed clothes laundering at the open-air laundry bar on Manee Nopparat Road, search for a sterling coffee house to nest in for a while, and then visit some temples that were only a short walk away from my hotel. Indeed, since today was a non-itinerary-driven day and Ronnie had other pressing business to attend to, the day was mine to do with as I pleased.

The Akha Ama Coffee in Chiang Mai is quite possibly a dreamy slice of bliss disguised as a coffee house. This bean plant to cup operation has a limited series of locations across Asia with a strong supply chain of ethically sourced coffee beans from a coffee plantation in Ban Mae Chan Tai, Mae Suai District, Chiang Rai Province. I drifted around the back streets of Chiang Mai, following the recommenda-

Intersection in the back streets of Chiang Mai.

tion to this serious coffee lover's bolt hole. A good walk away from my hotel. The atmosphere of this charming and delightful bamboo decorated establishment was gentle and conducive to imbibing many cups of their sublime and delicious coffee. The selection in their fully stocked shop was varied and generous. "Please share the seat. Thank you," read the sign taped on the table in a sweet pre-Covid gesture as I enjoyed my toasted sesame seed bagel and luxuriant cappuccino. This free Wi-Fi honey pot of a snug was a delight to hang out in for a morning.

Fully invigorated by my caffeine infusion, I ambled my way down to the Old City Moat straddled by Bunrueang Rit Road and Arak Road. The heavy traffic on both roads frames a beautiful array of peacock water fountains that runs along the full length of the moat, a welcome

sight in the harsh, punishing heat. Chiang Mai was established in 1296 as the new capital of Lan Na (Lan Na Kingdom "Kingdom of a Million Rice Fields") and succeeds the former capital, Chiang Rai. This originally square-walled and moated city is located on the Ping River (a tributary of the Chao Phraya River) and a major trading point of historic importance. Although each side of the moat is roughly 1.6 kilometers, to walk the entire walled and moated parameter comes out to a 6.4 kilometers square distance.

In yet another of my many "encounters" with Coil, this fourteenth-century moat is where John Balance and Peter Christopherson of the group Coil once took the Alexander Shulgin–designed psychedelic drug 2,5-Dimethoxy-4-ethylamphetamine (otherwise known as DOET). Supplied to them by the traveling rave collective Spiral Tribe, this substance sent them both on an extended, euphoric, and luminous chemically induced time traveling episode backward to the very pre-history bare fields of divine emptiness itself. Although some may find Coil's behavior in Chiang Mai to be possibly a little bit anti-Buddhist, this could not be further from the truth. The ancient and legendary substance called Amrita ("not death" or "immortal/deathless"), known as an essential sacramental drink found in Tibetan Vajrayāna Buddhism, also found in Hinduism, Sikhism, and Theravada Buddhism, is—as suggested in Mike Crowley's meticulously researched *Secret Drugs of Buddhism*—to be none other than the psychoactive fly agaric (*Amanita muscaria*) mushroom. This particular detail may in fact be the underlying reason for the seemingly unpalatable instructions for an ancient ritual found inside the Guhyasamāja Tantra (Tantra of the Secret Society or Community), which directs adherents wishing to obtain siddhi (material, paranormal, supernatural, magical powers, abilities, and attainments) to "perform [ritually] with excrement and urine as food." The psychoactive elements in the fly agaric mushroom are the same elements found inside the waste of both human urine and excrement, and due to the

The First Hell Garden 205

metabolic conversion of ibotenic acid into muscimol, their potency increases exponentially when passed through the body.

After a brief but enchanting stop at Wat Rajamontean, a Buddhist temple complex on Sri Poom Road to explore its gorgeous upper-level shrine and pay obeisance to the sublime Buddha located there, I walked farther down toward my ultimate destination: the restored foureenth-century Buddhist temple of Wat Phra Singh Woramahawihan. On the day I visited this temple complex, whose construction began in 1345 when King Phayu, the fifth king of the Mangrai dynasty, had a chedi built to house the ashes of his father King Kham Fu, local musicians played traditional folk music at the outdoor market surrounding its entrance. The required donation of twenty baht (the equivalent of forty-six pence back in 2022) turned out to be well worth the price of entry to view this large and arresting complex of buildings and their stunning architecture. (See color plate 10.)

The main attraction of Wat Phra Singh is Wihan Lai Kham. Built in 1345, this structure houses the famous golden Phra Buddha Singh statue, a sublime monument that is said to have traveled from India to Thailand via Sri Lanka, Nakhon Si Thammarat, and Ayutthaya to its final home in Chiang Mai. A prime example of classical Lanna architecture, the murals inside Wihan Lai Kham are sensational. Inside this profound structure which—unlike my visit to Wat Rajamontean—was teeming with tourists, I felt conflicted: Do I just stand and take photos, gawking like a tourist? Or do I get down on my knees and worship at this holy and very sacred site? I decided on the latter. There, among the throngs of tourists, I gave wai to this stunning and totally exquisite shrine, and after doing so, can honestly recommend that anyone hoping to show open and generous devotion at this exceptional shrine choose their timing carefully. Otherwise, securing a space on the floor in which to show your devotion without fear of bumping into numerous other visitors may prove challenging.

Outside, I lit some incense sticks and candles near the two bright

and shining pin-sharp golden chedis. One of them is the Kulai chedi, a small square-based chedi connected to Wihan Lai Kham by a tunnel that is not opened to visitors. Built as a pagoda with five tiered roofs by King Mueangkaeo (1495–1525), during its restoration, a golden box containing ancient relics was discovered. Removed for safekeeping and returned following the completion of the restoration, the contents of the chedi box contribute to the profoundly cosmic atmosphere of this place. It was a perfect sunny Sunday afternoon and my heart sang in the bright, searing sunshine. I felt the rituals of the last two or so days melt away, allowing my mind to rest and completely reset itself. Here, at Wat Phra Singh I found the respite I needed in order to come back once more into my mind after the Sak Yant ritual I had gone through only one day prior. As noted previously, extreme rituals, no matter how much healing or growth they provoke, can be stressful events on your nervous system; having space to mull over and process the transformation is critical. I was grateful to have the opportunity to work in some downtime, to turn off and plug into calm.

At around seven o'clock that evening, I discovered a treasure. Just around the corner from my hotel, I found an excellent restaurant that offers superb examples of northern Thai cuisine, which I had been wanting to try. Set in a Lanna house with a tree-lined garden, the highly popular resturant Huen Muan Jai ("happy home") has been offering authentic northern Thai food to Chiang Mai since 2011. Headed by Chef Charan Thipeung and favored by the Michelin Guide Thailand, I expected nothing less than total perfection. I found it. Bathing in the delightful ambience, I cruised with ease through the voluminous menu to select a dish. Although Thai standards such as Khao Soi were represented in delicious and moreish top form, I wished to try some hard-to-find traditional dishes. I finally settled on the Gaeng Plee, a spicy banana flower with pork soup, steamed rice, a northern Thai spicy pork salad, and a bottle of iced water served in a silver goblet. My dining experience at Huen Muan Jai was the

perfect complement to my idyllic and completely enchanting time in Chiang Mai. Although I highly recommend anyone visiting this city make Huen Muan Jai one of your stops, Chiang Mai boasts so many fine restaurants it would be difficult not to find one.

Monday morning, the thirteenth of January dawned. At 6:37 a.m., Ronnie and I stopped once again at a Café Amazon for an early coffee. The day's itinerary included a visit to a temple somewhere near the northern border country, a place where the landscape changed considerably and the atmosphere along with it. I was also interested in visiting Buddhist Hell Gardens. Ronnie knew of one located at an out-of-the-way temple complex in Chiang Dao district. Thailand's numerous Hell Gardens are like didactic Buddhist versions of Madame Tussauds on acid. These places of horror and heaven are meant to imprint a deep and overwhelming sense of fear designed to dissuade one from straying from the Five Buddhist Precepts. These precepts—outlined earlier in the book—are again as follows:

1. Abstaining from taking life
2. Abstaining from taking what is not given
3. Abstaining from sexual misconduct
4. Abstaining from false speech including gossip
5. Abstaining from intoxicants, which would cloud the mind

The interpretation and the attempts at the upholding of these precepts has bewildered and confounded the best of minds from countless generations across the world, including members of the laity. I personally see sexual misconduct as not cheating or taking part in any cheating with another's spouse or partner while still married or living together, irrespective of sexual persuasion. The second precept also holds within

it some issues that some may find troubling and difficult to understand. Buddhaghosa's "Five Precepts of Buddhism: A List of Buddhist Abstinences" (translated by Edward Conze) states that "to abstain from taking what is not given" means the appropriation of what is not given. It refers to the removing of someone else's property, to the stealing of it, to theft. While this seems simple to grasp, some may see gray areas in this precept and may even try to find loopholes in it. The quality of one's daily practice of living by the Five Precepts is what determines one's experience. I am not perfect. Far from it. But I try to forgive (and continue to forgive) myself for any perceived departures from the precepts. We are all a work in progress.

When Luang Phor Pina's spirit spoke to me at Wat Sanomlao I knew that things would get better if I accepted what he said to me and just made an honest revaluation of myself, examining my life up to that point and taking steps to implement a course correction. Lifting up the stone slab and having a good long look at what was squirming underneath was no pleasant task for me. The Five Precepts are definitely not a "higher than thou" credit card or a set of scout badges awarded for virtue signaling. They are the solid, concrete pavement across the sacred primordial swamp, hopefully guiding me to make more appropriate life decisions, resulting in success in my endeavors. My undiagnosed autistic condition aside, my decision-making capacity hadn't exactly allowed me to escape without some internal damage from the car crash of my existence however.

A one-hour-fifteen-minute trip from the city of Chiang Mai, the journey to the temple was relatively easy. As we coasted along the quiet early Monday morning roads, the moon shone like a silver pebble just above the mountain-lined horizon. At one point we passed a group of bare-footed monks walking along the roadside carrying their bowls for morning alms, a ritual that has happened for some considerable

time across Thailand. These monks rise early and then travel along the roads from the temple, collecting food and contributions from local people while offering blessings in exchange. Walking in a straight line (usually starting with the monk that has lived the longest at the temple, typically the abbot), the monks approach each participant (who will be on their knees) and place into each bowl something that is ready to eat, typically rice, water, or individually wrapped offerings they have either made especially or purchased specifically for the purpose of daily alms. Watching the monks, I felt I was witnessing something ancient, beautiful, and divine.

Ronnie and I traveled north up Route 107, making our way deep into Chiang Dao, a district (or they say in Thailand, an "amphoe") of Chiang Mai province. Nicknamed "Little Tuscany" due to the several varieties of wine produced in the area and slightly south of the border for the Shan State of Myanmar, Chiang Dao district has roughly twenty or so temples, all worthy of visiting. (See color plate 18.) We reached our destination at Chiang Dao Temple at precisely 7:20 a.m. We pulled up to a large bellied and seated golden Buddha and remarkably massive and imposing gong that was outside.

The length and width of Chiang Dao Temple's Hell Garden spans roughly the size of a cricket pitch. Located in the center of the temple grounds, the sculptures in the garden depict the fate of violators of karmic law as described by a book called *Trai Phum Phra Ruang* (or, the *Three Worlds According to King Ruang*). According to this fourteenth-century literary text, when a Buddhist dies, he or she goes before the Death King Phya Yom, who decides your fate based on your good and bad deeds. Death King Phya Yom weighs the record of each recently deceased human's good deeds (which are engraved in his thick and golden ledger) against their sins (which are scratched onto a piece of living dog leather). If the bad overshadows the good, then they are inflicted with the proper punishment (possibly for eons depending on the severity of the crime) before being reborn, reincarnated, and returned to earth.

210 *The First Hell Garden*

The garden boasts a collection of some of the most horrific and blood-splattered sculptures of human beings trapped in hell; the blood flow on these sculptures is not minimal in any way and is fully illustrated for maximum gore. The sculptures depict all manner of the gruesome techniques used by the servants of Phya Yom to punish violators of karmic law: molten lava is poured down the throats of sinners, spears are directed at goat-headed criminals, long spikes are driven up the noses of thieves, while cheaters are forced up the Ngiew Tree, which is regarded as a highly inauspicious and unfortunate tree in Thailand's folklore. In Buddhist lore any partners that commit adultery are sent to hell and are forced to climb up the tree's characteristically sharp spikes while dogs below rip at their flesh. People are sawed open, and restrained, bound, and gagged in just about every position imaginable. Streams and streams of blood poured down the tree sculpture as a hapless couple suffered the near miss of a spear into its trunk. Boiling pots of oil for burning souls, swords for beheadings, and all manner of hellish chaos ensued in this terrifying tableaux that gave me flashbacks from my time as an actor in The London Dungeon. (See color plates 11 and 12.)

There were also four towering Phi Pret (tall and dissolute ghosts)—both male and female—along the stretch of the sculpture garden easily reaching the height of a Sugar Palm Tree. These tall and constantly hungry ghosts are said to have a shrill voice, and—due to a mouth the size of a tiny needle hole—are unable to digest or swallow food since their mouths are too small to eat. They are depicted in the garden as suffering from thirst and starvation. The Phi Pret relate directly to Buddhist lore and serve to represent the consequences of being stingy, hurting, or swearing at your parents, preventing others from offering food to monks, or killing an animal without any guilt. All of this twisted nightmarish insanity was clearly represented in the highest definition sculpture in the middle of a beautiful and sublime temple complex in northern Thailand. I was perplexed, fascinated, disgusted, and in a state of awe. Here there were no nuances or subtleties of any kind whatsoever.

The First Hell Garden 211

Venturing beyond beyond the boundaries of the Five Precepts (227 for monks and 337 for nuns), will earn the violator reincarnation into hell. Here are the precepts and rules of conduct for monks, which fall into the following categories:

- 4 parajikas (defeats)
- 13 sanghadisesas (rules requiring a meeting)
- 30 nissaggiya pacittiya (confession with forfeiture)
- 92 pacittiya (rules entailing confession)
- 4 patidesaniya (verbally acknowledged violations)
- 2 aniyata (indefinite rules)
- 75 rules of training
- 7 rules for settlement
- 110 specific rules for nuns

The four parajikas (defeats) relate to expulsion from the monastic order for life. If a monk or nun breaks any one of the rules, they are "defeated" in the holy life; they fall from monkhood and are prohibited from becoming a monk again in this lifetime. The four parajikas for bhikkus are:

1. Sexual intercourse, any voluntary sexual interaction between a bhikkhu or bhikkhuni and a living being
2. Stealing, that is, the robbery of anything worth more than 1/24 troy ounce of gold (as determined by local law)
3. Intentionally bringing about the death of a human being, even if it is still an embryo, whether by killing the person, arranging for an assassin to kill the person, inciting the person to die, or describing the advantages of death
4. Deliberately lying to another person stating that one has attained a superior spiritual state, such as claiming to be an Arahant when one knows one is not or claiming to have attained one of the jhanas when one knows one hasn't

212 *The First Hell Garden*

Because I sincerely uphold in all instances a woman's right of dominion over her own body and strongly and unreservedly support a woman's human right to protect herself against anything that may damage her personal well-being, the third parajika—specifically the line "intentionally bringing about the death of a human being, even if it is still an embryo," makes me feel deeply uncomfortable.

I once pitched an idea to an online zine. I had some very strong images of the Hell Gardens I had visited and felt that maybe they would like to feature them. The reply was a little bit unexpected as they declined, feeling that the images were disturbing. But context is everything. In his 2019 photography book *Narok: Visions of Hell in the Gardens of Siam*, Stephen Bessac catalogs numerous examples of the diverse and explicit nature of the depictions of violence within the Buddhist Hell Gardens of Thailand. This scarce and highly coveted book is the result of Bessac's fascination with Asian, Mexican, and Thai death culture and his obsession with Thai crime magazines such as *Crime News* and *191*. Unlike some other cultures, death is not a taboo subject in Thailand. As for abortion, although nearly all of the Buddhist clergy view abortion as a transgression that will haunt the "sinner," it has been legal to terminate a pregnancy in Thailand for up to twelve weeks from conception since 2021.

Anthropologically speaking, Thailand has its own charms and has a myriad of bizarre and deeply weird practices that I find interesting. Humans in my own mind have total and complete autonomy over their minds and bodies. I support self ID and human self-determination. The Hell Gardens are pictorially speaking highly prized for their imagery that serve well to illustrate humanity and its obsessive attachment to horror (and body horror). Being a part of the Buddhist clergy has its own problematic and stressful rigors. Taking onboard the full 227 monk precepts is not done lightly and should only be considered after much personal contemplation. In the case of the monk Phra Na Wat he suffered two severe emotional blows before and after his going into

The First Hell Garden 213

a monkhood rains retreat. Firstly, his mother died, which can only be a very heavy weight of sadness to bear while holding the demanding list of precepts. Then three months later his girlfriend left him while he was in retreat, unhappy at his taking on vows of abstinence. This perfect storm of heart-breaking events drove Phra Na Wat to commit suicide by hanging himself in an outhouse some way from the main temple. The body-fluid-soaked rope he used for this tragic act was subsequently acquired and then sold on as highly sought after monk prai. Materials from a corpse or items that contain the essence of the dead, prai are the foundational elements of all necromantic magick working in Thailand. I have a small collection of monk prai that I commune and work with on a regular basis. I own a monk prai bullet amulet made by Ajarn Krit Payak, a master of Suai wicha from the northeast of Thailand on the Laos border.

This wild and darker magick is able to successfully bridge transgressive and more traditional forms of necromantic magick. While in a dispute with local mafia the monk Luang Phor Tavee was shot five times in the back of the head. The bullets, his blood, the soil on which he lay dead, his hair, holy powders, and some of his bone fragments all went into the making of this amulet. Offerings were made to his spirit to gain permission to use these materials while the matrix or load of the amulet was consecrated over a period of five days. The amulet gives extreme Kong Grapan (the attribute of invincibility) and high Metta (the attribute of loving-kindness and compassion for the self and others).

Another amulet I own is the extremely special Ong Kru Ghost Bone Phra Pid Taa. Made by Ajarn Apichai, this amulet has the bone powder of the monk Phra Suriya, a highly respected member of the Sangha, sadly struck down by lightning. According to Lanna belief, the body of a person who dies as a direct result of being struck by lightning is seen as having great Athan (that which is seen as supernatural in nature), particularly if the person themselves have magickal

214 *The First Hell Garden*

abilities. It is believed that Phra Suriya's spirit does not have the ability to pass on due to this very specific form of death, and now takes on the form of either a Suea Yen (the cool tiger with the coolness of emotion and ego) or a Suea Saming (a tiger that can assume the shape of a human because it is possessed by a human spirit), which is like a form of a shape-shifting weretiger, which, in due course, will become a protector of the temple where they once lived. This beautiful small amulet offers various powers such as Metta (loving-kindness), Saneah (the attribute of attraction), good fortune, the ability to lift the lines of fate, assistance in business, luck in gambling, and acts as a powerful protection against danger and black magick curses. It is said that the wearer will seem to have a presence with them since the weretiger spirit will be with them at all times. Weretigers in Thailand are seen as powerful shape-shifting spirits that can transform to have the head of either a man or a woman. Suea Yen and Suea Saming have various meanings in both northern and central Thailand. For example, Suea Saming can be a human who, through association with magick and sorcery, can assume the shape of a tiger. And then again Suea Saming could be an old tiger or old person whose body changes shape by natural cause.

Aside from the sculpture garden, another unique feature at Chiang Dao Temple worth noting is the massive statue of Rahu (or Phra Rahu as he is called in Thailand) that sits on top of a building some way from the sculpture garden of hell. (See plate 11 in the color insert.) Facing the surreal sight of this huge demon (who is quite obviously enjoying himself while making a meal of a planet), one can see the distant mountains, clearly visible far behind. Rahu is one of the nine major celestial bodies (Navagraha) in Hindu texts. A feared deity, in *The Mahabharata*, Book 3 (*Vana Parva*, or "Book of the Forest"), the superstitious ancient terror surrounding Rahu is very palpable indeed: "And all around there will be din and uproar, and everywhere there will be conflagrations. And the Sun, from the hour of his rising to that of setting, will be envel-

The First Hell Garden 215

oped by Rahu. And the deity of a thousand eyes will shower rain unseasonably. And when the end of the Yuga comes, crops will not grow in abundance." Often depicted with dark skin, missing the lower part of his body due to having been severed by God Viṣṇu (who caught him stealing a divine nectar), Rahu is the demon that devours the sun and moon and thus causes eclipses.

In Vedic astrology, Rahu, along with Ketu, are two very powerful forces that, when combined, control the karmic influences and situations through their axis. The symbol of Rahu represents the dragon's head and Ketu represents its tail. Together, they form one of the nine planets that control fate, namely Surya (Sun), Soma (Moon), Mangala (Mars), Budha (Mercury), Brihaspati (Jupiter), Shukra (Venus), Sani (Saturn), Rahu and Ketu (the shadow planets). Rahu and Ketu (otherwise known as the ascending node and descending node) are not actual planets per se, but points of intersection of the pathways that the Sun and the Moon take. In this cosmology, the Sun is viewed as a planet, and eclipses occur when the Sun stays in these specific intersectional points with the Moon. In the Vedic tradition, Ketu stays at the seventh house or directly opposite Rahu, but in the Thai tradition, Ketu has its own orbit, distinct from the Vedic Ketu. Thailand's Ketu orbit was discovered by King Rama IV, and facilitates forecasts for the exact date, time, and place for eclipses in Thailand.

During eclipses (eclipses and full moon magick in Thailand are very big and auspicious business), the full moon, and Buddhist days, Phra Rahu is given the full red carpet of offerings. If Phra Rahu is praised correctly he can be highly rewarding. All food offerings to Rahu need to be the color of black* (including black chicken), and all incense and candles are to be offered in groups of three, five, or (more importantly) eight. In Thailand, one may acquire black foods to offer in praise of Phra Rahu all in one pack, each with its own very specific meaning, as follows:

*I have even seen people use Coca-Cola as an offering since it is indeed a black liquid.

1. Black grapes are identified with having good business.
2. Black liqueur is identified with taking financial risks or investments.
3. Black coffee is identified with the fruition of all of your wishes.
4. Black jelly or shoa guay (grass jelly) is identified with careful thoughts.
5. Black beans are identified with making progress in your life.
6. Black sticky rice is identified with wealth and love from your family.
7. Black Thai cake is identified with receiving rewards, success, and good luck.
8. Black fermented eggs are identified with making successful contacts and errands.

The ancient Hindu myth of Rahu has been deeply integrated and disseminated within Thai society and features heavily in murals, paintings, sculptures, and amulets and has been interpreted in many ways throughout history. Rahu appears in temples as a protective door keeper, defining sacred Buddhist spaces. Rahu is an inherent part of the Buddhist and Hindu cosmology and is viewed a bodhisattva who may become the next Buddha. In the Buddhist religion, Rahu is initially first regarded as evil and cruel, and then in the end, becomes the Upasaka (follower of Buddhism) who cherishes the triple gems. While in Thailand, I also learned that Rahu has an attribute called Serm Duang, which is the power to realign the lines of fate and lift the fortunes of anyone that chooses to worship him.

The meaning of Rahu as a deity of fortune was boosted considerably during recent developments in Thai society, particularly during the full solar eclipse in 1995 and the economic crisis of 1997. It became a very popular trend among Thai people to worship Rahu in order to dispel bad luck and ensure their survival from the crisis, thus further transforming Rahu into a symbol of wealth and good fortune. I myself

have two Phra Rahu Galaa (carved one-eyed coconut statues). Since the one-eyed coconut occurs in only one out of every fifteen-hundred coconuts, these are highly sought after. Phra Rahu amulets are said to bestow Serm Duang (remember, that's the attribute to realigning your fate to be more beneficial) and remove negative karma and bad luck. As mentioned earlier, I was born on a Wednesday (way back in 1966), which in Thailand is designated as Phra Rahu's day. Because of this, I have an affinity with this sublime deity. On my first pilgrimage, Ronnie sold to me a Phra Rahu Galaa made by Luang Phor Pina himself. Created at Wat Sanomlao, the top and sides of this treasure (which sits with my five other bucha statues) are covered in gold leaf. I give praise to Phra Rahu every Wednesday via a khatha I acquired from the great Ajarn Spencer Littlewood (polyglot, magickal amulet collector, etymologist, biker, ex-Buddhist monk and Lersi hermit, historian, author, anthropologist, linguist, philosopher, occultist, and anarchist). This khatha needs to be chanted twelve times and goes like this: "Idtipiso Pakawaa Phra Rahu Sataewaa Samaa Winyaana Idtipiso Pakawaa Putta Sangmi." If you do plan to visit a Hell Garden in Thailand one must not view them as a theme park or an "attraction." They are faith-based hellscapes of suffering and horror that are meant to promote a response in you to lead a good, wholesome, and merit-based life. The violent extremism of the content may seem shocking, but their intentions are protective.

18

Phaya Nāga in Chiang Dao Caves

Yant Ittipiso Paed Tidt and Unseen Energies

After our visit to the Chiang Dao Temple, Ronnie and I drove back to the Chiang Dao caves for a second visit. Although I had visited them during my second pilgrimage in 2019, I knew that a second look at a location one considers familiar can result in new discoveries. In this case my assumption was correct. After we had arrived, I made some offerings of incense and candles outside a shrine, where I could hear a looped call to prayer being played inside. Since it was still relatively early, I took advantage of the peace afforded by virtue of the relatively few other visitors and went inside. Before going in, I gave a donation to the temple via a donation box outside. Any devotee who wished to praise the statues of monks inside could do so by placing the gold leaf (from one of the small packets of gold leaf available near the donation box) onto the monk's head. The process of holding a mobile phone while simultaneously placing gold leaf onto the head of a monk statue is a difficult and protracted balancing act. After some difficulty, the wafer-thin gold leaf wisped onto the monk's head and joined the countless other pieces that by now had formed a second layer of golden skin.

After moving back into a seated position, I was paying obeisance to Buddha at the shrine when an overwhelming sense of deep peace

flooded me. I couldn't speak. Somehow, I had merged with the temple and become at one with the location. Although disappearing into thin air is a trick that many magicians would like to master, the truth is, anyone with sufficient inner stillness can achieve it. I became detached, floating outside of myself, viewing my flesh body outside my skeleton frame. Who and what was this person doing in Thailand? As I merged with the temple, I ceased questioning. The lightness of my being lifted me up into a new and almost identity-free non-person, the Zed that I had been working all the long to become had now unbecome. If it were not for the photographs of this time period I would not know what had happened or what I experienced there. Clearly the passing from one temple to another had had an effect on me I had not anticipated. A sense of drifting calm filled my being. I tried to explain to Ronnie what had just happened but failed to convey it.

"It's different this time," I told Ronnie.

"In what way?" Ronnie asked.

"I don't know. It's just different. It just feels different."

After making my offering I walked up to a large golden statue of Buddha upon a hill just inside an area of jungle. On the way an outcrop of rock revealed a small open craggy area with a blanket inside. It seemed that this small place was currently being used as a meditational bolt hole by someone. I stood admiringly at the statue that had an umbrella above it. A sense of peace rained down upon me and I drank in the warmth now beginning to pervade the morning air across the Chiang Dao caves. Then, for one last time, Ronnie and I went deep into the caves to meditate among the shrines, spirits, and magnificent endless silence. After fifteen minutes, which seemed like an eternity, I wondered if I would be able to, like the ancient and profound masters before me, meditate in the caves for days, weeks, and years.

220 *Phaya Nāga in Chiang Dao Caves*

Meditating in caves has been favored by seers wishing to channel spiritual energy since time immemorial. Caves provide protection from weather and access to deep spiritual currents. In Thailand Nāga, divine netherworld residing, half-human serpent beings have merged with local traditions of dragons. Phaya Nāga are believed to live in water or caves playing a role in rain control. I sensed the writhing Phaya Nāga in Chiang Dao caves. Their exquisite unseen energies curled around me, again and again looping around my body. Padmasambhava ("Born from a Lotus"), also known as Guru Rinpoché (Precious Guru) and the Lotus from Oḍḍiyāna, the tantric Buddhist Vajra master from India who is said to have taught Vajrayana in Tibet (circa eighth–ninth centuries) attained the Mahamudra level of enlightenment through the practice of Vishuddha Heruka combined with the sadhana of Vajra Kilaya at the upper cave of Yangleshö, also known as Asura Cave. The location is considered the most profound of all locations connected with Guru Rinpoché. He spent time in retreat in two caves located in what is now the village of Pharping, Nepal. In the winter months he practiced at the sunny upper Asura Cave and during the summer months he descended to the lower Yangleshö cave. While at the Asura Cave he attained the fruition of the Great Seal of Mahamudra.

While not feeling like an ancient tantric Buddhist master, I did feel however that something major and fundamental had shifted inside of me over the course of my three pilgrimages. Although this deep recalibration felt akin to completing a hard system reboot, I soon started to wonder if the actual hard drive itself had been rewritten. My consistent enlightened activity had removed all of the obstacles to awakening. Inner awakening and magickal transformation are very much one and the same for me. Real and palpable changes had occurred over the years of the pilgrimages that were beginning to become very noticeable and very real. My weight, physical appearance, and hypersensitivity to either external or psychic stimulus had changed radically, the inner voices now were orchestrated in tandem

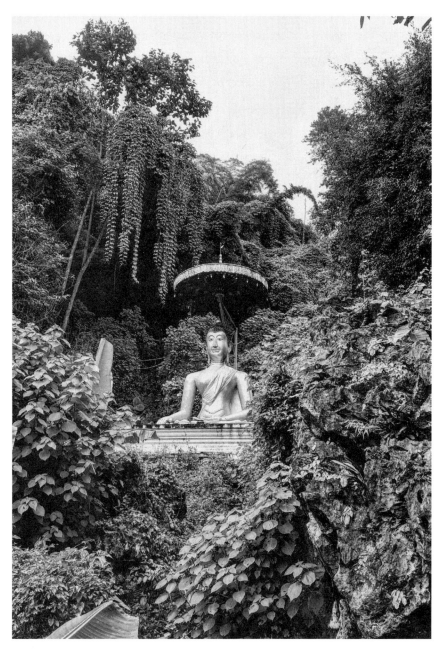

Buddha at Chiang Dao Caves. Photo by Sheer Zed (2018).

with the invisible world. Now, spirit voices availed themselves to me only when I sought their counsel, as opposed to thrusting themselves upon me via their own boundary-breaking behavior. My centeredness was no longer plagued or fractured by body-racking anxiety or self-doubt, and decades of internal damage was healed.

When I arrived back to the hotel I decided to spend the rest of Monday puttering around Chiang Mai, doing various things such as revisiting temples, dining at a charming outdoor vegetation-heavy restaurant called the Fern Forest Café, getting a very cool haircut at OH Barber Shop, and taking a five-minute tuk-tuk (motorized version of the pulled rickshaw or cycle rickshaw) ride from the center of town since my left leg muscle had suddenly decided to play up once again. I had consciously made the effort to reduce my carbon footprint during these pilgrimages to Thailand and although I felt slightly defeated at having to use this service at all, my leg throbbed like that of a wounded beast.

The long flights and other use of mechanized transport during my journeys had of course added to my footprint. The city of Chiang Mai faces serious issues regarding the environment, and I didn't want the heavy price of my personal transformation to be paid for in environmental damage. However, in this subtropical climate military-grade air conditioning is less of a luxury than it is a requirement.

Chiang Mai was called the most polluted city on earth in March 2021. In its burning season, thick fog settles over the city until the heavy rains come in April. The main issue that causes air pollution is the slash and burn agricultural practices—widespread in Southeast Asia—used by Thai sugarcane farmers. Logging concessions to Thai and foreign companies have also created widespread poverty as concessions and rights for the local tribes ceased. Hill tribes live inside the bounds of the 25 percent of land designated as protected area but

have been banned from engaging in any type of burning or agricultural methods, even if such methods are based on their traditions and beliefs. Subsequently, these tribes have been forced to move and work on land owned by logging and agriculture companies. The Chiang Mai provincial public health office reported 31,788 cases of patients who suffered from air pollution–related illnesses from January to March 2021. Anyone suffering from serious breathing or heart problems needs to either protect themselves from the bad air or else reconsider traveling to Chiang Mai completely.

Tuesday, the fourteenth of January 2020, dawned and the final visit to see Ajarn Daeng at his Samnak beckoned. Since my funds had been considerably depleted by this point (and since I had already achieved my main goal of acquiring a Mae Surasatee bucha at Ajarn Nanting's Samnak), Ronnie and I scratched off a southern excursion to the city of Mae Sot on the Thai/Myanmar border. Being in Chiang Mai and its environs had taken up a much more considerable amount of my time and resources than I had anticipated, relegating any further exploration of Thailand to a separate visit, which, at that point in time, I couldn't see happening. Before leaving Ajarn Suea for the last time he had told me he would see me again. Knowing Ajarn Suea was psychic didn't help me imagine how on earth I would do this and yet, somewhere deep inside, I knew that this could very much be a possibility somewhere in the future.

That morning, I had breakfast at a lovely breakfast place two doors up from the OH Barber Shop at 12 Ratchaphuek Alley, right around the corner from my hotel. Here, I enjoyed a beautiful cheese omelet, which was nothing short of perfect.* Before heading off with Ronnie

*Sadly, as of 2021 this divine dining establishment is no longer in existence, another casualty of the pandemic.

I hung out with the many cats in residence at my hotel Varada Place. Although I counted nine, there seemed to be a lot more. Some had collars and were leashed onto chairs at the front, which seemed a little bizarre since cats by nature are free spirits. I am guessing the hotel must have had trouble in the past, necessitating that they temper the more wild and feral members of their burgeoning cat commune.

Ronnie and I reached Ajarn Daeng's Samnak at roughly twelve noon. Ronnie had shown me a photograph of a rare form of the Yant Ittipiso Paed Tidt or the eight directions of the universe, and after much discussion prior to our visit with Ajarn Daeng, I had decided that my second Sak Yant would be the Yant Ittipiso Paed Tidt. Minimal and sparse, and in some small way, similar to the universal symbol of chaos (the chaos star), this beautiful multidirectional Sak Yant of which there are many variations removes danger and offers protection in whichever of the eight directions its wearer is traveling. Unlike the chaos star, it sends out raw magickal vibrations of protection while bestowing the attributes of Metta (loving-kindness and compassion for the self and others) and Serm Duang (which as you recall is the attribute to realign the fate of the bearer to be of greater benefit). This fine and elegant Sak Yant had all of the attributes a Paed Tidt Yant could offer, while also warding off ghosts and evil spirits. Chanting the mantras written in the Paed Tidt Yant offer further protection at each and every compass point:

1. I Ra Cha Ka Tha Ra Saa (when traveling to the East)
2. Thi Hang Ja Thoe Roe Thi Nang (when traveling Southeast)
3. Bi Sam Ra Loe Bu Sath Put (when traveling South)
4. Soe Maa Na Ga Ri Taa Toe (when traveling Southwest)
5. Pa Sam Sam Wi Sa Tae Pa (when traveling West)
6. Ka Put Ban Tuu Tam Wa Ka (when traveling Northwest)
7. Waa Toe Noe A Ma Ma Waa (when traveling North)
8. A Wich Su Nuch Saa Nu Thi (when traveling Northeast)

Today was the day that this Sak Yant was to be placed onto my lower back. I showed it to Ajarn Daeng. I expected Ajarn Daeng, who is not just a master of Sak Yant but also a living library, a repository of ancient sacred knowledge who has access to thousands of templates for a plethora of Sak Yant designs, to know immediately which template to use for my Sak Yant of choice. Not so. He pointed to a large pile of books and papers in the corner all relating to his work. We all sat down. As Ajarn sifted through his many papers hunting for the specific Sak Yant, Ronnie scrolled on his phone. I felt a little ashamed, embarrassed that I had chosen something so obscure whose template would be difficult to locate. There are many numerous variants of the Yant Ittipiso Paed Tidt, and it seems Ajarn Daeng has nearly all of them. Eventually he was successful, and twenty minutes later he came across the specific variant I had requested.

This time, the application of the Sak Yant was relatively straightforward. The template was placed onto the middle of my back and the design was marked into place. Ajarn Daeng then applied the intricate Yant Ittipiso Paed Tidt design onto my skin. In Buddhism, round Yant represent the Face of the Buddha (Phra Pakt Khong Phra Putta Jao). In the Brahman tradition, it is the face of the God Brahma as the meaning. If the Sak Yant has twelve leaves or points, it represents the cycle of dependent origination known as Paṭiccasamuppādam (the summary Buddha's teaching on the conditionality of all physical and mental phenomena of living beings). If a round Yant has eight outer points (such as the Yant Ittipiso Paed Tidt I had received) or petals, it symbolises the Dhamma wheel, or the Eightfold Path. The most well-known celebrated round Yant used in Sak Yant are as follows: Yant Paed Tidt, Yant Dork Bua, Yant Sariga Lin Tong, Yant Baramee Jee Sip Tidt, Yant Ngop Nam Oy, Yant Mongkut Phra Putta Jao, Yant Paed Daan Yant Mongkol Jakrawal, Yant Maha Mongkol, Yant Maha Laluay, and Yant Jakr Narai. Because this design was meant to be originally applied along with the "group rate" application of the Yant Soi Sangwan (and since, as you may

recall, I was completely unable to handle another round at the time) I had to make a separate offering for this. My offering was handed over to the donation bowl and Ajarn blessed the freshly applied Sak Yant.

This Sak Yant was easily applied. Indeed, I felt that this last Sak Yant was almost painless and its efficacy considerable. In addition to forms of sacred magickal geometry such as this offering incredible and supernatural protection while traveling in any compass point direction, they can also indicate extraordinary abstract concepts to the meditating practitioner. Sak Yant can assist you in your practice, helping you to attain leaps of consciousness and realize subtle truths through meditation and absorption in the ancient geometry of the Sak Yant. Once applied you become the Sak Yant and the Sak Yant becomes you.

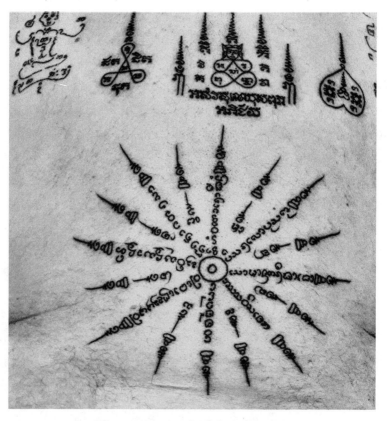

Sak Yant Ittipiso Paed Tidt by Ajarn Daeng.

We spent the rest of the day visiting the remarkable Wat Pha Lat, an ancient, secluded Buddhist temple high in the mountainous forested hills of Doi Suthep-Pui National Park. Vistors to this temple should be prepared for some rough and occasionally wild jungle terrain (think hiking boots), thick and very lush diverse flora and fauna, and a poetic vista at each and every turn. To say that this place was beautiful and utterly transcendent would be a large understatement.

There is a very large cross-section of ancient, modern, and extremely old temples, statues, staircases, water features, and shrines. At one point in its history, this genuinely magickal place was abandoned, which only adds to its profound, sacred atmosphere. Visitors are requested to show their respect to this important site by wearing appropriate clothing (shirts and tops must have sleeves, trousers and skirts must be longer than knee length), and to stay calm as much as possible, speaking in a quiet voice and behaving appropriately at all times. As an active monastery, the temple has a number of monks. You are within consecrated grounds. It wouldn't be difficult or a stretch of the imagination to contract Stendhal Syndrome here, the psychosomatic condition involving rapid heartbeat and fainting, which can occur when a person is exposed to the phenomena of great searing beauty.

I was overwhelmed by this sublime tract of ultimate heaven. Deep peace and serenity engulfed me as walked around Wat Pha Lat. There was far too much here that was memorable to highlight. My visit became an hour and a half of dreamy meditational mindscape musings dedicated to personal awakening.

In the evening after returning to my hotel, I decided to walk up along Huey Kaew Road to visit the Maya Lifestyle Shopping Center to see a film. However, this attempt completely failed. I was still tripping cosmic meditational balls after my epic visit to Wat Pha Lat. Nothing made sense. I was floating, walking around looking for the multiplex

cinemas on the top floor, while at the same time hoping to make some form of sense of everything around me. Seeing a massive pink plastic pig with a wool scarf, knitted wool ear muffs with a large stomach in high red pants sitting in the entrance of the shopping center didn't help much either. When I finally reached the multiplex cinemas on the top floor, I realized I had missed every single film's starting time.

I then decided to try one of the very expensive total massage chairs on the next level. They were uncomfortable and horrid. I continued to walk around dazed. Still, nothing made sense. Wat Pha Lat had opened a portal of divine inner peace and I was still there, tranquil, and happy in a state of bliss; anything else was just an imposition and a silliness affronting my freshly attained samādhi. Directly outside the shopping center was a shrine dedicated to Ganesha, the Supreme God in the Ganapatya sect. Ganesha's popularity in Thailand and across Southeast Asia has exploded over recent years. Various festivals and celebrity endorsements attesting Ganesha's potency have all catalyzed the promotion of this much loved and enduring Hindu deity who enjoys offerings of fruit (particularly bananas), milk, oyster sauce, and steamed rice sweets. The Brahman ritualist Thotsaphon Changphanitkun of Wat Khaek, Bangkok, asserts that the correct times to worship Ganesha in Thailand are between February and July on the ninth and fourteenth of every month (but never on a Tuesday). Every possible facet of inclusion, in all manner of designs for images, hangings, shrines, consecrated amulets, and Sak Yant, have been granted to Ganesha. Thai people identify strongly with the wealth and prosperity promised by this elephant-headed deity, the remover of obstacles, bringer of good luck, patron of the arts and sciences, and the deva of intellect and wisdom. Because of this, it is not unusual to find shrines dedicated to Ganesha at many, if not all, shopping centers. I departed the mall—the image of Ganesha's shrine, brightly spotlit against the backdrop of Chiang Mai's cobalt-blue night now firmly tattooed in my mind—and slowly made my way back to my hotel room where I meditated in peace until I slept.

19
Wat Mae Kaet Noi

*Ajarn Perm Rung's Gift and Goodbye
to the Cats of Varada Place*

Wednesday the fifteenth of January 2020, poured its warm and humid sunlight into my half-closed eyes. I walked over to the balcony in my room and looked out onto a sleepy Chiang Mai. Nothing seemed out of place, there was no sense of trouble or fear. And yet, a mere 1,243 miles away in Wuhan, China, a catastrophe of global proportions was unfolding. The horrors of COVID-19 were spreading like viral napalm wildfire. Thousands upon thousands of people were dying in droves, with survivors suffering the crazed panic of an authoritarian regime, whose denial rapidly gave way to hectic and wild lockdowns, isolation, and forced quarantine for all who had the dire misfortune of crossing paths with this novel, cruel, and terrifying invisible enemy.

Today was my last day in Thailand. I felt sadness and joy in equal measure. I so much wished to live here. I had, over the course of three visits over an equal number of years, fallen madly in love with this beautiful and magickal place. I felt as if I shared a deep intimacy with every aspect of this sublime realm. Although I recall the old adage about only being a tourist and never a resident, my feelings persisted for this strangely, gently chaotic, and weirdly surreal city. As he was fulfilling

his visa commitments, I asked Ronnie about the requirements for a retirement visa. I was surprised to learn that in Thailand, you can retire at around fifty years of age. The requirement was ultimately grounded in having £20,000 GBP for at least three months in your bank account. Although I doubted I would ever be able to meet such a financial requirement, I still dreamed about it.

Ronnie and I would take one last excursion before we made our way to Chiang Mai International Airport for the final time. The plan was to take a road trip to see the Hell Gardens at Wat Mae Kaet Noi in Pa Phai subdistrict, San Sai. The drive out was straightforward without incident or incursions, either by time warp or land spirits. This extraordinary garden was inspired by the abbot Phra Sa'ad (a.k.a. "The Clean Monk"), who had a powerful dream many years ago in which he was instructed to create a garden that would protect the villagers by teaching them the necessary moral codes to live by. A marvel of modern engineering, planning, and sculpture design and shrouded in trees, roving gardens, and a variety of lush greenery. If I thought that the Hell Garden at Chiang Dao Temple was hardcore, the sculptures in the Hell Gardens at Wat Mae Kaet Noi raised the bar.

As I strolled down the path flanked by a legion of coin-operated mechanical horror show machines showing abominations that would thrill any horror fan, scene after extremely violent and phantasmagorical scene in this Buddhist "Garden of Hell" (or Narok in Thai) tattooed themselves in my mind: discarded foetuses; a woman stabbing a baby; an emaciated man and woman, each with bottle in their hands and several more at their feet; a saw grinding back and forth hacking off the hands of thieves; young troublemakers and bullies impaled on giant fish hooks; a man with a wolf's head riding a motorbike over several disemboweled people as punishment for buying or selling methamphetamines; a corrupt judge—bribed to proclaim false verdicts and convict wrong people—his long tongue yanked from his mouth; a man with a penis split lengthwise with an axe; a woman with a pole thrust between

Praying skeleton at the Narok (Hell) Gardens at Wat Mae Kaet Noi.

her legs in retribution against adulterers and nymphomaniacs; a group of women fucking a man to death; a man with an insanely sized penis ripping open a woman so violently her guts spew out; a child spurting blood due to the very long knife inserted into him; a soldier shooting

232 *Wat Mae Kaet Noi*

a man in the back with a huge long telescopic gun sight; and a massive boiling pot filled with screaming people, all in the process of being boiled alive. It was the full nine yards. All of it intended to illustrate the potentially disastrous repercussions one faces if they stray from living a good life.

As in Chiang Dao Temple's Hell Garden, all of this judgement and damnation was overseen by the "Death King," Phya Yom. The textual background for this is from The Upajjhatthana Sutta ("Subjects for Contemplation"), also known as the Abhiṇhapaccavekkhitabbaṭhānasutta in the Chaṭṭha Saṅgāyana Tipiṭaka, a Buddhist discourse which is famous for its inclusion of five remembrances, five facts regarding life's fragility and our true inheritance. Two central Buddhist concepts highlighted in this discourse and echoed throughout Buddhist scriptures are: (1) personal suffering (dukkha), which is associated with aging, illness, and death, and (2) a natural ethical system based on mental, verbal, and physical action (karma). In the related canonical discourses the Devadūta Sutta, King Yama, the righteous god of death, in judging a newly deceased person's destination, asks whether or not the person has seen and reflected upon five "divine messengers" (devadūta). These five messengers are:

1. A newly born, defenseless infant
2. A bent over, broken-toothed old person (aging)
3. A suffering ill person (illness)
4. A punished criminal
5. A dead person (death)

Regarding the five divine messengers, Yama would query: "Good man, did it never occur to you—an intelligent and mature man—I too am subject to aging, I am not exempt from aging: surely I had better do good by body, speech, and mind? . . . [T]his evil action of yours was not done by your mother or your father, or by your brother or your sister, or

by your friends and companions, or by your kinsmen and relatives, or by recluses and brahmins, or by gods: this evil action was done by you yourself, and you yourself will experience its result." In the similarly named sutta Yama's interrogation is reduced to addressing the three universal conditions of aging, illness, and death. It was Maha Thammaracha I (born Li Thai), king of the Sukhothai Kingdom, and the first Theravada Buddhist philosopher to write in the Thai language, reigning from 1347 until his death in 1368 who wrote the *Traiphum Phra Ruang*, a religious and philosophical text that directly drew from the Devadūta Sutta descriptions of the various worlds of Buddhist cosmology, and the way in which karma consigns living beings to one world or another.

While slowly walking through these considerably large and sprawling gardens of this intensely vivid realm of Buddhist hell I was very glad to have taken my camera. I knew documentary evidence of this eye-popping extravaganza of carnage was necessary, as I probably could not rely on my memory to successfully detail it to my exacting standards. While inside this insane theme park Ronnie and I happened upon a group of children who seemed more startled to see us than the surroundings they all found themselves in. Their widened eyes and excitable behavior told me that they all thought this place was a riot and seemed to be loving every single moment of it. Christian hell paled considerably against this monster-sized Buddhist hell. In fact, nothing could have prepared me in fact for this mind-blowing visual head kick all for the cost of ten baht along with the ten baht for each of the many coin-operated, light-festooned horror machines that displayed horrors running the gamut from decapitations to full-on disembowelments. I had never seen anything like it in my life. Working at The London Dungeon had at best only partly prepared me for this shocking butcher's shop of terrors. I could only imagine how the emotional impact might increase when visited at night. (See color plates 13–17.)

After immersing myself in this strange world, the atmosphere back in the car felt a little deflated, as I felt time slowly dripping away as

the departure of my evening flight inexorably approached. Ronnie suggested we go to meet Ajarn Perm Rung Wanchanna at his Samnak, with whom I had discussed the idea of acquiring a Rāhu amulet before I go. The atmosphere then perked up as we traveled over to see this highly respected and successful Ajarn before my flight.

After a short drive we arrived at Ajarn Perm Rung Wanchanna's compound, an impressive complex that houses his family as well as his Samnak and shop, which is packed to the gills with incredible amulets, statues, See Pung, and various other items all pertaining to Thai Lanna Buddhism. His shrine is composed of a stunning array of devotional pieces. At the time I was there he was in the process of extending his compound into the next tract of land beside him. On the veranda was an army of Hoon Payon all made from wicker woven into soldier shapes. In the center of all of this sat a large crocodile head encrusted with numerous yants and semiprecious stones. After Ronnie and Ajarn Perm Rung Wanchanna got done exchanging initial conversation, we all walked into his shop which was a part of his home. I was taken aback by this tightly and well organized retail space packed with every imaginable magickal item. I walked slowly through Ajarn Perm Rung Wanchanna's stock, and was more than impressed by the row upon row of baskets, all full of amulets and perfectly displayed.

Ajarn Perm Rung Wanchanna, who became a Dek Wat (a child at a temple), has had a lifelong interest in magick. His consistent curiosity propelled him to learn all aspects of magick in depth, eventually leading to his ordination as a monk. After learning how to source the materials for amulets, he began to learn the aspects of khatha and Kom script and is now renowned for his talismans and his knowledge of ancient Wicha, Sak Yant, and Kasin Fai ritual. He is a disciple of the legendary teacher Kruba Kampeng, an expert in meditation who was ordained at Wat

Khao Sukrim. Kruba Kampeng specializes in Borikam Phawana, a kind of meditation that requires non-verbal mental chanting for long periods of time. Kruba Kampeng practiced Borikam Phawana for at least eighteen hours a day, continuously, over many years. At present (in old age) he can do eight hours a day. Kruba Kampeng is also proficient at Kasina, a visual meditation that requires one to look at and focus the mind on an object, and is proficient in the wicha of Maha Aoot Kong Kaphan (invulnerability), as well as the "Knowledge of Transferring Universal Energy."

Browsing Ajarn Perm Rung Wanchanna's backstock I saw various items I wished to acquire. I found a magnificent Rāhu amulet—one with a very large load, meaning payload or weight of all of the magickal ingredients included in the amulet—with numerous magickal and spiritually active ingredients. When I checked the price, my heart sank. The asking price was two thousand baht (in 2022, that was the equivalent of around £46 GBP), which I simply did not have. After paying for a guide, hotel, food, and other requirements that are associated with such an enterprise had finally taken their toll on my wallet. My budget had been ground down into nothing, Ronnie asked me if I wanted the Rāhu amulet. I told him that unfortunately, I didn't have any money left. Ronnie relayed this sad fact to Ajarn Perm Rung Wanchanna. It was then that something occurred that had not happened at any point during my three times visiting Thailand. Ajarn leaned over to a basket on his desk, dug into the contents, and threw over to me a surprisingly heavy square cellophane packet. I opened it and realized Ajarn had gifted me an uncased and beautiful golden Garuda amulet.

Described as the king of the birds, the Garuda is a Hindu demigod and divine creature mentioned in the Hindu, Buddhist, and Jain faiths. Throughout *The Mahabharata*, Garuda is a symbol of impetuous violent force, speed, and martial prowess. *The Mahabharata* character Drona uses a military formation named after Garuda while Krishna displays his image on his banner. Thailand even uses the Garuda (khrut) as its national symbol, known there as Phra Khrut Pha, which means

"Garuda, the vehicle (of Vishnu)". Used as the symbol of royalty, statues and images of Garuda adorn many Buddhist temples in Thailand.

Through Ronnie, Ajarn Perm Rung Wanchanna told me this was his gift to me. Ajarn knew that I was flying back home to the United Kingdom that very evening, and had blessed me with this profound amulet of protection with the very wings of the insignia of India, Indonesia, and Thailand itself. I was overwhelmed. I thanked Ajarn Perm Rung Wanchanna by performing a hearty wai toward him. I saw firsthand his compassion in action and felt completely humbled by his kindness and generosity toward me.

As I packed my suitcase later on at the hotel, a sense of finality hovered over me. After checking my room for anything that I may have forgotten to pack, I made my way down to the entrance to say goodbye to the cats. They seemed happy and content, nestled on their plush cushions. For the last time, Ronnie picked me up at the hotel and kindly drove me to Chiang Mai Airport so I could catch my evening flight to Heathrow. After I said my goodbye to him in the crowded departure lounge, Ronnie told me he was going to try the particularly fine Chicken Khao Soi again at the small airport café. As I walked up the escalator toward the international departure lounge I received a final text from Ronnie: "The Khao Soi was fab," he wrote. To which I replied: "Lucky you!"

20
On the Precipice of Pandemic
The Benefits of Acquiring Magickal Protection

On that fifteenth of January, as I passed through Suvarnabhumi Airport in Bangkok, seventeenth busiest airport in the world, eleventh busiest airport in Asia, and the busiest in Thailand, little did I know that the magickal protections that had been inscribed—both literally and figuratively—onto my body and mind during this third pilgrimage (and all of the ones that had come before it) had formed a wall of protection shielding me from contagion. In my mind there could logically be no other reason; traveling through this location would inevitably have brought me into contact with the COVID-19 virus, and yet I was spared from contracting the illness. This is in spite of the fact that on the fifth of January, a mere week prior, a sixty-one-year-old Chinese woman and Wuhan resident flew directly with her family and a tour group from Wuhan to Suvarnabhumi Airport in Bangkok and on the eighth of January, where she was detected using thermal surveillance and then hospitalized. Testing positive for COVID-19 four days later.

Many may find my reasoning for magickal protection to be scientifically unsound. Occam's razor, or the principle of parsimony, is the problem-solving principle that "entities should not be multiplied beyond

238 *On the Precipice of Pandemic*

necessity" and that of all competing theories or explanations, the simpler one (for example, a model with fewer parameters), is most likely the most accurate. It could just be that I got lucky. It could be that anyone infected by COVID simply wasn't in the airport at the same time I was passing through. And yet the heavy burden of likelihood was too weighty for me to pass it off as plain dumb luck.

Returning home to Blighty, a casual, easy atmosphere hung around me. I passed through customs without incident or issue, my collection of artifacts, amulets, and sacred statues all intact. At the very least I felt as if I had been enchanted; nothing could explain or account for my extreme good fortune as I slipped quietly back into the environs of Bristol. My first visual clue of the COVID pandemic hitting the United Kingdom was in February, a few weeks after returning from my third trip, when I saw a sign in the reception area at my local dentist in February restricting care to patients who had been to China or anywhere inside Asia within the last few days. Over the coming weeks and months, the world was to pitch and roll under the apocalyptic waves caused by the pandemic.

But, as the chaos outside continued to increase, the calm and well of stillness inside lengthened and extended. Each day I followed and still follow my practice, starting each morning with khatha of various kinds and making offerings to the shrine. The relationship I have with various amulets, deities, and rituals began to slowly embed themselves into my consciousness until they became part of my life. Either by design or fate or wrought by the rare and occasional emotional splinter or spat, I noticed things beginning to change. People, ideas, and ways of thinking ceased to exist in my life. I had entered the stream and was beginning to transform into a new being, untethered by attachments and unbothered by obstructions.

A noble disciple, bhikkhus, who possesses these four things is a stream-enterer, no longer bound to the nether world, fixed in des-

tiny, with enlightenment as his destination. From *The Connected Discourses of the Buddha, A New Translation of the Samyutta Nikaya*, by Bhikkhu Bodhi.

Over the next two years, with Ronnie's assistance, I was to undertake what I felt to be two very important personal remote rituals. First, I helped my elderly neighbor Margaret (who sadly passed away in April 2021) to receive a candle blessing from Ajarn Suea. Ronnie very kindly sent a Ganesha amulet to her (via me) as a gift to help her through a tough patch. Next, I organized an important ritual for my mother who underwent cataract surgery on her right eye and wanted a similar blessing to help her through this. However, this seemingly simple candle ritual turned into something quite different. I sent Ronnie what I thought would be the correct sum to undertake it. However, when Ronnie then got back to me he told me Ajarn couldn't do it because he needed to do a full and complete Satuang ritual instead. This particular ritual was considerably far more expensive and required an enormous eighty-four catfish to be released into the river at a monastery in Thailand. "That's a fuck of a lot of fish," Ronnie said in the voicemail. Although both my mother and I found this funny, I flinched and felt slightly panicked at the sudden change of pricing. I also wondered whether I was being stiffed in some way or not. Ronnie wrote to me and said that Ajarn Suea has said that he couldn't just do a simple candle blessing for my mother since she needed something far more advanced and robust because of her age (eighty-four years old equaling eighty-four fish), her star sign, and the specific requested requirement, which was a blessing for a cataract operation. Fortunately, with some extra charitable financial tamboon help from Ronnie himself, the ritual blessing was duly carried out; the eighty-four catfish spared, allowed to enjoy the rest of their lives living in freedom in the monastery river.

Over the last few years, I've undergone many rituals that have very much improved and strengthened the basis of my life. Layer upon layer, level upon level, each ritual has had a cumulative and direct effect upon my life in either subtle or sublime ways. Some rituals have been considerably more forceful and direct than others. I found that the two personal rituals that I undertook for myself post pilgrimage to be highly beneficial, offering sublime and remarkable results in many hidden and unseen ways. I found the Narai Plik Pan Din ritual in particular, a ritual of such force that it literally plows open abundance for you, to be particularly remarkable.

On the evening of Wednesday June 30, 2021, the Narai Plik Pan Din ritual was performed for me. Because this ritual can only be performed outside, its completion is totally beholden to the vagaries of the weather and natural elements, in this case, heavy tropical rainstorms caused the ritual to be canceled twice; it was only completed during a third attempt. Aside from cooperation of the weather, there are very specific caveats to be fulfilled in order for this ritual to be executed correctly. Firstly, there are only two days of the week that it can be performed on, Wednesday or Saturday. Mine was performed on a Wednesday, which as you may recall, is traditionally Rahu's day. Secondly, one must supply their name, birthday date and time, and a recent photograph to the Ajarn performing the ritual. Once the donation/offering is made it can then finally take place.

Where does this ritual come from and how did it evolve? Ajarn Apichai himself discussed the basis and the background of this ritual at length on a Facebook post:

Phantai (Phaya Phantai) has been revered since ancient times. The reason for this is that it's believed that Vishnu incarnated as a pig who came down to defeat the demons. Vishnu wished the world to have a happy life. Therefore, he incarnated as Varaha, a black pig or wild boar with a body of ten yojanas, with the height of one

hundred yojana, and sharp white fangs with lightning and smoke coming out of his body. Varaha went on a journey to find land for humans to live peacefully upon. Once Varaha found land the great pig dug deep into the land to till the soil and make it ready for humanity. At that very moment an evil giant Hiranyaksha cried out, demanding Varaha to not dig up the land because the race of giants that already lived there didn't want any human beings spoiling it for them. Hiranyaksha said to Varaha: "You are an arrogant pig and I have to teach you!" The two of them fought each other with the sound of thundering waters. In the end, Hiranayasa lost his stance and fell. Varaha, the Great Black Pig, thrust with his massive fangs through Hiranyaksha's chest. Hiranyaksha the evil giant died as Varaha took his fangs to dig the ground with. The plough which is a part of the ritual is believed to be like fangs of Varaha. Ploughs that have been specifically used in farm work are seen as good tools for this ritual. These have great power as they plough the soil and then the rice is planted. When the rice grows, there is abundance. Phantai has the power to turn your destiny from bad to good, to be prosperous and abundant. It can also be used to clear any mystical bad luck with things now going well!

Varaha is an avatar of the Hindu god Vishnu, the form of a boar. Varaha is generally listed as third in the Dashavatara, the ten principal avatars of Vishnu. Varaha is most associated with the legend of lifting the Earth (personified as the goddess Bhudevi) out of the cosmic ocean. When the demon Hiranyaksha stole the earth and hid her in the primordial waters, Vishnu appeared as Varaha to rescue her. Varaha slew the demon and retrieved the Earth from the ocean, lifting it on his tusks, and restored Bhudevi to her place in the universe. With all this weight embedded within this specific ritual I had high hopes for some form of breakthrough regarding my own abundance. These harsh and extremely uncertain times are creating considerable pressures for many

folks across the world and throughout the spectrum of society. Any Thai Lanna Buddhist magickal ritual that eases this pressure is very much to be welcomed and embraced. The diverse offerings within the beautifully crafted wicker woven trays present at the ritual were many and various.

Rahu is the specific deity directly praised during the Narai Plik Pan Din ritual. The action of praising Rāhu alongside my photograph with a consecrated plow in a ritual with black candles and food did evoke in me strong feelings that maybe this would work. On the first of July, 2021, the day immediately after the ritual, I noticed small, almost imperceptible new buds of abundance gently poking their heads out of the soil of manifestation. I sent a new music project over to a label a day after the ritual. The timing of this was rather interesting. Was this merely a coincidence? I witnessed other small but very pertinent results, such as receiving discounts and offers of discounts from seemingly random people and places, which piqued my awareness that this "abundance" was indeed manifesting for me in unusual and interesting ways. It could be claimed that I was merely inventing significant upswings in personal fortunes when in reality there were none. Nonetheless, I perceived only positive and fortunate effects from this ritual. I feel that the underlying power of this ritual is firstly the strength and craftsmanship of Ajarn Apichai, who is a highly accomplished Ajarn and expert magician. But it is also important to remember that magick is slow and takes time.

I believe that the timing of the ritual (Wednesday the thirtieth June 2021, which is Krishna Paksha Sashti Tithi or the sixth day during the waning or dark phase of moon in the Hindu calendar) also played a significant role in the successful triangulation of auspicious tenants, reinforcing the efficacy of delivery. Indeed, considering that this was only just the beginning of the plow directly digging up my metaphorical soil for abundance, I soon found that the ritual had, overall, already made good on its promise. After receiving an offer

requesting I write an article, along with the confirmation of another future music project, I came to understand that this ritual was indeed well worth engaging in. Then, a mere seven days later, on the eighth of June, I noticed a marked acceleration of fortunate processes, when I received multiple acceptances of written work and other notable opportunities for creating abundance.

The new moon on July ninth in Cancer and the Sun further accentuated this promise with more progressive upswings in personal abundance. This ritual provided unexpected dividends and is an excellent boost in helping anyone seeking extra magickal help to intervene in their lives during harsh and astrologically difficult times. Having a belief and interest in astrology does help but it is not a requirement; the effects of this ritual stand on their own merits. I have been pleasantly surprised by the instances of luck and good fortune that have popped up since I requested the Narai Plik Pan Din ritual from Ajarn Apichai. Another personal ritual I took part in was so very powerful that it ended my friendship with Ronnie, which is something I hadn't seen as likely or even remotely possible. An Ajarn offered an extremely rare and once in a lifetime opportunity to have a magick Takrut using the participant's exact personal astrological and personal details created specifically for this purpose and then placed directly inside a large statue of Buddha at an important Buddhist temple in Chiang Mai. As you may recall, a Takrut is a type of tubular amulet. They have an elongated scroll-like shape and are usually made of metal or palm leaf and are tied to the body with a cord. The Takrut itself has inscribed upon it yantra or yant, which are incantations and sacred geometric designs with Pali Gatha and Buddhist prayers (invocations and empowerment spells) based in Thai Buddhist, ancient Vedic, and animist traditions. These prayers are usually ancient Khom Pali script (a variant of Khmer script used in Thailand). Similar to talisman, Takrut have existed for centuries. Originating from Thailand, they are worn by Thai people as a protective amulet.

In northern Thailand Lan Na Tai Tham script is used in the creation of Takrut. In effect, this ritual encrypts your astrological essence into a spell before being placed inside an object of veneration and sanctuary located in a holy and sacred place. In terms of protection for a lifetime it really doesn't get any better than this. Takrut can be used for all sorts of purposes, from Maha Saneah (attraction, charm, charisma), Metta Mahaniyom (business success and popularity), Maha Pokasap/Lap (riches and attraction), and Kong Grapan (invincibility). The Takrut for the ritual at the Buddhist temple was made specifically by an Ajarn who possessed numerous wicha or knowledge of Thai Buddhist magic, derived from the Kampir Saiyawaet Grimoires of Lanna, Khmer, and Siamese origin, and from early Brahman influence through to the Atharva Vedas. The personalized, bespoke Takrut was then placed inside a large Buddha at the temple with the proceeds from this ritual going for tamboon directed at supporting this and many other Buddhist temples. This is a process akin to placing one's spiritual profile into a perpetually regenerative protection bank.

The hollowing out of—and placing of ritualistic objects inside—statues of Buddha has been a common practice for centuries. A seven-hundred-year-old Japanese Buddhist statue was revealed to contain 180 hidden artifacts crammed inside its diminutive figure. The statuette, found at the Hokkeji temple in the ancient Japanese capital of Nara, is seventy-three centimeters (thirty inches) tall, and has nested within it at least 180 items, including scrolls. Officials at the Nara National Museum, where the Buddha is currently on display, suspected that the statuette had a hidden compartment that contained something. A computed tomography (CT) scan revealed that the statue was basically hollow, the incredible X-rays revealing what looked like to be around thirty scrolls, relics, and other items ensconced inside the head section, and another 150 or so hidden in the rest of the figure.

On the Precipice of Pandemic 245

Also seen as an act of consecration, it is thought that placing objects inside a sculpture brings the figure literally back to life. Inside statues of Shakyamuni Buddha,* items such as amulets, Takrut, perfumed ashes, human organs, sutras (Buddhist scriptures), and other extraordinary items have been found. Researchers brought a millennium-old statue of the Buddha, which had been on loan to the Drents Museum in the Netherlands, to the state-of-the-art hospital Meander Medical Center in the Dutch town of Amersfoort in the hopes that modern medical technology could shed light on an ancient mystery. Hidden inside the gold-painted figure was a secret—the mummy of a Buddhist monk in a lotus position. The monk's organs had been removed and replaced with scraps of paper printed with ancient Chinese characters and other rotten material that has yet to be fully identified. The body is thought to be that of Buddhist master Liu Quan, a member of the Chinese Meditation School who died around 1100 BC. How the organs had been removed from the mummy remains a mystery.

The Buddha that had been cast for the ritual was in the Act (position) of Vanquishing, thus aiding its overall ability to protect the Takruts inside. This unique and exquisite Buddha was cast at a specialist foundry based near Phitsanulok, Thailand. The Buddha would then be installed and then blessed by the abbot of the temple. The Takruts of each person taking part in the ritual (including myself) were made in silver using their personal astrological details.

Aside from handing over my birth date, my active involvement was not necessary. Ronnie, who was helping to facilitate the ritual, sent me three videos and four photographs, accompanied by the following text: "Keep the vids and practice putting yourself into the Buddha." Done in order to center oneself in times of stress and anxiety, the practice of meditating yourself to be inside the statue of the Buddha was known to me long before Ronnie mentioned it.

Shakyamuni means "sage of the Shakya clan." It is another name for Buddha since he was born to the rulers of the Shakya clan.

In Burmese esoteric Buddhist congregations, meditational rituals around the practice of five visualization techniques, echo the idea of meditating yourself into the inside the statue of Buddha at Wat Doi Kham. Firstly, the devotee meditates sitting in front of the Buddha, visualizing an audience of Devas observing the exchange. A halo of six colors radiates from the Buddha. Devas pay respect to the Buddha as they rise from their seated position on the throne in the air. Secondly, the Buddha is seated above the head of the devotee. Thirdly, the Buddha slowly sinks down and covers half of the body of the devotee. Fourth, the Buddha moves up and down covering half of the body of the devotee. In the fifth and final stage, the Buddha completely covers the devotee, who is then transformed into the Buddha. The Buddha then contracts and dwells in the chest of the devotee with the Devas paying their respects, and the devotee has the Buddha now dwelling inside of them.

I felt that it would be okay to take one of the photographs from the ritual, crop it, and use it as a mobile phone background since I had become a part of a consecrated Buddha that would be enshrined at the temple. I then shared the carefully cropped photo onto my Facebook account, being careful to use the "friends only" setting. Since I had just under fifty friends on my account at the time, I really didn't think anything of it. Shortly after creating this post, a terse reprimand came from Ronnie dictating to me to remove it and change my post entirely.

For some strange and inexplicable reason, it felt as though something between Ronnie and I had just irrevocably ended. Over the course of our association Ronnie had, for no apparent reason, sent messages to me requesting that I immediately take down photographs I had posted of either myself and him together, solo photographs of him, or anything else that connected us in any way whatsoever. It was at this single moment that it dawned on me that Ronnie was more than just a sometimes slightly grumpy or irritable person; he was in fact a compartmentalizing control freak. I now strongly sensed that Ronnie possessed an underlying controlling and manipulative agenda. Having attempted

to embody the precepts and asceticism of Buddhism over the decades, something clear and deep inside spoke directly to me that it was now time to unfriend and unfollow Ronnie and respectfully move on. I respected (and still ultimately respect) Ronnie now, but now maintain certain reservations as to his overall intentions. From this time onward, I ceased answering any of his messages.

The statue of Buddha in The Act (Position) of Vanquishing now took on another meaningful resonant message. Although the very presence of this book might state otherwise, up until this point I had not willingly sought to make money out of my devotion to Buddha. And although the Taliban gave their own deluded reasons for destroying the ancient statues of the Buddha along the Silk Road, I do not harbor any strict or straight hard-line attitudes that attempt to impinge upon any creative innovative Western interpretations of how Buddha's image is used or represented. However, for me, requesting anyone to take down images of the Buddha (or indeed any revered holy image for that matter), irrespective of its perceived ownership or reasoning, is an anti-Buddhist sentiment. If this had indeed been consistently carried out over time, the simple, clear, and explicit instructions of Buddha's seated enlightened position would never have reached or impacted many countless people in the past, present, or indeed into the future, including myself. The lotus position (or Padmāsana) is an ancient cross-legged sitting meditational pose described, along with other asanas (sitting postures), in the eighth-century book *Patanjalayogashastravivarana*. The sacred lotus is used as a symbol of growth toward perfection and enlightenment as it is rooted in the mud at the bottom of the pond. Nobody owns the Buddha and nobody and nothing is higher than the Buddha.

I remembered one of the core teachings of Buddhism that clearly resonated for me at this sad but very necessary time of cutting away all of the ties that bind:

248 *On the Precipice of Pandemic*

At Savatthi. Standing to one side, that devatā recited this verse in the presence of the Blessed One:

'How many must one cut, how many abandon,
And how many further must one develop?
When a bhikkhu has surmounted how many ties
Is he called a crosser of the flood?'

The Blessed One:

'One must cut off five, abandon five,
And must develop a further five.
A bhikkhu who has surmounted five ties
Is called a crosser of the flood.'

(From "How Many Must One Cut?" in *The Connected Discourses of the Buddha: A Translation of the Saṃyutta Nikāya*.)

21
Cat Yants, Baphomet, and Jackfruit

Following the Trail of Peter Christopherson

One of the amulets I had acquired from Thailand is of great beauty and considerable power. It was apparent from the get-go that the Cat Yant Prai Nine Takrut amulet by Ajarn Tui wasn't like any kind of amulet I'd come across before. From the moment I opened the box that had taken three weeks to arrive from Thailand I knew that this amulet possessed a unique atmosphere, exuding a power and potency that makes it quite possibly one of the strongest protective amulets I currently own and work with. The detailing along the front of the amulet casing had fine finishing touches imbued by quality craftsmanship. The casing itself, which takes weeks to finish, is the main vessel for the magick. The seemingly brutalist style of the front plate inscribed with yantra script might be initially construed as vaguely primitive. However, one must not underestimate this amulet ("never judge a book by its cover," as they say).

As soon as I put the amulet on around my neck, an intense feeling, akin to a form of nervous trembling, overtook my entire upper body. I was surprised by this amulet's field of gravity and my marked physical reaction to it. Nothing has had an effect on me quite like this amulet,

apart from my interactions with a human leg bone amulet suspended in liquid prai, which nearly made me faint. As I ate dinner that evening, I tried to ride out the waves of energy that swept my body again and again. As time went on, these initial feelings decreased and have become more manageable. During what I'll call the initial rush, racing thoughts about a person that had attempted to mock and humiliate me indirectly on their social media feed coarsed through my mind. I directed my anger about this person directly into the amulet and asked the amulet to deal with them. The khatha for this is short and fairly easy to master and is to be repeated over nine times: Gan Ha Nae Ha.

Symbolically, cats possess special meaning in many cultures. In Celtic mythology, a fairy known as Cat Sìth takes the form of a black cat. On the harvest holiday of Samhain it's believed Cat Sìth could bless any household whose members left a saucer of milk out for it. Cat Sìth is also seen as a witch that can transform nine times. These transformations are reflected in an old English Proverb that says: "A cat has nine lives. For three he plays, for three he strays, and for the last three he stays." Thomas Fuller's 1732 book, *Gnomologia: Adagies And Proverbs, Wise Sentences And Witty Sayings, Ancient And Modern, Foreign And British*, expands upon this proverb with: "A cat has nine lives, and a woman has nine cats' lives." In Chinese culture, the number nine—called "the trinity of trinities" and considered one of the luckiest numbers—is also associated with cats, whom Chinese tradition also believes have multiple lives.

This is the first time Cat Yants—originally used in Sak Yant form only—have been made to wear in an amulet form. Originally, the Yant design was given only to certain chosen people. There is a terrifying ritual in which a person requesting the Cat Sak Yant is buried alive in a graveyard, their subsequent escape out of the grave being

the sole criteria used by the Ajarn to determine their suitability for receiving the Yant. So what exactly do the Cat Yants do that would require the interested party to be buried alive? Cat Yantras, most often applied around the waist in sets of nine or twelve, are legendary, must-have Sak Yants in the criminal underworld due to their ability to enable evasion and offer extreme stealth protection from practically any form of danger. The prize for surviving being buried alive was the bestowing of supernatural abilities that would give the wearer special cloaking abilities when involved in subversive activities, similar to the protection afforded by a VPN (virtual private network), which encrypts data and masks IP addresses to create a secure and private connection between a device and a remote server.

Although I decided that breaking the law in order to test-drive an amulet was probably not such a good idea, as it would require me breaking the precepts that I endeavor to hold and follow, I knew that evasion and avoiding danger can help with many non-criminal issues as well. As such, I felt that possessing such a power to cover my spiritual arse was still a good idea in the long run. For example, evasion may be viewed as a way to fulfill the obligation to tell the truth while also keeping secrets from those not entitled to know the truth. It dawned on me that the old school method for selecting bearers of Cat Yants—burying the seeker of the yant alive to see if they survived—was akin to the intense feelings I had experienced when first wearing the amulet.

The Takruts encapsulated within the amulet have been burned with the wood of a local maai kanun tree, otherwise known as the jackfruit tree (*Artocarpus heterophyllus*). Archaeological findings in India have revealed that jackfruit was cultivated in India three to six thousand years ago. In Vietnam, jackfruit wood is prized for the making of Buddhist statues in temples. The heartwood of the maai kanun is used by Buddhist forest monastics in Southeast Asia as a dye, giving the robes of monks in those traditions their distinctive light brown color. The Cat Yant Prai Nine Takrut amulet has also a male prai powder

mix from an accident victim, used as a binding agent to hold all of the Takruts together. While wearing my Hoon Payon amulet makes me feel like I'm driving a tank, wearing the Cat Yant Prai Nine Takrut amulet makes me feel as though I'm piloting a nuclear-powered aircraft carrier.

In terms of the future of magick in Thai Buddhism, hybridization is the next destination (Ajarn Mom Niranam Tribumi's remarkable glow in the dark and universal consciousness–focused Alien UFO Three Face Coin amulet, blessed by seven masters, is a case in point). It is however the work of the Ajarns, whose focused attention to the fusing of philosophies and hybridizing belief systems, that (for me) pays the most real and profound dividends. One rare example of hybrid magick crafting, Ajarn Apichai—without a doubt one of the finest and most accomplished Ajarns of his generation—has succeeded in weaving together diverse, Eastern and Western occult traditions and etymologies, to create the sublime and powerful one-of-a-kind Baphomet Prai amulet.

While some sources claim that the name Baphomet is a bastardization of the French *Mahomet*, it is speculated that the name may also be an almagam of the chief Latin phonemes "BAsileus PHilosophorum METaloricum," which is the sovereign of metallurgical philosophers. Otherwise known as The Sabbatic Goat, Lord of Balance, or The Goat of Mendes, this deity, which has its origins in Christian, Islamic, and Thelemic traditions and symbolizes the equilibrium of opposites, representing balance and the confluence of opposing forces, is now further enhanced by the sublime and profound majesty of Thai Lanna Buddhism and the work of a great Ajarn. The Baphomet amulet has many forms of prai inside, such as Phi Tai Hong ashes, Phi Tai Tong Glom ashes, and Prai Kuman ashes, along with prai from a male playboy who died on Saturday and was cremated on a Tuesday. These ashes, collected by Ajarn over a period of ten years, which have now been

mixed with ashes he collected from over one hundred different grave-yards, further mixed with more than one hundred kinds of Waan Maha Saneah powders, provides a powerful foundation for the magick within this piece to thrive. Once the required khatha is chanted, "Aehi Ba Pho Met, Maa Nee Maa Jut Ti, Ba Ti Son Ti, Itti Ritti, Jit Jay Ru Nee, Jit Tang Jay, Ta See Gang, Ru Pang Ni Mi Tang, Nu Paa Wa Toe, Na Ma Pa Ta," a fuel injection of causality, enchantment, and coincidental happening accompany it.

The Baphomet Prai amulet by Ajarn Apichai appeals to those that quest regularly within the realms of "androgyne" experimentation. Baphomet was summoned by Ajarn Apichai as an angel within a Thai Lanna Buddhist necromantic ritual. Hybridization is the future and the future is progressive and inclusive. Progression and inclusion are the touchstones for survival. Magickal transformation however can be a messy thing. It is not a sleek or clean process in any way whatsoever. In fact, it can often be a violent, painful—and at times deeply unflattering—event to behold or experience. Fortunately, unlike the Seth Brundle character in David Cronenberg's mutation bonanza *The Fly* (and although the idea of becoming seriously unbalanced and unhinged in some way was a possibility at certain points), my own magickal transformation was not some form of explicit body horror evolution/devolution marked by an intermittent series of bizarre and shocking hybrid manifestations ending in a descent into total madness. That is not to say my body and mind did not change. Indeed they did. After embarking on my series of pilgrimages to Thailand, following the long trail left by Peter Christopherson, by moving through all the elemental rituals of fire, air, water, earth, and sacred magickal ink, along with a certain amount of considerable pain (all augmented by many profound blessings), I found that I had undergone numerous and notable changes, some subtle, some seen and some unseen, that ultimately led and evolved me to where I am today.

Thank you, Peter Christopherson, your passing into the underworld made during a heart attack while asleep, countless blood clots dwelling

inside your body from years of air travel, countless myriad diamonds of your sublime artistry scattered across totality, the Left Hand Path summoned, followed, and then finally completed on the twenty-fifth of November 2010 in Bangkok.

Throughout the history of literature, one can find a plethora of instances that illustrate the idea of magickal transformation. The metamorphosis of the human being requires willingness by the subject to accept and build upon the changes requested of the philosophy that they are engaging in. Thai Lanna Buddhism adheres to a long-term view; although some activities such as Sak Yant and Kom curses may prove to be an exception, most healing and magick employed in a specific undertaking does not happen overnight. It was only over a period of three years, and only by carefully following the Five Precepts in conjunction with a daily practice and an adherence to certain rituals, that I experienced a total magickal transformation. My personal, day to day experience of life has considerably improved. Some may believe that the cultural nature of this highly unusual form of Buddhism relates to and bolsters only a strict form of specific Thai national identity. Maybe so. And yet, the magick I experienced during my intense pilgrimages and continue to personally practice has not only worked for me but has meaning that has developed into a long-term part of my life.

Is this just another case of some Westerner shacking up to a philosophical Thai bride? I think not. The pathway I've followed throughout my life has had a definite sequence and a clear evolving relationship with Buddhism, shamanism, and all of the magick inherent to it. Those that reduce the act of going on a pilgrimage to a form of "spiritual tourism" need to seriously reexamine and consider their reasons and motivations for doing so before they venture anywhere near such an undertaking. For into a brand-new unknown realm of existence and hidden supernatural forces you'll go, with the you that you were then also along for the ride. Maybe the old you will survive in some form. Or perhaps the ego will struggle and fight and try to keep its head above the water line of fate

that rises so fast you find you don't have enough time to pack up your fragile and brittle identity before it falls and shatters on the floor. As you travel over the flood plains, mountains, and endless roads of pilgrimage there will be no time to look back or doubt. Ties will be cut. Even the ties of those that seem to act as a guide for you—as it was with Ronnie and me—will be cut.

The idea of cutting a mental fetter, chain, or bond in Buddhism stems from the Pali canon. The word *fetter* is used to describe an intra-psychic phenomenon that ties one to suffering and shackles a sentient being to saṃsāra (the beginningless cycle of repeated birth, mundane existence, and dying again), the cycle of lives with duḥkha ("suffer-ing," "unhappiness," "pain," "unsatisfactoriness" or "stress"). By cutting through all fetters, one attains nibbāna (the ultimate state of soterio-logical release, the liberation from duḥkha and saṃsāra). All of this is easier said than done. And yet it must be done, for your personal prog-ress depends on your willingness to renounce your former life. No, you are not shaping yourself up to enter a monastery. What you are doing is, at the very least however, becoming a sotāpanna ("stream-enterer"), a person who has seen the Dharma and thereby has dropped the first three fetters that bind a being to a possible rebirth in one of the three lower realms (animals, hungry ghosts, and beings suffering in and from hellish states). For many this is enough, and for some years this was enough for me. Daily practice however leads you beyond this starting point and can over time develop things into something more.

Backward and forward, from here to America and then from America back to here and then a pause and then from here to Thailand, four times, backward and forward, I have ping-ponged across the planet flying like the Garuda. Buddha lived probably around 400 (not 563–483 BCE) which puts him slightly later than the Sophistic and Socratean Greeks. And yet the sound of the mother of all mantras, āum, defined by the symbol ॐ (from the Sanskrit "to urge" or "to attain") has been the underlying pulsation and emanation that has driven and

directed me. Maybe it was my quest to produce the sound of āum in my practice, music, and sound design, re-creating my visionary, mystical, or shaman-like experiences, that has led me across the world. Maybe there is some form of goodness and contentment to be found in this pursuit, working to create vortexes of love, peace, tranquility, and divine magick.

Asunder fly my ears, asunder my eye, asunder this light which has been put into (my) heart. Asunder wanders my mind, pondering far away.

—Bharadvåja Bårhaspatya in *Rigveda* 6.9.6-7

22
Remote Rituals

Ajarns Are Buddhist Technicians

Rituals performed distantly by an experienced Ajarn can and do have a real and substantial impact on a devotee who may not necessarily have to be present for this ritual to have an effect. Timing plays a part as well. I have gone through a number of remote rituals and can safely report that their depth and fecund nature are not blunted in any way whatsoever by the participant's geographical location. Their efficacy can be delayed however (as I have stated previously, Buddhist magick can be a slow and accumulative process), so it is important that instant gratification is not the aim.

I have undergone a series of remote magickal candle rituals with Ajarn Suea, Ajarn Nanting, and Ajarn Tui. Each of these rituals has had a real and significant impact on my life and also on my mother's life. On the twenty-second of October, in 2019, both myself and my mother participated in a Serm Duang candle ritual with Ajarn Suea, conducted in his Samnak in Thailand. Two handmade magickal candles were prepared, a photo of each of us, along with our names and dates of birth were supplied to Ajarn beforehand. Since this ritual happened during a period of time after my mother's diagnosis of breast cancer, just a couple or so months before my third pilgrimage with Ronnie in January 2020,

I hoped for some positive yields. I can say safely that it did. I feel very strongly that this particular ritual extended my mother's life by roughly three years and nine months. Not only did her cancer go into remission, but my third pilgrimage was also very successful.

A superb practitioner of candle magick, I have been extremely privileged to have had personal rituals undertaken by Ajarn Suea that have involved his excellent handmade candles. The Satuang ritual he performed for me during the Wolf Moon, as well as during his Serm Duang rituals, Ajarn dripped wax into the buckets of holy consecrated water, which are then used either for sprinkling upon the devotee or, in the case of the Serm Duang spiritual cleansing, the entire contents are poured over the head and body of the devotee. This magickal rite is called Yot Thian ("dripping wax"). When the chanting for the specific ritual ceases, the candle is then doused into the water and the consecration is then complete. The consecrated water is then sprinkled over the devotee using a bunch of twigs bound together, which then confer power.

Ajarn Nanting undertook the 2023 New Year's Day magickal candle ritual at the Mae Surasatee shrine near his home. I was fortunate enough to participate in this ritual as it is a strong ritual to undergo at the beginning of the year, popular among devotees for the effects of good fortune and protection against evil spirits that it brings. Again, the effects I felt (and still feel) were long lasting, making a real impact on my daily experience. Creating channels of protection within your own timeline are positive rituals to have done by an experienced and highly practiced Ajarn and sorcerer such as Ajarn Nanting.

The magickal candle ritual for work and luck, undertaken by Ajarn Tui (another very experienced and highly adept sorcerer), conducted at his shrine in March 2023 was a more personalized ritual. Topping up the magick from any previous rituals, it carried a new wave of accumulated magickal spell-casting toward me. Regular candle magick rituals from a trusted and experienced Ajarn can bring countless benefits to

the devotee. The candles are handmade using natural products. They are blessed, consecrated, and then burned at the precise astrological coordinates that guide the Ajarn to the exact timing for the lighting of and placement of the candles. This is done in order to extract the maximum impact in terms of auspiciousness and magickal pungency. If the devotee is present in Thailand for the ritual, yet another layer of added fecund magick can be installed into the candle itself, using strands of hair and personal details supplied by the devotee themselves.

Yet another remote ritual was peformed on the twenty-seventh and twenty-eighth of November, in 2023. On these dates, Ajarn Nanting performed the Loy Krathong ("to float ritual vessel or lamp") ritual, first at the Mae Surasatee shrine at his Samnak, and then (on the second evening) at a small river with a gentle flowing stream of water at an undisclosed location. On both days the ritual occurred at night. The Loy Krathong celebration takes place across Thailand in order to thank the Goddess of Water and River, Goddess Khongkha, or as she is called in Thailand Phra Mae Khongkha and also commemorates a holy footprint left by the Buddha by the banks of the Namada River in India. Phra Mae Khongkha is an emanation of the Hindu personification of the Ganges River and is known as Ganga in India. Ganga is often depicted riding a crocodile-like creature called Makara and mirrors the zodiac sign of Capricorn. Like Ganga, Phra Mae Khongkha is venerated and worshipped for her forgiveness of sins and her capacity to cleanse. Loy Krathong occurs on the evening of the full moon of the twelfth month in the traditional Thai lunar calendar, which is viewed as an extremely auspicious and lucky date.

My photograph, along with my date of birth and name was placed inside a Krathong, or buoyant decorated basket also containing a candle, incense, flowers, and lotus flowers, and was floated on a river. This ritual is seen to promote good luck and prosperity and to symbolically remove any resentment, anger, and negative feelings that may have accumulated over the year by literally floating them all away. I watched a

video of the whole process and found it to be a charming and utterly beautiful ritual to behold. As to the luck generated by this ritual and any consequential effects, I certainly found that there occurred a brightening and lightening of the general atmosphere afterward.

Ajarns are Buddhist technicians. They read all things (see and unseen) and refer to astrological manuals while scrying any reliable oracles when casting their magick. As well as being technicians they are knowledge repositories. They have inherited texts, diagrams, and admixtures of very rare and profound spiritually active ingredients handed down from their teachers and their teachers' teachers. Writing a definitive and academically sound book on the subject of Thai Buddhism and the "magick" therein would be fraught with considerable issues and become a living logistical nightmare to collate, since all Ajarns keep many unwritten and hidden secrets. Not only do they keep many hidden unrecorded secrets, but they also actively—through the art of misdirection—keep at bay any unwanted Western eyes from viewing important and foundational knowledge directly transmitted from teacher to student only. Interviewing them individually and acquiring at best what is a secondhand translation is not the whole story. There is certain knowledge that continues to be held in the oral tradition only. Therefore, attempting to compile into book form such a vast and endless tract of knowledge would ultimately be a risky and problematic act because the devil (as they say) is in the details; when the details are deliberately withheld, any form of full and complete disclosure is impossible.

Eastern philosophy, and all of the magick therein, has been quietly embedding itself into Western culture for quite some time. In 1954, a sixth-century Indian bronze Buddha statuette currently on display in the Swedish History Museum (in Stockholm) was discovered on Helgö, an island in Ekerö Municipality in Stockholm County, Sweden. Now known

as a major archaeological area, the old trading town on Helgö emerged around the year 200 CE. Looking back, it is easy to see that the Vikings have always been ahead of the curve in subtle and prescient ways.

In late 1852, Helena Petrovna Blavatsky's (a.k.a. Madame Blavatsky), quest for an alternative spiritual system in India ultimately led to the founding of The Theosophical Society, the organizational body of Theosophy. Founded in New York City in 1875, Theosophy—an esoteric new religious movement—drew upon European philosophies such as Neoplatonism and occultism, and Asian religious traditions such as Hinduism, Buddhism, and Islam. Crowley himself regarded Madame Blavatsky as his spiritual predecessor. It's worth noting that the very first Buddhist buildings in England were based on the Theravadan tradition, which is the state religion of Thailand (followed by almost 94 percent of the population), found also in Sri Lanka, Myanmar, and Southeast Asia. The London Buddhist Vihara was founded in 1926 by Sri Lankan monk Anagarika Dharmapala. First based in Ealing, after moving several times, it has come to occupy a building in Chiswick since 1994.

I mention this seemingly digressive connection only because Thailand is a Buddhist country that follows the Theravada ("Way or Doctrine of the Elders") tradition or denomination of Buddhism. The "elders" in question are the monks that preserve the traditions of Theravada Buddhism, which is one of the most conservative of its branches. Theravada came to Ceylon from India in 250 BCE. For a thousand years it existed mainly in Ceylon and southeastern India. Then, in the eleventh century it migrated from Ceylon to Burma, before eventually making its way into Thailand, Laos, and Cambodia. There is however evidence (dated c. 600 CE) for Pali, and therefore Theravada Buddhism, in the kingdom of Dvaravati in central Thailand. The regions of Bangkok, Chonburi-Rayong, Ayutthaya, Issan, Nakorn Pathom, northern and Lanna, Southern Region, Petchburi Province, and central Thailand do indeed all have their

own numerous and complex grimoires alongside countless subsets of various inherited grimoires.

Each town, city, and village has its very own special flavor and folklore idiosyncrasies. King Naresuan the Great, the eighteenth monarch of Ayutthaya Kingdom and second monarch of the Sukhothai dynasty, was king of the Ayutthaya Kingdom from 1590 CE until his death in 1605 CE. He ordered the Wicha Saiyasart Grimoire texts to be inscribed and stored at Wat Pradoo Roeng Tam. Many ancient magickal wicha of the grimoires were based at Wat Pradoo Roeng Tam, considered a great library of ancient magickal grimoires, perhaps the largest in Thailand. The great undertaking of inscribing and storing the ancient grimoires commenced in 1590 CE and was completed in 1605 CE. Since 1888, under the reign of King Rama V, Thailand adopted the Solar Calendar, also known as the Gregorian calendar. Years are counted according to the Buddhist Era, that is, 543 years greater than the Gregorian calendar.

It is important to view Thai Buddhism as a whole and not a series of singular separate subjects. Thai Buddhism is not a form of magick on its own. To fixate solely on the magick within Thai Buddhism and isolate it from from the broader context of the Buddhist system it resides in is dangerous. Those that present themselves in the field of transcendental magick in Thai Buddhism without ever acknowledging the Buddha and the extraordinary and compelling contributions of this great spiritual leader are charlatans and fraudulent tricksters, much like the sleight-of-hand and deceitful legerdemain performers that jump and pounce across the stage, hoping to trick you with their clever and convincing acts of dexterous deception, vampirically seducing your attention while cashing in on your subservience and patronage. Repeating a lie of omission until people start to believe in you is something Paul Joseph Goebbels and Carlos Castañeda made into an art form. Selling knowledge alone, purely for its own sake and not actually participating in any of the core values of the philosophical

system from which it emanated is, unfortunately, common and (in my opinion) a weak and highly inadequate form of spiritual leadership, one that begs to be rejected.

However, for every charlatan there is a person of integrity. Take Cecil Williamson for example. Screenwriter, editor, film director, and influential English neo-pagan warlock and founder of the Witchcraft Research Center* and the Museum of Witchcraft, Williamson was an authentic and active practitioner of magick in his own right. Williamson met Austin Osman Spare (English artist, occultist, draughtsman, and painter) through a mutual friend Gerald Gardner (Wiccan, author, amateur anthropologist, archaeologist, and founder of Gardnerian Wicca) in a South London café, where they discussed the idea that "thoughts are things" (a phrase used often by Williamson) at great length. One of the key elements in Spare's magickal system was the manifestation of images from his inner world into physical form. Even Aleister Crowley himself, whom Cecil Williamson met through Gerald Gardner, initially took refuge in the triple gem of Buddhism.

Elements of magick are indeed contained within the Pali canon in the forms of supernormal powers such as mind reading, a skill gained through ascetic or meditative practices as listed in the Kevaddha Sutta. That being said, the Pali Canon also warns that a preoccupation and obsession only with magick will ultimately become a fetter that must then be broken in order to achieve enlightenment. Maybe this is something that Williamson, Gardner, Spare, and Crowley may each have been just a little remiss in looking into. The trouble with the illusion of magick is that mere belief in it creates more demons. For me, Buddhist monk Ananda Metteya's final position, in which he renounced all of his former attachments, mastery of magickal techniques, psychic powers, and esoteric knowledge gained while a member of the Hermetic Order of the Golden Dawn in order to further fully embrace Buddhism, is one

*The Witchcraft Research Center was a part of MI6's war against Nazi Germany.

264 *Remote Rituals*

of the most powerful and profound acts of leadership, renunciation and nonattachment ever known in modern spirituality.

Buddha does recognize the idea of miracles, however. As written in the Pali Canon, and in particular the *Buddhadhamma; The Laws of Nature and Their Benefits to Life*, the Buddha classified psychic powers as one of the three kinds of miracles (pāṭihāriya):

1. Iddhi-pāṭihāriya: the miracle of performing psychic powers.
2. Ādesanā-pāṭihāriya: the miracle of mind-reading.
3. Anusāsanī-pāṭihāriya: the miracle of instruction: the teaching of truth, which leads to true insight and fulfillment.

23
The Final Pilgrimage
The Death of My Mother and the Arrival of Magia Thai

On the twenty-ninth of July 2023, my mother, Muriel Griffiths, died between the hours of two and six o'clock in the morning. After approximately two months of intensive palliative care and twelve years of acting as her daily caregiver, I watched my mother die from metastasized breast cancer. She was eighty-six years old. While caring for my mother I became acutely aware that I was actually watching her slowly die. In Buddhism, Maranasati (mindfulness of death, death awareness) is a Buddhist meditation practice of remembering and keeping in mind that death can arrive at any time. Buddha extolled the virtue of diligence each and every moment. In order to better meditate upon this, an American Buddhist monk allegedly kept a photo scrapbook he dubbed "The Buddhist Playboy" filled with photos of decaying corpses. Indeed, "corpse meditation" is an integral aspect of Buddhism, whose foundation lies in the Aṅguttara Nikāya, Satipatthana Sutta, and the Kayagata-sati Sutta, whose sections on the cemetery contemplations focus on nine stages of corpse decomposition as follows:

266 *The Final Pilgrimage*

- A corpse that is "swollen, blue and festering"
- A corpse that is "being eaten by crows, hawks, vultures, dogs, jackals or by different kinds of worms"
- A corpse that is "reduced to a skeleton together with (some) flesh and blood held in by the tendons"
- A corpse that is "reduced to a blood-besmeared skeleton without flesh but held in by the tendons"
- A corpse that is "reduced to a skeleton held in by the tendons but without flesh and not besmeared with blood"
- A corpse that is "reduced to bones gone loose, scattered in all directions"
- A corpse that is "reduced to bones, white in color like a conch."
- A corpse that is "reduced to bones more than a year old, heaped together"
- A corpse that is "reduced to bones gone rotten and become dust"

Corpse meditation has a purpose. When you see someone, you are merely beholding the external aspects of that physical person. In fact, our insane and torrid obsession with the outer body and all that it entails fails to consider the fact that we are made up of things like organs, bones, liquids, and fluids. Being reminded of the true nature of life, the impermanent and transitory nature of existence, is something we could all take the time to dwell upon.

Caring for my dying mother certainly gave me a crash course in this philosophic idea. I sincerely hoped that I would be able to care and support her while also being mindful of her slow and gradual disintegration passing into divine emptiness. Alleviating her fear, pain, or discomfort was the best I could offer her. Every day I brought her medication, liquids, sustenance, kindness, and any humor I could muster given the dire nature of the situation. The ensuing tidal waves of grief taught me that like an emotional nuclear weapon, death has a destabilizing aftershock that knocks you completely off your feet.

My years of hypervigilance as a full-time caregiver, left me feeling adrift, floating alone in space, dazed and numb. My grief was the bus driver waking me up after falling asleep on the night bus. My grief was total exhaustion with intermittent soliloquies to a ghost. My grief was a crater that I slowly but surely climbed from as I was constantly triggered by small and innocuous things that reminded me of my mum. My grief was a desert island that I patiently waited to be rescued from. My grief was the silence, the sunrise, and the dusk. My grief was sleeping in the afternoon on the sofa. My grief was talking and weeping uncontrollably about the massive new hole in my life to bereavement support counselors on the phone. My grief is something that I'm slowly but surely learning to live with. I knew deep down after my last visit that I would go on pilgrimage once again to meet the Ajarns of northern Thailand after the death of my mother. On the fourteenth of September, in 2023, nearly three years after my last visit in January 2020, this knowledge would manifest into reality.

Since I had ceased all communications with Ronnie, I would need to find a new connection to help facilitate my final journey to Thailand. I was grateful then to make contact with Magia Thai, an Italian Thai amulet website and ritual specialist with many local contacts and international connections, embedded in northern Thailand for over fifteen years. Over a period of ten months, I engaged in what I tentatively call "trust building" exercises with Magia Thai; I acquired amulets, Pha Yant, Bucha (statues), booked remote rituals with various Ajarns, and began a regular correspondence with them, all culminating in the organization of my final pilgrimage to Thailand.

Magia Thai had a highly experienced and superior female translator and seasoned, professional fixer and driver with deep contacts. I intuitively felt that the quality of my experience with Magia Thai

would be broader and more inclusive than my expriences with Ronnie had been, not only in terms of my room and board but also in terms of their ability to facilitate my interpersonal exchanges with the Ajarns themselves. I worked with Magia Thai to establish an intensive and event-filled two-week itinerary for September 2023. Over the course of these two weeks I hoped not only to further expand my knowledge base but—through numerous magickal rituals and the implementation of new Sak Yant—to prepare a strong and firm basis for what was essentially an entirely new life that now lay before me. My aim was simple: to totally transform and heal myself once again. I wished to cast off my previous self, that old and now redundant version of me hanging like a shroud over every aspect of my existence, and transform myself into a new magickal being. Although my old self had served me well, it was now once again time to say goodbye.

Little did I know that my fourth pilgrimage would be nothing short of an incredibly profound and intensive bombardment of raw, vital, sublime, and transformative *peak experiences*, which psychologist Abraham Maslow (in his 1964 work *Religions, Values, and Peak Experiences*), describes as "moments of highest happiness and fulfilment." Indeed, I would soon be in a series of trance states characterized by bliss and overwhelming joy and detachment from concepts like *time* and *space*. Inhibition, fear, doubt, and self-criticism would all dissolve and I would find myself in a state that Hungarian American psychologist Mihaly Csikszentmihalyi called "flow," a complete immersion and absorption into one's full potential, immersed in any current activity to the maximum potential. To be certain, into the boiling pot of Thai Buddhist magickal working I would go, entering previously uncharted realms. The veil would not just be lifted, it would be completely ripped away.

The Final Pilgrimage 269

After a roughly sixteen-hour journey from Bristol I arrived in Chiang Mai, Thailand on Friday the fifteenth of September 2023 at 8:48 a.m. The flight was without incident apart from an encounter with a man who, upon seeing my Ruesi Ta Fai Mala Lightning beads by Lersi Nawagod, said, "You must be a Buddhist," and promptly engaged me in conversation about the book I was reading, *Yoga Sutras of Patanjali*, as interpreted by Mukunda Stiles. This gentleman then, in an apparent attempt to demonstrate his depth of understanding and knowledge of this specific text (and indeed the whole of yogic philosophy), went on a crazed, mental roller-coaster ride. "Are you a teacher?" I asked him. "No, I just live my life," he replied.

I would have been taken in by his intellectual fireworks display were it not for the increasingly erratic, drunken, and petulant behavior that followed; he insistsed on shouting the word "Shazam!" every time it was mentioned in *Shazam! Fury of the Gods*, the film he was watching on the small digital screen in front of him, while thrusting his bare, dirty feet between the spare seats in front of him. His behavior brought to mind the following line from the *Yoga Sutras of Patanjali*: "Karma has two aspects: actions whose results are occurring, and actions whose fruit is yet to come."

At the International Arrivals area at Chiang Mai Airport, I was alerted to the sublime presence of the female translator from Magia Thai by a gentle touch upon my right arm. After making our introductions, we made our way to the entrance where a modern MG sports car pulled up and out climbed Magia Thai's fixer and driver, wearing sunglasses, his tan, Sak Yanted arms framed by a black T-shirt. I felt very early on during this pilgrimage that I had completely lucked out being with Magia Thai at the beginning of this adventure; not only was I to benefit from their remarkable knowledge base, but would do it in style, cruising around Chiang Mai in their high-powered sports car! I was nothing short of mesmerized by these two Magia Thai members' engaging, confident, and energized focus, and from the very first instance I

270 *The Final Pilgrimage*

felt welcomed and completely surrounded by their open-hearted hospitality and kindness; I also knew deep inside that what would happen over the next two weeks would prove not only memorable but profoundly life-changing.

I also deeply respected and appreciated their professionalism, assistance, and organizational skills during this remarkably organized itinerary that had the hallmarks of military precision. Since I was further along in my experience and studies in Thai Buddhism than most visitors they had welcomed, I was afforded an intensive itinerary, packed with many visits to Ajarns, Lersi, Krubas, and all manner of temples, sacred sites, and places of interest. The proposed itinerary however remained fluid, open to any improvisational changes we deemed appropriate and/or desirable. I also appreciated the clear boundaries between business and pleasure; right from the get-go, they clearly delineated what was expected of me in terms of any extra expenses I might incur while I was with them, whether for laundry, casings for amulets, or food. They also outlined the importance of having enough money for the purchase of vitally important offerings for each of the magickal rituals. Each Ajarn and each ritual would entail my offering very specific offerings, all of which were nonnegotiable. I would need to provide food, fruit, water, alcohol, flowers, candles, and all manner of animal meat and blood to the Ajarns in order to fully support the rituals. During the course of making our detailed preparations, the old adage "You get out of it what you put into it" came to mind. Due to the life-threatening nature of the work one of its members did in the field of journalism, Magia Thai asked that their identity remain anonymous. This added an air of mystery and secrecy surrounding their operations. To be certain, the entire time I was with them, I felt like I was dealing with some sort of covert secret unit.

As my plane touched down, we hit the ground running. At roughly 3 p.m., after I had exchanged money in Chiang Mai city center and settled into the chalet at a resort, I was taken to see Ajarn Suea. Since my

The Final Pilgrimage 271

last meeting with Ajarn Suea, things had changed not just for myself but also for Ajarn. He had moved to new and more extensive Samnak at Amphoe Hang Dong. It was more organized, with a much bigger collection of glass cabinets displaying all manner of perfumes, oils, amulets, arm Takruts, bracelets, with a wide and varied collection of bucha on the top. Here, I learned that there had been a ban placed on the shipping of certain statues and perfume oils, which I found strange. Despite this odd news it was very good indeed to see him again. His presence emanated the same warm, compassionate, and kind atmosphere and I felt as if I had come home again. He not only knew and remembered my name from three years ago but also named a specific Sak Yant on me without actually seeing it. He said he could feel it. I took off my top to show it to him.

Ajarn Suea is able to perform a specific form of divine esoteric meditative divination, taught to him by one of his teachers, who it is said excelled in this divinatory form. As before, I underwent the Serm Duang ritual bath outside, changing beforehand inside the brand-new bathroom. He then read my upper left arm and hands as he had done previous times. This time, he warned me of a person to watch out for. He described this individual to me in detail; curly hair, a short neck, and roughly orange to dark olive skin. Apparently, this person would attempt to break my back, metaphorically speaking. They would be dangerous, bringing me very bad luck. While I was somewhat disturbed to hear this warning, I was relieved that Ajarn had given it to me, as I now had an accurate description and would be slightly better prepared for this troublemaker. Strangely enough, it was only days later, while receiving Sak Yant from Ajarn Daeng, that I had a revelation as to who the troublemaker might be.

After purchasing a particularly fine Rahu amulet (for which Ajarn Suea supplied a delightful recording of the khatha for me), an attractive Lek Nam Phi bracelet that automatically removed negative energy, and three beautiful magickal candles, prepurchased offerings of cigarettes, a

garland of flowers, and a suggested money donation were placed inside a bowl for Ajarn. Packs of water were placed next the shrine. I was encouraged to make a request during the khatha chanted blessing to ask for abundance, prosperity, and protection against untoward people, all of which sounded good to me. After the blessing two magickal handmade candles were brought out. Using a scribe tool I inscribed my name and date of birth alongside the length of the candle. I then gave Ajarn two very small portions of my hair, which he rolled into the sides of the candle. I was then asked to take the candles outside and place them onto a shrine. There, they were lit and I made further requests while they burned.

Ajarn Suea then gave me some final pieces of wisdom. First, he suggested I receive a very specific form of Ganesha Sak Yant, the Phra Pi-Ganesha Barami, to be given by Ajarn Daeng. This yant, associated with material wealth and the guarding of valuable assets, is popular with people connected to the arts. I told Ajarn that I would have this done. Ajarn Suea then told me that I was not to eat any beef or buffalo within seven days of the ritual that had just taken place, as doing so would lessen the strength of the ritual. Although I was perplexed as to where exactly I would buy buffalo burgers in Chiang Mai, I was grateful for the heads-up and stayed true to his word.

As I departed with Magia Thai, I saw Ajarn Suea being escorted back to his living quarters. He moved with some difficulty as he was suffering from diabetes and was scheduled for some form of surgery. My heart went out to him. He is in my thoughts every single day. Since this time he has through exercise and rigorous dietary changes mastered his diabetes.

The sixteenth of September then dawned and a large and hefty five-hour Sak Yant session with Ajarn Daeng loomed ahead of me. My sleep

The Final Pilgrimage 273

that evening was fitful. Jet lag played havoc with my body and mind. Although the excellent Wi-Fi afforded access to twelve-hour white noise videos on YouTube, the sight of very tiny baby lizards (a sign of good luck in Thailand) on the ceiling of my chalet provided a much-needed distraction as I tried to sleep.

Morning at the chalet resort was a peaceful, sedate, and charming affair. As the only resident, I had been gifted solitary ownership of the entire resort, which was in a rich, diverse, and beautiful natural setting somewhere near two small, charming Buddhist temples from which very occasionally emanated the gentle and calming transcendental sounds of chanting. A sign at the front of the walled resort announced that the collection of fresh modern chalets, large swimming pool, open breakfast area, and charming water fountain at the front were collectively called *baramee*. Baramee in Thailand means having a personal charisma associated with success, being friendly, and having confidence. In traditional thinking, gaining charisma is linked to the development of good character through following the noble eightfold way as taught by the Buddha. Those perceived to have baramee become patrons and attract willing and loyal followers.

The continental breakfast was more than ample as I girded my loins, preparing myself for the epic tattooing ritual that lay before me. Once again, the appropriate offerings were acquired and we made our way to Ajarn Daeng's Samnak, which had been at the same location for over twenty-five years. A feeling of homecoming overtook me upon entering Ajarn Daeng's Samnak. Seeing his kind and warm face once again made me happy beyond words. Once again I enjoyed the gentle humor, the decent and caring mind of a master, a master of masters, in his sacred Samnak. The intense five-hour session would yield five separate Sak Yant on my back, circling around the central rare Yant Paed Tidt, one of which had been recommended by Ajarn Suea himself in his guidance to me. The five Sak Yant would be: Yant Maha Ra-Ruoi, Yant a-li-ya Sat See (repeated twice, one on each side of my

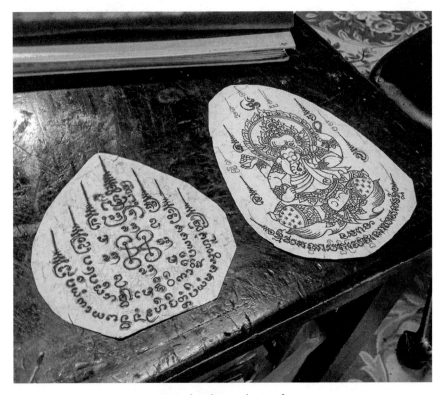

Ajarn Daeng's Sak Yant designs for me.

back), Phra Pi-Ganesha Barami (Ajarn Suea's choice), and finally Phra Rahu Kan-wan (day) Kan-kuen (night) on my lower back.

The preparation took some time. First, Ajarn shaved my lower back of any fine hairs. Then came the slow and delicate process of selecting the specific designs and ensuring a clean and crisp transfer of the images onto my back. Finally, I made offerings to Ajarn in front of the shrine in his Samnak to ensure a successful and beneficial Sak Yant ritual. Time passed under the needle. I went in and out of various different states of consciousness. Under Ajarn's instruction, I took occasional breaks for water and to walk around a bit in order to prevent pins and needles in my arms and legs.

I sat in a comfortable chair and was able to endure the pain. At one point however something strange happened. During the application of

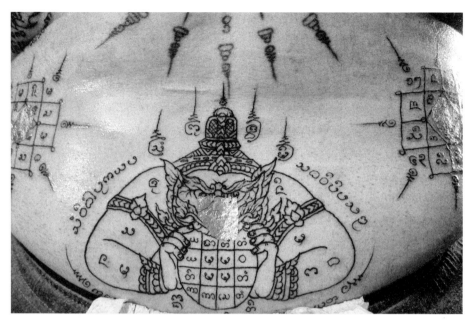

Ajarn Daeng's Phra Rahu Kan-wan (day) Kan-kuen (night) Sak Yant. Photo by Magia Thai.

the Phra Rahu Kan-wan (day) Kan-kuen (night) on my lower back, I experienced a flash of imagery containing information surrounding the prophecy Ajarn Suea had made to me about an individual with curly hair and a short neck that I would need to avoid. The information was filled with detail and I took careful note of the unfolding visions.

Apparently, when undergoing Sak Yant, and, depending on certain various circumstances, be it the kind of Sak Yant, the location on the body, and of course your current receptive state, channels for divinatory and visionary experiences relating to precognitive information within the body and mind are opened. In *The Varieties of Religious Experience: A Study in Human Nature,* William James stated: "Our normal waking consciousness, rational consciousness as we call it, is but one special type of consciousness, whilst all about it, parted from it by the flimsiest of screens, there lie potential forms of consciousness entirely different."

After each Sak Yant had been gold blessed and consecrated with Sompoi in front of Ajarn's beautiful and rich deity-populated Samnak, I felt a sense of elation and happiness that eclipsed my recent dark experiences surrounding the death of my mother. I felt raised up, in a profound state of deep inner peace and contentment. The presence of the five Sak Yants on my back now had the resolute feeling of completion and cohesion. A sense that the magickal Sak Yant designs were now actively working on my back both separately and together, in unison and as a whole, impressed itself upon me. (See color plates 20 and 21.) I had previously told my Magia Thai guides that I dearly wished to have what could be termed as a "full back." Namely, my entire back completely covered, interconnected, and filled by khatha, enclosing, joining, and harmonizing all of the separate Sak Yant designs, working together in unison on my back. As we left the Samnak, I was informed that this extraordinary idea, which had inexplicably come up from deep inside of me, might possibility be realized by Ajarn Daeng at some later stage toward the end of my current pilgrimage.

On Sunday the seventeenth of September, my guides took me to meet Lersi Nawagod, a profoundly gifted and knowledgeable Lersi who had studied under some of the most important and prestigious masters in Thailand. I had become aware of Lersi Nawagod through Magia Thai's sharing of his work with me and had acquired some exquisite items made by him (some of which I was wearing on my pilgrimage), specifically the Mala Lightning beads with a Lersi Ta Fai amulet hanging from it. The Lersi, Ruesi, or Rishi are traditionally the possessors of various powers: knowledge of herbal medicine, minerals, magickal invocations, and supernatural abilities such as levitation, teleportation, alchemy, and mind-reading.

The twenty-four thousand verse *Manthānabhairavatantra* refers

to Rishi as "one who is intent on spiritual practice (paricaryā)." They are seen as sanctified sages, saints, seers, and ascetics who have attained the highest states of enlightenment. Living reclusive lives in forests, mountains, or caves, these sublime beings are said to practice deep meditational states, developing their mental skills using secret occult techniques as handed down to them by their masters using only oral transmission. Allegedly they can do without food and sleep, and they can be wherever they want to be instantaneously. My meeting with Lersi Nawagod would prove worthy of such a remarkable and fascinating legacy of spiritual practitioners.

24
Modern Lersi

Ajarn Nanting's Magick and the Living Spirit of Suea Yen

Lersi Nawagod's Samnak and home resembled a large industrial compound with automatic sliding outer gates, high walls, security cameras, keypad system, and a series of buildings within a perimeter. I was somewhat surprised to enter into such a secure location in the very same village in which I was staying. We drove down a lane in the MG and pulled up under a sheltered entrance way. The phrase "By appointment only" crossed my mind as I stepped out of the car. To my left stood a long line of deities. All manner of large and ornate figures of strong presence and undeniable beauty.

I took my leave and went to the toilet on the other side of the parking lot. Small dogs yelped playfully and ran past me followed by whom I assumed to be Lersi Nawagod's daughter. I took my shoes off at the bathroom doorway and went inside to freshen up in the clean and modern linoleum-floored room. I felt that this was indeed a modern take on how a Lersi would live; isolated, magickly protected, and very secure with just enough separation from the outside world to make it a recluse's paradise.

Just outside the main entrance an area that was laid out for

candle-making and various other activities was in a state of organized chaos. Our party was then invited by Lersi Nawagod's wife into the Samnak. We followed her to a large room divided up into various sections that held many different glass cases, drawers and cupboards of varying subjects; a case of ultra-rare ingredients for amulets; a cased, spotlit area of extraordinary golden Buddhas in front of which Lersi Nawagod had his sitting area; an open shrine of numerous Lersi heads; and deities of all kinds in either wood, metal, or precious metals. There were also several framed photographs of Lersi Nawagod with various famous practitioners: one of Lersi in full monk's attire posing with Kruba Pornsit, one with Phor Sala Tan, the great necromancer of northern Thailand, and one with the legendary Burmese Ajarn Maha Kaew, whose body is seemingly completely covered in ink, although this is allegedly due to there being over twenty layers of Sak Yant tattoos which have given his skin a completely blacked-out look. (See color plate 19.)

I was somewhat in awe of Lersi Nawagod. His warm eyes and gentle but deeply penetrating stare that accompanied them told me that—despite some naysayers who claim that the lineage for true Lersi had died out years ago—he did indeed fulfill all of the requirements for the title of Lersi. Here before me, was seated a real and authentic Lersi and someone who was, as I was about to find out, replete with remarkable and potent magickal powers. I sat down near Lersi Nawagod and he immediately noticed that I was wearing the Mala beads he had made. He asked me to give them to him, which I immediately did. He took them, cupped his hand to a pot behind him, and then scooped out what I guess was some form of oil for the beads that he then carefully ran all along them, gently massaging them with the oil. I watched as the beads lit up, responding to the care they had just been given. He told me that these beads were very special and that he had only made a few. I felt humbled by this and told him I loved them very much indeed and was honored to own them. He nodded to me, pleased to hear this. I felt that at this point in time we had officially connected, my distant admiration

of him up to that point now confirmed by this very simple but sincere face to face exchange.

On that day, I was to receive a gold ritual blessing from Lersi Nawagod to attract luck, abundance, and good health. Gold blessings vary from practitioner to practitioner in Thailand. Each one has a variant that contains elements not available in any other similar rituals. This particular gold blessing by Lersi Nawagod was no exception, for within it were unique inclusions to be found nowhere but here. I was asked to lie down flat, my feet pointing away from the shrine and not toward Buddha, my head very near the Lersi. I was then asked to hold a large golden trident between my hands while assuming the position of prayer. White thick Sai Sin thread, was placed around me with the other end wrapped around a wand held by Lersi who then began to place large sections of gold leaf around my face while gently chanting. The gold leaf took some time to place since it is a difficult substance to manage, especially while conducting a complex ritual. I counted at least twenty separate pieces of gold leaf across my face, forehead, cheeks, nose, and chin. A remarkable golden face mask was then placed onto my face. Although I'm sure it was of Thai origin, it seemed a little Chinese in its design with its stylized eyes, thick red lipped mouth, and nose.

At this point I was feeling very attended to, gripped by a level of focus I had hitherto never felt before. Then, ever so carefully, Lersi placed the robe of the late Kruba Pornsit behind and on the top of my head and proceeded to chant in a robust manner. I knew that Kruba Pornsit was one of most revered masters in northern Thailand. Having his neatly folded monk's robe placed on the crown of my head was akin to having the Shroud of Turin placed on my head. In terms of a holy and sacred object, it couldn't get higher than this. Then the chanting suddenly stopped and under my closed eyes I felt delicate needle pin pricks—one, two, three, and four—all along my upper and lower lips around my mouth. These very unexpected tiny sharp

points, not penetrating my flesh but slightly nudging it, were the last elements of this incredible ritualized journey.

Afterward, two candles—one red and one yellow (one for health and one for good fortune)—were prepared with my name and date of birth inscribed upon them. These were taken outside and placed on a shrine, and lit, followed by my deep internalized wishes while in prayer. This intense but remarkably transcendent atmosphere was broken by our return to the interior of the Samnak where our party, along with Lersi Nawagod's wife, daughter, and niece, chatted together about the United Kingdom's weather and of course the vast array of many fabulous amulets that Lersi had made that were available to acquire. Behind Lersi, I saw a single, small gold-plated statue of Ganesha; the last of its kind, since all of the others in the group had gone in sales. I asked if could acquire this statue. I also asked if I could acquire something else. Something that has now become firmly placed in my mind as a point of experience.

Lersi was prompted to pull out from behind him a large jar halfway filled with dark liquid. I could see there were numerous Khun Paen amulets sitting in it, soaking up the liquid. He opened the jar and a huge concussion of smell, a searing scent, exploded around the room so powerfully that one of our party immediately took ill, quickly removing themselves from the Samnak. The scent was extremely sweet, with other indescribable background essences swimming around in it, the likes of which I'd never smelled before. Lersi said this was an Indian perfume that had very high-powered effects upon anything placed into it. I was fortunately robust enough to withstand the onslaught. Lersi then took out one of the amulets. It was a Khun Paen amulet, which, according to Lersi, was made up of a number of heavy prai elements. Upon closer examination I could see that fine hair was embedded in it and was coming off the amulet. Small chunks of human bone could also be seen. This simple amulet was very possibly one of the most powerful protective talismans that I'd come across. I could feel its magickal power emanating throughout the room.

"I'll take one," I said, without thinking.

Eventually, the time to leave arrived. Lersi asked me if I could put him up if he ever traveled to the United Kingdom. "Of course, Lersi. Anytime. Name the date and we'll do it!" I smiled and gave him, his wife, and his family the traditional wai.

Our next stop was to the temple Wat Sri Don Moon to meet the legendary Kruba Noi for a blessing. Located about twenty kilometers southeast of Chiang Mai, in the Saraphi district, inside the grounds of Wat Sri Don Moon is a white temple with an exquisite white marble Buddha inside. I was impressed at the scale and ambition of this incredible temple complex whose five-hundred-year-old temple is in a constant state of expansion and development, while inside the original monastery is a golden Ubosot, wooden pavilions, a Lanna-style stupa, and a Viharn filled with remarkable and noteworthy paintings.

Inside one pavilion was a massive golden Buddha. My sense of awe was such that I felt compelled to prostrate to this Buddha three times in obeisance. The side of one pavilion had a vast diorama of Buddha overseeing heaven and hell, clouds of billowing steam pouring from a small lake in front of it, while disembodied arms and hands reach out from hell. It was a profoundly enchanting and semi-disturbing scene, replete with immaculate detail and full rich colors. (See color plate 31.)

After wandering around this sublime, multifaceted temple, it was time to visit the obligatory temple shop. I was impressed by the large selection of high-quality items, all beautifully made, with international shipping options. I bought a small but charming Buddha that had all the attributes of a finely weighted bronze, with three Takruts embedded into the base. I told my guides I would give further baht, in the form of a donation, inside a supplied envelope in order to secure blessing from Kruba Noi.

Waiting for the blessing was something of an affair. A lot of people had turned up to meet Kruba Noi for a blessing, which was, according to my guides, not very usual for a day like this. Indeed, I saw some international faces in the crowd and noted several rows of chairs in which we were to sit while we waited, slowly moving along in a right to left movement toward the front. The meeting hall itself was an assault on the senses. A full sound system and flatscreen TVs playing documentaries about the temple, all in conjunction with a group of nine or maybe ten monks chanting into microphones. At one point, one of my guides became completely overwhelmed by the almost evangelical atmosphere and had to return to the car to center themselves again. I concurred that the atmosphere was intensive. Row after row of devotees went before the COVID-19-masked figure of Kruba Noi, now in his seventies, to receive his firm, direct, and resolute blessing for a variety of either personal objects of devotion or just themselves.

Kruba Noi became a monk when he was seven years old. He was born with an umbilical cord wrapped around him, which was seen as a sign of his future ordination into the Sangha as a monk. He studied under Kruba Pad who was the abbot of Wat Sri Don Moon before Kruba Noi. Kruba Pad is viewed as one of the top monks in Thai Lanna History who created facilities for the Samanera and bhikkhus of the region and improved the quality of life of the local community. Kruba Pad's cremation was visited by numerous strange, near miraculous, and inexplicable phenomena, and was overseen directly by Kruba Noi himself. Kruba Noi's Takrut amulets such as the Takrut Maha Ga Saton Glab, are highly sought after for their protective properties. It is said that a civil servant who carried the Takrut Maha Ga Saton Glab by Kruba Noi in Prae Province was shot at five times at point-blank range with a shotgun, with the pellets only grazing past the top of his head.

It was finally my turn to receive a blessing from Kruba Noi. Hearing my name spoken in Thai was unusual to say the least. On my knees, I pressed my palms together in front of this small but wiry old monk

whose voice was strong and powerful. He chanted a blessing for me and then blessed the Buddha next to the envelope with my donation in it. The monks around me then requested me to hold out my right arm toward Kruba Noi so that a Buddhist red cord bracelet denoting that I'd been blessed was tied around my wrist. Then, he did something I found surprising and utterly enchanting; he slapped his hand into my open palm as if to seal the deal. I got up and left, leaving the dizzy and pounding atmosphere of the meeting and blessing hall behind us, allowing the long line of devotees waiting behind me to receive their blessings. Outside, as if in union with the blessing, the skies opened up and a torrential subtropical rain fell down in gushing rivers. I took this to be a good omen, and felt at peace as we waited for the rain to cease. All things were alive with abundant moisture, the Nāga spirits slithering downward writhing endlessly in streams from up above.

On Monday, the eighteenth of September, I was to see the great Ajarn Nanting once again. On our way over to his Samnak, the exact same pattern of acquiring the correct offerings for the ritual we had performed previously was repeated. While in the car I talked to my guides. For some reason I felt that I didn't wish to have any further Sak Yant on my back. I knew that Ajarn Daeng had just undertaken a considerable amount of detailed Sak Yant work and I guess that I was just making a point that I didn't wish it to be touched in any way whatsoever, considering the finishing touches of interconnected khatha that were yet to finish it all off. Putting up barriers before I had even arrived at Ajarn Nanting's Samnak however was a fruitless and pointless act.

Arriving at Ajarn Nanting's I immediately went to pray at the shrine of Mae Surasatee outside before going into Ajarn's Samnak. It was very good to see him again. His warmth filled the room and he was genuinely happy to see me. My heart filled. My guides translated

the conversation we then had together. Ajarn knew that my mother had died and he could see that it had deeply affected me. Ajarn also had suffered from a great loss with the passing of his teacher and friend the great Kruba Pornsit who had passed two years ago. Ajarn said: "I share with you the pain of your loss. I am sorry to hear of your mother's passing." His words touched me deeply and I felt very moved that he had said this. Somehow, I managed to control myself and then discussed what exactly Ajarn had planned for me. It was revealed to me then and there that Ajarn Nanting had an extremely special and potent piece of high magick to perform in a ritual, something that immediately piqued my interest. Ajarn would place a Sak Yant upon my upper back called Payaa Kai Daeng, a triangular-shaped grouping of symbols and khatha designed to literally flip the luck back up toward me and push hard against any bad luck or black magick that had been cast against me.

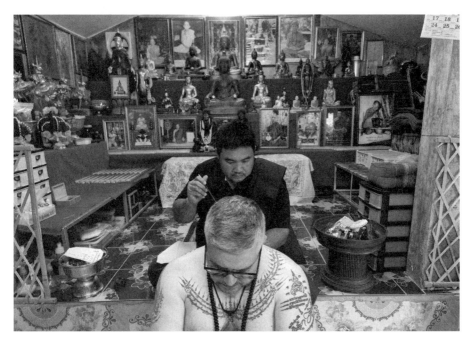

Ajarn Nanting applying the "Red Flower" Sak Yant at his Samnak. Photo by Magia Thai.

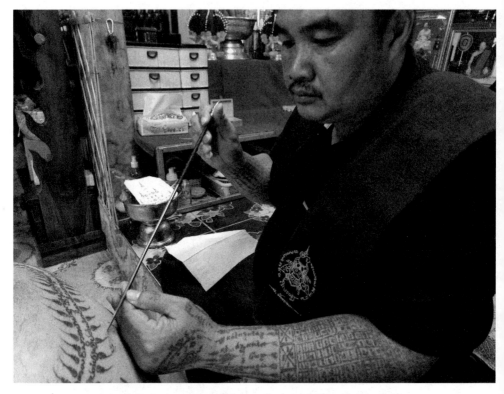

Ajarn Nanting applies Sak Yant with the rod. Photo by Magia Thai.

I discussed with Ajarn Nanting certain issues that had arisen during my mother's ill health. I described to him things that felt like roadblocks in her health care, mistakes that had been made during CT scans, and the general difficulties and delays that I believed contributed to the rapid rate at which my mother had passed. Ajarn Nanting felt certain that some form of black magick had been placed against my family. As difficult as this sounded, I felt that I couldn't argue with the logic or indeed the reasoning. The truth was, my mother's recovery had been sidelined time and time again, and I became angry at the thought that anyone would even consider doing such a thing. The ritual I was to undergo would act as a two-barreled blast against anyone who may have executed such an appalling thing.

I mentioned I was slightly concerned that Ajarn Daeng's work

on my back would be written over in some way. I was informed this would not be a problem at all; as with the very first Sak Yant devoted to Mae Surasatee I had with Ajarn Nanting, this particular piece of high magick was to be rendered invisibly. This time however, a very pale, rose-colored liquid would be used. A teacher by the name of Kruba Too had evolved a method of deep meditation that related directly to this pale rose-colored substance. While in deep meditation Kruba Too could instigate the growth and eventual blossoming of a red flower that is literally translated as "Red Flower." Ajarn showed me the small bottle of red flower ink to be used, along with a box of amulets made from the crushed petals and pollen of this specific bloom. I was impressed with the delicate and yet intense fragrance of the rare liquid as much as I was staggered by the enormous cost of it; amulets made with Red Flower command high prices, and Ajarn had quite a stash. Humbled and honored that such a rare substance was being used to tattoo my back, my earlier reservations disappeared. It took Ajarn roughly fifteen minutes to apply the Payaa Kai Daeng, which was followed by the gold leaf blessing. When he was done, only the faintest traces of the red coloration remained, barely visible to the human eye. (See color plate 22.)

After another ceremony at the shrine of Mae Surasatee, in which we lit four candles that were to work in tandem with the Sak Yant, we returned to the inside of Ajarn's Samnak where some very interesting items had caught my eye. Ajarn Nanting produces a fragrance specifically for Mae Surasatee, and combines it with a See Pung in a single package. Since Mae Surasatee likes perfume as an offering, I bought two packs of this special fragrance to spray around the bucha of Mae Surasatee at my shrine at home.

My next purchase was a large amulet. It is referred to as "an extraordinary charm for attraction, love and gambling wins." Inside the elongated bullet-shaped amulet with gold leaf suspended in Nam Man Prai oil was the submerged figure of a smiling naked man made out of bone. He was holding a sealed bottle of human ashes and had an erection

288 *Modern Lersi*

while in turn sitting on top of a red diamond-eyed skull surrounded by three or four Takruts. I was told that this amazingly potent amulet was good for attraction, luck, protection against negative energy, black magick, and evil eyes and good for promoting gambling winnings. The raw and immense energy emanating from this amulet was overwhelming and I acquired it without question.

As I took one last look around the shop, my eyes found a bucha deity statue that I had seen previously on Facebook, posted by someone whose account had long since disappeared. It was Khru Kai Kaew, the Great Father, Demon God of fortune, success, and wealth, of spirit control and necromancy, and a guide to those that practice the occult. This black emaciated male effigy sits cross-legged and has red eyes, fangs, long red (in this case golden) nails. He also sometimes has wings. Suggested offerings for Khru Kai Kaew are incense sticks, coconut, chives, fruits, sweets, and flowers, and the paying of respects to the teacher. One may also offer money to Kru Kai Kaew while stating one's wishes.

An air of confusion and controversy surrounds the origins of this deity, which adds to its mystique. Although not supported by historical evidence, some claim it depicts the revered mentor of Jayavarman VII, a former king in the Khmer Empire. Others say its creation can be attributed to a monk from Lampang province in northern Thailand, who carved the statue after a period of meditation at Angkor Wat in Cambodia, and gave it to Ajarn Suchat, one of his disciples. The controversy surrounding it arose when a large version of Khru Kai Kaew on the back of a truck was placed in front of a hotel in the Ratchadapisek-Ladprao area at The Bazaar Hotel, Ratchadaphisek Road, Bangkok. A violent barrage of angry complaints ensued after online followers of this deity suggested that the sacrifice of dogs, cats and rabbits to it would be very good for lottery numbers.

Half beast and half demon, some regard Khru Kai Kaew as a god of wealth, while others insist it is alien to Buddhism. Ajarn Nanting must have felt this statue had merit, as there it was, standing alongside the

other deities in his shop. I trusted his judgment and decided to acquire this strange yet attractive deity. Taking our leave, we thanked Ajarn for the beautiful ritual and then made our way home.

Tuesday the nineteenth of September would prove to be a day to remember. This day would mark the transference of the spirit of Suea Yen, the northern Thailand Lanna tiger deity, via Sak Yant ritual undertaken by Ajarn Tui. A heart-cooling Metta Type of tiger magick, *Suea Yen* literally means "Cool Tiger." Because its magickal functionality includes something called "Serm Yos" (the improvement of status and promotion), it is often used by soldiers and policemen in Thailand who have commanding positions. As usual, my guides and I prepared the required offerings for the ritual and blessing for my first visit with Ajarn Tui at his Samnak around the environs of Chiang Mai.

A former Luksit of Ajarn Nanting with whom—as you know—I've had the great privilege of meeting previously on numerous occasions, Ajarn Tui is a great master of ancient Lanna Sak Yant and highly gifted maker of amulets. We arrived outside his home in good time. While getting out of the car I felt a dizzy and surreal sense that the area was flooded by unseen movement and invisible energies writhing and spinning in the very air itself. Since I'm predisposed in terms of being very sensitive to comprehending unseen things I counted this incident as just another day at the cosmic office. Then it happened. While walking and approaching the Samnak, I reached down to touch the Nine Cat Yantra Takrut Prai amulet by Ajarn Tui that I had been wearing and found that it was not there. The cord remained, but the amulet was gone. Vanished. Startled, I alerted Magia Thai that maybe I had lost the amulet somewhere along the way to Ajarn Tui's. I looked down at the shredded cord around my neck. The amulet appeared to have quite literally been ripped off by

some force unseen to me. How could this be? How on earth did it get ripped off its cord? I panicked as I searched in vain for the amulet. I walked briskly back to car and there, on the ground, in the long grass was the square amulet, safe and undamaged. Inside, I related what had happenened to Ajarn Tui. "The cat has come home to its maker and couldn't wait to see me again," he said.

Offerings are a very important and essential part of Thai and indeed any form of occult magick rituals. They are the succulent coordinates for spiritual arousal, juicy and welcoming morsels that please unseen energies. They are the rocket fuel and spiritual food upon which Spirit feeds itself and is thus able to expand upon itself, granting abundance in return, offering back to devotees any success and accomplishments they may be seeking. For the Suea Yen Sak Yant ritual, raw meat, animal blood, offal, liver, stomach lining, a garland of flowers, cigarettes (both modern and the ancient Elephant brand), whiskey (the stronger the better), beer, incense, and a requested monetary donation were all offered with an open heart. (See color plate 25.)

During the previous evening, Ajarn Tui, in a separate unseen ritual, had called upon his Spirit teachers to come down on the very day I would be present in order to help, assist, teach, protect, and guide during the ceremony. I can honestly attest that their presence was likely; it felt as if the room was full of unseen Spirits. I felt lightheaded and a bit chaotic, almost as if I was standing inside a fully flowing stream, an invisible force coursing through my entire body. I did my best to stay centered and calm during this experience but had to call upon deep, inner reserves of calm in order to keep myself from becoming unseated or lost in this powerful, overwhelming energy.

At one point I was handed a glass full of light gray translucent liquid. The liquid had been infused and consecrated with limes, Sompoi,

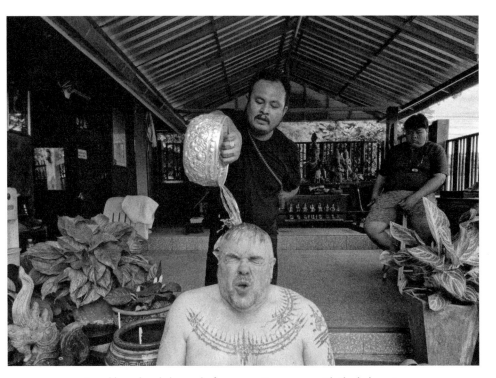

I am blessed and cleansed of any negative energy with the holy water. Photo by Magia Thai.

and various other herbal elements. I was told to drink it down. I was told that although I was full of Metta (loving-kindness) I also harbored small amounts of negative energy that needed to be dealt with and that the liquid I'd just consumed would either cause me to vomit up the negative energy, or pass naturally through my body in the form of urine. Since I really hate vomiting, I hoped for the latter (and fortunately, my body agreed with me). After I had downed the liquid, the same liquid was used by Ajarn Tui to give me a thorough cleansing bath, the shock of which knocked me sideways.

Afterward, while drying myself off, I began to weep inexplicably. The same hectic feelings surrounding my mother's death from only two months previous were obviously still rattling around inside me. Ajarn Tui then chose for me a very specific Sak Yant from his collection of

292 Modern Lersi

ancient Lanna Sak Yant designs. He chose the Suea Yen Sak Yant, imbued with an encrypted magickal square on its head along with various highly esoteric script embedded within and around the tiger's body. Using the traditional method of wetting the design with ink onto my arm, he pressed the design flat against my upper right forearm, leaving a clear diagrammatic trace of the tiger Sak Yant.

I was then instructed to sit next to Ajarn Tui and his Luksit, and to prepare myself for what I can only say was one of the most painful, powerful, and profoundly intense experiences of my life. As you may have surmised, receiving Sak Yant is ultimately a test of character, spirit, and devotion. Sitting next to the Ajarn for such an extreme ritual is to merge with them in deep connection. The Luksit firmly held my arm so that the skin would not move or wrinkle as the long, needle-sharp steel rod pounded again, and again, and again into the thin and tight skin of my inner right forearm, the ink slowly but surely spelling out the supernaturally empowered magickal design. Tiny, speckled blood spots briefly dotted my skin. The ink used is in itself a form of magick. In this case, it was black ink infused with the liver essence of a tiger and a bear, animals whose attributes are transferred to the recipient. In Thai Lanna Buddhism animals must not be deliberately killed, nor their body parts used for any purposes whatsoever; their deaths must have occurred under a very specific set of circumstances, specifically supernatural or natural conditions. This renders such necromantic materials rare and all the more difficult to come by.

As the Sak Yant ritual proceeded I became lost in a fluctuating haze of gentle swooning delirium, my other hand's finger and thumb tapping rhythmically in an attempt to circumvent the agonizing pain I felt on my inner right forearm. Stabbing, stabbing, stabbing, the magnificent Suea Yen, the tiger deity, came alive, creeping up my arm. After a considerable amount of time, the design, which had been tattooed onto my inner forearm using the ancient and traditional "fish egg" method, was finished.

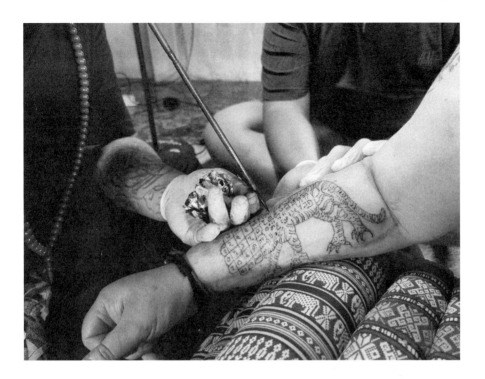

Ajarn Tui puts the finishing touches on the complex Suea Yen Sak Yant.
Photo by Magia Thai.

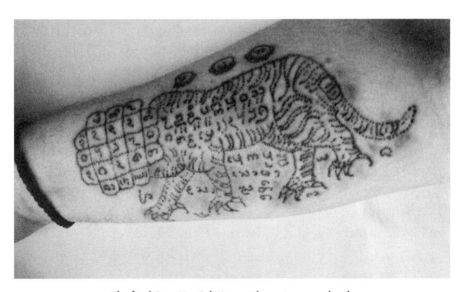

The final Suea Yen Sak Yant with magic square head.

As my body and mind continued to bask in the warm luxuriousness of endorphins now swelling up inside of me, Ajarn Tui asked me to sit directly in front of him for the final blessing. Then, an inexplicably incredible thing happened. I suddenly found I could not stand—or indeed sit—upright in any manner whatsoever. My breathing had quickened to short, shallow pants, much the way one would imagine a thirsty tiger would do after hunting for prey. Driven by some compelling force, I hunched down, and, now resting on my hands and feet, assumed the shape of a tiger on the floor. There, I crouched before Ajarn, transfixed in tiger mode, panting, as Ajarn Tui commenced the blessing, reciting the khatha for the Suea Yen Sak Yant in his strong, powerful voice. Deep inside me, panting growls ached to come out. I remained in this posture throughout the duration of the ceremony. One of our party confirmed to me later that I had indeed taken on the spirit of a tiger, my energy ramped and leaping up from the depths of my body. Clearly the transference of the spirit of Suea Yen was complete; the tiger's spirit now residing within the Sak Yant upon my right forearm.

At the end of the consecration of the tiger Sak Yant, Ajarn Tui ended his formal recitation with a long and tiger-eyed "Grrrrrrrrrrr!" aimed directly at me. After my trance state had subsided somewhat and I had assumed the form of a human once again, I managed to sit down on a bench off to the side of the shrine. Ajarn Tui then clearly instructed me in the techniques of working with the powerful Suea Yen Sak Yant. I took very careful notes to ensure his exact instructions could be followed to the letter. At this point things calmed and geared down even further, as if some kind of powerful spirit machine had been placed onto a lower and more mellow setting, and a sense of relief filled the Samnak. Amulets were purchased and blessed, conversations bubbled forth, a beautiful lunch was served by Ajarn Tui's kind and generous wife, and the magick candles that had been prepared earlier were lit as my sincere wishes surrounding this ritual were

silently made in my mind. This entire ritual from beginning to end was indeed something I would categorize as a "peak experience."

During this sublime ritualized ordeal, I found myself in various trance states of bliss and overwhelming joy. I had arrived at Ajarn Tui's Samnak wearing a cat amulet and now left as a tiger. The teacher spirits had been called down and now, after delivering their lesson, had departed. Ajarn Tui's great summoning of spirits had reached its convergence point inside the environs of his Samnak and now all of them had gone, dispersed skyward, vaporizing backward toward the spirit world, leaving the magickal Sak Yant talisman upon my inner right forearm. The Suea Yen Sak Yant shimmered in the daylight, its glistening fur of encrypted sigils speaking powerful new spells in the heat.

Later that evening I put on Ajarn Tui's tiger amulet. Each time I put it on a thin vale of condensation formed on the inside of the amulet, fogging up the image of the tiger. The tiger's breath was my own breath, the tiger's claws were my own claws, the tiger's heart was my own heart, and the tiger's tenacity was my own courage, prepared to be headless, but fighting until the death of time. A new animal spiritual warrior had been born.

25
Aftermath of the "Cool Tiger" Sak Yant

Homage to Ganesha and the Takrut Needle

Wednesday the twentieth of September reverberated in the aftermath of the highly eventful and transformative experience of Ajarn Tui's ritual. It came as something of a relief that our itinerary this day would take us to two very different, beautiful, and calming temples in Chiang Mai. The first was the Ganesha Himal Museum in the Yang Kram subdistrict, Doi Lo District. With over a thousand artifacts and statues of the Hindu deity of success, fulfillment, career, intellect, and luck and the remover of obstacles, the Ganesha Himal Museum was established by Mr. Pundhorn Teerakanon, who, after receiving an image of the elephant-headed Hindu god from his father when he was nineteen years old, went on to become a rabid collector of all things Ganesha for over thirty years. Now the basis of this incredible museum, his collection spans over a very large area, complete with fully consecrated and attended shrines, pavilions, ornamental gardens, the obligatory museum shop (which has a remarkable collection of quality items for sale) and—at one point—a copy of a British red telephone box.

Incense ritual at Ganesha Himal Museum.

At the "Worship Building" I paid 100 baht in exchange for the full attention of a master and a beautiful sung ceremony of worship, which included an offering to Ganesha before a red dot, a Tilaka,* was applied to my forehead. This mark denotes the Ajna Chakra (third eye or spiritual eye). I was then asked to take the incense, candles, and a small, folded paper square with written prayers on it outside to another open air shrine devoted to Ganesha. Here, I burned the incense, lit the candles, and then burned the paper square, circling it around my head seven times, as instructed. The overall effect was completely enchanting and totally uplifting. I slipped into a flow state, my consciousness drifting and dissolving into the surrounding environment. At one point I even felt as if I had left my body. This transcendental high was sublime.

The attention to detail throughout this gorgeous museum was considerable. Even the bricks themselves had been prayed over and inscribed

*Or as it's widely known a Bindi—in Sanskrit *Bindú* means "point, drop, dot, or small particle."

with devotional prayers. My time there was a definitely a healing balm. Despite the humidity, I floated in delight around this magnificent location—which contained far more treasures here than I could digest in a mere few hours—and was in awe at the variations and presentations of Ganesha in which I perceived Thai, Balinese, Lanna, Islamic, and North Indian influences.

I was lucky to obtain a silver Ōṃ ring purchased in the museum shop. Ōṃ is a symbol representing sacred sound in Hinduism. This ring has a middle section with repeated stamps around it of the glyph "Ōṃ." The idea around this wearable meditational tool is to chant "Ōṃ" and then, like a prayer wheel, spin the middle section so that wherever you go, you are able to invoke this primeval sound—otherwise known as "the cosmic sound" or "mystical syllable"—in a sonic affirmation to the divine.

The next temple we visited on this day, the Shiva Brahma Narayan Temple, in San Pa Tong, Chiang Mai, was no less spectacular. This new shrine is a miracle of construction. Photographically speaking, its vast collection of multicolored statues and buildings to the pantheon of Hindu deities makes it a visual cornucopia. It also has what is likely one of the most ornate and gorgeous shrines devoted to Ganesha outside of India. Although the actual elements that comprise the Hindu faith itself—the rituals, eschatology, ethics, teachings, metaphysics, caste system, and astrological guidelines for ethical and philosophical practices—are nowhere to be found, Hindu deities like Ganesha are part and parcel to Thai Buddhism and the devotional aspects are a critical component of this. This can be seen in this relatively new temple's inclination to correctly praise Ganesha, as witnessed in their ten-day Ganesh Chaturthi event. The final day of this event features a procession led by Ajarn Voraman, a female Ajarn who performs the Visarjan ritual, immersing a clay idol of Ganesha in a body of water (in this case a local river). The body of water represents the infinite (God) and the idol represents the soul seeking salvation. In this ritual,

Ganesha shrine at the Shiva Brahma Narayan Temple, Chiang Mai. See also color plate 30.

the immortal soul leaves the mortal body behind, surrendering itself so that it may reunite with the absolute, a process that symbolizes the cyclical spheres of birth and death and the reality of change and destruction.

This sublime Hindu-themed temple complex housed a lovely garden dedicated to the eleven emanations of Ganesh: Shakti Ganapati, Vijaya Ganapati, Nritya Ganapati, Harithra Ganapati, Veera Ganapati, Panchamukhi Ganapati, Siana Ganesh, Bala Ganapati, Runamo Chana Ganapati, Maha Khanadhi, and Maha Saraswati Guru Ganesh. Each statue was in full color, very detailed, and had descriptions of what each emanation represented and its corresponding mantras. Devotional music was piped into a shaded courtyard area.

At the temple store my guides and I acquired offerings that we then proceeded to take to the main temple of Ganesha, where, inside a very large temple room, at the back wall, stood one of the most incredible representations of the deity Ganesha I'd ever seen to date. (See above and color plate 30.) This large gold-, diamond-, and

enamel-encrusted statue stood at the back wall of the building, and before it was a shrine full of offerings, such as holy water, fruit, milk, flowers, sweets, a candle, and a square incense stick, which, when burned, would amusingly reveal a set of lottery numbers for you.

I took my offering tray and proceeded toward the shrine, where I sat down with my guides. We lit our candles and incense and then meditated for a while in front of the shrine. I felt a profoundly strong sense of stillness here. Feeling firmly rooted here, my earlier joy and sense of delight was replaced by a calmness and a deep absorption I found captivating. No music, no sounds, no sense of needing to perform for anyone, just the vast stillness when interfacing a deity that literally overcomes all obstacles. I ruminated on my life up to this point. Even in this extreme calm and inner bliss I looked back and saw that from an early age, my existence had been besieged by turmoil, chaos and man-made obstacles. However, I now understood these obstacles were the very pathway itself. What could have been regret or anger was replaced by the realization that all of life is messy, but that an unrelenting torrent of struggle and distractions are transmutable when one makes the sincere effort to disengage and detach, using the techniques of meditation and breathing.

I acquired a stunning amulet with an exquisite white coral and gold beaded cord made and blessed by Ajarn from the temple shop. The front enamel is devoted to the Hindu deity Kālī ("the dark mother"). This black, four-armed deity, sitting on top of two slayed men, surrounded by gold written mantras or khatha, depicts aspects of creation, destruction, and transformation. The back of the amulet contains four Takruts and four gems. In the middle is a single small rudraksha bead. These beads are made from the dried stone of the fruit of the rudrashka (*Elaeocarpus ganitrus*) tree and are often associated with the Hindu deity Shiva (in Sanskrit, *rudra* refers to Shiva and *akṣa* means "eye"), with larger seeds commonly used in the making of Mala necklaces. These seeds are believed to help foster family

harmony, bring health, give protection, and also to aid you in finding your soulmate.

The abbot of this notable temple is Ajarn Voraman, the very skilled female Ajarn mentioned earlier, who led the procession on the final day of the ten-day Ganesh Chaturthi event and performed the Visarjan ritual. One of my guides informed me that, for undisclosed reasons, nameless individuals had levied a criticism against Ajarn Voraman, and speculated that this criticism was motivated not only by envy of the temple's success but because of her gender. If true, I found such a discriminatory attitude jarring and incongruous. In my mind gender should not pose an obstacle to anyone accessing their own pathway into divinity; diversity in this regard should be viewed as beneficial, welcomed, and celebrated.

Throughout Asia's vast history in fact, there are many diverse, rich, and countless traditions of spirit possession, mediums, practitioners, and ritual specialists in all of the countries of Southeast Asia, which are not only led by and feature women but also include gay, lesbian, trans women and trans men. Some skilled practitioners are known to be able to inhabit numerous genders and deities during rituals of magick and possession.

The full bandwidth demographic of various female, gender fluid, and minority inclusion within the practiced spiritual arts has expanded exponentially since the early 1970s. In the last two decades, Thai queer spirit mediums have revived the cult of Ardhanarishvara, the Hindu deity whose name means literally "the lord who is half-woman." Ardhanarishvara features among other Hindi deities at the annual Navaratri festival celebrated at the Shri Mariamman Tamil Hindu Temple in Bangkok. In his 1995 piece "Buddhism and Saiya" (Phut kap sai), renowned Thai historian, writer, and political commentator Nidhi Eoseewong went even further, pointing out the important role women had played in pre-Buddhist Thai religion, "Women had a major leading role in "Saiya" [magical] rituals,

including being spirit mediums . . . For even though women had to bow at the feet of monks, men had to bow at the feet of female spirit mediums." In fact, it is precisely *because* of Ajarn Voraman's gender (along with her enchanting charismatic persona) that I found her interactions with the deity Ganesha to be of significant and considerable merit.

In his essay "On the 'Queering' of Ganesha," Phil Hine notes that Ganesha is often viewed as a queer deity. He notes points raised by Storm Faerywolf, in his book, *The Satyr's Kiss: Queer Men, Sex Magic & Modern Witchcraft* that attest to this, when Faearywolf claims:

> Ganesha is androgynous. He has a "male" body, but his plumpness, his "breasts," and his movements all signify a female register he is often associated with "oral" and "anal" eroticism. The former, due to his love of sweets, and the latter because he is situated in the Muladhara—the gateway to the anus—and it has been suggested that anal intercourse may have been part of rites aimed at awakening this primal-spiritual power.

Hine also points out how in *Gods of Love and Ecstasy*, Alain Daniélou states:

> In a special rite, prostatic orgasm linked with anal penetration plays an important role. This is connected with the cult of Ganesha, the son of the goddess and guardian of gates, whose Centre—according to Yoga—is in the prostatic plexus. A relationship seems to have been established between the Kundalini and the sexual organ . . . The secret sexual practices probably involve a momentary awakening of this power. . . . It can be said that . . . Tantric symbolism representing the Shakti in man at the level of earth in the Muladhara, in the form of a snake coiled around the phallus of Shiva and closing the orifice, has a deep significance.

Although Hine points out that "all this talk of 'rites' and 'cults' is at best speculative," he sums up what he believes to be "salient points" about Ganesha's gender and sexuality:

- Ganesha is the deity associated with the Muladhara chakra.
- That chakra is at the base of the spine. It's connected to the anus and is the seat of Kundalini.
- Anal penetration can stimulate the chakra and lead to a kundalini awakening.

But perhaps the best summation can be contained in the following quote from the Ganapati Atharvaśīrṣa, otherwise known as the Atharva Veda (in the Vedic scriptures of Hinduism):

You create this world. You maintain this world. All this world is seen in you. You are Earth, Water, Fire, Air, Aethyr. You are beyond the four measures of speech. You are beyond the Three Gunas. You are beyond the three bodies. You are beyond the three times . . . You are always situated in the Muladhara.

It is however Ajarn Voraman herself, who showed considerable thought leadership, compassion, and deep understanding of what being an Ajarn (for me) is all about when she posted the following statement on Facebook:

Have you ever been so discouraged that you don't know where to turn? Have you ever suffered so much that you despise the Holy thing that they do not save us? Have you ever felt like you don't know where to go next in your life? Remember that every walk in life has a destiny. Everyone has their good times and bad times in life, the amount of badness being encountered is just different. The Holy One is always willing to help and never let go of our hands, to walk with us, no matter what times we are in.

The Shiva Brahma Narayan Temple is supported by devotees of Hinduism both locally and internationally. Over Chiang Mai's illustrious history, Theravada Buddhism, Hinduism, spirit worship, and spirit mediumship have all become interconnected in some sublime and unseen way or other. Theravada Buddhist monks are often ideologically imagined as separate from spirit mediums, but in reality, the boundaries between the two are frequently blurred. In his seminal work *Studies in Sanskrit and Indian Culture in Thailand*, Satya Vrat Shastri identifies the importance of Hinduism in Thailand:

> The Puránas mention Indian ships laden with merchandize touching the ports in Suvarnabhümi which in all likelihood included Syámadesa, Siam, as Thailand was known then. Due to contact with the Khmers who were highly Hinduised people and the Indian immigrants the Hindu religion as well as the Sanskrit language found their way into Thailand. So profound was the impact of both that much of that is noticeable even now.

Thursday the twenty-first of September was also devoted to visiting temples. All located in Lamphun, each had its own special flavor, layout, and atmosphere. Lamphun, southeast of Chiang Mai and geographically larger than other provinces, is home to the Hariphunchai Kingdom, which dates back to the seventh century CE, over six hundred years before Chiang Mai was established. At this time, Lamphun was a major center of Theravada Buddhism and the location of many sublime temples. The first ruler of the Hariphunchai Kingdom was Queen Phra Nang Chamma Thewi, followed by forty-four of her descendants, before Hariphunchai fell to the Lanna ruler Phraya Mengrai, who founded Chiang Rai and Chiang Mai.

Plate 1. Taw Waes Suwan, Asura King of Wealth, Lord of the Northern Quarter of the Jadtu Maha Rachiga Heaven at Chiang Dao Caves.

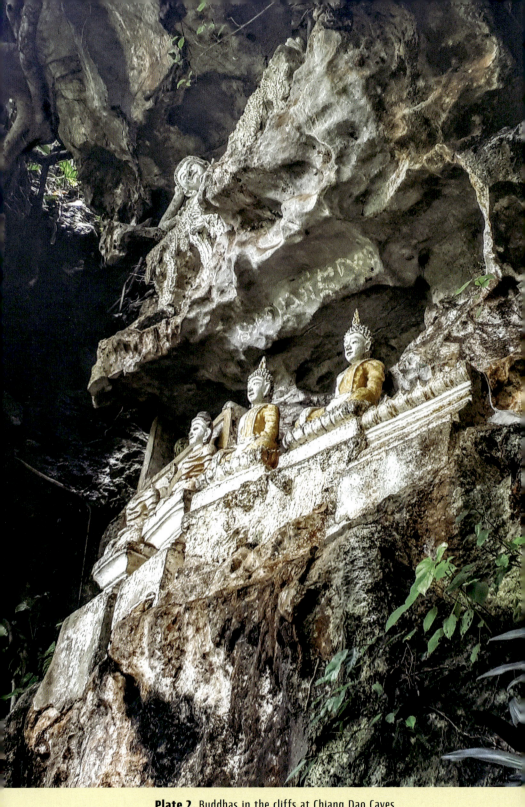
Plate 2. Buddhas in the cliffs at Chiang Dao Caves.

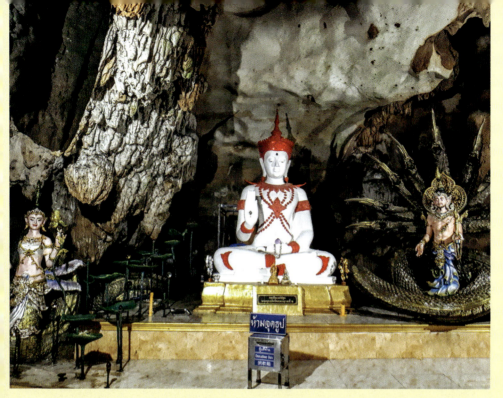

Plate 3. White-and-red Buddha and Nāga deities in the Chiang Dao Caves.

Plate 4. The Jedee Mae Nomm Fah stalagmite and statue of Buddha at Muang On Caves.

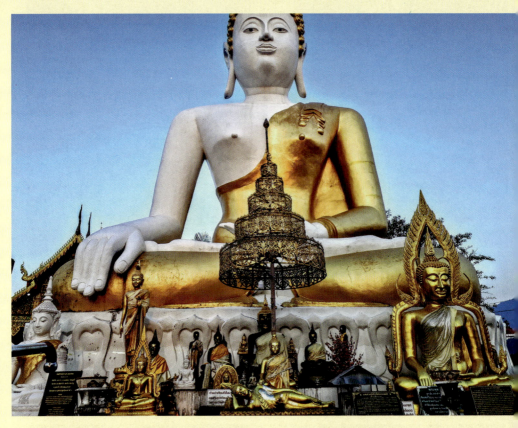

Plate 5. Golden Buddha at Wat Phra That Doi Kham.

Plates 6 & 7. Vishnu riding Garuda and other deities created by Luang Phor Pina at Wat Sanamlao.

Plate 8. Golden statue of Kruba Wong at Wat Phra Phutthabat Huai Tom.

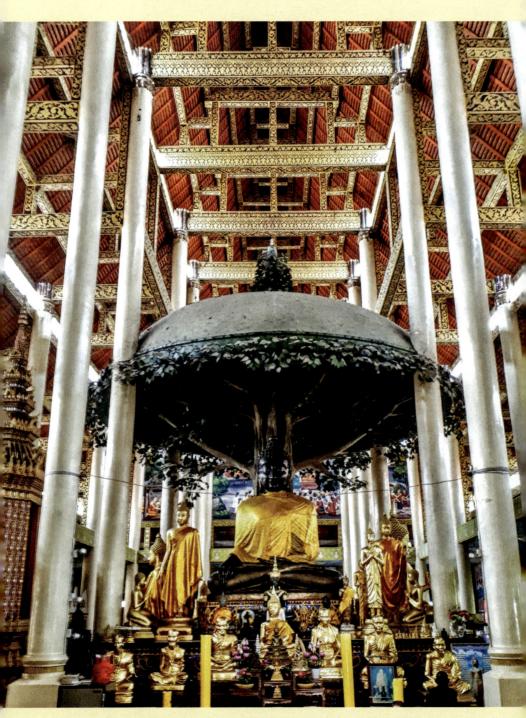

Plate 9. Front view of inner temple at Wat Phra Phutthabat Huai Tom.

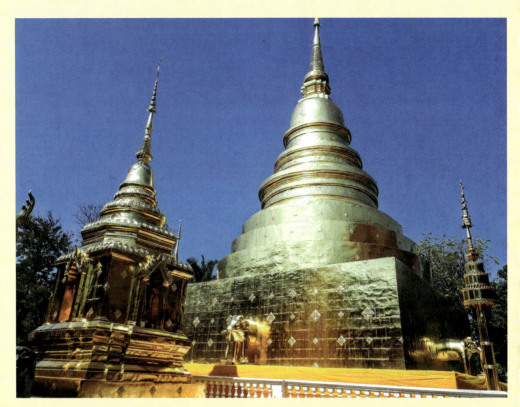

Plate 10. The Golden Chedi of Wat Phra Singh Woramahawihan, a fourteenth-century Buddhist temple.

Plate 11. Phra Rahu at Chiang Dao Temple.

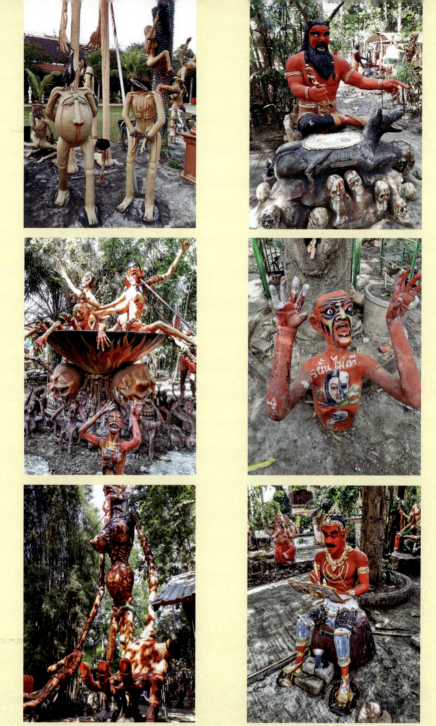

Top: **Plate 12.** Narok (Hell) Garden at Chiang Dao Temple.
Plate 13. Yama or Phaya Yom, God of the Underworld.
Center: **Plate 14.** Sinners being boiled at Wat Mae Kaet Noi.
Plate 15. Half-buried sinner at Narok (Hell) Gardens at Wat Mae Kaet Noi.
Bottom: **Plate 16.** Female Preta (hungry ghost) in Narok (Hell) at Wat Mae Kaet Noi.
Plate 17. Phaya Yom writing the misdeeds of sinners at Wat Mae Kaet Noi.

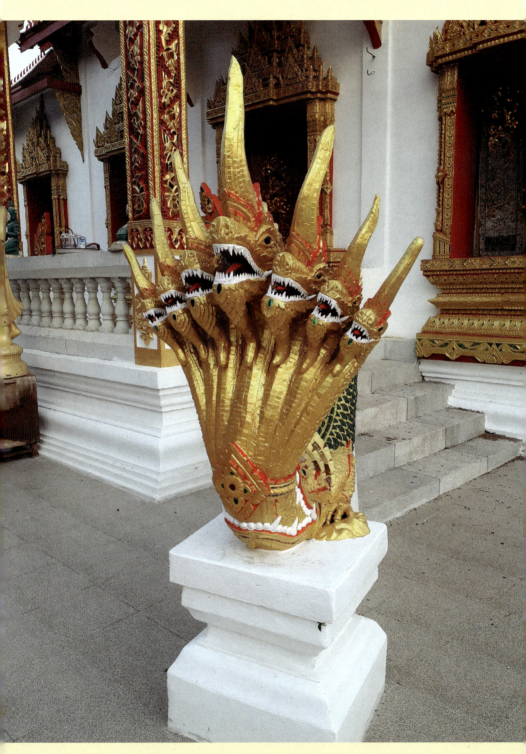
Plate 18. Multi-headed nāga at Chiang Dao Temple.

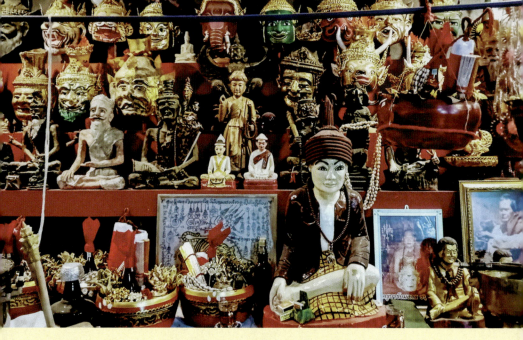

Plate 19. Lersi Nawagod's shrine at his Samnak.

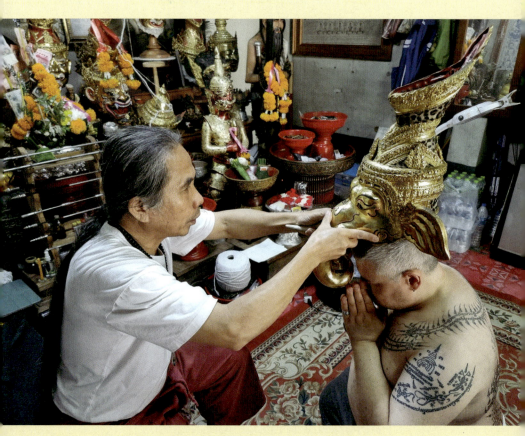

Plate 20. I receive a blessing with the Lersi Ganesha head by Ajarn Daeng. Photo by Magia Thai.

Plate 21. Ajarn Ting blesses a Pha Yant at the shrine in his Samnak. Photo by Magia Thai.

Plate 22. The completed Red Flower Sak Yant design with full gold-leaf blessing. The pale red pigment of the flower ink hides the secret details of the design. Photo by Magia Thai.

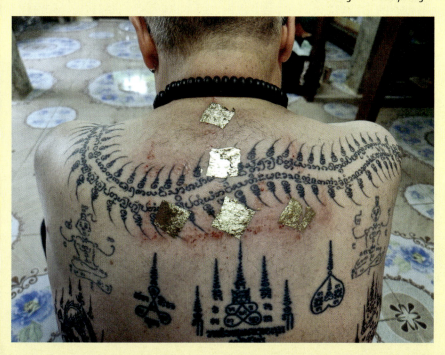

Plate 23. Shrine devoted to Lek Nam Phi at the Bor Lek Nam Phi Folk Museum.

Plate 24. An army of roosters at the Bor Lek Nam Phi Folk Museum representing good luck, prosperity, and protection against misfortune and demons.

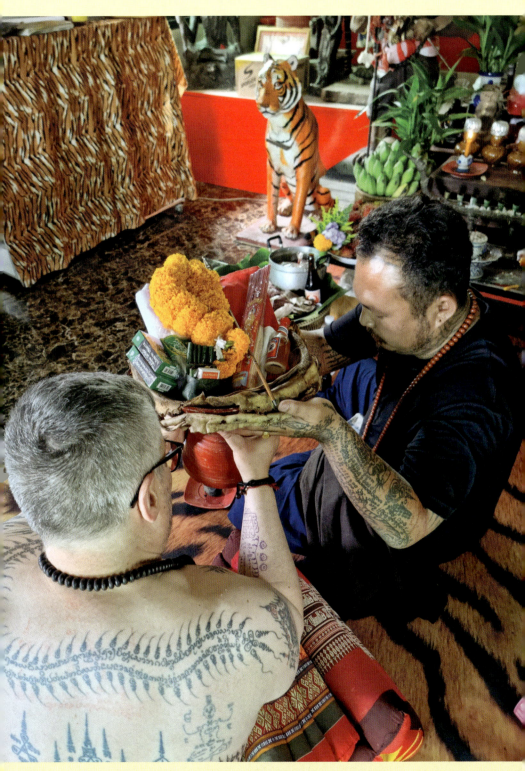
Plate 25. Making an offering to Ajarn Tui. Photo by Magia Thai.

Plate 26.
Por Gae Lersi Thai Fai head by Ajarn Perm Rung.

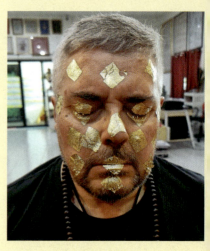

Plate 27.
The completed placing of gold leaf on my face by Ajarn Perm Rung. Photo by Magia Thai.

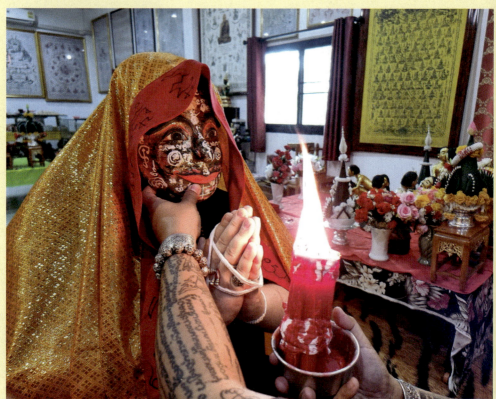

Plate 28.
Final blessing and consecration of the gold face ritual. Note Sai Sin thread around my hands. Photo by Magia Thai.

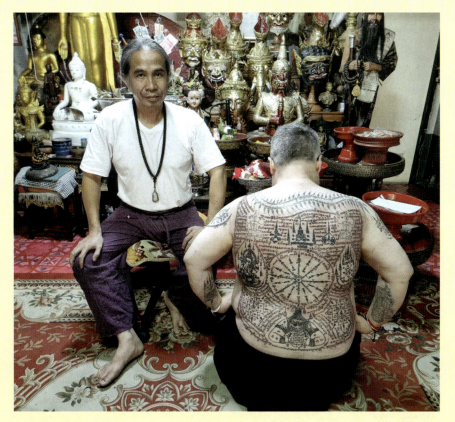

Plate 29. Portrait of Ajarn Daeng and me with my completed full back at his shrine. Photo by Magia Thai.

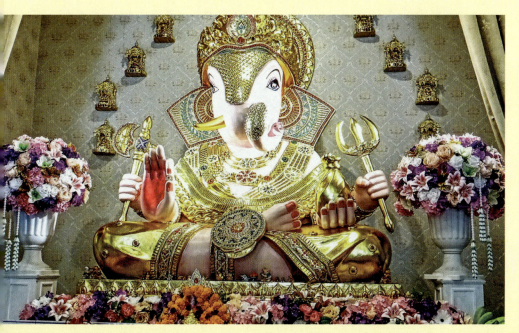

Plate 30. Ganesha shrine at the Shiva Brahma Narayan Temple, Chiang Mai.

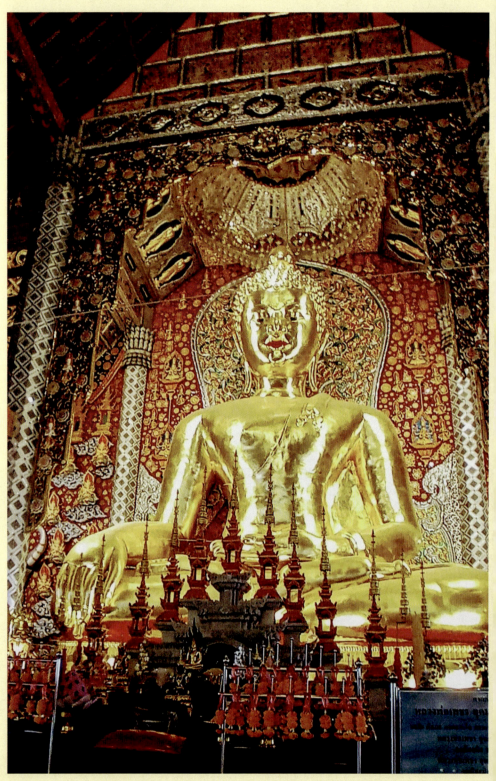

Plate 31. The golden Buddha at Wat Sri Don Moon, Chiang Mai.

Our visit today would first take us to Wat Phra Mahawan Woramahawihan, a temple established in 667 CE, where a statue known as Phra Sila Dam, Phra Phutta Sikkhi, or Phra Rot Lamphun can be seen. Over time the remaining vestiges of the ancient temple have been built over, though the atmosphere of this site is still as strong and vibrant as it was during its inception. In Thailand there is what is called a "league of five" Buddhist amulets long established as the most sought-after, revered, and powerful. This "league" is known as Benjapakee (*Benja* meaning "five" and *Pakee* meaning "regions"). The Phra Rod (*Rod* pronounced "Rord") amulet is the most famous among Lamphun province amulets.

In an act of profound geographical protective Buddhist magick Queen Phra Nang Chamma Thewi upon the completion of the four temples in the four cardinal directions gathered four hermits to the opening ceremony where the five "Phra Sukaputtapatima" amulets were first created, these being: Phra Rod, Phra Perm, Phra Bang, Phra Khong, and Phra Liang. These amulets were then placed and kept inside the four finished temples of Wat Phra Khongrorsee (North), Wat Phratoolee (South), Wat Chetawan (East), and finally Wat Mahawan Woramahawihan (West). Only after the temples were demolished many centuries later, did people start to find the Sukaputtapatima amulets buried in the remains and "rediscovered" the Phra Rod amulet at Wat Mahawan Woramahawihan during King Rama V's reign. The word *Rod* in Thai means literally "to survive," thus the name given to this amulet because of its highly protective, prosperous, and long-lasting enduring qualities.

On entering Wat Mahawan Woramahawihan I felt the waves of this turbulent but fascinating history and Buddhist high magick envelop me. The heat however certainly played its part in this heady feeling. As my guide and I trudged across the open courtyard area at the temple, I felt the strange sensation of moisture exiting my body, the intense sunshine's heat hammering out any resistance to this oven-baked pummeling. Two charming elderly ladies wearing large sun hats stood at the

temple's entrance beneath a sheltered stall. They gave directions to the temple and the two temple shops within it.

At the main temple steps, I stopped to remove my shoes. Through my socked feet I felt the boiling hot stairs as I walked up. I had started to wear socks on this pilgrimage precisely for this reason; I had learned that the high heat of the floors and stairs were at times too unbearable for the naked soles of my feet to tolerate. At the temple entrance I marveled at the ornate main hall that was flanked by two sets of three large, golden Nāgas. Athough I stopped to pay obeisance to the six golden Buddhas that surrounded the much-venerated Phra Rod that towered in the center, the primary focus of my visit however was to meet the venerable Kruba Tue.

As is quite normal in Thailand, the opening of the second temple shop on the right-hand side of the courtyard was delayed. I waited patiently for it to be opened, knowing intuitively that it would be well worth the wait because I knew a treasure trove of various items was waiting for me inside. After roughly twenty-five to thirty-five minutes, the shop owners arrived, followed by Kruba Tue. There is a permanent shrine and seating area inside the shop. When purchased items are requested to be blessed, Kruba Tue is summoned by the shop and he comes to bless any requested items inside the shop's shrine. Once inside the shop, my intuition was confirmed. Before me stood a collection of many beautiful statues, some of which had been made in the temple ovens, all carefully arranged throughout the shop. Amulets and other Buddhist paraphernalia populated every conceivable corner, shelf, and cranny. I was staggered.

Among the displays, a golden-leaf-blessed statue of a Lersi or Ruesi caught my eye. The seated Lersi or Ruesi Ta Fai statue represents occult knowledge and has a third eye. Around this statue, which was heavy and made from clay, was wrapped white Sai Sin thread. I immediately fell in love with it. Kruba Tue very kindly then undertook a blessing for myself and also for the statue. He inscribed khatha on the base, personalizing it to me and imbuing it with further magickal protections.

I believed this intriguing and heartwarming encounter with Kruba Tue would be the high point of the day.

I was soon proved wrong. Further explorations of the extraordinary environs of the ancient city of Lamphun revealed Wat San Pa Yang Luang to be one of the most exquisite temples I'd ever seen. I walked around the intense, white and golden intricately carved buildings, statues, with their ornate interiors and exteriors in a state of ecstasy. Formerly known as Wat Kom Lampong, Wat San Pa Yang Luang has complex history. According to the Thailand Tourism Authority the temple goes back as far as 531 CE. It is said to be the first Buddhist temple in the region of Lanna though this may well be disputed. After its construction relics of Buddha disciples Phra Sariputra and Phra Moggallana were placed inside the stupa. Queen Chama Thewi herself is said to have been cremated here, though her bones were later collected and contained in the Suwan Chang Kot Chedi at Wat Camadevi in Lamphun.

The twenty-second and twenty-third of September would mark the end of visiting temples and the return to visiting Ajarns for the undertaking of powerful magickal rituals. I was grateful however for the opportunity to make merit while visiting local temples, since it was very important in my mind that a sense of balance and appropriate attention was made during my pilgrimage. Making merit is not just a hollow, symbolic act for me. Far from it. It was essential to me that all quadrants in terms of philosophy, geography, meaning, and benefit were served in a meaningful manner. In Buddhism the term *Parikrama* refers to the clockwise circumambulation of sacred entities. By moving through the landscape of northern Thailand I genuinely and sincerely hoped that my presence would not just result in benefit to myself in the form of healing (something that I dearly wished for after the experience of seeing my mother

308 Aftermath of the "Cool Tiger" Sak Yant

die slowly of cancer) but also to help everyone I came into contact with, without any prejudice or discrimination. Parikrama must be done with Dhyāna (spiritual contemplation and meditation). If one is bored when visiting temples, it means one's Dhyāna is not engaged. With this firmly in mind I proceeded with complete mindfulness toward my next encounter.

On Friday the twenty-second of September I once again had the pleasure of meeting the great Ajarn Perm Rung. After my very short visit with him back in January 2020 I was now to receive the gift of a much extended—and what turned out to be an incredible—experience with this extremely talented, generous, and powerful Ajarn. Pulling up to the car port at his Samnak I noticed that he had expanded his living quarters, which now extended across the road and into another property. Such was the success of this Ajarn.

Walking into his office/Samnak confirmed this success. Before me, in what could only be described as an office and shop, was an air-conditioned room full of large tables upon which stood a myriad of amulets. I was stunned by the variety and the quality of these items. Around the walls were shelves packed with effigies, statues, and all manner of deities. The cosmic energy exuding from this array was magnificent. Ajarn Perm Rung and his lovely wife greeted me and our party. We were offered chilled drinks and then offered places to sit around his large office desk. Ajarn Perm Rung is a gentleman who exudes energy and positivity that is undeniably all-encompassing and not in any way exaggerated, bothersome, or overbearing. I bathed happily in his character and charm, which were a beacon of hope and endless possibility. My guides and I then began to discuss with Ajarn the ritual we were interested in and handed over the requested offerings for the blessing and magickal ritual.

My curiosity at this point then got the better of me. I got up and slowly but surely began making my way around the long and packed room, carefully inspecting everything on offer. There certainly was a lot, a vast collection of magickal items whose likes I had not seen on

Aftermath of the "Cool Tiger" Sak Yant 309

Lersi heads by Ajarn Perm Rung. See also color plate 26.

offer before: a very long line of finely finished Lersi heads, each on their own stand; a golden Buddha on an eight-leveled riser of Nāgas; ghost skin face masks; a resplendent army of heavily armed and non-armed Ganeshas; Kuman Thong dolls of many varieties; an army of golden Luk Krok statues (a luck-bringing, prosperity, and danger-warning child spirit, summoned inside of a dead fetus using black magick) in both gold and black; Buddhas personifying numerous variants from the plain to the most highly ornate; and row upon row of some of the finest and most powerful and beautiful amulets I have ever seen. It would have taken a large chunk of the day to look at every single magickal item Ajarn Pern Rung had in just this one room of his Samnak. Next door housed his considerable shrine where he conducted his rituals, and at one end of this room yet another set of cabinets housing his most expensive and valuable collection of amulets, some of them extremely rare.

Ajarn Perm Rung then graciously handed me a small brown pellet that was soft and smelled slightly of soil, which he encouraged me to chew and then swallow. He referred to this spongey "food" as Ya Chin Da Manni,* and told me it was medicine. I ate it without question,

*Because I could not find this substance referenced anywhere, in any form whatsoever, *Ya Chin Da Manni* is a phonetic transcription from my video recording.

310 *Aftermath of the "Cool Tiger" Sak Yant*

knowing that when an Ajarn offers you a magickal substance you damn well better take it lest you risk offending them, something I would not allow to happen on this pilgrimage.

After swallowing the medicine I felt an immediate huge boost of energy, very much as one might feel from a vitamin injection. Although it did not resemble a psychoactive "high," I did experience a full-body response of energy empowerment that felt a little bit like a spongey soil version of Red Bull. Afterward, I was told that Ya Chin Da Manni contains minute gratings of bear, deer, and tiger hair. I wondered how on earth such a combination had been arrived at in the past to merit such a combination and ruminated that maybe this strange substance, which was a "medicine" for boosting my energy channels, had countless lurid and dark iterations. It was extremely easy to be completely consumed and totally seduced by the electricity generated by all of this magickal power. However, I reminded myself that I was there specifically for a gold face blessing, which had its own special variations and unique qualities that only Ajarn Perm Rung could summon.

I took my place in front of Ajarn at his shrine. He began the ritual with a blessing, touching my face while chanting khatha. He then placed gold leaf on various parts of my head; my eyelids, forehead, chin, cheeks, nose, lips, temples, and even my tongue were covered in gold leaf. Ajarn Perm Rung then drew a script upon my gold-leafed tongue with a wooden steel-tipped magick inscriber carved into the shape of Taw Waes Suwan, the Asura King of Wealth and Lord of the Northern Quarter of the Jadtu Jula Maha Rachiga Heaven. This powerful deity protects all temples and is the lord of all riches. Servant of Buddha Shakyamuni, he commands ghosts, demons, and monsters. Each piece of gold leaf around my face was carefully inscribed by Ajarn using the magick inscriber. Then, a lush golden silk cloth with thick red outer lining inscribed with magickal symbols was placed over my head and body. Sai Sin thread was wrapped around my hands while in the position of prayer, and an ornate

face mask with numerous gold Pali and Lanna symbols was held over my face by Ajarn while he held a large thick red candle and chanted the final consecration and blessing. (See color plates 27 and 28.)

Little did I know there would be an unscripted surprise from Ajarn Perm Rung following the gold face ritual, one that would take my guides and me very much by surprise. Thinking we were done, I started to stand up from where I was sitting. Ajarn stopped me, asking me to stay put as he wished to do something extra for me. I asked my guides what this "extra" thing was. They told me Ajarn would not tell me what he was doing before he did it. Perplexed but intrigued, I remained sitting as Ajarn Perm Rung took hold of my right arm and said, "This won't hurt. Not long. It will be quick." He then reached down toward his hip and picked up what I understood to be a Takrut

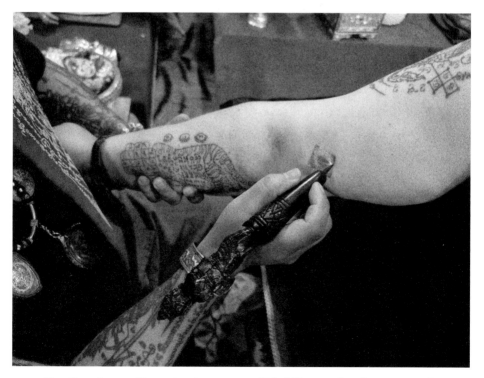

Ajarn Perm Rung making an inscription on a gold leaf blessing after the insertion of a Takrut Needle into my arm. Photo by Magia Thai.

312 Aftermath of the "Cool Tiger" Sak Yant

Needle. As you may remember, Takrut needles are tiny, ultra-thin, needles (usually made of gold), scrolled up with a magickal khatha written on the inside of it. They are placed under and inside the skin. What happened next was so fast it would have been useless to object. Ajarn carefully pinched my arm skin and with the precision of a master, slowly but carefully inserted the Takrut needle into my arm. Although Takrut needles are said to bring numerous benefits such as good luck, protection, and improvement in the levels of loving-kindness received, Ajarn Perm Rung was more specific about the benefits: "You will have a fantastic life now."

The insertion of gold Takrut needle is widespread across Asia. During my second pilgrimage (as you may recall), I was offered a gold Takrut needle to be placed underneath my third eye, but after some initial research revealed that in one case, an incorrectly inserted Takrut had migrated away from its insertion point, breaking through the skin somewhere on the recipient's face, I politely declined. I knew however that Ajarn Perm Rung was a consummate and highly trained professional with a reputation beyond reproach. Rolled gold Takrut needle such as the one I received (placed through an incision into the skin under the upper right arm) are very popular among soldiers, police, and those who constantly encounter various kinds of risk and danger, including those involved in high-risk businesses and investments. Gold Takrut needles are in fact legendary, known to have miraculous protective powers. The painless insertion of the gold Takrut needle felt like I had transformed into a magickal gold leaf–covered spiritual cyborg warrior with brand-new programing, a blessed ecstatic devotee with enough gold to make an Aztec god blush, the same gold the Aztecs regarded as the very product of the gods, calling it literally "excrement of the gods."

The amulets I had bought, including a triangular Phra Ngang Panneng with bone chunks from a suicide victim on the back, were then blessed. I then held up the offering bowl filled with money and

other requested items to Ajarn and the final blessing was completed. We began to make our way out of Ajarn Perm Rung's magnificent treasure box Samnak.

On our way out, Ajarn Perm Rung mischievously beckoned to us in a final sneaky act of show and tell. At the back and to the side of his shrine there was an ordinary bucket. This bucket had in it what looked to be a large and long-headed animal skull, marinating in an unctuous and bizarre liquid. It could have been the skull of any number of animals. Neither I nor my guides could quite identify what kind. Ajarn explained that since the wicha governing the magick of this particular ritual dictated that it wallow for a very long time. Ajarn Perm Rung was not someone who would cut corners. His exceptional and truly profound magickal abilities were known by one and all in northern Thailand. I for one can attest to this. "Chok dee krap!" ("good luck") Ajarn Perm Rung said as I left. I gave him a deep wai and thanked him for wishing me luck, luck that I was sure would now grace me by the truck load.

26
The Countryside Sorcerer

Rivers, Mountains, and the
Temple to Luang Phor Tuad

Saturday the twenty-third of September 2023, my guides and I set out to meet Ajarn A Klongkarn. I had looked forward to meeting the powerful countryside sorcerer known as Ajarn A Klongkarn (aka Ajarn Suthep) whose work I had admired from afar for a long time. Previously I had acquired a remarkable male and female Suea Yen Pha Yant from him. Because it was stained with the blood and urine of a car accident victim, this funeral cloth was charged with a power and energy of a violent death. Items with such an energy infused in them are valued for their potent magickal power, and thus greatly sought after in Thai Buddhist circles. I was gutted when the package was stopped by Revenue and Customs as it entered the United Kingdom. Over the years, many items had traveled to me from Thailand without issue. This was a first. Fortunately, after I cast a release spell at my shrine at home in order to free it, the package arrived unopened and unmolested. I wondered what on earth Revenue and Customs would have done if they had opened it and seen a blood- and urine-stained cloth with male and female tiger deities cavorting all over it. Goodness knows.

Tigers, as you have probably gathered by now, not only occupy a prominent place in Thai culture but also appear widely in the accounts of monks who practice the wandering meditation ascetic known as *thudong*. Thailand's relentless modernization has given way to rampant deforestation and thus this ancient spiritual art of purification has become a victim of this so-called progress. A *phra thudong* (ascetic wandering monk) or *phra thudong kammathan* (wandering ascetic meditator monk) practices and observes the thirteen ascetic practices as found in the *Visuddhimagga* (The Path of Purification), the great treatise on Buddhist practice and Theravāda Abhidhamma written by Bhadantácariya Buddhaghosa in approximately the fifth century in Sri Lanka. Tigers are regarded with fear and respect and are seen by monks as an opportunity to reach one-pointed samādhi. Samādhi, the great thudong master Phra Ajarn Thate Desaransi explains, is "a gathering of the mind's energies so that they have great strength, able to uproot attachments . . . and to cleanse the mind so that it is, for the moment, bright and clear." There is one recorded instance of a monk encountering tigers during thudong. While traveling to Lom Sak in Phetchabun Province during the 1930s, a monk named Luang Phor Chaup Thansamo was suddenly surrounded by two enormous growling tigers, their heads measuring forty centimeters wide. Luang Phor Chaup Thansamo withdrew into stillness and entered into deep samādhi concentration. He remained in this meditative state for several hours. When he emerged from his samādhi, the tigers had retreated and the forest was quiet once again.

Our drive to Ajarn A's took us along some unusual country roads, passing not much more than the odd temple here and there. As we followed the winding Ping River, deeper and deeper into the rural countryside outside Chiang Mai, I started to worry that we were on the verge of getting lost. I now understood that a visit to Ajarn A Klongkarn was not for the faint of heart; only the truly devoted and courageous would venture this far outside civilization to see him. The journey seemed to go

316 *The Countryside Sorcerer*

on for miles upon miles. Gradually it became clear we were approaching a village. Indeed, not even that. It turned out to be something more like a hamlet, nestled around the corner of a small temple. We proceeded down a small back road and pulled up to what could only be called a country village shop vaguely resembling a garage. As I got out of the car I saw a plastic awning advertising a Thai citrus soda drink hanging over an open shop front. Next to the shop frontage was a small shrine with Ganesha, two small golden lions, a spirit house, and what looked to me like a golden Kuman Thong statue. Soon, a woman appeared. It turned out to be Ajarn A's wife, who had come out to greet us. She said that her husband was waiting for us.

We walked down a small lane and soon found ourselves in front of a building with a side-facing porch and a set of stairs off to the side. There at the top stair stood Ajarn A, smiling down at us. We all gave him a wai, and, while holding the ice chilled can of coffee his wife had kindly given us, made our way inside to his Samnak. A statue of a Lersi watched us as we climbed the stairs, along with a large black bin covered with numerous Lanna script, whose purpose was unknown, but would soon be revealed. At the end of the porch was a shrine composed of a beautiful hand-sculpted and painted Lersi, accompanied by a similarly presented Sihuhata (which means four ears, five eyes in Thai). A beloved Thai deity in temples, homes, and businesses across Thailand Sihuhata is said to eat charcoal and shit out gold. The story behind this deity involves a young boy from an impoverished family, who, obeying his father's dying wishes, buried his father's body in the mountains. After the body had completely decomposed and the boy went to collect his bones, he noticed that the bones all pointed in the same direction. Before taking the bones home to worship his dead father, the boy set animal traps in the direction the bones pointed to. Upon returning to the animal traps later, the boy found that a creature with four ears and five eyes had been caught. Believing this creature to be a reincarnation of his dead father, the boy named it Sihuhata and took the creature

home. After not eating anything for quite some time, the boy was surprised when the creature Sihuhata ate some charcoal that had dropped out of the fire and excreted gold nuggets, making the boy rich.

Sihuhata's four ears and five eyes relate directly to the Buddhist doctrine of the Four Immeasurables (Brahmavihara) and the Five Precepts. The ritual that had been previously discussed and arranged with Ajarn A, an ancient and long initiation to join me with the spirits, was not a usual one, involving a considerable amount of text that would take a long time to recite. I felt that this ritual would be special. Ajarn A has a unique ability as a country sorcerer to call upon spirit and cast serious magick, his training under the late great Kruba Pornsit affording him the complete admiration and respect of his peers. I was in awe at the breadth, depth, and variety of offerings, which included a piece of my fingernail and hair, small bananas, what looked like crispy noodles, green vegetables, cut pieces of lemongrass, citrus fruit, oysters, candles, tubular crisp biscuits, sesame seed toast, and numerous other items I could not identify.

First, Sai Sin thread was tied around my head. Then, after my handing over of a bowl with money and offerings to Ajarn A, the marathon recitation began. After the blessing and offerings had been completed, the next step in this epic ritual began. Sitting cross-legged underneath a tent-sized Pha Yant, I was draped in a very beautiful and large Pha Yant made by Kruba Pornsit with a Lersi mask on top of my head and another line of Sai Sin thread running back to Ajarn A. The ritual went on for nearly forty or so minutes of chanting. Surprisingly, my focus and concentration remained sharp even in the humid heat and I managed to stay clear throughout what some might have termed an ordeal, though one not without its own pleasures, which included absorbing myself into the many lines of Buddhist text, following the rising and falling cadences as they sang out from Ajarn A.

Finally, I was blessed with Sompoi and the box of offerings was removed, to be tended to by Ajarn A alone in a separate and secret part

of the ritual. I was told that Ajarn A would go into the countryside somewhere completely secluded. He would then empty the box of offerings onto the ground and split them into two separate piles. He would relocate each one of the piles in two completely separate directions, with one pile representing bad luck and the other good luck. Ajarn A would then literally move any bad luck away from me and then move into its place only good luck. Although I wasn't sure how this particular aspect of the ritual worked I found it to be an intriguing form of soil-based magick.

I was then asked to put on a stripey loincloth for a ritual soaking with Sompoi that was to take place near the big black bin outside. The big black bin was filled to the brim with Sompoi water, and I was dosed a number of times by Ajarn A. After changing back into my clothes Ajarn placed a white tilaka on my forehead. As mentioned, a tilak is a mark placed at the point of the ajna chakra (third eye or spiritual eye). It has various decorative purposes, either as a symbol for sectarian affiliation, or for special spiritual and religious occasions.

Ajarn A then gifted me a Ganesha amulet from a pile of amulets next to his shrine, after which I made offerings for three more. After the ritual was completed, Ajarn A asked me how I felt. I told him I felt as though my spirit was outside of my body, in touch with something that was indescribable and sublime. I said I felt light and diaphanous, though I'm not sure how this would be correctly translated into Thai.

Ajarn A (aka Ajarn Suthep) is truly a great teacher and profound master of magick in possession of considerable talent, skill, and supernatural abilities. Throughout my visit I was struck by his personal aura of calm and inner peace. Nothing seemed to faze him. Memories of his kindness and sincere compassion would endure long after I returned home. Visiting and taking part in a ritual with as great a countryside sorcerer as Ajarn A, was for me quintessential. The journey to meet him wasn't easy. The ritual and its components weren't easy. The day and its heat weren't easy. And this is the point. Some of the most important and enduring things in life are not easy.

Sunday the twenty-fourth of September was spent doing quiet "Sunday-like" things, such as visiting a fine and excellent institution in Chiang Mai called The Shaman Bookshop, filled with over forty thousand second-hand books and many cats, where I spent a happy, carefree hour or so browsing the endless collection of books and purchased a number of relatively rare works on Buddhism. Quite simply it's book heaven. This packed and fascinating place is well worth anyone's time. Reading and returning your books within a year affords one an automatic 50 percent off their next purchase, which is a pretty sweet deal. My guides and I then went to an extremely large shopping mall called Big C for supplies before dining at a charming and unpretentious local diner for our evening meal. I can say in all honesty that it was indeed a perfect day.

Monday the twenty-fifth of September was spent journeying to a temple high in the mountains, a long way outside of Chiang Mai. The abbot of Wat Mae Ta Khrai, the great and highly respected Kruba Teainchai who has been living at Wat Mae Ta Khrai for over twenty-five years, was not always there. He simply cannot be pinned down for anything vaguely resembling an appointment or timed meeting. Such was the impermanence and fluidity of all busy and hardworking Buddhist monks. As such, making this journey would be something of a gamble. As we set off on our long trip of over an hour, I wondered if our visit would yield fruit. Would we be able to actually meet Kruba Teainchai? My guides told me our chances were roughly fifty-fifty. Such was the gamble; a literal stab in the dark that could go either way.

Mountain temples are sites one should definitely attempt to visit while on pilgrimage. These isolated, liminal places can have forms of magick within them not easily accessed through the usual channels. Set atop a

320 *The Countryside Sorcerer*

mountain, visiting them can bring one closer not only to the elements but to the spirits as well, something I was soon to find out. Wat Mae Ta Khrai is located in the Mae Ta Khrai National Park, composed of complex mountain ranges with various types of forestry: deciduous dipterocarp (a tall forest tree common to Southeast Asia), mixed deciduous, tropical rain forest, dry evergreen, and coniferous forest. Occupying 513.20 square kilometers at 400–2,030 meters above sea level, this national park provides water supply to people residing in the surrounding areas and supports a large cross section of rich wildlife ranging from a myriad of birds to muntjacs, deer, gibbons, and wild boar.

Rich in lush vistas and gorgeous flora and fauna, our long journey to the temple was enchanting. By the time we arrived at the temple we had already spent so much time moving through a magickal landscape it didn't matter if we didn't meet Kruba Teainchai. Even so, the final approach to Wat Mae Ta Khrai for the first time is something I may never forget. Poking up over the forest are two massive golden heads of the monk Luang Phor Tuad (other variations of his name are Luang Pu Thuat, Luang Phor Tuat, or Luang Pu Tuat), that the temple erected in a loving memorial to his remarkable achievements. Beloved by the Thai people, Luang Phor Tuad's legendary status has evolved over time. Born into poverty in the Dee Luang subdistrict, Sathing Phra district, Songkhla, Thailand, over four hundred years ago during the reign of King Maha Tamaracha of Krung Sri Ayutthaya, from a very young age Luang Phor Tuad displayed (and was very much predisposed) for a life in mysticism and spirituality. After receiving an education in Pali (the ancient Khmer script used for Buddhist texts at Wat Gudti Luang) and his ordination as a monk at the age of fifteen, he then went on to study under Somdej Pra Chinsaen at Wat See Hyong and Nakorn Sri Tammarat at Samnak Pra Mahatera Biya Tassee. His life is filled with countless recorded instances of miracles and great acts of compassion, though some may be more fable than fact.

One instance in particular remains an enduring testament to his great learning. While Luang Phor Tuad was living and studying in the Thai city of Ayutthaya, a rivalry arose. The king of Sri Lanka, envious of the rising power of Ayutthaya kingdom, offered to the king of Ayutthaya seven large boats, all made of gold. However, in an act of cruel spite the ruler devised a unique and seemingly impossible challenge. In order to get the gold, a particularly difficult Buddhist puzzle involving the translation of eighty-four thousand golden coins, each one inscribed with a letter from the Abhidhamma (ancient third-century BCE Buddhist texts), had to be solved by the monks of Ayutthaya kingdom in seven days or less. If they succeeded in completing this extraordinary challenge Ayutthaya would receive the golden boats. However, failure would result in the Ayutthaya kingdom falling under Sri Lankan rule.

None of the monks could solve the puzzle. In what is said to be a form of divine intervention, Luang Phor Tuad appeared in the Ayutthaya ruler's dream, signifying his imminent arrival and assistance. After Luang Phor Tuad's arrival he completed the entire translation (despite the absence of seven missing coins), revealing the knowledge of the Tripitaka hidden inside each syllable. Having saved Ayutthaya from Sri Lankan invasion, the citizens of Ayutthaya expressed their gratitude to Luang Phor Tuad in the form of a great celebration. Instances such as this, along with his seemingly supernatural attributes, raised Luang Phor Tuad to legendary status. I myself would soon experience a small but significant sample of these profound magickal qualities at the temple that now loomed before us.

Upon arrival at Wat Mae Ta Khrai I was informed by my guides that Kruba Teainchai was indeed present. I took this to be a sign and girded myself for meeting this highly accomplished Buddhist master. My feeling that something wonderful was about to happen flooded me as I walked toward one section of the large and sprawling temple. It seemed that I had entered into a factory space as the roof and walls had a similar type of construction materials.

322 *The Countryside Sorcerer*

Walking toward an area that holds a large central shrine, we came upon Kruba Teainchai who was seated cross-legged in front of a large statue of Buddha. I bowed and we discussed what I wished for in terms of a blessing. A sign next to Kruba Teainchai showed a list of suggested offerings. I placed my donation inside an envelope and offered it as a donation, which would go to the upkeep of the various buildings that needed consistent maintenance. Before I handed it over, I was asked to write my name on the envelope as well as my mother's, since Kruba Teainchai wished to do something special for both myself and my late mother, a gesture I found touching.

We began to chat. He saw that I had Mala beads and a Khun Paen amulet, which he immediately blessed for me. After I told Kruba Teainchai when my birthday was, he referred to a book next to him, which was some form of divinatory guide regarding people and their birthdays. During this astrological consultation I was given advice on my health, my wealth, and suggestions regarding my personal life, all of which I accepted and made note of. Clearly I was being guided to make some course corrections that could be beneficial for me.

It was at this point an interesting thing happened. Kruba Teainchai asked me if I knew about Luang Phor Tuad and suggested that chanting his khatha would help to promote protection along with many other benefits. In a strange twist of fate, some months prior—during my Buddhist studies—I had learned the khatha of Luang Phor Tuad by heart and was able to chant it word for word for Kruba Teainchai: "Namo Potisadto Aakandtimaaya Idti Pakawaa." Kruba Teainchai's eyes widened. Visiting foreigners turning up to the temple with foreknowledge of a very specific and ancient khatha wasn't something that happened every day here. He turned to my guides and told them he was impressed. He then suggested I go through a ritual with him to which I agreed. The ritual that Kruba Teainchai undertook was simple but very beautiful. I was to take an ornate glass bowl and a jug that was filled with water and slowly pour the water into the bowl

while Kruba Teainchai chanted a Buddhist text. I commenced pouring the water. At one point, I heard him say my name. I continued to pour the water. Then he said my late mother's name. At this point I became a little emotional. By some minor miracle I had managed to synchronize my water pouring in time with Kruba Teainchai's completion of his chanting of the Buddhist verses. To complete the ritual, I was to take the glass bowl outside to the nearest tree and pour the water at its base.

The returning of water to the tree represented the cyclical nature of life and death. In this way, it was also an act of honoring of my mother's spirit in heaven. As I emptied the bowl at the base of the tree, I could feel tears welling up inside. I stood at the tree thinking about my recently deceased mother. I felt instinctively that this ritual was a way of recognizing the fact that she had indeed gone to heaven, something that I had not allowed myself to think up until that point. This small

Massive Luang Phor Tuad statues at Wat Mae Ta Khrai.

324 *The Countryside Sorcerer*

but pertinent closure was immensely healing. Aside from the meaning it had bestowed, it allowed me to attain a sense of closure to this pilgrimage.

Back inside, I shifted my attention to the temple shop for amulets and other items, all of which Kruba Teainchai was more than happy to bless. The blessings would take place at a shrine in another part of the temple complex, underneath one of the massive statues of Luang Phor Tuad. I was amused to see Kruba Teainchai hop into a golf cart and drive over the road to the shrine. I imagined that any assistance in transport, irrespective of how it looked, would save Kruba Teainchai untold amounts of energy, which could then be directed otherwise. Underneath the massive statue of Luang Phor Tuad I felt humbled and in awe of its size and grandeur. Kruba Teainchai blessed various items my guides had purchased. As for me, I had only one item to bless: a gold metal amulet of Luang Phor Tuad. Kruba Teainchai recommended I chant with it every day; on Mondays in particular I was to chant Luang Phor Tuad's khatha a staggering twenty-five times. If I needed to cleanse myself Kruba Teainchai instructed me to put the amulet into a glass of water, chant Luang Phor Tuad's khatha three times, and then drink all of the water. We thanked Kruba Teainchai for all of his kindness and compassion during our visit. It had been a privilege, honor, and truly memorable time meeting this remarkable Buddhist monk and practitioner of Buddhist magick. We waved goodbye to him and watched as he drove off in his golf cart.

Before we left Wat Mae Ta Khrai there was one more place that warranted a visit. Just down the road from the main temple is Wat Mae Ta Khrai's very own Hell Garden, a fine example of a truly surreal and haunted place. And when I say haunted, I mean it in a real and most profound sense. To reach the garden we walked down a worn dirt lane with a fairly healthy gradient. A sense of dread and foreboding filled me as I approached the garden, which was located near a small tributary of water. Three huge, towering statues (two males, called Nai Ngean,

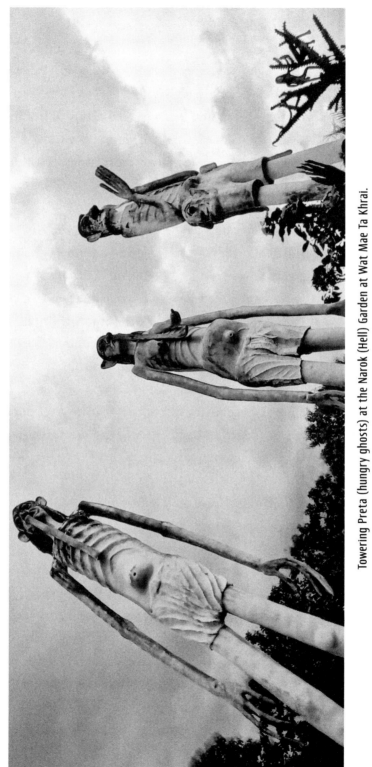

Towering Preta (hungry ghosts) at the Narok (Hell) Garden at Wat Mae Ta Khrai.

and one female called Nang Thong) stand high above the garden. Emaciated, their tongues extend down their skeletal bodies over their distended bellies. Their appearance gives them away as Preta, which (as you already know) are "hungry ghosts" in Thai folklore. Preta is the Sanskrit name for a supernatural being widely identified in Hinduism, Buddhism, Taoism, and Chinese folk religion as some form of tortured soul who's undergoing suffering greater than that of humans, particularly in regard to extreme levels of hunger and thirst. The statues are both impressive and intimidating.

Around their base stand many great spirit houses, rows of them. Along the perimeter of these central figures are various tableaux of violent and horrific scenes: a stage of dancing skeletons playing musical instruments; several naked men and women all pulling multiple yokes attached to a chariot while its rider berates them all; captive people being put through instruments of torture; human beings submerged in a boiling cauldron while being stabbed by spears; corpses rising from their coffins; and—on the other side of a small river—a line of vile demons approaching the scene as if in some supernatural horror film. I managed to make my way around this particularly unsettling place and made my way back toward the entrance. I had visited Hell Gardens before in Thailand but this one had an especially eerie quality to it. Was it the isolated location? Or did the atmosphere have a certain spooky edge about it? I thought perhaps it was the row upon row of spirit houses acting like batteries, charging the place with supernatural energy, something I had not previously noted in other Hell Gardens.

After a little while, the clouds seemed to darken. I saw in the distance swirling storm clouds gathering. Then, walking up toward the main road I was subject to a bizarre occurrence. Appearing suddenly out of nowhere, from dense humid still air, a vast shushing wind wall blew strangely and strongly up and through into the surrounding trees, leaves, and bushes. An invisible chorus of spirits hissed a symphony of

an arrival, the coming storm warning all who dared stay outside in this haunted place that a torrent was about to rip down from the sky. Our party quickly walked toward the car. In a very short space of time, the sky had gone from blue and sunny to suddenly opening up to release torrents of rain, hammering the hot dry concrete underneath our feet. Safely inside the car, we quickly drove away as if we were out running the ghosts, demons, and spirits that were left behind in the Hell Garden of Wat Mae Ta Khrai, one of the weirdest, most peculiar, and haunted Hell Gardens I had ever visited.

27
The Proverbial Full Back

One Whole Side of My Body Becomes a Sacred Talisman

Like a long-awaited and much-anticipated ceremony, Tuesday the twenty-sixth of September finally arrived. The last two days of my fourth pilgrimage, once previously distant, were now upon me. This pilgrimage had been extremely eventful. I felt as if I had reached a plateau and now walked on some form of high invisible plain, a place that no human feet had ever trod. Many great acts of magick had been cast and devotion made. I looked back into the past and could not recall such an intense gathering of magickal rituals in such a short space of time. It was as if all of the required groundwork had been laid for the very last act to commence. This last act being the sealing, encircling, and harmonizing of all the separate Sak Yant on my back with almost a sutra's worth of interconnecting Sak Yant khathas applied by the master of masters, Ajarn Daeng. In tattoo parlance, I was to have what is known as a full back. As you may have surmised by now, acquiring Sak Yant is a very long, slow, and completely devotional pathway. There are rules that simply have to be upheld. In 2017, seven long and incredibly turbulent years ago, I acquired my very first Sak Yant. And on this day my teacher Ajarn Daeng would grace my back with sacred khatha, thus

completing this magickal seven-year cycle. This final act would prove to be a complex task.

I did not know whether this would be the very last time that I would see Ajarn Daeng—or indeed any of the great Ajarns—here in northern Thailand. This was something that I could not see despite my deeply involved love affair with this sublime and beautiful country of powerful Buddhist magick, although I did wonder if I might live here someday.

I was informed only two days prior that Ajarn Daeng had space available to see him. I was of course overjoyed to learn of this. It seemed a fitting and very appropriate ritual to end this fourth pilgrimage upon.

I entered his Samnak at 1 p.m. ready for the ritual, which would take a few hours to complete. I learned that, depending on how things went, there might possibly be time to do a single extra Sak Yant on my left forearm to mirror my right forearm's Suea Yen Sak Yant by Ajarn Tui. The cost to seal my entire back with khatha by Ajarn Daeng would be twelve thousand Baht (£271 GBP). Although I knew it would hurt and would be an extreme ordeal for me, the urge to seal my back with ancient khatha could not be denied. It had arisen inexplicably, from deep inside of me, a direct message from the spirits that guided me. It could not be reasoned or bargained with. My mind, body, and spirits were all at one with this.

I was asked to sit leaning on a cushioned chair facing away from Ajarn. Using a thick red felt-tip pen, he carefully drafted the design for the ancient khatha, joining and encircling all of the Sak Yant on my back. He took his time. His samādhi during this operation was strong and intense; I could feel his care and attention to detail during the mark up. Though time seemed to drift, I estimate that this initial preparatory stage took roughly forty minutes to complete. When he was done with this stage, we then took a break, in which I was given a chance to enjoy Ajarn Daeng's lovely sense of humor. His cheeky and kind face shining, he jokingly told me that this was my last chance to

back out of this ritual. I laughed and said, "There's no turning back now!"

After our break I resumed my seat and then the inking began. I was surprised when the pain I was expecting didn't arrive right away, not knowing that the real agony would arrive much further into the ritual, when the needle would hit the raised areas of my spine, bringing with it extreme levels of pain, which (as I had done many times before) I took on and accepted completely. I felt every single character of ancient khatha drilled into the flesh on my back, taking note of each moment of pain while embodying the contemplative aspects of vedanānupassanā, the contemplation of feelings as exemplified by The Venerable Mahāsi Sayādaw in his lecture "The Teaching of the Buddha-Sāsana," "When mindfulness and concentration have grown stronger, the painful feelings during the noting may disappear as if taken away."

Time smeared itself across the afternoon haze as every inked line of mantra followed Ajarn Daeng's template diligently. My mind and body drifted into trance states only to be knocked back out of them when the needle hit the flesh near the bones in my back. I wondered at one point how on earth this would all look. I had been guided by spirits to have this ritual done and could not question their reasons or choices now.

After four to five long hours of this ritual we stopped. The end had arrived. I was filled with endorphins as I slowly got up. I was asked to stand still so that a photograph could be taken of Ajarn's work. I looked at what had been captured. My entire back was alive and moving with Sak Yant and khathas. They danced and moved in a complex, yet clear pattern. Each of the Sak Yant spoke their messages out into the world. My back had become a sacred text, an open illustrated grimoire, a field of dreaming and magickal deities and symbols, all pulsating in the afternoon light in Ajarn Daeng's Samnak. I was silenced, in awe of this achievement and immediately gave Ajarn Daeng, my teacher and

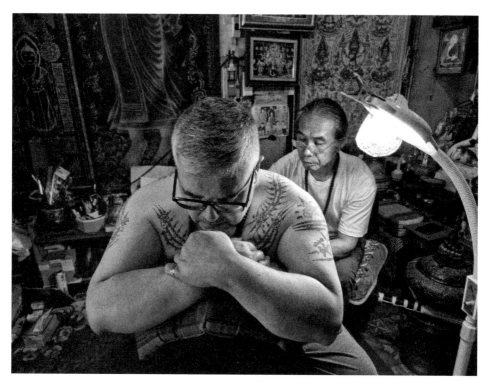

Ajarn Daeng applying Sak Yant. Photo by Magia Thai.

my friend, a deep wai, a feeling of incredible gratitude and respect flowing from me, the words from Ray Bradbury's novel *The Illustrated Man* echoing in my swooning mind:

> The colors burned in three dimensions. They were windows looking in upon fiery reality. Here, gathered on one wall, were all the finest scenes in the universe; the man was a walking treasure gallery. This wasn't the work of a cheap carnival tattoo man with three colors and whisky on his breath. This was the accomplishment of a living genius, vibrant, clear, and beautiful.

After I returned to this plane of existence and managed to gather myself together, I was told there was indeed still time left to do one

more Sak Yant. I was game. I resumed my position next to Ajarn Daeng. Somehow, by some remarkable and bizarre feat of magick, Ajarn Daeng reached into one of the large plastic bags that held his many countless Sak Yant designs and, seemingly at random, pulled out a design that perfectly mirrored the Suea Yen Sak Yant on my right arm by Ajarn Tui. I was astonished; the proposed design was complementary, though not completely identical to, the one on my right arm (see page 293).

The design was placed tentatively on my left forearm so we could see what it looked like next to the one on my other arm. Sure enough, the designs were perfect together. The proposed design for my left forearm, the Khun Phen Chom-Talat, even had a magick square in its center, very similar to the one that made up the Suea Yen's head on my right arm and had a stylized figure in scripture above and lines of khatha surrounding it. This magickal design would give me numerous attractive qualities, promoting strong responses in those around me. Its application was quick, and upon completion, it looked sublime. After this, we all relaxed. The completion was a relief but the sense of achievement was considerable. We had climbed a tattoo Everest of magick.

The twenty-seventh of September would mark the very last day of my fourth pilgrimage. I spent most of the day packing, pulling together all the amulets, statues, and other magickal paraphernalia I had accrued over the last two weeks. It was a fair amount. Fortunately, I managed to successfully secure them all within the confines of my suitcase, and after enjoying one last lunch with my guides, I began the long, slow, and drawn-out journey back to Bristol. After a two-week-long pilgrimage into Buddhist magickal hyperspace, anything outside this world now seemed pedestrian and pallid. In my mind, I returned to each and every single day, remembering the rituals I had gone through. I marveled at how much had been accomplished, lingering on each and every note

The Proverbial Full Back 333

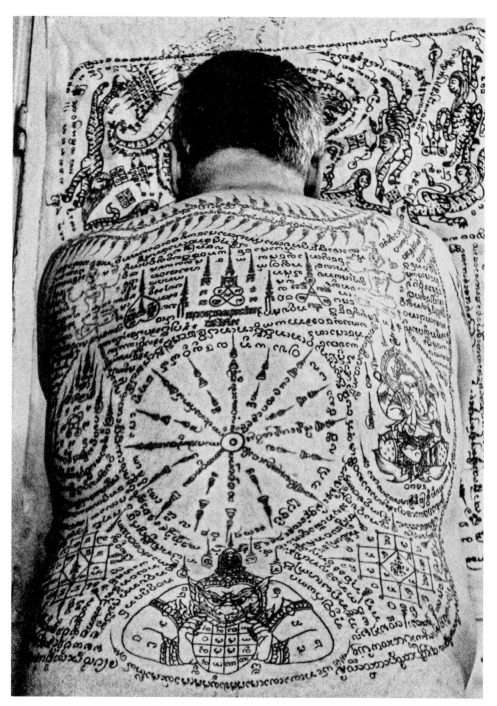

My finished full back of Sak Yant.
Note Ajarn Suthep's Suea Yen Pha Yant in background. See also color plate 29.

of the Buddhist magickal rituals I had undergone. My state of reflection slowly transformed into a state of sammāsana ñāna, knowledge and comprehension of the three marks of existence (characteristics of mental and physical processes), namely *anicca* (impermanence), *dukkha* ("suffering," "cause of suffering," or "unease"), and *anattā* (without a lasting essence). As the long, drawn-out process of transformation arose and dissipated, bright lights surrounded me and a joy of unspeakable depth welled up inside me.

CONCLUSION
This Magickal Mapping
Ruminations on Silence, Chanting, and a Spiritual Pathway

The magickal mapping of my chosen spiritual pathway of the last seven years has certainly had its ups and downs and turning points, full of surprises, losses, various challenges, and ordeals. My learning and personal development have been infused upon and within my body and mind. It is my daily consistent practice of Buddhism itself however that has been the backbone of this experience, and will remain so, throughout this lifetime. Life *is* practice, after all. In terms of Buddhism, what it means to practice can be different to many people, depending on which school of Buddhist thought one subscribes to. The oldest and most prominent schools of Buddhism are Theravada and Mahayana. Chanting, an integral part of both of these traditions and at the core of my daily practice since the early 1990s, is one of the most powerful rituals a practitioner can undertake.

I am grateful to have been afforded the backdrop of silence necessary to engage in this practice. For from silence comes all things, including life itself. That being said, it may seem contradictory that I have been on a sonic quest for most, if not all, of my life, a quest that began when I was very young, the very first time I heard the sound of that

336 *Conclusion*

acoustic guitar outside my home. Sound, and the sacred aspects of it, have enchanted and fascinated me throughout my life and continue to do so. While my sonic quest may seem contradictory to the need for silence, in reality, sound and silence are yin and yang, double-sided twins that cannot exist without each other. And yet, for some strange reason they still seem to be so vastly different from each other. Gerardus van der Leeuw, historian and philosopher of religion, in his *Religion in Essence and Manifestation: A Study in Phenomenology*, explores the numinous and mysterious character of sacred sound and sacred language:

> The word . . . is a decisive power: whoever utters words sets power in motion . . . Raising the voice, emphasis, connection by rhythm or rhyme—all this endows the word with heightened energy . . . [such that] singing, rejoicing, and mourning generate greater potency than mere speaking . . . More important still is the vast power which always emanated from such cult terms as Hallelujah, Kyrie eleison, Amen, Om; a mystical tone-color is attached to them, while their very incomprehensibility enhances their numinous power . . .

In his book *Aspects of Indian Thought*, Gopinath Kaviraj expounds on the power of sound by highlighting the magickal power of words, which constitute the very keys that open the locked doors of truth and reality:

> In magical theory the "real" name of a god or an idea contains the essence of that god or idea, and therefore enshrines its power. Using the name turns on this power automatically, in the same way that pressing the light switch turns on the light . . . In the ancient world there was a widespread belief in the existence of a secret name of infinite power which automatically controlled everything in the universe.

This Magickal Mapping 337

Chanting a mantra is an act of sonic magick personified into sound values that shape and change the inner and outer worlds of both the chanter and his or her surrounding environment. I cannot emphasize enough how positive an impact chanting each and every morning and night (just before sleep) has on one's health and personal well-being. Chanting is protection, consecration, realization, and transformation. In his book *Ewiges Indien* (Eternal India), Heinrich Robert Zimmer describes "mantra" thus:

> it is compulsion to form a pictorial image (zwang zum Denkbild) compelling beings to be as they are in their innermost essence. It is therefore knowledge (Erkenntnis), it is mutual inherence of knower and known . . . it is compelling force, magical instrument by which immediate reality—appearance of gods, the play of mystical powers—is wrought . . . *Mantra* is power.

One could say that I have literally chanted myself into consciousness. As such, for me, chanting is essential. By chanting one becomes completely absorbed into the khatha or mantra that one has either been given or has gravitated toward. By immersing one's self in this sacred practice one assumes the ability (and some might say responsibility) to catalyze the divine essence of the creative force of the universe itself. Chanting not only brings one home to one's true self but also acts as a centralizing and stabilizing force, securing your place and location within this sublime continuum.

All that being said, chanting is only one form of meditation, and meditation is a universal practice that is interpreted in countless ways. When one engages in the consistent practice of desisting from habitual or emotional responses that contaminate one's stillness and silence, the relinquishing and surrendering of oneself from compulsive and addictive reactions and instead residing quietly in the pure undiluted simplicity of sitting and just being, one achieves an inner peaceful

338 *Conclusion*

sanctum of detachment from the self and the mind's tyranny. The reality is that reaching samādhi, a state of meditative consciousness, a blissful form of total meditative absorption (from the Sanskrit *sam*, "to bring together" and *ādhi*, "to place on, put, to impregnate, to give, to receive: the bringing together of cognitive conditions") can be achieved through silence, chanting, or both.

In a practice that involves chanting—which all forms of various spiritual pathways have identified as a technique in some form or other within their own tradition—the mind will naturally find itself in a state in which the desire to speak disappears once chanting has ceased. Peace and stillness surely taste sweet once this first step has been taken. Directing your mind to stay one-pointed for a long period of time can gather energies to reach attainment, uproot attachments, cleanse your mind, and ward off disease. In reaching samādhi, the subject disappears, transforming into a channel through which Satti-Panna (mindfulness and wisdom) accompanies every level of calm. It is Satti-Panna that lifts the practitioner out of the abyss of Avijja (self-obscuring ignorance).

Although I didn't do it consciously, I first started building sacred spaces when I was a child. My bedroom, unbeknownst to me at the time, was a shrine. Building a shrine (sacred space) in one's home is something I highly recommend, irrespective of one's path or denomination. Keeping a shrine requires discipline and a consistent and compassionate loving focus on one's devotion to all deities, spirits, and local natural forces that one feels an affinity with. A shrine need not be elaborate or complicated. It does not require large amounts of money or access to infinite resources to create. My first shrine was a very simple wooden Buddha in front of a framed picture of a print of Amoghasiddhi, one of the Five Wisdom Buddhas of the Mahayana and Vajrayana tradition of Buddhism. I made simple offerings and kept my prayer beads there. From these simple beginnings (and certainly since my four pilgrimages to Thailand) my practice (and my shrine) has expanded into something far more elaborate and wide ranging. Various other Buddhist, Hindu,

and animist deities have since made their presence known in my life, namely Phra Ngang, Sihuhata (Four Ears and Five Eyes), Lersi Narot, Pujow Samingprai the Tiger faced Lersi, Khru Kai Kaew, Ganesha, and Mae Surasatee. And all of it happened over a great deal of time, many years to be exact. Slow is calm, and calm is peace.

Although one's shrine does not have to align to any format. There are a few basic but nonnegotiable rules for creating one. The first is that Buddha (and the shrine itself) must be at least two-and-a-half feet off the ground. Buddhas need to be in an elevated position at all times, and no deity can stand higher than the Buddha. Unless they have had a plinth specifically designed and built into them for their free-standing placement, Buddhas placed directly onto the ground shows a distinct lack of respect to the image and creates bad luck. Likewise, in order to properly absorb the characteristics and emanations from each and every deity that is present on the shrine, all statues of deities must be roughly at (or above) the level of one's third eye.

As with shrines, there is in fact no single, predetermined way to correctly enter any perceived spiritual pathway or seemingly identified system. Belief and practice happen quite naturally within you. In fact, one need not fork over money, email addresses, or anything else to someone else in a quest to attain consciousness of what your heart and mind already knows. In my opinion, being a practicing Buddhist can be rendered in simple fashion, without fanfare or hoopla. Less can indeed be more in this case.

Some Western aficionados of Thai occultism who are not practising Buddhists seem to think sin is just a part of human existence. Buddhism in its myriad of forms does indeed attract countless seekers because on the outside it seems to have a relaxed and casual view of sin. This cannot be further from the truth. Buddhism recognizes wrongdoing. The three poisons in the Thai Theravada Buddhist tradition refer to the three root kleshas (mental states that cloud the mind and manifest in unwholesome actions), which ultimately lead to all negative

340 *Conclusion*

actions. These three states are delusion, also known as ignorance; greed or sensual attachment; and hatred or aversion. The Buddha Dharma Education Association have stated, "The idea of sin or original sin has no place in Buddhism." Buddhism is not like any other form of theistic belief system and is not a monotheistic philosophy. Buddhism stands alone from traditional monotheistic and polytheistic religions due to its nontheistic nature. Buddhism does not adhere to the worship of an official God or deity. Instead, it centers around the teachings of a remarkable individual known as the Buddha and the pursuit of enlightenment. Thai Buddhism however does have practices linked to deities, Thai folklore, spirits of the land, water and mountains, wizard monks, magick, necromancy, Lersi, ancestors, animist beliefs, and so forth. In *The Amitābha Sutra as Discoursed by the Buddha*, in the chapter "The Forty-Eight Vows of Amitābha Buddha" (who was possibly a monk named Dharmākara) the eighteenth vow says:

> If I should attain Buddhahood, yet sentient beings of the ten directions who aspire to be reborn in my land with wholehearted faith and joy, even having just ten thoughts [of my name], would not be reborn there, may I not attain perfect enlightenment. The only exceptions are those who have committed the five great violations and those who have slandered the right Dharma.

In Thai Theravada Buddhism the "Five Great Violations" are called Ānantarika-karma and are viewed as the very worst of all possible crimes. These five crimes or "violations" are: injuring a Buddha, killing an Arahant, creating schism in the society of Sangha, matricide, and patricide. Ānantarika-karma in Theravada Buddhism is such a heinous transgression that it causes the perpetrator of any of the said five crimes to be reborn in hell immediately after their death. The Five Precepts are all nonnegotiable. Every action, good or bad, has an inevitable and automatic effect in a long chain of causes, an effect

This Magickal Mapping 341

that is independent of the will of any deity. The relaxing of any of the Five Precepts is a serious misunderstanding of them, for they provide boundaries that are impervious to rationalization. The keeping of the Five Precepts is the spiritual energy that powers Sak Yant tattoos. Without any form of devotion to the Five Precepts, your practice will stagnate and your Sak Yant will lose their power. The keeping of the Five Precepts in a humble, and, when necessary, discreet manner ensures an indefatigable compass on your spiritual pathway. As Ajahn Nyanadhammo of the Buddhadhamma Foundation during a teaching has said, "Keeping of the Five Precepts, that's the foundation for being a human being. The difference between human beings and humanity and the animal realm is that we can make the moral decision, the intellectual decision, to choose for ourselves to say that I am going to live to a certain standard."

The subconscious mind does not have a format. I myself have allowed intuition, random elements, solicited (and unsolicited) guidance and advice and chance circumstances, to inform my choices. At one time a very clear and almost urgent quest to obtain a bucha of Mae Surasatee had obsessively gripped me. It was as if I had been possessed and in a way I was and still remain so. It was William Blake in *The Marriage of Heaven and Hell* that said, "Thus men forgot that all deities reside in the human breast."

Another time, after I had returned to the United Kingdom after one of my pilgrimages, I was casually walking down the local high street when I found myself face to face with a series of golden Thaistyle Buddhas. Staring out at me from behind the window of a local charity shop, the Buddhas, whom I had not seen in this shop window prior to my departure, must have arrived while I was away. This synchronous and serendipitous event encouraged me to go inside and purchase one of these beautifully rendered statues, which now occupies the highest point atop my shrine, looking down at me as I engage in my practice.

342 *Conclusion*

I found that strange and unusual coincidences such as this that presented and unfolded themselves to me during my pilgrimages both abroad and at home, added depth and considerable meaning to my pathway. Although not everyone following a pathway that holds a deep and heartfelt meaningfulness in your life will experience things as drastically as this, it doesn't take much time or effort to quietly observe and note the sublime nature of this profoundly interconnected continuum we dwell in, and to see the many interconnected instances of direct involvement and recognition surround you. This ability, in Buddhist terms, means one is a Stream Enterer, one who—through the development of right understanding, the first factor of the Noble Eightfold Path—has attained the path and the fruition of the first stage of enlightenment. The Pali word *sotāpanna* literally means "one who entered (apanna) the stream (sota)." There are four progressive stages of spiritual development here, namely: Stream Enterer (Sotāpanna), Once Returner (Sakadāgāmin), Non-Returner (Anāgāmi), and Arahant (Arahat).

My love and devotion over the decades to music was also a very important, clear, and open invitation for the deity Mae Surasatee to enter into my body and thus into my mind, thus transporting me into the very heart of Thai Buddhism itself. Euterpe, the Muse in Greek mythology who presided over the art of music, musicians, and producers of all persuasions across time I see as one of the sisters of Mae Surasatee, and have drawn inspiration from all forms of deities, goddesses, and gods. The techniques and practices of invoking their presence and assistance in the creation and manifestation of art through rituals and spells are as countless as there are stars in the sky. I perform my daily practice of meditating, chanting, and making regular offerings to each of the deities and spirits that I commune with and in the center place of pride stands Mae Surasatee, direct descendant of the Hindu goddess Saraswati, which translates from Sanskrit literally as "she who has ponds, lakes, and pooling water" or occasionally, "she who possesses speech." This Hindu goddess of knowledge, music, art, speech, wisdom,

and learning forms part of the trinity (Tridevi) of Saraswati, Lakshmi, and Parvati. Since I received my inked Mae Surasatee Sak Yants, Mae Surasatee quite literally has had my back. Her holy and sacred presence is always with me.

Another important aspect of maintaining a shrine is the use and daily replenishment of water. My daily focus is in fact underpinned by replenishing my shrine with fresh water, chanting various khathas or mantras, and making offerings to Buddha and the various deities that reside there. This practice is akin to a practice known as hydromancy. In *Wisht Waters: The Cult and Magic of Water* by Gemma Gary, she describes hydromancy as "The practice of making oracular and divinatory use of water . . . a collective term for a variety of specific methods and rites."

The practice of the replenishing of water is the act of reestablishing and renewing portals to allow all manner of spirits to pass through. The water is also an offering in of itself to the spirits and ghosts present, and can be done in a number of ways. For example, Master Krit, an Ajarn in Bangkok, makes five cups of fresh hot tea as an offering to honor his five masters. Water is life. Placing fresh water on your shrine every day is a commitment to life, as well as recognition of the spirits that dwell out of sight.

In Bangkok, in the grounds of Wat Indrawihan lies a hexagonal building, hidden by several shady trees with a curved pathway. Entering this building gives on the impression of entering a cave. It is called Tham Bo Nam Mon Somdet (Cave of the Holy Water Pool of Somdet To). Somdet To (1788–1872), known formally as Somdet Phra Buddhacarya, was one of the most famous Buddhist monks during Thailand's Rattanakosin period. Somdet To left many precious things after his passing, including many completed Buddha statues and temples, along with eighty-four thousand Phra Somdej amulets. He was renowned for his wisdom (giving talks about the Dharma at the royal palace and to the public throughout Thailand) and famous for his

knowledge, meditation, and prayer. He also created the Phra Somdej amulet, popular among collectors. The Cave of the Holy Water Pool of Somdet To is a rare shrine that consists of a cave containing holy water, residing in near complete darkness. Here one is encouraged to sit and meditate in silence, taking in the holy waters while listening to the Jinapañjara Kāthā, The Victor's Cage, a beautiful Buddhist song that is piped into the shrine.

My daily work with numerous different amulets in my collection is also administered via an intuitive and, at times, random basis. Some individuals believe one should only have a limited, certain amount of amulets. I respectfully disagree. Purchasing amulets is very much in line with making merit since many, the purchase of many (if not all), help to sponsor the makers, their families and any temples from whence these talismanic tools of magickal potency are born. Some amulets I collect, others are given to me, and others make their way to me in other ways, either randomly or with a deliberate purpose. I am, for whatever bizarre reason, something of an amulet magnet. With this in mind, if I come into contact with or hear of someone who is experiencing a difficult patch in their life I have been known to sometimes give them an amulet, often accompanied with simple instructions, a gift that in no way should be interpreted as an attempt to convert this person to Buddhism. My underlying motivation for passing an amulet on to someone is pure; amulets can often change someone's luck and they can offer protection. Very often I do not receive money for doing so. It is just my way of passing on a spiritual life raft, a gift, in a time of trouble.

Some days I feel the need to lean more into one certain kind of amulet while on others I have a combination of amulets. I wear them around my neck and always have one or two inside a velvet bag in each of my trouser pockets. Amulets are ultimately devoid of meaning however unless the person wearing them is able to support these sacred profound Buddhist/Hindu/animist/necromantic magickal tools with a strong backbone, focus, discipline of belief, integrity, high character,

and commitment of a stone-cold practitioner that ultimately makes them powerful. The tools as they say are only as good as the one that wields them.

The Duang Ta Pra Arahant Song Sap Badtiharn Yim Rap Sap Onk Kroo Nam Reuks 4 Takrut amulet by Luang Phu Khaw Haeng that I often like to wear, contains monk hair and blood relics from an arahant. An *arahant* (Pali) means "worthy one" or "perfected one" and is the highest ideal of a disciple of the Buddha. He or she was a person who had completed the path to enlightenment and achieved nirvana. Arahants are described in Verses 95 and 96, of the Dhammapada (translated by Acharya Buddharakkhita):

There is no more worldly existence for the wise one who, like the earth, resents nothing, who is firm as a high pillar and as pure as a deep pool free from mud. Calm is his thought, calm his speech, and calm his deed, who, truly knowing, is wholly freed, perfectly tranquil and wise.

Looking back, I now see that this magickal seven-year cycle was ultimately a devotional pathway, one led by sound, music, spirits, guided by my Guardian Angel, whom I honored by making offerings and wishing them a final farewell during a powerful ritual beneath the full Wolf Moon, named by Native Americans after the wolves that howled during the winter nights. It was originally thought that they did so due to hunger, but now is believed that they did so for numerous reasons, including as reaffirmation of the honorable and unseen spirit connections to their pack. How appropriate. I do hope that it has been in both sincerity and the deepest of respect that I have walked with peace in every step, beginning with my first initial love of, obsession and fascination with music and ending in the very heart of Mae Surasatee herself, the sublime angelic Burmese deity whom for me embodies music itself and is the highest sacred goddess and guardian of the Tripitaka, Buddhist

scriptures (of which a very infinitesimal tiny amount is now inked on my body), wisdom, knowledge, and charm, all of which links her to the Indian goddess of Saraswati. To this sacred holy goddess I am now inextricably linked and have become a fully initiated devotee of her.

I hope my book serves you in your life and helps you along your chosen pathway, irrespective of what that may ultimately turn out to be. If you're being guided and led by powerful but invisible impulses, then you can do nothing else but trust that the endless variety of hidden guides and teachers are leading and teaching you, guiding you along the path to somewhere you need to be, and to which, invariably, you'll end up being.

A thousand spirits watch me day and night. However, only one will lead me up into the light. It is now with a quote from the book *Devotion in Buddhism* by Ananda Metteya that I will end this work. It is my hope that these words, supported by a life of selfless devotion, will guide you on your way.

> *Our gifts must be in deeds of love; of sacrifice*
> *and self-surrender to those about us,*
> *must be our daily offerings*
> *in worship of the Exalted Lord.*

Bibliography

Aeusrivongse, Nidhi. "The Devarāja Cult and Khmer Kingship at Angkor." In *Explorations in Early Southeast Asian History: The Origins of Southeast Asian Statecraft.* Edited by John K. Whitmore and Kenneth Hall. University of Michigan Press, 2020.

Aiyar, K. Narayanasvami. *Thirty Minor Upanishads.* Vasaṇṭā Press, 1914.

Anderson, Benedict. *Language and Power: Exploring Political Cultures in Indonesia.* Cornell University Press, 1990.

Ariyesako, Bhikkhu. "The Bhikkhus Rules: Guide for Laypeople, Theravada Buddhist Monk's Rules." Sanghaloka Forest Hermitage, 1998.

Ashley-Farrand, Thomas. *Healing Mantras: Using Sound Affirmations for Personal Power, Creativity, and Healing.* Ballantine Wellspring, 1999.

Assavavirulhakarn, Prapod. *The Ascendancy of Theravada Buddhism in Southeast Asia.* Silkworm Books, 2010.

Baird, Ian G. "The Cult of Phaya Narin Songkhram, Spirit Mediums and Shifting Sociocultural Boundaries in North-eastern Thailand." *Journal of Southeast Asian Studies 45,* no. 1 (2014): 50–73.

Baker, Chris. *The Tale of Khun Chang Khun Phaen: Siam's Great Folk Epic of Love and War.* Edited by Chris Baker and Pasuk Phongpaichit. Translated by Chris Baker and Pasuk Phongpaichit. Illustrated by Muangsing Janchai. Silkworm Books, 2010.

Balance, Jhonn. *Moon's Milk: Images by Jhonn Balance,* Collected and Collated by Peter Christopherson and Andrew Lahman. Strange Attractor Press, London, 2024.

Bapat, P. V. *2500 Years of Buddhism.* The Publications Division Ministry of

348 *Bibliography*

Information and Broadcasting, Government of India, 1956.

Baten, Jorg. "Economic Determinants of Witch-Hunting." Research paper. Department of Economics, University of University of Munich, 2003.

Bessac, Stephen. *Narok: Visions of Hell in the Gardens of Siam.* Timeless Editions, 2019.

Beyer, Stephan. *The Cult of Tara: Magic and Ritual in Tibet.* University of California Press, 1978.

Bhagavad Gita, The. Translated by Juan Mascaro. Penguin Books, 1962.

Bharati, Agehananda. *The Tantric Tradition.* Rider & Company, 1965.

Bird, Michael. "Peter Christopherson: Benevolent Outsider by Michael Bird." Brainwashed. 2008. Accessed April 6, 2024.

Blake, William. *The Complete Illuminated Books.* Thames & Hudson, 2000.

———. *The Marriage of Heaven and Hell.* Legare Street Press, 2022.

Bodhi, Bhikkhu (translator). *How Many Must One Cut? from The Connected Discourses of the Buddha: A Translation of the Saṃyutta Nikāya.* Translated by Bhikkhu Bodhi. Wisdom Publications, 2000.

Bodhi, Bhikkhu (translator). *The Connected Discourses of the Buddha, A New Translation of the Samyutta Nikaya Vol II.* Translated by Bhikkhu Bodhi. The Pali Text Society, 2000.

Boowa, Venerable Acariya Maha Kammatthana. *The Basis of Practice.* Chuan Printing Press, 1995.

Bradbury, Ray. *The Illustrated Man.* Voyager Classics/Harper Collins, 2002.

Brown, C. Mackenzie. *The Triumph of the Goddess: The Canonical Models and Theological Visions of the Devī-Bhāgavata Purāna.* State University of New York Press, 1990.

Buddhaghosa. "Five Precepts of Buddhism." Translated by Edward Conze. Tricycle: The Buddhist Review. n.d.

Buddhaghosa, Bhadantácariya. *Visuddhimagga.* Buddhist Publication Society, 2010.

Buddharakkhita, Acharya (translator). *The Dhammapada: The Buddha's Path of Wisdom.* Translated by Acharya Buddharakkhita. Buddhist Publication Society, 1985.

Chadchaidee, Thanapol. *Thai Ghosts and Their Mysterious Power.* Booksmango, 2019.

Chang, Garma C. C. *The Hundred Thousand Songs of Milarepa.* Translated by Garma C. C. Chang. Shambhala, 1999.

Chaudhuri, Joyotpaul. "108 Steps, The Sino-Indian Connection in the Martial Arts." *Inside Kung Fu*, January 1991.

Churton, Tobias. *Aleister Crowley in India: The Secret Influence of Eastern Mysticism on Magic and the Occult*. Inner Traditions, 2019.

Cœdès, George. *The Indianized States of South-east Asia*. University of Hawaii Press, 1968.

"Coil: An Interview with John Balance by Tony Dickie." Compulsion Online. Accessed June 3, 2024.

Conway, Susan. *Tai Magic: Arts of the Supernatural in the Shan States and Lan Na*. River Books, 2014.

Conze, Edward. *Buddhist Scriptures*. Translated by Edward Conze. Penguin Books, 1959.

Coward, Harold. "The Meaning and Power of Mantras in Bhartrhari's Vakyapadiya," in *Understanding Mantras*. Edited by Harvey P. Alper. State University of New York Press, 1989.

Crowley, Aleister. "Berashith: An Essay in Ontology, with Some Remarks on Ceremonial Magic." in *The Collected Works of Aleister Crowley (1905–1907)*, Volume 2, Foyers Society For The Propagation Of Religious Truth. Printed by Ballantyne, Hanson & Co. at the Ballantyne Press, 1906.

Crowley, Aleister. *777 and Other Qabalistic Writings of Aleister Crowley*. Weiser Books, 1986.

Crowley, Mike. *Secret Drugs of Buddhism: Psychedelic Sacraments and the Origins of the Vajrayāna*. Amrita Press, 2016.

Cummings, Joe. *Sacred Tattoos of Thailand: Exploring the Magic, Masters and Mystery of Sak Yan*. Marshall Cavendish Editions, 2012.

Daniélou, Alain. *Gods of Love and Ecstasy*. Inner Traditions, 1992.

Davis, Erik. W. *Deathpower: Buddhism's Ritual Imagination in Cambodia*. Columbia University Press, 2016.

Denham, Val. *Dysphoria*. Vanity Case Records, 2013.

Denham, Val. *Tranart*. Timeless Editions, 2015.

Dickie, Tony. "Coil: An Interview with John Balance." Compulsion zine 1, no. 1, Winter 1992.

Djurdjevic, Gordan. "Secrecy in South Asian Hindu Traditions 'The Gods Love What is Occult.'" *The Routledge Handbook of Religion and Secrecy*. Edited by Hugh B. Urban and Paul Christopher Johnson. Routledge, Taylor & Francis Group, 2022.

Bibliography

Docena, Thea Lynn, Josef Christian Doquesa, Lorenzo Heramil, and Pamela Anne Isip. "One Art Two Fates: A Comparative Study on Thailand's Sak Yant and the Philippines' Batek." Academic research paper. Department of Sociology and Anthropology, Loyola Schools Ateneo de Manila University, 2018.

Drouyer, Isabel Azevedo, and René Drouyer. *Thai Magic Tattoos: The Art and Influence of Sak Yant: How a Belief May Change Your Life*. River Books, 2013.

Edwardes, Michael. *A Life of the Buddha: From a Burmese Manuscript*. The Folio Society, 1959.

Eoseewong, Nidhi. "Buddhism and Saiya," (Phut kap sai). Unknown journal and publisher, 1995.

Faerywolf, Storm. *The Satyr's Kiss: Queer Men, Sex Magic & Modern Witchcraft*. Llewellyn Publications, 2022.

Fitzgerald, Robert. *Sharp Practice: The Ritual Dagger in Bon Sorcery and Vajrayana Buddhism*. Three Hands Press, 2019.

Foll, C. V. "An Account of Some of the Beliefs and Superstitions About Pregnancy, Parturition and Infant Health in Burma." *Journal of Tropical Paediatrics 5*, no. 2 (1959): 51–59.

Foxeus, Niklas. "'I am the Buddha, the Buddha is Me. Concentration': Meditation and Esoteric Modern Buddhism in Burma/Myanmar." *Numen 63* (2016): 441–45.

Fuller, Thomas. *Gnomologia: Adagies And Proverbs, Wise Sentences And Witty Sayings, Ancient And Modern, Foreign And British*. T. and J. Alman, 1819.

Ganguli, Kisari Mohan. *The Mahabharata of Krishna-Dwaipayana Vyasa*. Translated by Kisari Mohan Ganguli. Project Gutenberg, 2005.

Gardner, Alexander. "Ra Lotsāwa Dorje Drakpa." The Treasury of Lives, 2009

Gardner, Gerald B. *Keris and Other Malay Weapons*. Orchid Press, 1936.

Gary, Gemma. *Wisht Waters: The Cult and Magic of Water*. Three Hands Press, 2013.

Gaynor, Mitchell L. *The Healing Power of Sound: Recovery from Life-Threatening Illness Using Sound, Voice, and Music*. Shambhala, 1999.

Gravers, Mikael. "Building Moral Communities in an Uncertain World, A Karen Lay Buddhist Community in Northern Thailand," in *Charismatic Monks of Lanna Buddhism*. Edited by Paul T. Cohen. NIAS Press, 2017.

Gray, Denis. "Thailand's Buddhist Nuns Fight for Equality." Nikkei Asia. Accessed May 27, 2024.

Grey, Peter. "Fly the Light." Paper presented at Psychoanalysis, Art & the Occult Conference London, United Kingdom, 2016.

Gombrich, Richard F. *Theravāda Buddhism: A Social History from Ancient Benares to Modern Colombo.* Routledge, 1988.

Goodwin, Charles C. and Hyaku Hachi No Bonno. "The Influence of the 108 Defilements and Other Buddhist Concepts on Karate Thought and Practice." *Furyu: The Budo Journal*, no. 7 (1996).

Guillou, Anne Yvonne. "Potent Places and Animism in Southeast Asia." *The Asia Pacific Journal of Anthropology 18*, no. 5 (2017): 389–399.

Gunaratana, Bhante. *The Four Foundations of Mindfulness in Plain English.* Simon and Schuster, 2021.

Harrison, Paul. "Meditation and Dissociation, What You Need to Know." The Daily Meditation. Accessed October 8, 2024.

Hartsuiker, Dolf. *Sadhus: The Holy Men of India.* Thames & Hudson, 2014.

Haug, Martin. *The Aitareya Brahmanam of the Rigveda.* Edited and translated by Martin Haug. Sudhindra Nath Vasu, M.B., 1922

Hay, Mark. "Permanent Buddhism: Buddhist Tattoos." Tricycle: The Buddhist Review. Accessed March 5, 2024.

Hengsuwan, Manasikarn, and Amara Prasithrathsint. "A Folk Taxonomy of Terms for Ghosts and Spirits in Thai." *Manusya: Journal of Humanities Regular 17*, no. 2 (2014): 29–49.

Hesse, Hermann. *Siddhartha: An Indian Novel.* Translated by Hilda Rosner. Penguin Books, 1922.

Hine, Phil. "On the 'Queering' of Ganesha." Enfolding. July 15, 2022.

———. *The Pseudonomicon.* New Falcon Publications, 2004.

Holroyd, Stuart. *Magic, Words, and Numbers.* Aldus Books, 1976.

Irons, Edward A. *Encyclopaedia of Buddhism.* Checkmark Books, 2008.

Ishii, Yoneo. *Sangha, State, and Society: Thai Buddhism in History.* Translated by Peter Hawkes. University of Hawaii Press, 1986.

Iyengar, Rishi. "An Indian Mob Threatened to Skin an Australian Man for His Hindu Goddess Tattoo." *Time.* Accessed May 27, 2024.

Jackson, Peter A., and Benjamin Baumann. "Worlds Ever More Enchanted, Reformulations of Spirit Mediumship and Divination in Mainland Southeast Asia," Introduction in *Deities and Divas, Queer Ritual Specialists in Myanmar, Thailand and Beyond.* Edited by Peter A. Jackson and Benjamin Baumann. Nordic Institute of Asian Studies Press, 2022.

Bibliography

James, William. *The Varieties of Religious Experience: A Study in Human Nature, Being the Gifford Lectures on Natural Religion Delivered at Edinburgh in 1901–1902*. Random House, 1902.

Jenx and Ajarn Metta. *The Thai Occult: Sak Yant*. Timeless Editions, 2017.

Jenx. *The Thai Occult*. Translations by Bon. Timeless Editions, 2018.

Jung, C. G. *Collected Works of C. G. Jung, Volume 14: Mysterium Coniunctionis*. Edited and translated by Gerhard Adler and R. F.C. Hull. Princeton University Press, 1970.

Kaviraj, Gopinath. *Aspects of Indian Thought*. University of Burdwan, 1966.

Keenan, David. *England's Hidden Reverse*. Strange Attractor Press, 2016.

Ketmunee, Ruesi, Ruesi Phuttavet, Ruesi Chaichatri, Phra Pattarayano, and Phra Jakkrit. *The Lost Wizards of Thailand* (documentary). Pahuyuth, n.d.

Khanna, Madhu. *Yantra: The Tantric Symbol of Cosmic Unity*. Inner Traditions, 2003.

Khuddaka Nikaya. *Therīgāthā* (Poems of the Elder Nuns). 6:4 Ninth book of the Khuddaka Nikaya. n.d.

Kitiarsa, Pattana. *Mediums, Monks, & Amulets, Thai Popular Buddhism Today*. Silkworm Books, 2012.

Krutak, Lars. *Spiritual Skin: Magical Tattoos & Scarification*. Edition Reuss, 2012.

———. "Master of Sak Yant: Ajarn Matthieu Duquenois." *Rise Tattoo Magazine* 39 (2015): 60–67.

Lastrucci, Francesco. "Inside the Thai Temple Where Tattoos Come to Life." *The New York Times*. Accessed March 7, 2024.

Leys, Simon. *The Hall of Uselessness: Collected Essays*. Black Inc, 2011.

———. *The Hall of Uselessness*. NYRB Classics. 2013.

Litha, Phya. *Trai Phum Phra Ruang* (or, the *Three Worlds According to King Ruan, a Thai Buddhist Cosmology*). Center for Southeast and Asian Studies, University of California, 1982.

Littlewood, Ajarn Spencer. *The Book of Thai Lanna Sorcery*. Buddha Magic Multimedia & Publications, n.d.

Littlewood, Ajarn Spencer. *Sak Yant Buddhist Tattoos - Sacred Geometry, Magic Spells, Animal Possession* by Ajarn Spencer Littlewood, self-published eBook, Thailand, 2010.

Magee, Mike. *Kali Magic*. Twisted Trunk, 2022.

Maitreya, Ananda. *The Dhammapada*. Translated by The Venerable Balangoda Ananda. Parallax Press, 1995.

Maslow, Abraham H. *Religions, Values, and Peak Experiences.* Ohio University State Press, 1964.

McDaniel, Justin Thomas. *The Lovelorn Ghost and the Magical Monk: Practicing Buddhism in Modern Thailand.* Columbia University Press, 2011.

———. *Wayward Distractions: Ornament, Emotion, Zombies and the Study of Buddhism in Thailand.* NUS Press in association with Kyoto University Press, 2021.

Mettēya, Ānanda Bhikkhu. *Selected Writings of Allan Bennett, Bhikkhu Ananda Metteya (Volume 2 of Allan Bennett, Bhikkhu Ananda Metteya: Biography and Collected Writings).* Equinox eBooks Publishing, 2024.

———. *The Religion of Burma and Other Papers 1929.* Theosophical Publishing House, 1929.

Ñâĸ Hǎeng. "Luang Phor Pinak Piyataro." Regalia Thai. Accessed November 27, 2023.

Ñanasampanno, Ajaan Maha Boowa. *Forest Dhamma: A Selection of Talks on Buddhist Practice.* Translated by Ajaan Paññavaddho. Forest Dhamma Books, 1999.

Narajo, Claudio, and Robert E. Ornstein. *On the Psychology of Meditation.* Viking Press, 1971.

Odier, Daniel. *Tantric Quest: An Encounter with Absolute Love.* Translated by Jody Gladding. Inner Traditions, 1997.

Patterson, Ryun. *Vanishing Act: A Glimpse into Cambodia's World of Magic.* Blurb, 2015.

Patterson, Steve. *Cecil Williamson's Book of Witchcraft: A Grimoire of The Museum of Witchcraft.* Troy Books, 2014.

Patton, Thomas Nathan. *The Buddha's Wizards: Magic, Protection, and Healing in Burmese Buddhism.* Columbia University Press, 2018.

Payutto, Bhikkhu P. A. *Buddhadhamma: The Laws of Nature and Their Benefits to Life.* 1995.

———. *Buddhadhamma.* Translated by Robin Philip Moore. Buddhadhamma Foundation, 2021.

Reed, Jeremy. *Altered Balance: A Tribute to Coil.* Infinity Land Press, 2015.

Rosseels, Lode. "Gaṇeśa's Underbelly: From Hindu Goblin God to Japanese Tantric Twosome." University of Ghent, 2015–2016.

Rukmani, Dr. T. S. *Yogasutrabhasyavivarana of Sankara Vivarana Text With English Translation and Critical Notes Along with Text and English*

354 *Bibliography*

Translation of Patanjali's Yogasutras and Vyasabhasya (2 Volume Set). New Delhi, India: Munshiram Manoharlal Publishers, 2001.

Sayadaw, Mahasi. "Teaching of the Buddha-Sāsana." *Lectures by Mahasi Sayadaw on World Missionary Tour.* The Selangor Buddhist Vipassana Meditation Society, 2018.

Schaik, Sam. *Buddhist Magic - Divination, Healing, and Enchantment Through the Ages.* Shambhala, 2020.

Shastri, Satyavrat. *Studies In Sanskrit And Indian Culture In Thailand.* Parimal Publications, 1982.

Sidisunthorn, Pindar, Simon Gardner, and Dean Smart. *Caves of Northern Thailand by Pindar Sidisunthorn.* River Books, 2006.

Sim, David. "India: The intricately tattooed bodies and faces of low caste Ramnami Samaj Hindus." International Business Times (UK). Accessed May 27, 2024.

Simeoni, Manuela. "Use of the Latin Word Superstitio Against Pagans." Wayback Machine. Accessed March 5, 2024.

Smith, Frederick M. *The Self Possessed: Deity and Spirit Possession in South Asian Literature and Civilization.* New York: Columbia University Press. 2006.

Snyder, Gary (1961), "Buddhist Anarchism." *Journal for the Protection of All Beings #1.* City Lights, 1961.

Some Bizzare Records (various artists). *If You Can't Please Yourself You Can't, Please Your Soul.* 1985.

Sotthibalo, Venerable Ajahn Kukrit. *Buddhawajana: Sotāpanna Handbook, Volume 2.* Buddhakos Foundation, n.d.

Soulsby, Nick. *Everything Keeps Dissolving: Conversations with Coil.* Strange Attractor Press, 2022.

Spare, Austin Osmond. *The Book of Pleasure (Self-Love): The Psychology of Ecstasy.* Self-published, 1913.

Spiro, Melford E. *Burmese Supernaturalism: Expanded Edition.* Routledge, 1978.

Stengs, Irene. "Collectible Amulets: The Triple Fetishes of Modern Thai Men." *Etnofoor,* vol 11, no.1 (1998), 55–76.

Stiles, Mukunda. *Yoga Sutras of Patanjali.* Interpreted by Mukunda Stiles. Weiser Books, 2021.

Subramuniyaswami, Satguru Sivaya. *Dancing With Siva: Hinduism's Contemporary Catechism.* Himalayan Academy, 1993.

Tambiah, Stanley Jeyaraja. *Buddhist Saints of the Forest and the Cult of Amulets: A Study in Charisma, Hagiography, Sectarianism, and Millennial Buddhism.* Cambridge University Press, 1984.

Terwiel, Barend Jan. *Monks and Magic: Revisiting a Classic Study of Religious Ceremonies in Thailand.* Fourth revised edition. NIAS Press, 2012.

Thera, Venerable Kiribathgoda Gnanananda. *Mahamevnawa, Pali-English Paritta Chanting Book.* Mahamegha, 2015. Accessed 4 July 2024.

Thin, Daniel Ilan Cohen. "The Fine Print on Thai Tattoos." Tricycle Magazine, Spring 2022, Accessed March 5, 2024.

Tiyavanich, Kamala. *Forest Recollections, Wandering Monks in Twentieth-Century Thailand.* University of Hawaii Press, 1997.

Tully, Caroline. "The Importance of Words and Writing in Ancient Magic." Necropolis Now, 2009.

Van der Leeuw, Gerardus. *Religion in Essence & Manifestation: A Study in Phenomenology.* George Allen & Unwin, 1938.

Vyasa. *The Mahabharata,* Book 3 (Vana Parva), Section CLXXXIX. Translated by Kisari Mohan Ganguli. 1883–1886.

Waite, A. E. *The Pictorial Key to the Tarot.* William Rider & Son Ltd., 1910.

Walsh, Roger N. *The Spirit of Shamanism.* Mandala, 1990.

Wannakit, Nittaya, and Siraporn Nathalang. "Dynamics of Power of Space in the Tai-Yuan Chao Luang Kham Daeng Spirit Cult." *Manusya: Journal of Humanities, Special Issue,* no. 19 (2011).

Wasserman, James. *Hasan-i-Sabah: Assassin Master.* Ibis Press, 2020.

Watson, Burton. *The Lotus Sutra.* Translated by Burton Watson. New York: Columbia University Press, 1993.

Witzel, Michael. "R̥sis, the Poets of the R̥gveda." *Brill's Encyclopaedia of Hinduism.* Edited by Knut A. Jacobson. Leiden, 2009.

Yorke, Gerald. *Aleister Crowley, The Golden Dawn and Buddhism: Reminiscences and Writings of Gerald Yorke.* The Teitan Press, 2011.

Zed, Sheer. "It's All Down in Black and White, Thai Lanna Buddhist Occult Tattoos of Magickal Power." *Conjure Codex* volume 1, no. 5. Edited by Jake Stratton-Kent, Dis Albion, and Erzebet Barthold. Hadean Press, 2022.

———. "Magical Violence Within Buddhist and Eastern Philosophy." *Rituals & Declarations* volume 2, no. 3. The Lazarus Corporation, 2021.

———. "My Life as a Warder in the London Dungeon." *Rituals & Declarations* volume 2, no. 2. The Lazarus Corporation, 2021.

———. "On Being a Shaman." *Indie Shaman* 49, (2021).

———. *Thai Occult Road Trip.* 2019.

———. "Working With and Collecting Thai Lanna Buddhist Amulets." *Rituals & Declarations* volume 2, no. 1. The Lazarus Corporation, 2021.

Zimmer, Heinrich Robert. *Eternal India: Leitmotifs of Indian Existence.* Müller & Kiepenheuer, 1920.

WEBSITES

magiathai.com

thewarriorshouse.com

sakyantchiangmai.com

Index

Page numbers in *italics* refer to illustrations.

abortion, 212

Aghori sect, 48

Ajarns. *See also individual Ajarns*
 as Buddhist technicians, 260
 defined, 2
 secrets of, 260
 typical time as monks, 7

Ajna Chakra, 297

Akha Ama Coffee, 202–3

Akhara script, 146

A Klongkarn, Ajarn, 314–18

Alakshmi, 47

Amanita muscaria, 204–5

Amrita, described, 204

amulets, *65*
 author's work with as intuitive,
 344–45
 Bao Boon Chim, 67
 Baphomet Prai, 252–53
 blessed by the guru, 94
 Cat Yant Prai Nine Takrut, 249–52
 Centipede, 174–75
 Dao Star, 63–68

Duang Ta Pra Arahant, 345

Elise, 88–90

Garuda, 235–36

Hoon Payon, 56–57, 90–91

Jing Jok, 75

Kālī, 300–301

Khun Paen, 281

Kuman Thong, 88–89

Luang Phor Tuad, 324

necessary training for using, 88

Nine Cat Yantra Takrut Prai,
 289–90

Ong Kru Ghost Bone, 213–14

Ouroboros, 175

Panneng amulets, 54–55

Phra Ngang Panneng, 54–55

power of, 87–94

Prai Krasip, 57, 91–92

Rahu, 235, 271

Scorpion, 174

Takrut Mah Ga Saton Glab, 283

they choose you, 87, 94

three Mae Surasatee, 193–94

358 *Index*

tiger, 295
 as votive tablets, 88
amulet trays, in Chiang Mai, *71*, 72
Ananda Metteya, 263
anattā, 334
Anderson, Benedict, 172
anicca, 334
animism/animistic devotion,
 43–44
Apichai, Ajarn, 76–80, *93*, 132–36,
 161–62, 176–77, 240–43
 his hybridization, 252–53
 on the Narai Plik Pan Din ritual,
 240–41
arahant/arhant, defined,
 61, 345
Ardhanirashvara, 301
Atharva Veda, 303
Ayurveda, 113

Balance, John, 30–31, 204
Bao Boon Chim amulet, 67
Baphomet Prai amulet, 252–53
baramee, defined, 273
Bennett, Charles H. A., 20–21
Bessac, Stephen, 212
black (color), 46–47
black magick, 46–52
Blake, William, 341
Blavatsky, Helena Petrovna, 261
Bön religion, 49
Borikam Phawana, defined, 235
Bradbury, Ray, 331
Brisnoodles, 158
buchas, 114
 defined, xiv, 190

Buddha, 255
 Buddhas at Chiang Dao Caves,
 Plate 2, *Plate 3*
 defined, 4–5
 Golden Buddha at Wat Phra That
 Doi Kham, *Plate 5*
 Golden Buddha at Wat Sri Don
 Moon, *Plate 31*
 hair of the, 180
 images of the Buddha, 246–47
 placement of, 339
Buddha statue
 at Chiang Dao Caves, 219, *221*
 in a window, 341
Buddhism, 4–6, 31, 335. *See also*
 Thai Buddhism; Zen Buddhism
 beliefs of, 340
 introduction into Thailand, 44–45
 magick as always part of, 45–46
 and miracles, 264
 origins of, 45–46
 and Thai magick, 42–52
Buddhist precepts, 4, 31
 and Sak Yant, 4–6
Buddhist statue, containing 180
 artifacts, 244
Buddhist symbols, Western misuse of,
 12–13

Cabaret Voltaire, 29
Carradine, David, death of, 18–19
catfish ritual, 182–84, 194–96
cats, 250–51
Cat Sìth, 250
Cat Yant Prai Nine Takrut amulet,
 249–52

Cat Yants, 250–51
Cave of the Holy Water Pool of Somdet To, 344
Centipede amulet, 174–75
Centipede Sak Yant, 119–21
chanting, 336–38
Chao Luang Kham Daeng cult, 101
Chao Mae Tuptim shrine, 18–19
Chiang Dao Caves, 99–103, 218–20
 Buddhas and Nāga deities, *Plate 3*
 Buddhas at, *Plate 2*
 rock formation at, *102*
Chiang Dao district, 209
Chiang Dao Temple, *Plate 11*, *Plate 18*, 209–15
 Hell Garden in, *Plate 12*, 209–15
 Rahu statue at, 214–17
Chiang Mai
 back streets, *203*
 described, 70
 environmental issues of, 222–23
 history of, 204
chicken soup, 140
Chin Athan, defined, 54
Christopherson, Peter, 30–32, 35, 181, 204, 253–54
Coil (band), 29–31, 41, 181, 204
corpse meditation, 265–66
 purpose of, 266
COVID-19, beginnings of, 228, 238
Crowley, Aleister, 20–21, 48, 261, 263
Crowley, Mike, 204
Csikszentmihalyi, Mihaly, 268
cultural appropriation, 14–16

Daeng, Ajarn, *Plate 20*, 117–21, 224–26, 272–76, 328–32
 applying Sak Yant, 171–72, *331*
 biography, 118
 Samnak of, 117
 and Yant Soi Sangwan Sak Yant, 197–201
Dalai Lama, 33
Daniélou, Alain, 302
Dao Star amulet, 63–68, *65*
Davies, Owen, 160
death and dying, 123–25
death awareness, in Buddhism, 265
Death King Phya Yom, *Plate 17*, 209–10, 232
Denham, Val, 28n*
Dhammapada, The, vi
Dharma, defined, 5
dirty khatha, defined, 59
dissolute, meaning of term, 68–69
divine messengers, 232–33
"Do You Believe in Magic?" exhibit, 156–59
Drouyer, Isabel Azevedo, 6–7
Drouyer, René, 6–7
Duang Ta Pra Arahant amulet, 345
dukkha, 232, 255, 334

elders, 261
Electro Punk '86, 83
Elise amulet, 88–90
enlightenment, 340
Entwistle, John, 27–28
Eoseewong, Nidhi, 301
Euterpe, 342

fetter, defined, 255
first pilgrimage (author's), 59–85
Five Buddhist Precepts, 207–8, 317,
 340–41
Five Great Violations, 340–41
flow experiences, 268
Four Immeasurables, 317
fourth pilgrimage (author's), 267–334
 author's aim for, 268
full back
 author's, *Plate 29*, *333*
 defined, 328
Fuller, Thomas, 250

Ganesha
 as androgynous, 302–3
 eleven manifestations of, 299
 popularity in Thailand, 228
 ritual at Shiva Brahma Narayan
 Temple, 298–301
Ganesha Himal Museum, 296–98
 incense ritual at, 297, *297*
Ganesha shrine, *Plate 30*
Ganesh Chaturthi event, 301
Ganga, 259
Gan Suam Takrut, 173
Gardner, Gerald, 263
Garuda, *Plate 6*, 235–36
 and Vishnu, *Plate 7*
Garuda amulet, 235–36
Gary, Gemma, 343
gender discrimination, 301–2
Ginsberg, Allen, 21
gohonzon, defined, 33
Golden Buddha at Wat Phra That
 Doi Kham, *Plate 5*

Golden Buddha at Wat Sri Don
 Moon, *Plate 31*
golden koi, 196–97
Golden Temple, The, 165–67
gold leaf blessing (of author),
 Plate 27, *Plate 28*, 310–12, *311*
gold ritual blessing, from Lersi
 Nawagod, 280–82
Gordon, Matthew, 12–13
Griffiths, Muriel (author's mother),
 265–67
Guillou, Anne Yvonne, 43–44
Gupta, Sanjukta, 47

hair of the Buddha, 180
Hawkins, Alex, 155
Helgö, Buddha statuette found in,
 260–61
Hell Gardens, *Plates 12–17*, 207–12,
 217
 at Chiang Dao Temple, 209–15
 described, 207–8
 reasons for their existence, 217
 at Wat Mae Kaet Noi, 230–33
 Wat Mae Ta Khrai, 324–27
Hine, Phil, 302–3
Hiranyaksha, 241
hitting, in a spiritual relationship,
 147–48
holy water cleansing, *291*
Hoon Payon, 56–57
Hoon Payon amulet, 56–57, 59,
 90–91
"How Many Must One Cut?",
 248
Huen Muan Jai, 206–7

Index 361

hungry ghosts, 324–26
hybridization, as future of Thai
 magick, 252–53

If You Can't Please Yourself . . ., 28–30
Illustrated Man, The (Bradbury), 331
interconnectedness, 342
invisibility, 63

jackfruit, 251
James, William, *275*
Jing Jok amulet, 75, 92
Jing Joks, described, 92
Jing Jok Sak Yants, 133–38
 author's, 133–38, *134*
Jolie, Angelina, 8
Jung, Carl, 157

Kālī amulet, 300–301
Kan-kuen, 275, *275*
Karen (reader), 55–56
karma, 90, 133, 232
Kasina, defined, 235
Kasin Fai ritual, 78–80
Kaviraj, Gopinath, 336
Keris, 143–46
Kerouac, Jack, 21
Kesey, Ken, 164
Ketu, 215
khathas, 91
 defined, 9, 54, 64–65
Khom Pali script, 243
Khruba Siwichai, 180–81
Khru Kai Kaew, 288
Khun Chaiwat Wannanon, 123
Khun Paen, 161–63, 176

Khun Paen amulet, 281
Khun Paen Khrong Muang Yant,
 176–77
Khun Phen Chom-Talat Sak Yant,
 15, 332
Kom curse ritual, 132–33
Kong Grapan, 213
Kraftwerk, 27
Krathong, defined, 259
Krit Payak, Ajarn, 213
Kruba, defined, 125
Kruba Kampeng, 234–35
Kruba Noi, 282–84
 biography, 283
Kruba Pad, 283
Kruba Pornsit, 192, 280, 285
Kruba Teainchai, 319–24
Kruba Tue, 306–7
Kruba Wong, *Plate 8*, 125–26
Krū Khmer, 50–51
Kulai chedi, 206
Kuman Thong amulets, 88–89
kundalini, 175
Kung Fu, 18

Lamphun, history of, 304
league of five amulets, 305
Leeuw, Gerardus van der, 336
Lek Nam Phi, 143
Lek Nam Phi bracelet, 271
Lek Nam Phi shrine, *Plate 23*
Lersi, 107–8, 109–13, *111*
Lersi Day, 107–8
Lersi deities, 108–9
Lersi Ganesha head, *Plate 20*
Lersi heads, *Plate 20*, *309*

362 *Index*

Lersi Nawagod, 276–82
 biography, 279
 shrine of, *Plate 19*
Leys, Simon, 163
LGBTQ issues, 212, 301–3
lightning wood, 114
Littlewood, Ajarn Spencer, 217
Liu Quan, 245
"Lost in Exotic Pastures" (Zed), 96
lotus position, 247
Loy Krathong ritual, 259
Luang Pho Poen, 6
Luang Phor Pina, 60–64, *61*, 66–68,
 85–86, 123–25, 208
Luang Phor Thongdam, 108
Luang Phor Tuad, 320–22, *323*
Luang Phor Tuad amulet, 324
Luang Pi Nunn, 5–6
Luang Pu Suk, 176
Luan Phor Tavee, 213

Mae Surasatee, 9, 160, 287, 342–43,
 345–46
 appropriate offerings for, 193–94
 described, 75–76
 Sak Yants of, 182–94, *191*
Mae Surasatee amulets, 193–94
Mae Surasatee bucha, 190–93
Magia Thai, author establishes
 connection with, 267–70
magick. *See also* amulets; Sak Yant;
 Thai Buddhism
 black, 46–52
 defined, 159–60
 and hybridization, 252
magickal candle ritual, 258–59

magickal mapping, 335
magickal shops, 70–71
Mahāsi Sayadaw, 330
Maha Thammaracha I, 233
mantras, 337–38
 defined, 40–41, 47
 described, 337
 enemy distruction mantra,
 47–48
Margaret (author's neighbor), 239
Marie, Tina, 105–6
Marpa, 48–49
Maslow, Abraham, 268
materialism, 1
meditation techniques, 25, 337–38
Meed Haek, 145
menstruation, 11–12
merit, 307–8
Metta, 213–14, 224
Mihira, Vara, 113
Miit Mhors, defined, 142
Milarepa, 48–49
miracles, and Buddhism, 264
misuse of symbols, 12–13
Mongol hordes, defeat of, 49–50
Muang On Caves, Jedee Mae Nomm
 Fah stalagmite, *Plate 4*
Muay Thai Fighter Spirit, *144*
music
 author and, 26–32, 83, 96
 author's love for, 342
 and the occult, 28

nāga, at Chiang Dao Temple, *Plate 18*
"Nam Myoho Renge Kyo," 36–38
Na Naa Thong ritual, 77–79

Nanting, Ajarn, 75–76, 182, 258, 284–89, *285*
 applying Sak Yant, *286*
 Loy Krathong ritual, 259
 and Mae Surasatee Sak Yants, 184–94
Narada, 111–12
Narai Plik Pan Din ritual, 240–43
Naresuan the Great, King, 262
Ngiew Tree, 210
nibbāna, 255
Nichiren Buddhism, 33, 36–38
Nichiren Daishonin, 36–37
nine (number), 250
9 face Lersi Roop Lor Nur Ngern, 108
Nine Cat Yantra Takrut Prai amulet, 289–90
Nooke, Adrian, 158–59
Nyanadhammo, Ajahn, 341

Occcam's razor, 237–38
Odier, Daniel, xiii–xiv
Ōṁ, 40–41
Ōṁ ring, 298
108, 112
Ong Kru Ghost Bone amulet, 213–14
Ong Kru Khun Paen amulet, 161–63
Ouroboros, 175
Ouroboros amulet, 175
overtoning, 40

Pali Canon, and magick, 263
pandemic, beginnings of, 238, 2228

Panneng amulets, 54–55, 77
parajikas, 211
Parikrama, defined, 307–8
Payaa Kai Daeng Sak Yant, 285–87
peak experiences, defined, 268
peninsula, defined, 43
Perm Rung Wanchanna, Ajarn, 234–36, 308–13
Phantai, 240–41
Pha Yant, 76
 defined, 71
 described, 137–38
Phi Pret, 210
Phjra Lersi Narot, 111
Phra Khan well, 143
Phrakru Arkchakit Sopoon, 67
Phra Mae Khongkha, 259
Phra Nang Chamma Thewi, Queen, 305
Phra Na Wat, 212–13
Phra Ngang, 114–15, *115*
 described, 54–55
Phra Ngang amulet, 54–55, 87
Phra Ngang bucha, 157
Phra Ngang Penneng amulet, 114
Phra Rahu Kan-wan, *Plate 11*, 275, *275*
Phra Sa'ad, 230
Phra Suriya, 213–14
phra thudong, 315
phra thudong kammathan, 315
Phutthawat, defined, 122
pilgrimage
 the nature of, 1
 and Sak Yant, 9

364 *Index*

pilgrimages, author's. *See* first
 pilgrimage; second pilgrimage;
 third pilgrimage; fourth
 pilgrimage
 the impetus for, 163–64
 the year between, 153–60
Pluuk Sehk, defined, 119
Polley, Jason, 12
Por Gae Lersi Thai Fai head, *Plate 26*
Power, defined, 172
Prai Krasip amulet, 57, 91–92
Prapod Assavavirulhakarn, 44–45
preta, *Plate 16*, 324–26, *325*
 defined, 326
protections, magickal, 237, 244
psychometry, 155
Pujo Samingprai Tiger faced Lersi
 bucha, 149

queer spirituality, 301–3

Rahu, 214–17, 242
Rahu amulet, 235, 271
Rahu statue, at Chiang Dao Temple,
 214–17
Ra Lotsāwa Dorje Drak, 50
Ramayana, The, 113
Ramnamis, 14
reading, importance of, xiii
recordings of the author, 83–84
"Red Flower" Sak Yant, *Plate 22*, *285*,
 287
remote rituals, 257–64
 impact of, 257
retirement visas, 230
Rig Veda, vi

Rishis, 109–10
 defined, 277
rituals, remote, 257–64
Rod, defined, 305
Ronnie, 56, 81–82, 84, 96. *See
 also* first, second, and third
 pilgrimages
 author meets, 53–54, 60
 in Chiang Mai, 70–80
 ending of the relationship with the
 author, 246–47
rooster statues, *Plate 24*
Ruesis, 109–13
 described, 109–10
rules of conduct
 for Buddhist monks, 211
 given by Ajarns, 10

sacred spaces, 338–39
Sacred Tattoos of Thailand
 (Cummings and White), 14
Sadhu Amulets, 70
Saiyasart, defined, 176
Sak Yant. *See also specific Sak Yants*
 author's final five from Ajarn
 Daeng, 273–76, *274*, *275*
 and Buddhist precepts, 4–6
 defined, xiv
 forms of, 1–2
 hazards of, 3
 influences on, 6
 integrity of, 8–9
 as magickal software, 3
 maintaining power of, 9–10
 prerequisites for, 2, 5–6
 as real magick, 16

rules for applying, 171–72
spiritual power of, 119
you become the, 226
samādhi, 338
defined, 177, 315
types, 177
Samnak
defined, 74
described, 172–73
saṃsāra, defined, 255
Sangha, defined, 5
Sankhawat, defined, 122–23
Saraswati, 342–43, 346
and Mae Surasatee, 185–86
Satsana Phi beliefs, 143
Satti-Panna, 338
Satuang ritual, 75, 258
and catfish, 182–84, 194–96
Saty Vrat Shastri, 304
Scorpion amulet, 174
sculptures, placing objects in, 244–45
second pilgrimage (author's), 95–152
See Pung, 192
Serm Duang, 224
Serm Duang ritual, 104–7, 257–58,
 271
Shakyamuni, origin of name, 245n*
Shaman Bookshop, The, 319
Sheeran, Ed, and Sak Yant, 7–8
Shinde, Eknath, 47
Shiva Braham Narayan Temple,
 298–301, 304
Ganesha shrine at, 299
shrines, 338–39
and use of water, 343
Sihuhata, 316–17

silence, 335–38
sin, 339–40
sinners, *Plate 14*, *Plate 15*
skeleton, praying, *231*
Smith, Frederick M., 190
Snyder, Gary, 21
soft power approach, 7
Somdet To, 343–44
Sompoi, 9, 317–18
sotāpanna, 255, 342
sound, power of, 335–38
spaces, sacred, 338–39
Spare, Austin Osman, 20, 263
spirit houses, described, 141–42
stream-enterer, 238–39, 255, 342
Suea, Ajarn, 3, 74–75, 104–7, 114–16,
 150, 168–70, 223, 239, 270–72
biography, 104–5
remote rituals by, 257–58
and Satuang ritual, 182–84,
 194–96
and three-lined Yant Soi Sangwan,
 169–71
Suea Saming, 214
Suea Yen, 214
Suea Yen ritual, 289–95, *293*
suffering, 232
supernatural phenomena, 63
Suthep, Ajarn, 314–18
syncretism, defined, 42

Takrut
defined, 243
Gan Suam Takrut, 173
uses for, 244
Takrut belt, defined, 76

366 Index

Takrut Mah Ga Saton Glab amulet,
 283
Takrut needles, 312
 defined, 96
 gold, 312
Takrut ritual, 243–48
Tambiah, Stanley, 94
tantra, defined, 47
Tantric Quest (Odier), xiii–xiv
tarot readings, 157–58
tattoo guns, vs. rod, 170–71
tattoos, spiritual. *See also* Sak Yant;
 Thai magick
 traditions of, 2–3, 14
tattoo tradition, 2–3
Taw Waes Suwan, *Plate 1*, 310
Teerakanon, Pundhorn, 296
Thach Saing Sosak, 52
Thai Buddhism
 described, xiv
 magick in, 262–64
 Thai Lanna Buddhism, 187–88,
 254
 viewed as a whole, 262–64
Thai magick
 and Buddhism, 42–52
 sources of, 42–44
Thai Occult Road Trip (album), 156
Tham Bo Nam Mon Somder,
 343–44
Theosophical Society, The, 261
Theravada, described, 261–62
third pilgrimage (author's), 152,
 161–236
Thotsaphon Changphanitkun, 228
three jewels of Buddhism, 4–5, 176

three marks of existence, 334
Three of Swords, 105–6
three poisons, 339–40
Tibetan black magick, 49–50
Tibetan Book of the Dead, The,
 125
tiger amulet, 295
tigers, in Thai culture, 315
tilak, 318
Tilaka, described, 297
Ting, Ajarn, *Plate 21*
Tomasin, Jenny, 155–56
Tui, Ajarn, 249, 258–59
 making an offering to, *Plate 25*
 and Suea Yen ritual, 289–95
Tully, Caroline, 40

unalome symbol, 198

Varaha, 240–41
Vayne, Julian, 159
Violations, Five Great, 340–41
violence, magickal, 46–52
Visarjan ritual, 301
Vishnu, 241
 riding Garuda, *Plate 6*, *Plate 7*
visualization techniques, 246
Voraman, Ajarn, 298, 301–3

Waite, A. E., 105
wat, described, 122–23
Wat Bang Phra, rules of conduct,
 10–11
water, and shrines, 343
Wat Mae Kaet Noi, 230
 Hell Gardens of, 230–33

Wat Mae Ta Khrai, 319–27
 described, 320
 Hell Garden of, 324–27
Wat Pha Lat, 227–28
Wat phra Mahwan Woramahawihan, 305–6
Wat Phra Phutthabat Huai Tom, 123–27
 inner temple, *Plate 9*
Wat Phra Singh Woramahawihan, 205
 Golden Chedi of, *Plate 10*
Wat Phra That Doi Kham, 165–67
 Golden Buddha at, *Plate 5*
 standing Buddha at, *166*
Wat Phra That Doi Saket, 122–23, *124*
Wat Pradoo Roeng Tam, 262
Wat Sanomlao temple, 60–64
Wat San Pa Yang Luang, 307
Wat Sri Don Moon, 282–83
 golden Buddha at, *Plate 31*
Wat Tham Muang On Caves, 178–81
Wat Umong, 82
Weizza, 186–87
Wicha, defined, 176
Wihan Lai Kham, 205–6
Williamson, Cecil, 263
witch hunts, 51
Wolf Moon, 345
women
 in Buddhism/Buddhist magick, 11–12
 discrimination against, 212, 301–2

word, sacred, 336
writing, as exorcism, xiii

Ya Chin Da Manni, 309–10
Yama, *Plate 13*, 67, 232–33
Yant. *See also* Sak Yant
 most celebrated round Yant, 225–26
Yant Ittipiso Paed Tidt, 224–26, *226*
Yant Kru, 176
Yant Phra Lak Na Thong Sak Yant, 118–21
yantras, defined, 2–3
Yant Soi Sangwan Sak Yant, 197–201, *199*
Yant Takaab, 119–21
Yoga Sutras of Patanjali, 269

Zed, Sheer (author). *See also individual events and places*
 and chanting, 36–39, 95–96
 early interest in Buddhism, 95–96
 early life and influences, 17–41
 early spiritual experiences, 17–18
 effect of rituals on his life, 240
 ending of relationship with Ronnie, 246–47
 ends cannabis use, 154
 father of, 22–24
 father's death, 53, 56, 74
 first introduction to magick, 22–23
 first Sak Yant, 75–76
 full back, *333*
 his transformation into a magickal being, xiv, 254–55
 literary inspirations for, 20–21

at the London Dungeon, 33–35
mother's death, 265–67
and music, 26–32, 83, 342
and Nichiren Buddhism, 36–38
out of body experiences, 24–25
personality of, 105–6
quits drinking, 85–86
recordings of, 29, 39, 83–84, 96
ritual for his mother, 239

Ronnie met by, 53–54
sonic quest of, 335–38
vision of grandfather, 38–39
visitation by sādhu (dream), 36
as Warder, 33–35

Zen Buddhism, 147–48
Zopa Rinpoche, Lama, 46